* A Year at the Movies *

A Year at the Movies

ONE MAN'S FILMGOING ODYSSEY

Kevin Murphy

HarperEntertainment
An Imprint of HarperCollinsPublishers

HarperCollins books may be purchased for educational, business, or sales promotional use. For information please write: Special Markets Department, Harper-Collins Publishers Inc., 10 East 53rd Street, New York, NY 10022.

FIRST EDITION

Designed by Adrian Leichter

Library of Congress Cataloging-in-Publication Data
Murphy, Kevin, 1956–
 A year at the movies : one man's filmgoing odyssey / Kevin Murphy.—1st ed.
 p. cm.
 ISBN 0-06-093786-6
 1. Motion pictures. I. Title
PN1994 .M83 2002
791.43—dc21 2002024229

 05 06 ❖/RRD 10 9 8 7 6 5

For Julie and Bill, my mom and dad.
And for the audience.

Prologue
December 31, 2000

Beginning tomorrow, January 1, 2001, I, Kevin Murphy, promise to go to a theater and watch a movie every single day, for an entire year. In fifty-two chapters, one for each week of the year, I'll explore the world of moviegoing from the point of view of you and me, the regular crowd, the great demographic ocean. I will endeavor to experience every conceivable type of moviegoing venue, from the mundane to the unique to the ridiculous, no matter where it takes me.

I will track down and visit the smallest movie theater in the world.

I'll work at a multiplex for a short, painful stint.

There's a theater in an igloo in Quebec. I have to go.

2 • KEVIN MURPHY

I'll venture to Sundance and Cannes with no credentials and stand in line with the rest of the noncelebrity schmucks just trying to get a ticket.

I'll live on nothing but movie theater food for a week.

I've found a tiny ninety-year-old silent theater in the Australian bush. I'm there.

I'm not planning to see a *different* movie in a different *theater* every day. I don't see the point, unless what I'm doing is a stunt, which it isn't. Okay, maybe a little. But I want to be able to crawl around my local multiplexes and see what makes them tick. I want to be known by name at my favorite venues. I want to explore the same film under different conditions; for instance, I want to know if date movies still exist, so I plan to take seven women out on a date to the same movie, much to the consternation of my spouse, Jane.

But I will, every day, endeavor to see the public presentation of at least one motion picture.

In a theaterless emergency, I'll deploy my lifeboat: a pair of compact movie projectors, one 8mm and one 16mm, and a case of vintage films in both formats, which I'll carry everywhere I travel. I'll put up the screen, get some chairs, and invite anyone within shouting distance to the Lifeboat Cinema. Admission is free.

Since I'll be traveling on long overnight plane flights—in coach, mind you—to explore the moviegoing world, I will be counting airline films, since they are after all motion pictures exhibited publicly, albeit in the world's most expensive movie theaters.

I'm ready and raring to go. For the entire month of December I have engaged in a movie fast. Giving up movies is harder for me than abstaining from talking. I found myself calling my brother Chris, who teaches religion at Boston College, to see if there was some spiritual basis for a dispensation so I could watch *It's a Wonderful Life*. No dice. So, I am dying to get out there.

I'll witness nearly all of Hollywood's theatrical releases next year, plus tons of independents, shorts, festivals, animations, church screenings, sneak previews, and revivals. I'll watch 'em all.

This isn't just a trip to the local chain, this is an expedition.

• • • • •

So why am I doing this? What the hell is my deal, anyway?

Over the course of ten years on the TV series *Mystery Science Theater 3000*, I hefted a fifteen-pound plastic puppet over my head for an obscene amount of money. I was also party to the review, in whole or part, of some three thousand six hundred fifty movies—roughly one movie per day, every day, for ten years.

Mostly they were bad films, but that was the intention; often I would leave work with a sort of audiovisual numbness not dissimilar to placing an iron directly on the brain tissue and hitting the burst-of-steam button.

I was losing my taste for movies.

When the series ended in 1999, and I returned to the theaters, I didn't like what I was seeing. Multiplexes were erupting around me like massive concrete sores. I began to notice fewer and fewer people happy as they left the theater, including me.

Something had to be done, and I was the man to do it. Ten years of cinematic sink-trap sludge had steeled me for it. *MST 3K* made me a movie iron man. A cinematic decathelete. And now I needed a challenge worthy of my mettle.

We've forgotten how to watch movies. We go to the multiplex, stare at the menu board, trundle off, stand in line, buy the snacks, sit down, stare at a large screen in a black box. It's like watching television in public.

Worse, from the inside, *all theaters look the same*. Even fine old movie palaces, starkly updated, creep toward uniformity, like Wal-Marts and allergy clinics. You could club me on the head in screen twelve of the Mall of America 14, bind me, gag me, blindfold me, fly me to Manhattan, and dump me at screen five of the Times Square AMC 25, and I wouldn't know the difference until I stepped outside.

With the exception of that small and passionate band of American cinephiles—and you know who you are—we're buying products rather than experiences.

Why am I no longer satisfied when I walk out of a film, even a good one? When was the last truly memorable experience I had watching a film?

In the cold spring of 1981, while attending grad school in Madi-

son, Wisconsin, my cousin Billy finagled us tickets to a sneak preview of a "Steven Spielberg/George Lucas Production." The title wasn't given. I'd loved *Jaws*, *Close Encounters*, and *American Graffiti*; and although the *Star Wars* series was kind of a dopey mess, it was great fun and revived an entire genre. These were two of my favorite filmmakers, working together.

It was at the Esquire Theater on Mifflin Street, one of the oldest theaters in town, and sometime in the sixties the owners had added a screening room, ninety-eight plush velvet seats, with a brilliant screen and state-of-the-art stereo sound. Perfect.

No previews, right into the film. There was an air of anticipation, refreshing at the dawn of the Reagan era. We'd be screening a film we knew absolutely nothing about. Good or bad, it was free. What the hell.

It was *Raiders of the Lost Ark*.

From the outset, each and every person in that theater got sucked in, laughing at the jokes, thrilling at the stunts, hissing at the Nazis. No cynicism, no jaded boredom, several eruptions of spontaneous cheering. It was a one-hundred-fifteen-minute roller-coaster ride, the most wonderful experience I'd ever had in a movie theater, and I didn't even have a date.

Events such as this are not just movies, but genuine adventures; the films themselves when removed from their context amount to nothing. The company, the mood, the venue—they're as integral to a moviegoing memory as they are to a romantic meal, a thrilling concert, a great ball game. Think of going to the south of France and eating at Wendy's; seeing Yo Yo Ma in a shopping mall, opening for a boy band. It just wouldn't be the same. Life amounts to what we experience, not what we consume, but I'm afraid we've become a nation of consumers.

Is there any hope? That's what I want to find out. I want to immerse myself in the moviegoing universe and report back that there's still hope and talent and energy out there. Ultimately, I want to know if the cinema is still alive.

Are you with me?

Grab your ticket and let's go.

—*Kevin Murphy*

General Cinema Centennial Lakes 8, Edina	**Vertical Limit**
General Cinema Centennial Lakes 8, Edina	**Cast Away**
Mann St. Louis Park Cinema 6	**How the Grinch Stole Christmas**
Mann Hopkins Theater 6	**Red Planet**
General Cinema Mall of America 14	**Wes Craven Presents Dracula 2000**
Muller Family Theaters Lakeville 18	**Chocolat**
Imation IMAX Theater, Minnesota Zoo	**Dolphins/Galapagos 3-D** (Double feature)

My Eyes! My Spine! Aaagh!
Sitting in the Front Row

I am blasting right out of the gate with a test of physical endurance and agility: I'm watching seven films from the front row of the theater.

My first thought was that it might somehow bring me "closer" to the filmgoing, or even filmmaking, process. I was so wrong. Sitting in the front row hurts. I don't care how young or old you are, it's too close in most theaters and downright physically taxing in others. I saw ten-year-olds rubbing their necks and pivoting their backs like JFK on a bad day. And these weren't all pillowy little suburban Pugsleys, either. A brace of seemingly fit teenage girls in track suits were compelled to move from the front row of *Cast Away* before the movie even started.

So why are these seats here? For one, kids love them. Especially for action or space films. I noted kids running for the first row for the latest *Star Wars* movie. Poor, stupid kids. Many of them moved back and several seemed damaged by the ear-splitting THX sound, but I understand the sentiment. Somehow the front row promises to pull you right into the fantasy world "up there." If it fills your whole field of vision, how can you not become part of it?

Well, you don't. You remain behind the glass, looking in. At a live performance, with actors or musicians, the front row affords immediacy to the action on the stage, which occasionally is so profound you can find yourself feeling you are actually part of the performance. Which means you may want to avoid this row when attending tony performance-art pieces or Gallagher shows. But the front row in a movie theater only shows you just how large body parts can seem and still be in focus.

Here's a little scientific experiment:

Part 1: Imagine standing six inches away from a figure who is compelling in some way. Let's say, oh, I don't know, for an example, hmm, how about . . . Charlize Theron? There she is, six inches away from you, so close you can hear her breathe, smell her *parfum*. She doesn't see you, she's trying to shake some ass-kissing vampire from *Vanity Fair*, so you get just a touch closer. You can even see the wispy, fine baby hairs on her upper lip and that mole thing she has going on her neck, either of which on a person less drawn in your mind as a human vessel of raw erotic power would cause you to back off quickly.

But not with Charlize. Nosirreebob.

No, from six inches away, without doing a thing, she compels you to act like a rutting baboon, forsaking all other familial and intimate relations you may have in your life, chucking it all into the breach on the patently vain hope that she would turn around and see you. And then Charlize Theron would say "hello" in a manner so dense with meaning it would take a week to unpack.[1]

1 You're in line at the buffet table behind her, I forgot to mention that. Oh, and she's getting herself some raw oysters, a whole plate of them!

Remember, this is a *scientific exercise*.

Part 2: Go stand six inches away from a *picture* of Charlize Theron. There she is, six inches away, so close you can smell the paper and the tang of soy ink mixed with a cologne sampler. Here, Charlize will never turn around, because *you are looking at a picture from six inches away, you moron!* and the closest you may ever get to the woman is in the hands of the cop who is cuffing you outside her window at 4:00 A.M.

If you wish, please substitute "Wesley Snipes," "Christine Todd Whitman," or maybe "RuPaul" for Ms. Theron in the above experiment, taking care to adjust for perfume or cologne.

The point is that *a movie does not get better as you get closer;* in fact, I'm here to tell you it gets *worse.* There is a special place in every theater where the cinematographer, the editor, and the sound designer all like to sit, and that's about halfway back in the auditorium, dead in the middle. From there, the screen fills your field of vision without overcrowding, and the three-dimensional imaging of modern sound design presents its own stage, perfectly balanced and presented for this part of the auditorium.

But in the front row, things get distorted, special effects fall apart, and the experience takes on grotesque aspects, which I'll describe anon.

Aesthetic experience aside, the actual *physical* experience of the front row is nothing short of daunting. At the end of the week I consulted a chiropractor, Dr. Bruce Lindberg, here in Bloomington, Minnesota, who gave me a brief examination and determined that there was nothing wrong with me. I think he knew I just wanted a professional opinion and a few pithy quotes.

It seems that locking one's neck in the same position for an extended period of time will undoubtedly cause stress, particularly on the trapezius muscles, which if you follow wrestling you'd recognize as the Goldberg muscles. Imagine cradling a phone in the crook of your neck for two hours. That's the effect.

Dr. Lindberg affirmed the fundamental rule: If it hurts, don't do it. If it hurts but you must do it, do it as little as possible. If you are writ-

ing a book and agreed, like the bozo you are, to sit in the front row of a movie theater for a week, consult a health professional.

The first movie I saw from the front row was *Vertical Limit*. By the time you read these words, *Vertical Limit* will probably be available for a buck at the local Goodwill. The special effects in *Vertical Limit* don't actually rate the use of the adjective "special," because they're merely effects, almost like symptoms, and from the front row they reveal themselves in their full computerized glory. There is no illusion here, you see those climbers and their daring feats as nothing more than composited images. It's no tragedy though, because it ruins no one's illusion that this is a good film.

So far the most frightening movie I've seen up close is *Cast Away*, if for no other reasons than the sheer size and constancy of nostril presentation. Cinematographer Don Burgess (*Forrest Gump*, *Summer Camp Nightmare*) chose to shoot a wealth of close-ups at or slightly below eye level, which affords a good view of the nostril area on most conventionally built human faces. This is not uncommon, it's the way we look at people slightly taller than ourselves, it's a subtle way of building integrity and respectability into a character simply by means of portraiture.

In the front row, it's an invitation . . . to a NIGHTMARE!!!!!

I saw *Cast Away* in a modest multiplex theater on a screen thirty-two feet wide by seventeen feet four inches high. The front row was set back thirteen feet three inches from the screen to the bridge of the nose of my uncomfortably seated spouse, Jane. Now, Tom Hanks has a pleasant enough face, which is good, because you have to look at it for two hours and twenty-three minutes. And from thirteen feet three inches away, Mr. Hanks's proportional measurements are monstrous, including an ear a full eight feet high.

I refuse to talk about the front-row screening of *Grinch* until I have been to a counselor.

Red Planet, a hard-boiled Science-Fiction-with-capital-letters sort of movie, was merely annoying as I was only twelve feet away from the screen. It was like watching a tennis match.

Wes Craven Presents Dracula 2000 was not a bad film, just terribly

conventional. The front-row experience was simply painful. The closeness only served to make the effects seem token and obligatory, and I came away from the experience convinced that I now know what the inside of Rob Zombie's head must look like.

My favorite front-row film was a complete surprise: Lasse Halstrom's excellent *Chocolat*. I saw it in an old theater, in a very comfortable front row a full twenty feet away from the screen. This is a simple, small film, full of character portraits and intimate moments. Visually it has a splendid palette, better than any of the week's other films, with the oppressive Lenten gray of northern France set off by the luscious reds worn by Juliette Binoche and the sumptuousness of all that chocolate.

I capped off the week with two documentaries in the breathtaking IMAX theater at the Minnesota Zoo. I believe I'm not exaggerating when I suggest that the screen is seven hundred feet high and nine hundred thirty feet wide. They wouldn't let me jump down and measure it, so I had to guess. You should know that I once guessed the weight of the diminutive Mexican actor Cantinflas at a whopping seven hundred pounds, so take my estimate with a grain of salt.

I'd like to say that the double feature of *Dolphins* and *Galapagos 3-D* was my favorite front-row experience, just because I love IMAX enough to dedicate a chapter of this book to it. But I can't do that.

As stunning as the IMAX picture is, and as carefully as IMAX theaters are laid out to afford everyone the best possible view, it's just too big a screen, and being that close detracts from the amazing sharpness and detail of the picture. In fact, as I snuggled into the front row, a concerned usher tapped me on the shoulder and said, "You might want to move back, it really doesn't work from here."

And that's my final front-row postulate: It really doesn't work from here.

So, why are the seats so damn close if it doesn't work? The answer is as simple as a four-letter word: $$$$. I'll give some credit to any theater that sets the front row back at least twenty feet from a good-size screen, and I might even sit there if I have no choice, as long as I have my trusty inflatable neck pillow.

Muller Family Theaters Lakeville 18	O Brother, Where Art Thou? (Date)
Carmike Apple Valley 18	Dude, Where's My Car?
Regal Cinema Eagan 16	Proof of Life
Regal Brooklyn Center 20	Miss Congeniality
Muller Family Theaters Lakeville 18	Chocolat (Date)
Coon Rapids Kerasotes Showplace 16	O Brother, Where Art Thou?
Carmike Cinemas Oakdale 20	Thirteen Days

A Week at the Googolplex
Fear of Cinema in the Suburbs

This week, for as many days as I can stand it, I'm visiting theaters with more than eighteen screens. The term "multiplex" is too benign. I heard Tom Hanks call them "tetrahedraplexes." I call them googolplexes. Whatever the term, they are the unstoppable wave of the future.

In truth, although the seats are very comfortable and the screens are clean and bright and the sound is first-rate, I get the feeling I'm going into a sensory deprivation tank to take part in some sort of mass experiment. Often enough it's true.

I hate these giant blockhouses stuffed with cushy, charmless high-

tech screening tombs, these monstrosities where you order your movie like a fast-food-meal combo and the experience has all the memorable charm of said meal.

Some people will argue that beyond a good print, good sound, and comfortable seats, a theater might as well be a black box. These people are simply wrong.

They're wrong because the films are being designed to fit the market, and that's us, the poor bleating ewes who show up at the googolplex and order a film like a Number Three Combo, Biggie Sized.

As long as the industry sells film like a product, we'll continue to buy it as such. I blame television, the greatest complacency generator and product delivery system since the devil introduced sin, which means that as a television producer I'm partly responsible. I'm sorry.

I have an unhealthy fantasy, a sort of oracular nightmare of a future in which movies don't have titles, they have versions. A light comedy is a LiteCom; a subset, then, such as a drippy Nora Ephron–style extra-womany movie is a LightCom 5.2 NE. Plot? Character? Story? Setting? Context? Point of view? Screw that noise; who really cares? You know how you want to feel, and LightCom 5.2 NE will do it for you.

In my fantasy these theaters have installed all manner of scientific gadgets in the seats. There are galvanic skin sensors and EKGs and eye-movement measurement devices to monitor people's psychophysiological reaction to the movie. It's all probably a lot more accurate than a focus group anyway. Most people wouldn't mind, especially if you give them a couple of free movie passes.

It all sounds far-fetched, but if you'd told me when I was ten that I'd be going to an eighteen-screen theater to have my choice of pretty much every current Hollywood release, I would've thought you were crazy, and I also would've thought it sounded really cool.

In theory, googolplexes *are* really cool. All these movies at your fingertips, in terrific little theaters with stadium seating so the guy with the Afro doesn't prompt you to move. Retractable armrests with built-in drink holders. Double-wide seats for couples or Harry

Knowles. State-of-the-art projection systems, sound, and screens. I decided I ought to give them a shot before I thoroughly condemned them.

So I did the whole deal, tried to have the full, modern moviegoing event.

I drove to suburban theaters in a sport utility vehicle. I picked my movies and times on my cell phone in my car on the way to the theater.[2] I would have bought my tickets using my cell phone, like the trim sexy, phone-toting hip-hoppers in the Verizon wireless ads, but setting up my cell phone to do this would require more time than driving to work, earning the necessary money for the movie, driving to the bank, cashing the check, driving to the theater, and purchasing the ticket.

My first stop was the Muller Family Theaters Lakeville 18. It's the googolplex closest to my home, and still a good half hour away on the freeway. From the highway the Lakeville 18 looks like a displaced airport terminal. Acres of sand-colored brick bereft of any style, with a parking lot I believe actually used to be Iowa. Inside it has eighteen theaters, one hundred yards of concession stands, and a lobby that could comfortably contain Cirque du Soleil. Every popular new release is available, from noon until midnight, and there's even room for the odd Miramaxian "independent" to nab a screen now and again.

I saw six films of varying quality and genre, and there was just one I'll remember a year from now: *O Brother, Where Art Thou?* The rest of them were stunningly formulaic recombinant stories told much better elsewhere.

Proof of Life (ActionDram 3.1, with a Meg Ryan plug-in) greatly bolsters my opinion that Meg Ryan has no talent other than being just as cute as a little button.

Miss Congeniality (LiteCom 4.1, available in Jimmy Smits or Benjamin Bratt versions) with the equally cute-as-a-button Sandra Bullock, also features William Shatner. I used to love Shatner's hammy

2 You'll be happy to know I pulled over first.

melodramatic acting style, but now he has become a sad parody of himself, and in this genuinely stupid comedy about the FBI infiltrating a beauty pageant, he has proven to be the Bert Parks of our time.

But first I saw *O Brother, Where Art Thou?* Actually, I saw it twice. Thank God for the Coen brothers.

In hit-or-miss fashion, Joel and Ethan Coen are slowly creating a body of cinematic literature that will long outlive their careers. Their newest comedy is classic, a direct link to Aristophanes, addressing broad cultural themes by presenting low-mimetic comic buffoons, battered by their society, blundering through their lives. It's chaotic, unstrung, all over the place, unreal, and it's a work of art.

I contrast this experience with seeing *Dude, Where's My Car?* at the equally massive Carmike Cinemas Apple Valley 18. *O Brother* and *Dude* are not dissimilar: Both have dumb comic heroes trying to get back something they lost. The principal difference is that *O Brother* is sublime and *Dude* is a hundred-minute lump of infected pig offal.

But what am I expecting? Folks aren't here to experience *le cinema*. Nope. They don't want to be challenged, nuh-uh. They're here to be *entertained*.

I saw *Dude* in a theater peppered with teenage dudes with their hats on backward in an otherwise empty auditorium. This was the target audience. Nobody laughed. Were they entertained? I asked one of these kids, "Was that entertaining?" He shrugged and said, "It was all right, I guess." Again I asked him if he had been entertained, and he got uncomfortable and said he wasn't sure what I meant.

Being entertained now seems to require no effort on the part of the entertained. They just have to show up. Nowhere was this more clear than the Coon Rapids Kerasotas Showplace 16.

Walking into the Showplace 16, you enter what looks like a small international airport run by teenagers—impeccably clean, cavernous, and lit in the daytime by a massive glass wall reminiscent of the old LAX main terminal. The choked mob of Saturday-night moviegoers are cordoned into several lines to the ticket desks, and then through what looks like a massive metal detector staffed by a dour middle-aged white man wearing a painfully ugly bright-blue hat.

In fact everyone on the staff is wearing one of these supposedly jaunty, ultramarine, English driving caps, with varying degrees of failure. The young friendly fellow behind the ticket desk smiled when I asked him, "Do they make you wear those hats?" He looked around for a moment and said, bluntly, "Hey, do you think I'd wear this if I had a choice?"

Nobody is smiling. Everyone is getting somewhere. Films let in and out every ten minutes or so. Screening rooms line concourses and folks file in, get entertained, file out.

This is the death of cinema, right here folks. This is hell.

The last film of the week was *Thirteen Days*, which I saw at the biggest theater of them all, the Oakdale 20. From the outside it looks a little less like an airport and more like a casino. I took in a matinee on a subzero Sunday, and the place was empty.

All those screens. All those loser movies.

The auditorium for *Thirteen Days* was magnificent, well laid out, extremely comfortable seating, terrific sound. And of course it's a shame that it's thirty miles from the urban center and showing the likes of *Thirteen Days*.

It could have been a good film, and it didn't really need Kevin Costner, who plays Kenny O'Donnell, part of Kennedy's Irish Mafia. The O'Donnell of history did have a tangible place in the Kennedy administration and was a confidant of the president. But as retooled by this film, it feels like Costner took all the classic portraits of the Kennedys and pasted his own lumpy kisser onto them, like an imposter trying to rewrite history.

On my way back home, I noticed that several of the cars leaving the theater went to a Wal-Mart next door. Then I understood what was bothering me: The pod people have won, and everything is fine and wonderful.

What have we gained with a googolplex? A consistent level of product, delivered with a dependable level of convenience, to a consumer base that wants their money's worth every time and gets it.

And what have we lost in the process? Only passion, risk, and community—in short, the things that make a public art like cinema

both public and art. These googolplexes are cinematic Wal-Marts, staffed by proles trained in Corporate Employee Rules of Order.

After a solid week of googolplexing I have mixed feelings. Part of me wants to picket them in a Nader-like crusade simply to wake people up. When I see the dull blank faces of people filing into *Proof of Life* and see the same dull blank faces come out, it makes me want to cry. At least people who saw *Chocolat* were moved, the people who saw *O Brother, Where Art Thou?* were either giddy or pissed off.

But they felt *something*.

I'd like to see these massive, overbuilt, and underutilized venues screen things way off center, like a Cocteau festival or a series of banned films. It's a shame that the country's best screens are being used for the country's stupidest films.

But, hey, I'm a snob, and the googolplex is no place for a snob. So, I'll come here to see massive galaxy-wide blockbusters when they come out. If I'm going to be desensitized into a mindless stock animal, I may as well do it with a cushy ergonomic seat and magnificent THX-certified sound.

✳ WEEK 3, JANUARY 15–21 ✳

City Club Cinema, Grumpy's Bar, Minneapolis	**Stroszek**
Landmark Lagoon Cinema, Minneapolis	**State and Main**
General Cinema Mall of America 14	**Antitrust**
Uptown Theater, Minneapolis	**Crouching Tiger, Hidden Dragon**
General Cinema Mall of America 14	**Snatch**
Oak Street Cinema, Minneapolis	Hong Kong Series: **Last Hero in China**
General Cinema Mall of America 14	**Traffic**

Monday Night at Grumpy's Bar
The City Club Cinema

Near the ill-fated marshmallow dome of the Hubert Humphrey Stadium, across the wide boulevard from the Liquor Depot, Grumpy's Bar has the smoke-filled charm of a bingo hall. The bartender looks like Moby. If you don't know Moby, think instead of Dustin Hoffman in *Papillon*, only a bit taller. I order a beer, and present a coupon. He gives me a practiced fuck-you smile.

The entire economy of the upper Midwest runs on coupons. Coupons are the scrip that entices us suburbanites out of our recliners and into the downtown venues. Coupons are currency, and we carry them around in books the size of Sunday school Bibles. They're

worth more to us than cash because they imply something that is free, and if something is free it must be worth something, otherwise, why would there be a coupon for it?

Presenting a coupon to the bartender strips away any pretense of Tom Waits–style cool my leather car coat and American Spirit cigarette may have given me. I am laid bare as a suburban yutz, too cheap to buy my own beer. I slink into the back room for tonight's screening.

Monday night is movie night at Grumpy's, home of the City Club Cinema. My friend Peter Rudrud, his pal Kevin Karpinski, and a small group of cinephiles calling themselves National Projects, comb the world's 16mm catalogs for the most obscure and delightfully nostalgic films. These guys don't make a penny; they do it because they love it, which is the very best reason to watch movies.

Free movies. A dollar off on beer, every Monday night. You can smoke a cigar. How can you not go?

If I were a late-stage alcoholic with a lot of cash, I could die in a place like this. Rough but clean. No vomit in the bathroom sink. And a terrific midwestern menu; somehow Grumpy's remembered the food. Monday night outside of football season is tomblike for most bars, so Grumpy's was happy to offer its narrow back room for City Club Cinema.

The back room is actually nicer than the bar proper, intimate and comfortable, bare-brick walls warmed by tiny lamps on the bar-height tables. There's a garage door in the back of the room and tables outside for nice summer evenings. The menu offers myriad forms of serum cholesterol. I ordered a half-rack of ribs and a full order of tater tots.

Allow me to sing of tater tots.

These are nuggets of bliss, small prayers answered by the flinty russet fields of Idaho. Potatoes fresh as an autumn dawn, fried deep, oh so deep, right down to their very souls. Potatoes so well coddled and lovingly cared for are bound to be grateful for their tuberous vegetable lives, and, being so loved, they in return extend every bit of potatoey flavor outward from themselves as they die, not unlike the Buddha, reclining on his side, growing to massive proportions as he

transformed from this life to the next, the confines of the earth no longer large enough to contain the boundlessness of his nature.

I might simply have said that these are damn good tater tots, but I doubt you would have taken me at my word.

Tonight my tater tots accompany Werner Herzog's 1977 foray into America, *Stroszek*. I have very broad cinematic tastes, but they don't include depressing German films. I always feel that life is miserable enough without dwelling on it, but directors like Herzog and Fassbinder and Wim Wenders seem to revel in it. But for sheer depression, Herzog is your man.

Stroszek is about a miserable man who moves to Wisconsin to become even more miserable, and then he kills himself. The end. And Herzog manages to make Wisconsin, beautiful Wisconsin, look like the bleakest landscape on the earth, like Siberia, or, even worse, Nevada.

My favorite City Club Cinema memory is last fall's screening of *Duel*, Steven Spielberg's debut movie, made for television, a document and tribute to his talent as a filmmaker. *Duel* is a pure suspense film; in fact, it contains almost nothing but suspense. A business guy, an average Joe, drives across the desert, late for an appointment. He tries to pass a slow clankity fuel truck; the truck won't let him. Average Joe guns by, but soon finds the same truck bearing down on him. The duel begins.

Duel stars Dennis Weaver, which surprisingly doesn't hurt the film too much. We never see the menacing truck driver, but in my seventies-tuned imagination, I like to think it was Claude Akins, the ham-faced fellow best known for the TV truck opera *Movin' On*. I fancy *Duel* as the classic truck-based television pairing, forces of good and evil portrayed by Dennis Weaver and Claude Akins, respectively.

See this movie if you can, and, above all, see it projected. Spielberg films, especially the early ones, are best seen in public, if for no other reason than the fact that they can make the whole room gasp.

Spielberg films are full of gross stuff like people getting ripped, bitten, sliced, and otherwise segmented into chunks, and he throws snakes and bugs around like rice at a wedding. But he shows the gross stuff with a cold eye and a brutal sharp-focus authenticity, using none

of the grandeur or morbidity found in virtually every horror film of the past ten years.

I've seen *Duel* a dozen times and I still cringe and gasp at all the right places. So, I was very much looking forward to seeing it, projected, with a beer and tater-tot buzz working. But before the screening, my friend Peter who was running the show that night, sheepishly approached my table and quietly showed me the *Duel* film can. The distributor had sent him a chop-job of the film, what they called a "condensed version," ninety minutes of vintage Spielberg cut down to twenty-three. I wondered what possible market there could be for this, and came up with no answer.

First of all, making a *condensed* version of a movie then continuing to call it the same movie is like pouring vodka in grape juice and calling it wine. Only the connective tissue remains and all the best parts evaporate in the reduction process. This is not a sauce, it's a film; it oughtn't to be reduced. So, I sadly watched the condensed version, and sighed throughout. The tension was nonexistent, the collective gasp never materialized, and, worst of all, my tater tots got cold.

But I'll return to Grumpy's for the City Club Cinema every Monday night that I can manage. It's an adventure in film-watching, the process having as many twists, turns, and surprises as the films themselves, maybe even more. I applaud Peter and Kevin for showing movies for the sheer love of it, and for reaching way back into the film vault. Next week is Lee Marvin, and I can only hope we don't get the condensed version of *Cat Ballou.*

Eccles Theater, Park City	**Enigma** (World Premiere, Sundance Film Festival)
Silver Mine Museum	Slamdance Film Festival Shorts Series V
Holiday Village Cinema II, Park City	**Home Movie** (Sundance Film Festival)
Main Street Mail, Park City	**Mulligan** (Fresh Fest, alleged film festival)
Club Creation, Park City	**Behind the Red Nose** (Lapdance Film Festival)
Main Street Mall, Park City	**Starwoids** (Nodance Film Festival)
Yarrow Hotel, Park City	**Scouts' Honor** (Sundance Film Festival)
Egyptian Theater, Park City	**The Invisible Circus** (Sundance Film Festival)
Uptown Theater, Minneapolis	**Shadow of the Vampire**
Oak Street Cinema, Minneapolis	Hong Kong Series: **Heroes Shed No Tears**
IMAX Theater, Minnesota Zoo	**Galapagos 3-D**

Leaving No Ass Unkissed
How to Ruin a Perfectly Good Film Festival

I have never seen so many cell phones in one place in my life. It's like the Christmas party at Nokia around here. All the people I see—in restaurants, on the street, in the shops, even on the ski slopes—they all clutch their slim little phones to their heads, blathering loudly and walking aimlessly. They have no problem with this, because they all believe that they are more important than you or I.

Welcome to Park City, Utah, host of the 2001 Sundance Film Festival (and all of its unwanted offspring). For ten days in January, Park City becomes a freak show crammed with thousands of vain idiots who believe that their jobs are the most important things in the world.

These aren't filmmakers, they're studio executives. Every other man I saw was short, balding, and looked either anxious or annoyed; it was like a city full of MBAs. Every other woman I saw looked like she wanted to beat me up, probably because she kept slipping on the snow in her ridiculously dysfunctional boots, causing her too-tight jeans to ride up so high in the crotch as to become a denim tampon.

What does all this have to do with watching movies? Nothing, as far as I can tell. It has to do with the buying and selling of movies, which has made Sundance less of a film festival and much more of a trade show. What if your local home improvement show occupied a small town instead of a convention center, and called itself a "domestic arts festival"? Well, that's the same pretense going on here.

Outside my hotel, an airport van skids into the lot, nearly wiping me out. There's a laser-printed sign in the window: CAA/MOTOROLA SHUTTLE. A woman steps out, dark and lovely, impeccably arrayed, head to toe, in that most fashionable and expensive of mountain gear, Marmot. Pulling the Nokia away from her head for a moment, she asks the first person she sees (me) for change for a hundred. She looks like a movie star; I look like a hockey fan. Oddly enough, and rare as it is, I have five twenties. She is not surprised.

Here's how you get movie tickets during Sundance if your girl at the studio, your agent's girl, or some other corporate entity's girl hasn't gotten them for you; in other words, if you're a common dope like me:

- Go to the theater two hours before show time and get in line.
- The line you are in is the sign-up line for the wait list. Wait here an hour.
- After an hour, a woman with a clipboard, a headset, and bad hair will take your name and give you a number.
- Now you can leave the sign-up line and get in the wait-list line. Pay your money, receive a wait-list thingy, and wait here for another hour.
- After the important people with passes have gotten their

seats, and if your number is low enough on the wait-list line, the same woman or another like her, only with worse hair, will direct you from the wait-list line to the ticket line, where you turn in your wait-list thingy for a ticket.

• Then you can go stand in line to get into the movie.

This is the way it goes here. Nobody's surprised. Nobody in town is surprised by anything, just annoyed or impatient. You see, people from big studios are important, their jobs are critical to the fate of the nation, they deal with tens of millions of dollars and they are constantly making decisions. Incredibly important decisions, obviously vital to the survival of life itself.

Those of us who are not Hollywood studio executives better serve them or get out of the way.

The problem with Sundance is that it attracts more studio executives than it does filmmakers. These balding little weevils are the people who inhabit the present and future model of the film studio: college-trained eunuchs who have never exposed a frame of stock in their lives, trading like brokers, scouring the screenings of Sundance in hopes of finding the next whatever or the next whomever, and buying his or her product at a fraction of its usual cost. The poor, hopeful, talented hardworking filmmakers are at their mercy, and their product cannot help but be biased toward a sale.

Sundance screening venues are generally bland and nondescript, ranging from the Eccles Theater, a massive high-school auditorium no doubt paid for by festival windfall, to the Yarrow Hotel and Conference Center, where screenings have all the aesthetic ambience of a software launch.

And the movies? Don't get me wrong; this is still a well-considered and potentially groundbreaking film festival, as it has been since its conception. There are a lot of good movies, several excellent, a few outstanding. But there are also a great number of quite bad and alarmingly conventional movies, too, and they are invariably the most prominently featured, best attended, and, of course, most highly profiled in the national press.

Sundance seems to have evolved itself into a corner. The brave experimentation of someone like Richard Linklater is overshadowed by the patently pop conventions of the big movies. Linklater brought us *Suburbia*, *Dazed and Confused*, *Slacker*. He has two wonderfully odd movies here. He exemplifies the soul of this festival for me: the possibility to change the movie industry from within, to offer new alternatives to old conventions, to embrace new technology and techniques, and advance the vocabulary of cinema. And yet the people on the phones care only for Linklater and his work because he was once the next whomever, but the news cameras would in midsentence turn away from a telling interview with Linklater if the Rock happened to cross the street behind him. It's the fickle nature of Sundance's overexposure.

And it's the very reason a great number of alternative festivals have cropped up around the ankles of Sundance.

Slamdance, the best and the best run of these alternatives, has gotten so big it's had to move out of its old home base in a cheesy Main Street hotel. Now it's at the top of Highway 224 in a restored nineteenth-century silver mine above Park City. It cannot be lost on the organizers that their festival would now look down on Sundance. I imagine these film rebels thumbing their noses and dropping their North Face Sherpa pants to moon their rejected father festival below.

Slamdance has all the energy and vigor that Sundance used to have, not too long ago. While Park City below is full of bland, worried, self-important studio executives, Slamdance seems more like a grassroots political party headquarters, alive with action and dialogue, everyone talking passionately about film, about the filmmakers they love, and noticeably less about themselves. IMac computers are scattered around like drink coasters, offering free Internet and word processing for everyone, and there always seem to be a few open. Coffee is everywhere, as is Red Bull, plentiful and free. Ask anyone for help with anything, and they'll help you.

There's a decided friendliness and a palpable feeling of joy up here at Slamdance headquarters. Maybe it's because the air is so thin,

maybe it's the free cans of Red Bull, but more likely it's the energy that spins out of the feeling that Slamdance has success and legitimacy now. With more than two thousand applicants, twenty-five films in competition, a growing number of Slamdance winners and alumni getting coveted distribution deals, and reviews under their own heading in *Variety*, Slamdance is definitely here.

At Slamdance I watched with delight a terrific series of shorts, capped off by the exceptional *The Accountant*. And I watched it in the most inventive of screening rooms, where digital video was broadcast to several projection screens in small, comfortable intimate areas seating maybe thirty. No wait list, no line. Brilliant.

And here's what I love the most, in a quote from Slamdance's own press release: "The Slamdance feature competition section is limited specifically to first-time filmmakers working with limited budgets who have not yet found U.S. distribution." So while at Sundance the red carpet is rolled out for skinny pop stars with millions, the door at Slamdance is open only to the new, the brave, the slightly crazy. Down in the town they're talking deals; up in the silver mine they're advancing art.

And they're not alone. Alongside Slamdance are Nodance, Digidance, Slam Dunk, Lapdance, and a handful of other -dances, all vying for the attention of the press and the people on the phones. In some instances, they, too, are advancing the art.

Ultimately this means many more great films, perhaps thousands of really bad films, and not too many ways to discern them. To find something truly different, and perhaps truly satisfying, you have to hit the streets and take your chances; it can be like buying lunch in a Calcutta street bazaar.

How fitting, then, that the most memorable and moving experience I had in Park City was a poorly shot Hi-8 video documentary self-portrait of a thirty-year-old circus clown from Rhode Island.

I first met Zippo the Clown at the Nodance Festival, some commandeered retail space at the Main Street Mall, in Park City. Zippo was handing out flyers promoting his film, *Behind the Red Nose*. For a clown, Zippo's repartee was alarmingly peppered with "dude,"

"*bee*atch," "shit," and "fuck, man." Zippo smoked Marlboro reds and freely shared them. Without prompting, he told us of his self-produced movie about his life on the road as a genuine circus clown; about his director and crew, who turned out to be crack heads; and about his replacement crew, which was his little brother, who'd never held a camera in his life.

Let me be frank: I hate clowns, always have. Ever since a loud sweaty giant of a man with greasy face paint hurled me above his head at the Ringling Circus when I was about four. So, it was with understandable disgust that I first encountered Zippo. I don't revel in clown-hate humor, but Zippo had all those off-putting clown attributes: loud, in your face, sweaty, nervous, bordering on full psychosis. And now this guy had gone and made a movie. About himself.

I watched the only Park City screening of *Nose*, at lunchtime in the back room of Lapdance. Surprisingly the room was half full, about fifty people. At lunch hour, this is a minor triumph.

The movie played. And it was far and away the best moviegoing experience I had in Park City, and the first film to engross me emotionally and choke me up in many years.

Zippo's real name is Brad Steele, and he is indeed a clown by trade—a young, troubled, sensitive, angry, somewhat directionless man who has a gift that few clowns have: making kids laugh without scaring the bejesus out of them. As mad and shattered as his private life is, his soul is that of an entertainer, and he struggles to give the world his song and dance. Many people from Neil Simon to Federico Fellini have portrayed this torture.

I think that, in his own crude way, Zippo has beaten them all.

As he deals with his oppressive father, his Medea-like girlfriend, his dopey film crew, and his even dopier brother, he descends to the lowest depths of depression right before our eyes, and manages to survive by clowning for kids, which gives him life. The film was brutal, crude, genuine, compelling, and oddly hopeful. It didn't change my opinion about clowns, not by a long shot, but it certainly changed my opinion about Brad. I had been ready to dismiss him as another Park City freak until, suddenly, through his film, he lost his stereotype and

became a human of genuine dimension, a suffering soul with whom I could identify.

As only happens after a successful screening, people spontaneously gathered around Brad to shake his hand. I could barely speak as I looked at him with new eyes. Still in his coveralls, still in his makeup, still in his pain. Now, I know this sounds corny, but I had gotten to know him. His film is, and most likely will remain, one of my most profound and memorable moviegoing experiences.

On my last morning at Sundance, I awoke to a foot and a half of Utah's famous powder snow, a true gift from God. It was seven-thirty as I walked up Main Street to breakfast before my last film.

Gone were the throngs of thin, short anxious men, gone the annoyed women in dysfunctional boots and fluffy hats, gone the goateed dudes with the caps on backward and the roll-neck sweaters, gone the cell phones, the bare midriffs, the tattoos, the floor-length leather coats, gone the attitude, the off-putting arrogance, the echoey sound of a thousand asses being kissed. In their place was a silence of a little bitty town under snow.

It felt a lot like Minnesota, like home.

How Not to Look Like an Asshole at Sundance

A FEW TIPS FOR SURVIVING THE WORLD'S MOST PRETENTIOUS FILM FESTIVAL

Wear nothing made of fur or skin with fur trim. A shearling coat will compel dozens of young filmmakers to shoot you like Old Yeller.

Do not talk on your cell phone in a crowded restaurant. This is what the *friggin' lobby is for.* But chances are, if you're used to disturbing other people's lunch by loudly talking into your cell phone to someone in Los Angeles, you have been an asshole for so long you are proud of the fact.

Do not wear your ski clothes to film events. Avoid wearing anything that says North Face or Marmot on it. Avoid boots that are larger than Neil Armstrong's. And, for the love of God, never, *ever*

wear a massive Polarfleece jester's hat in primary colors that's larger than three average-size human heads. Not only will you be perceived as an asshole, but a poor stupid asshole as well.

Avoid a tan if at all possible. Certainly avoid any semblance of a booth tan; this marks you as a special kind of asshole no matter where you are. This is "independent film," so the paler the better.

Do not carry a Palm Pilot or a Handspring Visor or any sort of Pocket PC. And if you do, don't pretend you don't know how to use it. That is the path to assholiness. Better to be perceived a geek than an asshole.

On the ski hill, wear no skiwear bearing the brand RALPH LAUREN SPORT. This is not sporting wear, it is fashion wear, designed to be draped over the tanned naked skin of pouty, swollen-lipped pan-Euro teenage models; it has no real functionality.

Do not drive a Hummer in Park City. Do not drive a Lexus 4WD, an Infiniti, a Cadillac Escalade, or a Land Rover Avenger. An Audi Quattro Wagon is pushing it. A good rule of thumb remember, this is only if you want to *avoid* looking like an asshole—is to drive a rented car or a four-wheel-drive vehicle at least five years old with an original sticker price of under $25,000. Otherwise, it's Asshole City.

If you are an aspiring filmmaker, tell no one. Identify yourself as a director only if you have actually directed at least one entire film that has been seen by people other than you, the crew, family, and friends. If you have to lie about working in film, tell people you're a union gaffer. Ultimately, it is better to identify yourself as "unemployed," because it is true.

If you are a producer, shut up. Identify yourself as a film producer, even if you are, and successful at it to boot, and people will see you as a puckered sphincter that talks. I'm sorry, but it's just true. I don't make the rules here.

Do not eat dinner in a restaurant. Park City is a tiny town that crams about seven million people into condos and hotels for ten days at festival time. Which means the restaurants are always full. Which means you can't get a reservation. Which means if you *do*

get a reservation you probably have an assistant named Kami or Jamais, all decked out in Dale of Norway with a satellite phone and a gold card, who can spend three hours on the phone getting you a table for twelve tonight because it's her job.

Do not use first names when talking about anyone recognizable (except Prince), unless you know him intimately, meaning you have had him over for a basketball game.

Avoid saying the following:
- "Oh, yeah, I saw that."
- "Todd Solondz is a genius."
- "Development hell."
- "Telluride is much more real."
- "My Yukon is stuck. Can I use your phone?"
- "Todd Solondz is inconsistent."
- "I have a [script/deal/cousin] at [any remotely successful studio]."

Do say the following:
- "Jesus, how much did you pay for those pants?"
- "Spare some change?"
- "Where's the porn at?"
- "Who's Todd Solondz again?"
- "My rental car's on fire."
- "God, I'd like to put it to your wife." (Say this only to big stars; they're weird enough to consider it.)

The best bet is to avoid any human contact whatsoever. Granted, if you have come to Park City to meet people, this becomes a challenge.

Finally, if you have a film entered in the festival, relax and enjoy. You're probably not an asshole. You probably are a talented, enterprising, hardworking individual with some prospect for success. This means that at least half the people in town will think you are an asshole. But that's okay. Half the people in town are attaching their own egos to the likes of you.

Mann St. Louis Park Cinema 6	The Gift
Mann Hopkins Theater 6	Meet the Parents (Dollar night)
Mann Hopkins Theater 6	Remember the Titans
Mann Hopkins Theater 6	The Legend of Bagger Vance
Mann St. Louis Park Cinema 6	The Pledge
Hôtel de Glace, Beauport, Quebec	Le fabrication du "Le grande Nord"
General Cinema Centennial Lakes 8, Edina	Valentine

Je gèle mon derrière pour l'amour du cinema[3]

Quebec City and the Cinema de Glace

Deep in the brutal snow zones of the Atlantic North, whipped by the winds that made the Perfect Storm so dang perfect, sits the stunning old-world tableau of Quebec City, undoubtedly the Frenchiest spot on the North American continent.

And it is here, in the utter dead of an already punishing winter, that I have traveled from the equally cold but decidedly less Frenchy land of Minnesota for slightly less than twenty-four hours, in three planes, four shuttle buses, and two taxis, for no other reason than to watch a movie in an igloo.

3 I Freeze My Ass for the Love of Cinema.

The cinema is ensconced in the Hôtel de Glace, which is, depending on how you choose to look at it, either Quebec's most charming or idiotic attraction. Not too many years ago, some Swede got it in his head that people would come from all over the globe to look at a large building made entirely of ice and snow; what's more, they'd pay to do it; and, what's even more, they'd pay even more to spend the night in it.

An enterprising group of Quebecois businesspersons took one look at the lovely shimmering Swedish moneymaker, so fragile, so intricate, so cold, and decided, "*Merde*, we could do that!"

And do it they did. And, like a fool, I came.

This whole thing was the fault of my in-laws. They have been very excited by my career, as bizarre as it is; it reflects some sort of glamour not normally found in Owatonna, Minnesota. They also tend to think that I'm smarter than I actually am, for which I'm flattered. But they are not at all sheltered down there in the frozen plains; they keep up with world political and cultural events better than most of us. So, not long after I'd started this yearlong cinematic expedition, they called in a tip.

"There's a movie theater in an igloo in Quebec City. Have you heard about it?"

"Um, yes, I think so," I lied.

"We heard about it on CBS. It's part of a whole hotel made out of ice and snow, it's pretty adventurous." My mother-in-law, Kay, has the heart of a world traveler, and if she can't do it herself, well, then she's happy to live it through her loved ones.

Less than three weeks later I am standing in the dark, slipping like Buster Keaton, shuffling the hundred yards from a warm and exquisite French restaurant to the frigid, eerie Hôtel de Glace. I found a cheap airfare and a free weekend, creating a twenty-two-hour window of opportunity to get up here and see this thing.

Being from Minnesota and therefore a hibernal hard-ass, and wanting to travel light, being a travel hard-ass, I eschewed the remarkable warmth and excessive weight of my Sorel Pac boots (comfort-rated to ⁻30°F) and my Eddie Bauer Ridgeline Parka (comfort-rated ⁻25°F)

for my fashionable ski sweater and leather jacket (comfort-rated maybe 40°F) and my fashionable but frictionless Australian Blundstone walkabout boots (comfort-rated 75°F). This was patently stupid. The floors in the hotel and cinema were made of snow, as were the walls, the ceilings, the furniture, the chandelier in the great room, the glasses in the bar, everything. The ambient temperature inside the place is about 25°F, and even the Quebecois, normally heartier than the heartiest Minnesotan, wear their parkas and pacs. Therefore I felt like an idiot, shivering like a busted junkie but looking good doing it.

The hotel is indeed impressive, carved out of forty kajillion tons of ice and snow by the only professional igloo contractors in Quebec. Softly lit in warm colors, bedecked with lovely ice sculptures and furniture carved out of ice and snow, it simultaneously evokes the indomitable winter spirit of northern people and a page out of the *Inferno*. Several bedrooms, each containing several beds, soon will be stuffed with folks who have paid roughly a hundred bucks each to spend the night here. They will sleep in polar-expedition style sleeping bags set on top of caribou pelts set on top of plywood boards set on top of massive blocks of ice.

These hotel guests, or "suckers," mill about with those of us who've paid ten bucks Canadian just to walk around in the place. Many are already shivering. Several have fled for the warmth and shelter of the Manoir Montmorency restaurant just down the hill, which has a toasty fire going and offers a brilliant winter menu and an exceptional wine list, all at reasonable prices. I talked to a couple from Manhattan, whom I'd seen in the lobby of the cozy restaurant applying several extra layers of sock. Why are you here, I asked them. Well, we read about it in the paper, and it sounded like an adventure. An adventure? To sleep in a room with six other total strangers at an ambient temperature normally utilized to preserve meat?

I also took their cue, went to the gift shop, and happily shelled out an obscene amount of Canadian dough for a pair of thermal socks. My feet thanked me the rest of the night.

My brain thanked me, too, because my first stop in the Hôtel de Glace proper was the Absolut Ice Bar. The good folks at Absolut know

what to sponsor, by golly. Nowhere has a bar been more welcome or appropriate. It offers straight vodka in Absolut's various flavors, served in fist-size blocks of ice with holes cleanly drilled in the middle. I order an Absolut citron. The French-speaking bartender, God bless him, understands the universal language of liquor. It goes down faster than it should. He smiles, standing there before me, bottle in hand. I only have to glance at my ice chunk pony and he refreshes it. Wonderful.

I know that cold and alcohol can make deadly bedfellows, that hard drink actually opens the capillaries near the skin and serves to *lower* the body temperature. But it also numbs out those receptors in the brain, and damed if it doesn't make me happy to boot. For the first time since my Saab turboprop touched down on the tarmac four hours ago, I am warm.

Perhaps you're wondering why I haven't gotten to the cinema. Perhaps I was wondering that, too, as the vodka kicked in and gave me the keen insight that even my new high-tech socks wouldn't keep my feet warm for too much longer, standing as I was on refrigerated snow. I sought out the cinema forthwith.

The cinema is the quietest part of the whole Hôtel de Glace, perhaps because even the dumbest among the guests and visitors don't really cotton to sitting still in this cold. Move and drink, move and drink, that's the order of the evening. So, to help out, I smuggled my fourth Absolut into the show.

The cinema is set up quite nicely. The snow provides terrific sound insulation, and the screen, also made of snow, is a dandy reflector. The ceiling vaults into the darkness. Seats carved out of the snow are arranged in tiers, covered with wood planks and caribou pelts. There is a comforting calm in here. I'm the only one in the theater. I hear my breath, see its moistness as I exhale cloud after vodka-misted cloud. As I tuck my frozen butt cheeks into a pelt, a lovely young hotel attendant pokes her head in and smiles, *Voulez-vous voir?* I respond, *Mais bien sûr, c'est pourquoi je suis là*. I'm hoping I said "But of course, that's why I'm here," but I fear it came out, "However, buttery man, I am suing the bacon-house." Her response tells me my drinker's French is working.

The lights dim. The film begins, and of course it's in French. It is a documentary about the making of yet *another* film, an IMAX Film, called *Le grand Nord. The Great North.* It chronicles life above the Arctic Circle and the management and preservation of the once-great caribou herds of Canada's extreme northern plains and islands.

Perfect. I'm sitting my ass on a caribou pelt, watching a film about caribou. I'm freezing said ass in a theater made of snow, outside one of the coldest cities on the continent, watching a film about a place even colder.

A gaggle of people walk in, talking loudly in French. It's a family, a large one, accessorized by uncles and aunts. No doubt they came for dinner at the maison, and stayed to see the Hôtel de Glace. Most people make an evening of it like this. The family chatters away, led by dad. They flop onto the pelts and begin to talk less and watch more.

I hear groans and sighs. I hear the matter-of-fact words, *"Alors, bon les sacrés caribous. Allons-y,"* or something close to that, which best resembles, "Hmm. Neat. Friggin' caribou. Let's blow." I guess it'd be like a Minnesota dairy farmer forced to watch a film about dairy cattle, perhaps called *Holstein!*

However, I stayed. I stayed because it's my job, because of the irony of sitting on a pelt of the very animal cared for on the screen, through darting, tagging, medical care, relocation. I realize that this is all part of the promotion, this film promoting another film, the Absolut Ice Bar promoting the hotel, the hotel promoting Absolut and IMAX films, and all the other sponsors, promoting the hotel and each other, all in a glorious frozen orgy of promotion, all meant to bring tourist dollars to Quebec. And what an odd way to bring in tourists, to promise them they will be cold and uncomfortable.

I watch the film twice. I end up spending close to two hours in that theater. My feet are no longer cold, and I don't know if that's good or not. But it's okay; I have come to the cold and accepted it, learned more about it. I realize that sitting in this theater is perhaps no crazier than the times I've stood frozen in a blizzard-ravaged ski lift line, or watched my speed-skater friends vie for the national team in the thirty-below weather of West Allis, Wisconsin; no madder than run-

ning from a hot tub and rolling in the snow, only to feel the ten million needle pricks of hot water when I jump back in. Not only is this a clever way to enjoy the cold, really feel the cold, get to know it, it's also a very civilized way.

In a short while, I'll sit alone in the dining room of the Manoir Montmorency and enjoy the best Canadian culture has to offer: sip a smashing merlot and tuck into a duck breast with balsamic reduction and a puree of beets while I listen to a tight jazz trio work through thoughtful renderings of Monk and Mingus.

But for now, I sit in silence after the film ends, and I feel the place. The eerie quiet and cold. The muffling of the three-foot-thick snow walls. The sound of my heart pounding. The numbness of my feet. The sparkling stars of snow crystals as the projector sheds light on the wall. This indeed is a unique movie-watching experience, and no matter how odd or dumb or magnificent the place is, once again I am all the better for having gone out of my way to see a movie.

✳ WEEK 6, FEBRUARY 5–11 ✳

City Club Cinema, Grumpy's Bar, Minneapolis	Theme: "The Devil Made Me Do It"
General Cinema Centennial Lakes 8	Traffic
General Cinema Mall of America 14	Double Take
General Cinema Mall of America 14	The Wedding Planner
Brattle Theater, Harvard Square, Cambridge	Why Has Bodhidharma Left for the East?
Brattle Theater, Harvard Square, Cambridge	Breaking the Waves
Brattle Theater, Harvard Square, Cambridge	Prelude to Kosovo
Brattle Theater, Harvard Square, Cambridge	Ordet
Brattle Theater, Harvard Square, Cambridge	Bringing Out the Dead
Circle Cinemas, Newton, Massachusetts	Hannibal

Sit Up Straight, God's in the House

Death, Rebirth, and Paper Airplanes at the Boston Faith in Film Festival

To attend the Boston Theological Institute's first Faith in Film Festival, I'll have you know that I gave up free tickets to the annual World of Wheels Car Show at the Convention Center, and therefore a good chance to get an autograph from one Petty or another, perhaps even meet Donny Most.

But I was compelled to attend this festival because I am a person of faith. As to the nature of my faith, it's really none of your damn business. And I was intrigued by the theme of the festival, death and rebirth, probably because I'm terrified of dying.

The festival was held at the Brattle Theater, in Harvard Square.

Perfect. It's one of those theaters you wish every small town had, mixing new movies with the old, showing films in repertories of theme, language, artistry. It's one of the few places left where they would show retrospectives on *screenwriters*.

It's also a fittingly run-down, drafty, uncomfortable old place with a rotten screen and even worse sound, like most small-town theaters. But people don't come here for the amenities, they come for the literature. It's for a different kind of film lover, the ones who delve into the *text*, the *meaning*, the *cultural ramifications*. In other words, eggheads, longhairs, and snobs.

Friday

Why Has Bodhidharma Left for the East?, by Korean artist Yong-Kyun Bae, is the most lucid description of Zen I have ever encountered. As I watched this movie I started smiling and didn't stop until long after the movie was over. It seems I actually understand something about Zen! Of course, the smugger I get about it, the less I seem to have learned.

Responding to the title, most of us Westerners might answer, "Who are you, who is this Buddy Drama feller, and who the hell cares?" But this enigmatic question is part of a koan, a staple of Zen teaching, one of many in the essential Zen text the Wu-Men Kuan (you youngsters out there, please don't confuse Wu-Men Kuan with the Wu-Tang Clan. It's an easy mistake).

I'll give you the whole koan:

A monk asked Chao-Chou, "What is the meaning of Bodhidarma's coming from the West?"

Chao-Chou said, "The oak tree is in the courtyard."

Now if I were the monk, I would've been tempted to smite Chao-Chou, several times, with whatever was handy, for any number of reasons; and that is exactly why I'm not a monk.

Koans are mind-cracking, often irritating, seemingly pointless riddles or dialogues, which if contemplated in the right spirit will help students crack through the confines of their own limited ability to see

the world as it is and become enlightened, often like a bolt out of the blue.

Koans are often structured like a classic comedy routine. A student (let's use, for this example, Lou Costello) asks the teacher (Bud Abbott, then) a thoughtful question (the setup), to which the teacher responds with a seemingly unrelated or paradoxical answer (the punch line). Sometimes the teacher drives the point home with a sharp crack of his *kotsu* staff on the student's back or the top of his head (the sight gag), which causes the student to reel (the pratfall) and perhaps think more deeply not only about the answer but about the question.

This is what I love about Zen! The answer doesn't always satisfy the question, even though it *directly answers it!* In fact the whole film *Bodhidharma* is the essence of this very koan, and a subtle explanation unravels. If you are at all interested in Buddhism but can't get past the utter foreignness of the teachings, this is the film for you. Sit back, stay sober, let the film happen. The whole cycle of life plays out, birth to death and beyond, with splendid artistry, in the roles of a Zen master, a student monk, and a small child.

Between films there was a reception at the Episcopal Divinity School. You can always tell an academic department reception by the small chunks of cheese on toothpicks and the predominance of blush wine. Several people made speeches, a plaque was given. I preoccupied myself watching two young students stuffing their pockets with nuts, cold cuts, and the cheese chunks. I think one of them slipped a bottle of blush in her pants.

Well fueled by bad wine, we all went back to the theater for *Breaking the Waves*. It's a brilliant, searing, tragic exploration into simple faith, abuse, death, and life.

And I hated it.

I acknowledge that it's a great film, and I still hated it. I hate films that start out with a depressing premise and plummet from there. They're like Nine Inch Nails songs. Besides, I'm not a big catharsis fan. I can get sad enough as it is without some genius filmmaker helping me along. I also had a headache from the blush.

Further, I couldn't get past the fact that the lead actor, Emily Wat-

son, is a dead ringer for Gary Oldman, right down to the smirk and the sweaty upper lip. Ms. Watson turns in a terrific performance, steeped in her character, a simple woman who is still a child in her mind, torn apart by the cruel world. She was even nominated for an Oscar, yet I keep thinking, *Doggone it, that's Gary Oldman in drag*.

I'll give the film another chance sometime, because the conditions under which I saw it made me hate it more. A professor of some damn thing or another handed out a bunch of papers before the screening. They were "study guides" with a number of "questions" designed to provoke "conversation." Since this festival was put on by educators, I guess somebody felt it ought to be like a classroom.

Bull.

I was sitting in the balcony (the best seats at the Brattle) and immediately I made my study guide into an airplane and sent it floating down. If folks noticed, they didn't let on. I didn't stay for the discussion afterward.

Saturday

We start the day fresh with a locally made documentary about Kosovo, done with a PBS sensibility but great craft by John Michalczyk, who is also chair of the Boston College Fine Arts Department. The film addresses how religion has shaped the conflict and how faith has tried to forge a path to peace. The naked lens of the photographers and the candid comments of the doc's subjects told me that religion has failed to bring peace—in fact, religious zeal has provoked great horror.

All right, then. Perfectly sad and drained, we plunge headlong into Carl Theodor Dreyer's 1955 Danish film *Ordet*. It is only two hours long, but it feels like two years. It's a strange, melodramatic thing, and it will either captivate you or send you screaming from the theater.

In a nutshell, it's the story of a family in rural Denmark, maybe a hundred years ago. Dad is an inflexible religious fundamentalist. He has a son, Mikkel, who's an atheist; another, Anders, who wants to jump religions and marry outside the family's faith; and yet another, Johannes, who thinks he's Jesus.

So, it's a lot like Minnesota.

Ultimately, Inger, the wife of atheist Mikkel, dies in childbirth. No, she doesn't. Wait—yes, she does. The movie goes back and forth on this in a scene that lasts eleven months, real time. But she does die, and her children come to Johannes (Jesus) and ask him to raise her from the dead. Johannes bolts, I believe for three days. And he comes back, no longer smelly and in rags, but cleaned up and obviously sane. Thing is, *he still believes he's Jesus*, and he performs a miracle all the same.

Ordet is a powerful, spellbinding fable of death and rebirth, of grace and redemption, of tolerance and forgiveness. It is considered one of the greatest films of its kind ever made.

And the audience laughed at it.

One reason is the characters, their stereotypical Scandanavian-ness. They all seem like they stepped out of *A Prairie Home Companion*. Caricatures. Big, intolerant Danes.

Another reason to laugh is the coffee. Honestly. These people are obsessed with coffee. I counted about ten separate occasions in which characters sat down to have coffee, making a huge fuss over it every time.

But the biggest reason to laugh was the technique. Everything is symbolic and portentous. The perdurable shots, the stultified pacing, the stony seriousness of it all. The pace is slower than the Great Boston Molasses Spill of 1919.[4] And the sheer mass of the melodrama weighs down on a modern audience like an old sweaty grandma.

So, we, the audience, chuckled. Then laughed out loud. Then heckling started. I heard "Oh, come *on,* get *on with it!*" from the back of the room. Remember these are theologians, Harvard folk, film scholars. And still we laughed and heckled what has been called one of the greatest films on faith ever made.

All this leads me to a thesis: We have outgrown classic cinema. But we are also too immature for it.

Dreyer developed his art in silent films and never left these tech-

4 B. Lent, *The Great Molasses Flood* (Boston: Houghton Mifflin Company, 1992).

niques behind. Only one generation in this century grew up on silent film. They learned to read spectacular film style, an art form that evolved and matured faster than rock and roll. But this film style was abandoned so quickly and thoroughly it makes you reel. Along comes *The Jazz Singer*, and, wham, silent film gets it in the head. Chaplin struggled to make silent films an enduring art form, and he couldn't do it. There was no money in silents, so they died.

But there is a direct link from *Ordet* and Dreyer to the film that closed the festival, *Bringing Out the Dead*, by Paul Schrader and Martin Scorsese, and my favorite film in the festival. *Bringing Out the Dead* addresses the very same themes as *Ordet*, but in a style as different as night from day. Both are in the transcendental style, using film techniques to create an experience beyond the narrative; something spiritual, emotional.

Paul Schrader is brilliant at this kind of writing. Remember *Taxi Driver*? *Raging Bull*? *The Last Temptation of Christ*? (Okay, forget *American Gigolo*.) I have no idea how he writes a script for a movie like this. The screenplay is an astounding thing to read.

Bringing Out the Dead is nonstop, almost non-narrative, experiential. It's three days in Purgatory, with glimpses of Hell along the way. Its stage is the lives of paramedics in New York City. But ultimately, like *Ordet*, it is a story of grace and redemption.

I loved this movie. The audience loved this movie. If they were honest, the whole audience would cop to loving it head and shoulders above *Ordet*. *Ordet* is a lecture, a slow sermon on a hot day in a stuffy church delivered by Reverend Lovejoy from *The Simpsons*. *Bringing Out the Dead* is an acid trip.

Sitting in the Brattle Theater, shivering because the heat sucks, I watched the audience watch this film. They were riveted. *Bringing Out the Dead* was made for us. And made very well, in a manner barely conceived of in 1955 when *Ordet* was made. It is proof to me that we've outgrown Dreyer.

Here's the funny part: Paul Shrader loves Dreyer. He learned from him. He even wrote about him in the book *Transcendental Style in Film: Ozu, Bresson, Dreyer*.

We sat there, intelligent, sophisticated film lovers, and we squirmed like fourth graders. And during a festival of faith in film, with God watching and everything. All because we were unused to a classic style of filmmaking, and too impatient to learn from it.

In short, as a culture, with more movies available than ever before, we are becoming film illiterates.

Shame on us.

✳ WEEK 7, FEBRUARY 12–18 ✳

Yorktown Cinema Grill, Edina	**The Emperor's New Groove** (free)
General Cinema Centennial Lakes 8, Edina	**Hannibal**
Suburban World Cinema Grill	**Billy Elliot** (snuck in)
Carmike Cinema, Apple Valley	**Left Behind**
Landmark Lagoon Cinema, Minneapolis	**O Brother, Where Art Thou?**
Cinema Café, New Hope	**102 Dalmatians**
Lakeville Theater	**Quills**

Dinner (*Burp*) and the Movies, Part One
The Cinema Grill

What a country we live in. In the old days, we had to go to a snack counter to bring armloads of artery-stiffening snacks into the theater and spill them all over ourselves. Nowadays, we can sit in cushy swivel chairs and order up all manner of meaty sandwiches, ultimate nachos, and deep-fried versions of virtually any processed food. God bless America!

Yes, all over this great country of ours, cinema grills are sprouting up like genetically engineered crops treated with preemergent herbicides. From Seattle to Winter Park, from Fort Wayne to Raleigh-Durham, serving off-release movies and food ranging in quality from

decent to downright suspect. And, here in the Twin Cities, home to four such, the cinema grill seems like a brilliant scheme.

Seems like it, but it ain't.

In three of these venues, I had a perfectly unpleasant experience. Only once did I emerge brimming with hope and without intestinal gas. Carefully planned and executed, the notion of the cinema grill is an invitation to a very pleasant night out for dinner and a movie. But, in general, it is a place where volume is high, quality is low, and people don't seem to care.

Why? Because we're a massive people. Good God, but we're fat. Minnesota itself is one of the fattest states in what is officially the fattest country in the world. We've even beaten out the biscuits-and-gravy-loving South, in part because our winters last thirteen months and in some long spells we don't get out of our snow pants for an entire decade. People here often look like walking sausages, particularly in the early summer, when skin reappears, all veined and bloated and pink. Enough to put you off your lunch.

Our nation is getting fatter for the same reason that we're getting dumber. Our expectations have slammed through the floor of the sub-basement and lie somewhere beneath the earth's crust. A full belly is more important than a stimulated palette; a two-hour dispensation from thought is preferred over any sort of mind play.

Minnesotans don't seem to know what good food is. Only the rural English have stupider palettes. With the exception of the more cosmopolitan Twin Cities, you can't get a good meal anywhere, unless you like overdone beef, soggy steam-table vegetables, batter-fried cod, and pudding.

Another factor is a keen sense of denial. You can't get away with calling macaroni and cheese "pasta" anywhere else in the world. Bacon is not a food group. Salad dressings *without* buttermilk in them do exist.

Wednesday is all-you-can-eat night at the Yorktown Cinema Grill in Edina, Minnesota, and the joint is jumpin' for the seven o'clock show. If you're from Minnesota, you can eat one hell of a lot. Second to the Minnesotan love of coupons is the love of the all-you-can-eat

option at restaurants and at the bulk feeding stations we euphemistically call "buffets." It's not surprising that Minnesotans wedge themselves onto charter flights and head by the thousands to Las Vegas in the winter, and wedge themselves in to midsize sedans and drive to the local casinos the rest of the year. It's not for the gambling; it's for the buffets. In fact, I can safely surmise that it was for our benefit that the term "all you can eat" slowly has been modified to "all you *care* to eat." The distinction is critical, making the phrase more of an invitation to have your fill than a challenge to tuck it away like a French goose until your liver explodes.

But we're not alone, thanks to the cinema grill; the combination of middling second-run movies and sub-prison-quality food is all the rage. Menus abound with several varieties of sandwiches, pizzas, and the entire deep-fried pantheon. Here's one such menu's description, exactly as printed, of the ultimate nachos:

> *Tortilla chips toped with your choice of beef, chicken or plain, covered with Monterey jack cheese, lettuce, tomato's, onions, black olives with Jalapenos and salsa on the side.*

Ultimate nachos tend to appear everywhere, and once again I'm reminded that nobody knows what the word "ultimate" means, or it wouldn't be on a menu. "Ultimate," even broadly defined, means last, final, altogether remote in the universe. That's not how I like to think of my nachos. I don't want to look at that massive platter of corn chips, "toped" as they are with beef, chicken, or plain, thinking they may be my last nachos. I don't want them to be my *first* nachos either; I simply don't want them to be *my* nachos in any sense. I don't want *any* food I put in my own personal mouth to be described by any restaurateur as the last of that particular dish I'll ever eat.

And the movies? All of them are well out of their major release; some are so far off release they might as well star Lillian Gish. Which is not to say they're the cream of Hollywood either. Among *Vertical Limit*, *What Women Want*, *The Family Man*, and *The Emperor's New Groove*, I chose *The Emperor's New Groove* because it was the only

one that didn't feature a tanned meaty Hollywood regular. Instead, it features the short and skinny talents of David Spade, in what might be his funniest performance to date. The seating is much like the lobby bar at any airport Marriott, so it looks comfortable without actually being comfortable. I ordered a turkey sandwich and fries, which, about an hour into the film, were loudly served by my waiter as I watched this latest Disneymation offering. It was lightweight and goofy, which is the opposite of the food I had. I'd never before known a turkey sandwich to be heavy and serious.

On the weekend I made the mistake of attending a matinee at the Cinema Café in New Hope, Minnesota, without inviting any children. Bring this food-and-movie concept to kids and the result is a Chuck E. Cheese without enough entertainment to hold the kids' attention.

All children younger than ten under the influence of soda pop behave like baboons in the wild. They run, hands over their heads, generally saying the same thing: "*Aaahbwaaabuhhhbwaaa!*" over and over again, as parents (and a lot of suckered grandparents), already exhausted, do their best to ignore the din and order massive greasy pizzas.

A small boy runs up to my table, spreading the baboon call, holding his half-gallon cup of Tahitian Treat before him like a sacrament, slamming it into the edge of my table and sending a spray of fruit flavor in five directions. This barely slows him down. He casts me an odd glance, as I am the only childless single adult in the room, then turns his lower primate behavior back toward his home table. He has not been missed.

The lights go down, a little; the neon and fluorescent wash remains high, so the screen is never quite bright enough. I get the feeling that this is what a lot of these families do at home, eat pizza while the television blares, only here they don't have to clean up after themselves.

The movie begins: *102 Dalmatians*. The food arrives: pizzas everywhere. Kids gorge themselves and attain the middle-distance stare cultivated by regular TV watching. For precious minutes the place is quiet.

Too bad the film is too dull to hold the kids' attention. Now fueled by more soda pop and pizza, the primate din begins anew, and children are everywhere, impulsively escaping their parents' authority and careening around in the sickly half-dark like Roller Derby queens.

All of this is preface to my delight in one particular cinema grill, the Suburban World Theater, oddly situated in the perfectly urban Uptown section of Minneapolis.[5] This could easily become one of my favorite theaters in town. It is a single screen, one of the last in this whole metropolitan area. The interior decor has been preserved and restored in a sort of Mediterranean style, fake porticos festooned with fake greenery behind which soft pastel lighting glows. In the dark, the effect is actually quite nice, and gives the theater a feeling of great space. Dozens of tiny lights in the ceiling sparkle like stars throughout the screening, accented by an old-fashioned, slowly rotating transparency projection of lofty moonlit clouds. The whole effect is intended to put the audience in a lush courtyard of a villa, perhaps on the Amalfi coast, on a perfect summer evening, after several *limoncellos*.

Of course it doesn't work, but it's a nice try, and the fact that anything so architecturally evocative still exists in the era of black-box stadium-seating death holes is extremely heartening. Seating is arranged in tiers like terraces, with tables and chairs bunched close but not New York close (remember what I said about Minnesotans, we tend to take up a lot of room). Quiet, efficient wait staff float in and out like Hamlet's dad, never seeming to get in the way, while refills of ale and steaming plates of pasta, grilled fish, and light crusty pizza appear like magic.

On my first visit to the Suburban World, the feature was *Billy Elliot*, a movie I quite liked, and liked even more while drinking a freshly tapped Newcastle Brown Ale and munching on a Maryland blue crab cake that was actually nicely done. In fact the whole menu

5 I must point out to Minneapolis newcomers that Uptown is south of downtown, which is just plain stupid and I think intentionally confusing. Nobody told me this when I moved here, and it took me nearly eight years to figure it out on my own. It's one of many reasons why, when left to my own wiles, I'm late for everything.

at the Suburban World is a cut above, as is the service, which is probably why it gets sold out so often.

The thought that a theater serves a decent wine or an excellent beer while showing an eclectic and consistently good array of off-release and re-released films is enough to keep me coming back. But sitting back in my comfy chair, sipping the froth of my Newkie Brown, nibbling the last of my crab cake, thrilling as skinny little Billy dances madly with passion, anger, and heart, I look up at the theatrical night sky and feel that, yes, this is right, this is what a cinema grill should be, a tiny two-hour vacation that fills my heart without the risk of heartburn.

Somebody got it right.

City Club Cinema, Grumpy's Bar, Minneapolis	Adventures in Learning Series
Oak Street Cinema, Minneapolis	**Alieta, Queen of Mars**
Walker Art Center, Minneapolis	**Vagabond**
Walker Art Center, Minneapolis	Selected Shorts by Agnès Varda
Walker Art Center, Minneapolis	**The Gleaners and I**
United Artists Eden Prairie 4	**Down to Earth**
General Cinema Mall of America 14	**Monkeybone**

Movies at the Museum
No Popcorn

Welcome to the Walker Art Center's Auditorium. There is of course no smoking in the auditorium, please, and no food or beverage of any sort, but feel free to scribble in notebooks and swish your pashmina scarves around and grunt thoughtfully at every pithy moment in the film you're about to see so those around you think you get the film-maker's deepest thoughts and intentions, even though you'd probably rather be home in the old chair in your underpants drinking a Garten Brau and laughing at reruns of *Jackass* on MTV.[6]

6 I am using the objective impersonal sense of the noun "you" here. One could substi-tute the term "one" if one wished. One should not imply that I am referring to myself sit-ting at home in my underpants drinking a beer and watching *Jackass*. Certainly not I.

There are several art museums that stoop to exhibit films in the Twin Cities, but most notable is the Walker, arguably the area's best museum, or at least the one that has the richest patrons. At museums in general, and at the Walker in particular, the screening venue is more sterile than an operating theater, with no architectural interest of its own to get in the way. It's a symphony of gray and white, lit with halogen spots, steep and large, with all the charm of a multipurpose lecture hall at a state university. Seats are appropriately uncomfortable, snugged close together because we all know that art patrons are thin and wan, and want to take up as little room as possible with the body to make more room for the ego.

I have a suggestion for any art museum owners out there who want to put in a screening room: As long as you're going to overpay to have the damn thing installed anyway—you always do, don't kid yourself, it's an art museum—and since it's planned to be completely charmless, why not call the guys who install stadium-seating multiplexes? Don't you want your patrons to be comfortable? Don't you want them to come back? And since you're trying to get as close to an empty space without inherent style of its own, what better model is there for this than the multiplex? Hell, while you're at it, put in two screens, or eight. Have the German postexpressionists on one screen, the New Wave on another, experimental films on a third, another for erotica and other porn that passes for art. And put in a concession stand, only sell baguettes and salad Niçoise and Old Vine zinfandel. Do it right and you won't need those grants from cigarette companies.

Museums often adopt a sacramental attitude about movie exhibition. Films at the Walker are presented with a sense of reverence and awe that's stifling. Even if a film is funny, a laugh is a self-conscious act that brings odd glares from those around you. I have a belly-driven guffaw that sounds like an angry sea lion, so when I laugh in a museum theater, people get up and move away, often hitting me with their pashmina scarves in a refined act of passive indignance.

I'm in the middle of a fourteen-film retrospective tribute to French filmmaker Agnès Varda. We've just seen Varda's 1985 work *Vagabond*, original French title *Sans Toit Ni Loi*. The last image of the film is of the protagonist, Mona, lying dead in a ditch. We've just seen this aim-

less drifter of a teenage girl throw her life away for want of something better that she can't even describe. And now, at the end of the film, after Mona has taken handouts and rejected friendship from pretty near everyone, she lies where we found her at the film's start, dead in a ditch in a nowhere town, dead from exposure, frozen to death, contorted, rigid, ashen, bleak. Dead as hell.

Remember, this is not fun. This is art.

Man, is she dead. Look at her there, cold as lunchmeat. Pinkish gray, like bologna or cottage loaf. So's her dress. So's the culvert she lies in, and the sky, and even the soil. Cold. Bleak, washed out. The whole film has a color scheme so muted you'd think it was black-and-white with some Magic Marker in places.

I think Agnès was going for a point here.

She always does. I became infatuated with her, this seventy-year-old French filmmaker, the only woman to rise out of and thrive in the French New Wave era, alongside guys like Truffaut and Goddard. But she differs from her male counterparts slightly; while the boys gathered under the noble title auteur, Agnès chose for herself the more humble and accurate term *cinécriteur*, or cine-writer. She is an intentional filmmaker, not leaving a thing to chance. She selects her locations, angles, characters, lines, edits, all very carefully. What you get out of her style is almost the opposite of what I hate about "art" filmmaking: accident passing for brilliance.

When I was in college I had to suffer through two semesters of horror called experimental filmmaking, in which I heard rooms full of students picking their dope-stained brains trying to find fitting accolades for some of the most pointless images I've ever seen projected. This was the late seventies, when disorientation and shock value seemed to be the greatest achievements of the art film world.

My problem with museum screening audiences is the same problem I had with my film school classmates: I want to hit about two thirds of them with a sack full of heavy cheese, over and over again. Because they aren't honest. They grunt knowingly during the screenings because they're supposed to, they look to each other to see if they should like the film; and if any criticism is offered in the obligatory

Q&A afterward, more times than not it is a self-serving display of knowledge.

There is no such conceit in the films of Agnès Varda. She is as honest a filmmaker as I've ever seen, a well-disciplined and skilled maker of fictional, documentary, and more abstract non-narrative films, and her style is at once well controlled and extremely loose and open, so it appears as if her films just happen by themselves. This is a monumental achievement. People aren't used to it. It's why films like hers don't play at the googolplex, and why they actually belong in a museum, more than a lot of the movies with repeated shots of found footage and sound loops and scratches on the print and all manner of tiresome manipulation. Film's best virtue is that it tells a story so well, and Agnès is an exceptional storyteller.

After the film, it's time for the dreaded Q&A, in which members of the audience attempt to demonstrate how erudite they are. A young woman notes that while the character Mona starts writing her name in the dust on a mirror, M-O-N, The Doors' song "The Changeling" plays on the radio, intoning a lyric about money. The young woman asks Agnès if this was intentional.

Now Varda seems like a very gentle soul, but for a moment she looks like she wants to hit this dope. "Of course it's intentional," she patiently answers. "This is a fiction, a construction, and nothing happens purely by accident." This moment struck me because it drove home how stupid we are when it comes to film literacy. It's like asking how Kermit works.

My favorite film in the Agnès Varda series is her most recent, *The Gleaners and I*. It's a very personal documentary, actually a memoir, about people who glean, or take what's left over, whether it's potatoes in the field after the harvest (a French tradition) or the junk people leave on the street corner for the truck, or a discarded house. But it's also about the path each of us takes on the way to death, as our bodies eventually age and fall apart. Agnès catches her hand in her digital video camera, and notes the age, the entropy, the growing uselessness of her own body and her sadness toward her eventual demise.

Sounds like it ought to be depressing, right? It's not. It's actually a

celebration of life at the elemental level, when we do away with our trivial wants and desires and simply live on what the world leaves behind. It doesn't have to be a desperate life; in fact, it can lead to a fullness we can't find on the retail level.

This is far from experimental. There is greater skill, intention, and polish in Agnès's seemingly loosely constructed vérité stories than there is in any Ridley Scott film. In other words, this is filmmaking at its best. This is craft, deft enough to become invisible, to draw us in, engage us, involve us.

I enjoy the fact that Varda is capable of creating so natural a film that the camera disappears, and things happen as if by fate or by accident. This isn't a trick, you don't "feel like you're actually there" because you are actually *here*, in the audience, witnessing a story being told by a master storyteller. The *story* is the actual experience, and we're its mute participants. All except for those pashmina swishers who grunt thoughtfully at the appropriate moments.

We are now in an era of TV broadcasting in which the craze is "narrative nonfiction," or "unscripted drama," or what I like to call "bogus documentary." But thanks to unwatchable frauds like *The Real World*, *Road Rules*, *Big Brother*, and the like, traditional narrative is giving way to less structured, more visual interpretation all over the place, and for the first time since the seventies we might have a generation of filmgoers who *actually like* unconventional film techniques instead of just *pretending* to like them.

Let's face it, anyone who can sit through even ten minutes of Darren Arnofsky's π has a pretty high tolerance for pain. But now we've raised up an entire pop audience on the kind of stuff you used to see only at NYU or the Kitchen or a dozen other annoyingly arty venues, all in New York. Oddly enough, it's the MTV generation that might crack open the art of filmmaking once again.

And maybe this is good, because *The Gleaners and I* has been held over at the Film Forum in New York. This makes me very happy, but I'd go a step further and show it on a wall in the Bowery for free. I would cheer to see Agnès Varda's work taken out of the sanctuary of the art museum and into the streets whence it came.

Yorktown Cinema Grille, Edina	**What Women Want**
United Artists Eden Prairie 4	**Saving Silverman**
General Cinema Mall of America 14	**Snatch**
Silent Movie Theater, Hollywood	**It**
Silent Movie Theater, Hollywood	Laurel and Hardy Selected Shorts
Loews Cineplex Edina 4	**3000 Miles to Graceland**
General Cinemas Centennial Lakes 8	**Finding Forrester**

A Kidney Stone of a Week
Pain and Delight in Moviegoing

I did it all for the movies. In one week I experienced the most excruciating physical pain of my life, sat through a classic Hollywood pitch meeting, nearly ruined this whole project, and had the most fantastic and memorable moviegoing experience of the entire year.

Monday Night

I've returned from my last foray to a cinema grill, the dreary Yorktown Cinema Grill, home of the synthetic Reuben sandwich and watery root beer. I just saw the most startling horror movie I've seen in years: *What Women Want*. A weepy, leathery Mel Gibson in pantyhose;

Helen Hunt's standard sour, desperate single-woman role, her pelicanlike face frowning and scowling as she droned her lines; the odd blend of silly comedy and high melodrama. Gustation has turned to indigestion and I go to bed with a dull pain in my lower left abdomen.

Monday, Midnight

I dream of being kicked repeatedly around the lower back area by the cast of *3000 Miles to Graceland*. Kevin Costner's pointed alligator boots pummel me. Suddenly, the hand of God reaches down from the Nevada sky holding a char-grilled potato, still in its foil wrapper; only this potato has been cooked to such a high temperature it's measured on the Kelvin scale and radioactive isotopes are released. God miraculously installs the potato in my left kidney, still glowing as it converts hydrogen to helium. Then the pain begins. My kidney starts to glow, mutates into an organism with its own intelligence, and begins to speak. "I'm in trouble, you better look into me."

I awake. The kidney pain remains.

The dream potato is still there, searing and cooking my kidney so that I can almost smell it, and it almost smells delicious. The pain comes in waves and I actually yell from it, causing my beloved spouse to call the Nurse Line. "Get you and your kidney to the hospital, pronto," they say, and we do.

I can't sit still. The ten-minute drive to the emergency room is eternal. The twenty-minute wait in the waiting room stretches out through centuries. I climb on the furniture, grunting like a mandrill. People around me cringe. A nurse asks me to urinate into a plastic cup. I believe he is kidding, since I can barely stand and I'm sure to miss the cup by a country mile. Somehow I manage, and in the fifteen minutes, or entire ice age, that it takes to run the urine screen, the pain crescendos.

There is nothing I can write that will describe this pain. There is nothing in the world that can prepare you for it. I'm told that taking a .32 slug is less painful. Being gut-stabbed with a dirty spoon in a prison cafeteria is less painful. The pain is transcendent, delivering me to a realm of understanding I've never known; a mind-body connection unlooked for and downright revelatory.

The doctor arrives. He looks like the lead singer from Smash-mouth in a doctor costume. Through clouds of pain I surmise that, no, he's not barking like a dog, he's telling me that I have a kidney stone passing from my left kidney through the ureter into the bladder, and that morphine is on the way.

Sweet, blessed morphine. The pain abates, the divine potato cools, and I'm left with a ghostly impression of pain that gives me a three-dimensional image of my urinary system.

I have been told that a kidney stone is the closest a man will ever come to unabated labor pain. And what immediately springs to mind is how absolutely stupid and off the point the movie *What Women Want* is. What women want is understanding, mutual respect, and, when the time comes, a damn good epidural.

Tuesday Evening

The residual pain, I've been told by a urologist, is due to the cat-litter-size kidney stone that scraped the wall of my ureter, a hair-size tube twixt the kidney and the bladder. That's why I still have pain, and blood in my urine. And, oh, since you still have this little thing in your bladder, could you pee into a sieve for a few days so when you finally pass the stone we can analyze it?

I apologize for the level of detail, and heretofore I will refer to the entire experience as "the unpleasantness."

I've been given a good supply of Vicodin, an opioid-and-Tylenol cocktail that makes you simply forget you have pain, also that you have an address and a car and several important things to do. Still, I must see a movie, and wisely I seek out the easiest target, a film so devoid of intelligence and sophistication I could watch it in a coma and still remember the whole thing. I choose *Saving Silverman*.

Saving Silverman, easily the dumbest of the current Gerund ProperNoun brace of movies—there's always one around: *Losing Chase*, *Finding Forrester*, I could make a case for *Crouching Tiger*—is playing at the Eden Prairie Mall, which oddly enough was the shoot-ing location for the Kevin Smith disaster *Mallrats* (Kevin had his own Gerund ProperNoun film, *Chasing Amy*). It is a mall theater, and con-tains every bad thing that implies: tiny crummy auditoriums, stale

popcorn, warm soda, bad sound, bad screens, employees dumber than me on Vicodin.

I have a lot fun sitting in the theater munching rubbery popcorn, sipping warm lemonade, and watching *Saving Silverman*, swimming around in a Vicodin haze. It makes me stupid, disoriented, and gullible, which I'm certain is the target audience for this thing. I am alone in the theater except for an elderly gentleman who curses in disgust and leaves the theater twenty minutes in. "Jesus" is all he says. "Jesus."

Wednesday Evening

The dull throbbing pain is finally subsiding, and I'm coming out of a forty-eight-hour fog. For the life of me, I can't remember the movie I saw yesterday. I try every memory exercise I know, and I know a lot. Nope, no dice. I have to check my notes.

Today is better: Guy Ritchie's *Snatch*. This is fun to watch even without drugs. I love English comedy, even when it's violent and somewhat misogynistic, which it usually is. There's maybe one good-looking person in the whole cast. It's the kind of film Quentin Tarentino could make if he had an actual soul.

Tonight the movie is not the problem. It's the bathroom. A crowded bathroom when you're drinking five liters of water a day and peeing into a strainer is no fun. And at the Mall of America 14, they don't clean the bathrooms as often as they should. One or another urinal always seems to be cresting the levee and pouring out mint-scented gray water everywhere. I try to wear rubber shoes when coming here. I have to go to the bathroom four times during the movie, waiting for that little chunk of cat litter to drop into the strainer.

I'm tired of this, but it won't get any better. Tomorrow I board a plane for Los Angeles.

Thursday Evening

I'm here with my partners and pals, Stoney and Andrew, to pitch a TV show. Pitching a TV show is very much like going to the emergency room for a kidney stone, except you don't get any morphine.

But that's not important now. Tonight I'm sitting in the Silent Movie Theater on Melrose, in Hollywood, and it's a gem. It looks like a museum piece; I've never seen a theater this clean. The woodwork shines, the ancient seats perfectly restored to their original 1942 level of discomfort, the screen a respectful distance from the front row. There's a nice old electric Würlitzer and a Yamaha digital piano, the only anachronism here. Even the popcorn comes in little striped boxes. Tonight we're seeing *It*, starring Clara Bow. Clara was a beautiful young woman and became a great silent actor—she was the J. Lo of her time.

The film is a dopey comedy of manners about a working girl in a department store who falls for the rich owner. Through a classic comic error, he believes that she had a child out of wedlock, and is scandalized. She plays along, outraged that a single mother is anathema to him. You might think that's a pretty progressive theme for the twenties, but the truth is we haven't come much further.

There are plenty of films around that, through one lineage or another, have stolen directly from this plotline. It's nothing new. The French and English did farces like this onstage in the 1800s. The Italians did it earlier. The Romans stole from the Greeks. The Greeks stole from everybody. Shakespeare's comedies, while generally not funny, are certainly more enlightened than most anything you see today. I find a lot of people who look back on silent films as quaint or crude. They just haven't spent enough time around them.

Friday Afternoon

I'm sitting in a TV pitch meeting hoping my kidney stone doesn't capriciously decide to pass. I have to urinate like a Thoroughbred, but one of the rules of a pitch meeting is never to excuse yourself to the bathroom in the middle of the meeting unless you're going to get the gun that's strapped to the flush box, come back, and kill the Turk.

Here's how a TV pitch meeting works:

Say you have a nifty idea for a TV show. Say further that somehow you have cultivated the respect, or at least the attention, of a handful of people who actually fund and distribute TV shows. Unless you cur-

rently make millions for a network, you now have to parade your idea in front of a variety of colorless, humorless, but terribly well-groomed executives dressed like lawyers.

This is the Eunuch's Court. These are people who want to be in the creative arts but aren't creative enough. So, they listen to other people's ideas and try to shape them into a marketable product. Sometimes they do this while you're talking to them.

My job is to pull down my pants and show them my funny parts, figuratively. I have to give them a lucid description of the idea, and, further, I have to do it in a way they'll like. Furthermore, it's a comedy, so I have to give them a flavor of what's so damn funny about it, and fur-thererer, I'm trying to impart humor to a roomful of people who have a duller sense of humor than my urologist.

The Guy We Really Want To See won't be at the meeting. That's too bad, because eventually the Guy has to hear our idea and say yes, or it won't happen. This Guy could fund our show with a phone call. He's the only Guy (sometimes the Guy's a woman, but not often, not yet) who makes actual decisions, but he depends on the room full of dull people to advise him.

But the Guy is out of town and wants us to see the room full of dull people first. To me, that spells death. If The Guy We Really Want To See really wanted to see us, he would. But he won't, so instead we go through the same purgatorial experience I've been through at least thirty times.

My partners and I are brought into the drab meeting room. Two women roughly my age wearing ill-fitting designer suits and a lot of hair product greet me. There's one young guy who won't stop grinning and never says a word. I think he might be an autistic savant brought in to throw us off.

I think of opening the meeting by telling them about my kidney stone. About being doubled over on the waiting room chair, grunting like a mandrill, about the divine nuclear potato installed in my abdomen by the hand of God. In hindsight, I should have, because these people never cracked a smile through our description of a very funny execution of a very solid concept.

When these meetings go well, the folks in the ill-fitting suits are more like an audience, and it can actually be fun. This time, it feels like I'm arguing before the Third Federal Circuit Court of Appeals. They nod thoughtfully and take notes. They smile painfully at the funniest stuff we have, real lung-hurting face-reddening stuff, too.

Surprisingly enough, they say this:

Okay, we really like this a lot, let's run some numbers.

This is not good. But it's not bad either. This means they want to know how much it costs. It's not a Yes, but it's not a No either. It's a Definite Maybe. A No would sound like this:

Okay, we really like your idea. Thanks for coming in.

However, it's certainly not a Yes. A Yes sounds like this:

Wow, this is great. How long are you in town? Can you fly back out and see The Guy next week?

While a Definite Yes sounds like this:

Holy shit! We gotta get The Guy on the phone right now. Don't you dare go anywhere else. We're picking up your flight and your hotel; you better move to the Four Seasons.

A Definite Maybe is much rarer than a No. It means they'll put our idea in a pile with a bunch of other Definite Maybes and let The Guy decide.

This is the business I've chosen to be in. And this is why, most of the time, I'd rather excuse myself in the middle of the meeting, go to the bathroom, and grab the gun.

Friday Night

I'm leaving tonight on the red-eye at midnight. But I have to see a movie first. I've decided to return to the Silent Movie Theater, and I have been rewarded beyond measure. It's the high point of my year.

It's intermission. Tonight we've been watching a series of classic Laurel and Hardy shorts. They are some of the funniest things ever filmed, and this would be enough by itself to make my night. But the organist makes my night a dream.

Before the movie starts, the organist is helped to the big old triple manual, nearly lifted onto the bench. He looks to be at least ninety.

The Silent Movie Theater's proprietor, Charlie Lustman, introduces him as Bob Mitchell, who has been accompanying silent movies for seventy-six years.

Seventy-six years. That's 1925. That's when tonight's movies were made. That's before Lindbergh.

This is a direct lineage to the birth of the movies, a rare and fragile bridge to a time beyond common memory. This is like meeting Moses.

"It was 1924, actually," Bob Mitchell tells me later as he gives me a powerful handshake. "Christmas time. I was living in Altadena, out in the country, and I was a tall feller for my age. I could reach the pedals when I was ten years old, so I played the organ at church. My mother was a real stage mom, like a lot of mothers were, and she brought me to the theater. They said I could play between the shows, so I did. But the accompanist didn't show, and the movie started so I kept on playing.

"Nobody noticed! I just kept on playing. When the accompanist showed up, boy was she surprised. Me, I got the wits scared outta me when I saw her, and I jumped up, on the seat, then on the organ console, then across the stage and right out of the theater."

He came back, and he played for them all. He played at the Egyptian, the Chinese, the Million Dollar. He played for Chaplin, for Keaton, Lloyd, Pickford, Laurel and Hardy. He played the shorts, the features, the intermissions. He's played the recorded soundtracks for many classic silents.

Bob Mitchell is a walking national treasure. In his slight frame and powerful hands is the history of early American cinema. And I got to hear him play.

He knows these films; he's accompanied many of them more times than he can remember. On the Laurel and Hardy short *Habeus Corpus*, a pure shtick parade through a graveyard, Bob knows the beats, the surprises, the pratfalls, the poignant moments, and he sets the tone, anticipates the mood, and, best of all, knows when not to play, heightening the comic suspense, making us ache for the grand punch line at the end of a long setup. For me, he makes the film.

Go to the Silent Movie Theater and hear Bob Mitchell, and

the history, the pure joy of moviegoing in America will open up before you, and you might realize why movies are so much damn fun. I did.

Saturday Afternoon

I just saw *3000 Miles to Graceland*. I'd rather have my kidney stone attack again. I can't imagine anything more antithetical to last night's magic. This film embodies everything I hate about modern movies. Kevin Costner is a cultural criminal and ought to be locked up for crimes against truth and beauty.

Sunday Night

What a week. Back from Los Angeles, still having a mild lower abdominal throb, no chunk of cat litter in the strainer, so the strainer gets tossed. Tomorrow at 5:00 A.M. I board a flight to Zihuatanejo, Mexico, and I've spent the whole day packing. A touch of jet lag, residual painkiller, and the quick turnaround have me disoriented. But the day is done, and I snuzzle in bed early with my beloved spouse, Jane.

I doze. Jane sits up. "Hey, did you see a movie today?"

What?

"You didn't see a movie today."

I bolt up. She's right. Dear God, I'm ruined. Only nine weeks in and I've already blown it. "Wha tibe id it?" (I'm pretty tired.)

"Nine-thirty."

Race to the newspaper. Something, anything. *Finding Forrester* starts at ten. Jane smiles warmly. "Well, you wanted an adventure, didn't you?"

I throw my coat over my pajamas, we race to the theater. It's nearly empty. We hold hands and watch Gus Van Sant's dewy-eyed portrait of genius and passion and snobbery. Sure it's corny, but I thoroughly enjoy the experience. We're going to The Movies. And I'm finding out that if I maintain the spirit for it, and I set my expectations right, I'll enjoy this adventure no matter where it takes me, even if I'm in pain.

Except when I have to see a Kevin Costner film.

Ryan International Airlines Flight 912	**Chicken Run**
Gringo Cinema, Casa de los Suenos Tropicales	**Saps at Sea**
Gringo Cinema, El Burro Borracho	**Sons of the Desert**
Gringo Cinema, Hacienda Eden	**The Mob**
Casa de Cultura, Zihuatanejo	**Hannibal** (English with Spanish subtitles)
Gringo Cinema, Casa de los Suenos Tropicales	**Future Shock**
Gringo Cinema, Casa de los Suenos Tropicales	**Sons of the Desert**

Bring Your Own Chair

Playa Troncones and the Gringo Cinema Series

The regular crowd is wandering into El Burro Borracho, the Drunken Ass. Men and women in their fifties, gray-haired, tanner than a fielder's glove, wearing California beachwear and smoking, every last one of them smoking. It's Indio beer and añejo margaritas all round, and out come the Marlboro reds. Out beyond the wicker lamps of this open air, palm branch *palapa*-covered restaurant is the beach and the Pacific Ocean. Big old rollers rhythmically remind you where you are, day and night. They serve as the bass note, the rhythm section for everything. A local friend has told me the thing he hates most about being off the beach is the silence. I'd like to find that out for myself.

"When's the movie start?" everyone asks me. Eight o'clock, I tell them, plenty of time to get a few in you. Everyone in town knows there's a movie here tonight, and a good twenty people have shown up so far. That's a big crowd for Playa Troncones, la Union, Guererro, Mexico, only twenty miles north of the high-rise hotel hell of Ixtapa and a world apart. Here there are no high-rises, except for the bizarre, boxy, white Malibu-style beach house that weird new-age *gringa loca* built. This is a town of about two hundred fifty Mexican farmers and fishers and about fifty gringos, some retired, some working in Ixtapa or Zihuatanejo.

Troncones has none of the amenities a lot of tourists look for in Mexico: no discos, no parasail boats, no beach-roaming musicians, no fancy restaurants or blender drinks. Maybe three swimming pools in the whole town. You have to throw your toilet paper in the wastebasket, even after going number two. That's enough to keep thousands away right there. And of course there isn't a movie theater within thirty miles.

I love this place, and I couldn't let this or any other journey get in the way of my movie watching. So, I've brought my trusty Eiki Super-Slim 330 slot-load 16mm movie projector, four movies on eight reels, a queen-size bed sheet for a screen, a bunch of clamps, some rope, an extension cord, and replacement parts.

Vladimir, the proprietor, chief cook, and maître d' at El Burro, strolls over with a grin. Vladdy is the best restaurateur I have ever met, and this after working in five-star restaurants for ten years. He speaks English better than most Minnesotans, but he's never been out of Mexico. I've heard him speak German, some French, and a little Italian. His food is unparalleled, his service proper but never stiff or formal; this is a beach cantina. He could run any dining room on the planet, from Le Cirque in New York to the Peninsula in Singapore. But here he is at home, wearing a T-shirt and jeans and an apron, living in one room with a fan and a Bible, as happy as anyone I know.

Had he ever seen Laurel and Hardy movies? "Yeah, sure," he says, but most of all he loved the Mexican films: El Santo, Cantinflas, the crime serials, the superheroes. Vladdy grew up in Pantla, a tiny bunch

of houses on either side of the highway about ten miles from here. "We used to go into Zihua on Saturday for the movie," he said between drags on a Marlboro. "Before the city had electricity, they had a big generator on the back of a truck. It was in the square. Everybody had to bring their own chairs."

Vladdy used to help them crank up the generator—that's how he paid his admission. "My pals and I, we climbed up in the big old trees in the square. Did you know that there are chickens up there?"

Chickens? In the trees?

"Yeah," he says matter-of-factly, "the chickens, they'd roost up there. When the film broke, and everybody was hooting and whistling, we would grab a handful of chicken shit and throw it at the screen."

Vladdy!

Tonight it's *Sons of the Desert*, a corny farce that plays like an episode of *The Flintstones*, but we get to enjoy the flawless timing, the almost painful schtick, the dumb jokes, the double takes, the impossible predicaments, everything for which Laurel and Hardy are famous.

We're set up in a corner of the bar. The credits roll, and people gather like moths. Few people have televisions here in Troncones, and fewer still have videos. Nobody gets to see the old movies anymore. Everybody laughs at the jokes, they cheer for Stan and Ollie, they hiss the bad guy. Vladdy strolls by with a chair in his hand. "You see? I brought my own!"

I love my job.

I managed to get to the big town, Zihuatanejo, once during the week to watch a movie at an actual movie theater. I felt I had to. Zihuatanejo is known to many as the town that Andy Dufresne heads for in *The Shawshank Redemption*. It's changed. There are eighty-five thousand people there now, but it's still a pretty port town boasting two cinemas. I chose the big one, the Casa de Cultura, because it had a matinee of *Hannibal*.

The theater is positively soviet in style: huge, at least five hundred seats, with bare, stained walls, lit with that hideous fluorescent milk-wash that makes the darkest skin look pale. The dingy snack counter offers a variety of things I've never seen before, most of them involving

cacahuetes, peanuts. Popcorn sits mounded in picture-perfect little open-topped boxes, and it looks to have been there since the seventies.

There are six people in the theater including my friend Brad and myself. The seats are vintage leatherette stuffed with horschair. There's a soccer match at the stadium right next door. It almost drowns out the movie. There's a cat howling behind the screen. The floor is stickier than flypaper. The screen is terrible.

No matter. Videos are how people get their movies in Zihua these days; I'm told that people flock to the theater in the summer because it's air-conditioned. Other than that, the selection and the accessibility of video have all but wiped out public display of movies here. Which is too bad, in my opinion, because I think that it has also had a deleterious effect on the Mexican filmmaking community. The theater lures people with crappy American blockbusters like *Hannibal*.

I'm tempted to leave after the first hour of this dog, but it's worth staying till the end to see one line translated: *Carumba hola, Clarisse.*

Back to the beach, to Manzanillo bay, to Hacienda Eden. It's a ten-room bed-and-breakfast on the prettiest stretch of beach on the Pacific coast. It has a point break, and I'm not talking about a Keanu Reeves movie, but a nice long wave that breaks off a point. Here, on a good day, it rolls out about half a mile, and the surfers flock here to take nice long rides. Sounds perfect, but you better be good because if the rocks don't get you, the sharks might.

Eden is run by Eva Robbins and Jim Garrity, a couple of gringos who drove down the coast a few years back and when they saw this place they stopped and decided, hey, a feller and a gal could carve out a living in the alternative hospitality industry, right here. So they built a very homey and comfortable six-room hacienda and a dining area. Then they partnered up with the best gringo chef in the whole state of Guererro, Christian Schirmer.

Jim, a lanky, thoroughly affable fellow with an Indiana drawl, has strung some strong cord in the trees so I can hang the screen. Eva, a fine hostess who speaks about a jillion languages, totes her newborn son and offers us some cold Indios. Chef Christian brings us Mexican

chocolate torte on the house and hands me a massive Havana cigar, a Romeo y Julietta Churchill. I get the idea that these folks are happy to see a movie. The night is warm and dry, the bugs are singing, and there's a light breeze swaying the palms and the manzanillo trees. It's a perfect night to watch an old movie under the stars.

The Mob is a 1951 film noir starring Broderick Crawford, a fellow who always looked like a cartoon dog to me. He's a hard-boiled cop who's on the trail of a gang of hard-boiled thievin' hoodlums. It's so hard-boiled the movie's yoke has turned green. There are more recognizable character actors in this film than a 1951 SAG meeting. Richard Kiley has a prominent role, while a very young Charles Bronson has one line. Ernest Borgnine is the mob boss, and he's actually *thin!*

My favorite bit-part gem is gravel-voiced John Marley, who lives in our memories as Horse-Head Guy, the Hollywood producer who awakens to find the head of his prize Thoroughbred in his bed in that riveting scene from *The Godfather*. The man was nominated for an Academy Award, appeared in more than fifty movies, but thanks to Francis Ford Coppola he'll always be Horse Head Guy.

The moon rises full and bright, backlighting the crowd with pale blue against the gray wash of the gangster movie's reflection. The projector light catches wisps of cigar smoke. Couples snuggle as they watch the corny old film.

It wasn't that long ago in small-town Mexico that the only way to see a movie was like this: outdoors, under the stars, bring your own chair. I'm sad to realize that video has killed it. But, for now, I can picture Vladdy up in the trees with his pals, back before electricity on a night like this.

The film breaks. People hoot and holler as I run to the projector. Somebody yells, "Quick, grab a handful of chicken shit!"

I don't know how movie watching can get any better than this, and I'm only three months in.

Ryan International Airlines Flight 912	The Whole Nine Yards
Loews Cineplex Edina 4	15 Minutes
General Cinema Mall of America 14	See Spot Run
U.S. Air Flight 126	Bedazzled
U.S. Air Flight 126	Unbreakable
Prince Charles Cinema, London	Sing-Along **Sound of Music**
Odeon Cinema West End, London	Enemy at the Gates
Prince Charles Cinema, London	Sing-Along **Sound of Music**

Knowing Funny

London and the Sing-Along Sound of Music

I'm in Leicester Square on a Sunday afternoon and, although it's pissing down rain and cold as a meat counter, the streets are packed. Tourists wander about, utterly lost, looking for bargains on the latest musicals and drama from the cheap-ticket booths. Pickpocket fodder. Leather-clad Londoners have finally crawled out, many hung over from the night before (it was St. Paddy's Day). I stand on the cobblestones outside the Prince Charles Cinema, dressed in a nun costume, smoking a cigar.

It's a damn fine nun costume, too. Somewhere between the traditional order of St. Francis and School Sisters of Notre Dame, a flowing

black cassock, smooth floor-length scapular, crisp collar and cowl, starched wimple and coronet. It's splendid, and it's deeply disturbing.

London is heaven for a moviegoer. All around the West End, in Leicester Square and Covent Garden, which are mainly known for their live theaters, are dozens of cinemas, big and small, showing at any time just about any movie you'd want to see. New releases, old classics, foreign gems, obscene disturbing art films, documentaries, in dingy little single-screens and sumptuous multiplexes, bunched around the West End and scattered around the city. Next to New York, it's the best moviegoing town I've ever been to.

I've come for one particular event: the Sing-Along *Sound of Music*. The show now plays in a dozen cities around the world, but, for over two years now, the Prince Charles Cinema has been the ancestral home to this oddity. I decided I had to come to the source, because if the English do anything better than any other country on the planet, it's making each other laugh.

The Friday night Sing-Along *Sound of Music* proved my point. The theater was packed, all eight hundred plus seats. It doesn't hurt that there's a bar in the lower lobby, serving bottled beer, wine, and those liquor soda pops from our friends at Smirnoff. The Sunday matinee is decidedly less bawdy and more of a family affair, making me wish I hadn't been so chicken and worn my nun-drag for two nights, but I ask you to imagine a big-ass Yank like me riding the tube with ten thousand drunken Brits, in a nun costume.

Here's how it works: The full movie is played out, in wide-screen glorious Technicolor, with all the lyrics subtitled at the bottom whenever a song breaks out. You can even sing along with the abbey choir as they launch their Gregorian chants. Better than half the crowd seems to know most of the lyrics, and they sing them in full voice, off tempo and off key, but who cares? After a few pints of bitter, it's all just yelling anyway.

A hostess introduces the whole show, and guides us through the little bag of goodies left in each theater seat: flash cards for "How Do You Solve a Problem Like Maria?"; a patch of curtain to help Julie Andrews catch a clue as to how to make the children's play clothes; a

sprig of phony edelweiss to be held aloft during, naturally, "Edelweiss"; a party popper to pop when the captain and Maria first kiss (dozens are set off prematurely).

Then comes the parade of costumes. Hundreds of these revelers are dressed up in *Sound of Music* drag. There are a good hundred nuns, ranging from shy middle-aged conservatives in slapdash costumes, to lovely young women in positively sinful mini-habits, showing lots of leg and drawing catcalls from the gallery.

There's a requisite assortment of the movie's characters: Maria, the captain, the kids, a handful of Nazis—but far more inventive costumes as well. I counted four brown paper packages tied up with strings, two blokes named Ray (a drop of golden sun), the entire octave scale from do to do, and one daring woman in a red-and-white leather cat suit purporting to be the Austrian Flag. She won second place. First place was awarded to a frightened little kid dressed as one of the frightened little kids. It was a sympathy vote.

This is far different from the *Rocky Horror* experience, less depraved and self-possessed. People don't get on the stage to sing their favorite parts; everybody sings. And everybody hollers at the screen, making the Friday night show the most sexually charged screening of a G-rated film you've ever seen. When the baroness tries her best to win back the heart of the captain, I hear the bellow, "Hop it, you great cow!" When teenager Liesl sneaks in through a window and Maria asks her where she's been, we hear, "She's been out shagging Rolf!" Rolf appears, and the whole mob barks like dogs, "Rolf! Rolf! *R-r-r*-olf!"

And everybody sings, every lyric, every verse, in full beery voice. When the mother superior sings "Climb Every Mountain," you'd think the place will fall apart, and by the end people are on their feet.

This is fine English tradition, this heckling mob. Back in the day, when Billy Shakes and Benny Jonson were the dogs, the theaters swarmed with groundlings, who milled about in front of the stage, the cheap seats if you will, only there were no seats. If they didn't like a play, they would let the company know, and loudly. Unruly audiencing is ancient history for Londoners, continuing through vaudeville and

music hall, the theater of the common folk, who were always invited to have a singsong with the band.

The comments start to fly. Every scene with a trace of innuendo is verbally savaged. Any hint of leg from Julie Andrews draws filthy cheers and boner jokes. Every straight line receives a lewd punch line. Every nun scene draws a perfectly inappropriate lesbian joke. Not even the adorable kids are spared. Every poignant moment is skewered. The movie is more than three hours long, but when you leave, sides aching, head swimming, you'd swear you could do it again.

I did screw up the courage to don the habit for the Sunday matinee, and I won Best of Nun, but everyone was too polite. Too many kids. I longed for the groundlings of Friday night.

The whole experience reminded me what I like best about comedy, flat-out ridiculous laughter. Make 'em hurt. Let the crowd join together and take over. It may work only in England, where I believe the decades of the music hall, the Goons, *Monty Python*, and—God forbid—*Benny Hill* have given the English a devious streak, a cracking good sense of timing, and the ability to improvise. I'm convinced that along with a taste for stomach-lining soup, the English have an innate sense of humor.

I'm sure the Sing-Along *Sound of Music* is a lot of fun in New York or Los Angeles or Dublin or Minneapolis. But I'll bet you a fiver that nothing beats the London crowd on a Friday night.

U.S. Airways Flight 99	**Pay It Forward**
U.S. Airways Flight 99	**Best in Show**
Landmark Lagoon Cinema, Minneapolis	**Pollock**
Oak Street Cinema, Minneapolis	**Billy Liar**
Mann St. Louis Park Cinema 6	**Exit Wounds**
Mann Hopkins Theater 4	**Best in Show**
Oak Street Cinema, Minneapolis	Hong Kong Series: **Assassin**
Loews Cineplex Edina 4	**Before Night Falls**

All My Heroes Look Like Movie Stars

Why I Didn't Watch a Single Moment of the Academy Awards[7]

Last night was the—hell, I don't know six hundred and seventy-third—annual Academy Awards[7] presentation, a name I'm not even allowed to use in public without hanging a copyright or trademark symbol next to it. So I'll use my own pet name, The Annual Runnin' of the Egos. Intentionally, I avoided all of it and all references to it. Earlier in the week I had been cultivating an inventory of heroes—histor-

7 ACADEMY AWARD(S)®, OSCAR(S)® OSCAR NIGHT®, and OSCAR® statuette design mark are the registered trademarks and service marks, and the OSCARS® statuette the copyrighted property, of the Academy of Motion Picture Arts and Sciences.

ical, archetypal, personal—and I found that they all had faces assigned to them by Hollywood and adopted by me, and that frightened me.

By Sunday a realization swept over me: Every image of a hero, historical figure, icon, myth, archetypal individual, ghost, or demon carries with it an image of some actor or character out of the movies. There's no getting around it. All week I had been penciling down an inventory of the inhabitants of my head, and those imagined were cast, generally, by Hollywood.

Let's start with the heroes of my earliest memory: Jesus and Superman. Jesus equals Jeffery Hunter in *King of Kings*, blond, tanned, wispy rock-star hair, perpetually windblown, straining down toward us Hell-bound souls as he strained for the touch of His spiritual brother John in the movie. As for Superman, the surprisingly lumpy, middle-aged shape of George Reeves in a snug leotard certainly tamped down any nascent homosexual tendencies my child-brain harbored for years.

My childhood Christianity has a brilliant all-star cast. John the Baptist looks like Charlton Heston. Apostle Peter is James Farantino. Pontius Pilate is Telly Savalas, and yes, he says "baby" a lot. Herod is, of course, Peter Ustinov (who convincingly doubles as Nero). The Virgin Mary is Olivia Hussey, and I'm damned for sure because I keep mixing in *naked* Olivia Hussey from *Romeo and Juliet*. God the Boss is that light behind the clouds accompanied by a Miklós Rózsa score, and it is no accident that the Voice of God has been played by both Cecil B. DeMille and John Huston in their times.

Then we come to fairy tales, fables, and children's stories in general. Disney has done a terrific job of appropriating our imaginative imagery, and therefore has achieved the loftiest success Hollywood has to offer. I cannot imagine dwarfs other than the Disney dwarfs. I cannot imagine another Pinocchio or Cinderella.

I don't think there's one of us who does not see Boris Karloff as Frankenstein's monster, or Bela Lugosi as Dracula, unless you grew up with film-school snobs for parents and you envision Max Shreck as Nosferatu/Dracula, or, if you're still a snob, Willem Dafoe as Max Schreck as Nosferatu or if you're simply a loser, giant-haired Gary Old-

man. And in spite of Arnold Vasloo, the Mummy still carries Karloff's face for me.

And on it creeps, into every specter of literature. Vincent Price inhabits every Poe story I read to this day. Ron Moody and Oliver Reed pilfer *Oliver Twist* and imbue this fragile nightmare with dippy music. Richard Basehart is Ishmael, but, oddly enough, when I read Ahab he becomes not Gregory Peck but John Huston. I know, I know, and I'll get myself to a good Jungian therapist as soon as I finish this chapter. On the other hand, Jeremy Brett has pleasantly taken over the role of Sherlock Holmes forever in my mind, and he's much more convincing than old Basil Rathbone.

One of the things good fiction affords us is the ability to imagine its universe without having it all laid out for us. We get to share in the creation of the characters by interpreting the author's imagery and incorporating it into our own world. This is good, this is healthy, it's why fiction is so much fun, and why so many movies are adapted from literature rather than cut from whole cloth. It's also what gives life to Shakespeare over and over again, reflecting a million facets of human culture throughout history. It makes it immortal, or at least enduring. *Hamlet* could play on stage and on screen for centuries. I'll stick my neck out and predict that *The Matrix* will not. I for one want to imagine *my own damn Hamlet*, wearing his own face, not Kenneth Branagh's or Mel Gibson's or even Olivier's. I'd have to kill myself if I envisioned Hamlet with the face of Ethan Hawke.

A lifetime of movie watching has had this insidious effect. And it doesn't just happen with adapted works; my mind casts movie stars involuntarily! Reading *Gravity's Rainbow* in college, I could not help but cast it with the combined cast of *Catch-22* and *Kelly's Heroes*. In fact the whole of World War II plays in my head as it played on the screen, no matter if I read Stephen Ambrose or James Jones or Joseph Heller. Officers become Robert Mitchums and Henry Fondas while Ernest Borgnines, Monty Clifts, Tom Ewells, and Harvey Lembecks trudge by as the Camel-puffing dogfaced infantry. My head still spins around until my neck snaps when I think of Audie Murphy playing himself in his own life story. And in my mind's eye, the World War II Memorial would not be inappropriate if it held the image of Steve McQueen.

But if course it's completely inappropriate! It's madness! It's easier to find a decent picture of George C. Scott playing Patton than a picture of the actual bastard himself. Our own contemporary history gets bought up, fictionalized, and thrown back at us so fast the wrong images end up being the most enduring.

I don't see Gandhi in my mind's eye anymore, I see *Gandhi*, Ben Kingsley. That's plain wrong. And I've been fighting like hell to eradicate the image I have of the troubled Prince Siddhartha, Gautama Buddha, the enlightened one, the Tatagatha and teacher, the Jewel in the Lotus, as a well-oiled Keanu Reeves. This gives me nightmares.

My literary heroes now pop right out of Mental Casting. Glenn Close is Clytemnestra. Pee-wee Herman is Columbine. Liam Neeson is Beowulf. Peter O'Toole is Merlin. John Goodman is Falstaff. Glenn Close, again, is Lady Macbeth. Al Pacino is Faust. John Malkovich is Willy Loman. Sidney Poitier is Brutus Jones. Chris Isaak is Sal Paradise. Fiona Apple is Lolita. Anthony Quinn is the old Buendía, and Antonio Banderas, John Leguizamo, Mark Anthony, and Ricky Martin are his progeny.

I've had enough of this. I want my imagination back. I want the heroes that I see on the screen to transmute the screen, to be larger than their cinematic lives. I don't want to see the guy who played Jesus on the cover of *GQ*; it's too much cognitive dissonance for my fragile psyche. So, I avoided the Academy Award and instead went to the movie theater and saw a glorious movie, *Before Night Falls*, and found a new hero, the writer Reinaldo Arenas. And I applaud the actor, Javier Bardem, who so reminds me of a young Raul Julia in his grace, his power, and control of a role, and who did such a wonderful job of presenting the writer Arenas that he became transparent; I believe that if I had ever met Arenas that I would have known him for his own acts and works, rather than for the actor who played him. There aren't enough awards to give Bardem what he deserves for his performance. Much, much more so than the dopey melodramatic characters in *Gladiator*. Movies like *Before Night Falls* give me hope for the long struggle ahead, and remind me that to avoid four hours of movie industry self-tribute is the first step toward getting my heroes back.

✴ WEEK 13, MARCH 26–APRIL 1 ✴

Loews Cineplex Edina 4 — **Traffic**
Uptown Theater, Minneapolis — **In the Mood for Love**
Heights Theater, Minneapolis — **Now Hiring** (World Premiere)
Oak Street Cinema, Minneapolis — **Peter**
Mann St. Louis Park Cincma 6 — **Heartbreakers**
Landmark Lagoon Cinema, Minneapolis — **Crouching Tiger, Hidden Dragon**
Oak Street Cinema, Minneapolis — Hong Kong Series: **Young and Dangerous**

The "Art" Film
Films That Are S'posed to Be Good for You

This week I will meditate on the alleged "art film," a name broadly given to films that don't follow the Syd Field–screenplay diagram, or films that make critics spout wonderful things. For example: *In the Mood for Love*, by Wong Kar-wai, has been described as follows:

- Reserved gushing: "Boldly mannered yet surprisingly delicate" (J. Hoberman, *Village Voice*);
- Typical gushing: "A swooningly cinematic exploration of romantic longing" (Kenneth Turan, *Los Angeles Times*);
- Flat-out verbal orgasm: "Probably the most breathtakingly

gorgeous film of the year, dizzy with a nose-against-the-glass romantic spirit that has been missing from the cinema forever" (Elvis Mitchell, *New York Times*).

In fact, every critic I looked into had nothing but gushing things to say about the film. And I have to agree, that it is a film so full of mood, so independent of traditional narrative, so evocative of . . . and sublime in its nuanced . . . so . . . slow . . .

The film was so friggin' slow, I fell asleep three times.

It was so repetitive that one of the times I woke up I thought I'd slept through the damn thing and was watching it again. The pace ground down to the point that I thought the projector was stuck. I wanted to ask the film if I should get out and push. I've been to educational filmstrips that had more momentum. It was a Tuesday, and when the credits rolled I looked at my watch expecting it to be Thursday, but only ninety-eight minutes had passed.

See it and tell me if I'm wrong. Here's the deal: Mr. Chow and Mrs. Chan have just taken rooms in the same tiny apartment building in Hong Kong, next door to each other. Their respective spouses, Mrs. Chow and Mr. Chan, are never around—in fact, when they are around they're never onscreen. They're always off on "business" in "Singapore." Get it?

This leaves Mr. Chow and Mrs. Chan plenty of time to go to work, come home, get some take-out, walk in the rain in slow motion, pass each other in the hall, and call in sick for work, probably due to a forty-eight-hour ennui bug.

Roughly seven and a half hours into the film, Mr. Chow and Mrs. Chan begin to exchange greetings, indulge in small talk, all from a respectful distance. They pass each other on the way to and from work, they notice each other when they go to get take-out, they bump into each other in the hallway.

Granted, any Hollywood film would have the pair humping like poodles by this point, but Mr. Wong holds back. At about eleven hours into the movie, the two go out for tea. They realize when they do that Mr. Chan owns the same tie that Mrs. Chow gave to Mr. Chow, and

that Mrs. Chow totes the exact type of handbag that Mr. Chan gave to Mrs. Chan!

If you're following me, this is a fragile conversation, actually a terrific scene, in which we realize that while Mr. Chow chats so pleasantly with Mrs. Chan, the complementary Chow and Chan are banging away in Singapore.

Now something's going to happen, right? Wrong, Mr. Wong. Mr. Chow and Mrs. Chan show the kind of restraint normally given to tales of courtly love and guys who've had their weenies lopped off. Instead of indulging in vengeful sex, they write martial arts serials together and moon around endlessly, rehearsing what they'll say to their partners.

The ensuing tension is massive. It's like spending two hours rubbing your stocking feet on deep pile wool carpeting, building up a fifty-thousand-volt static charge, but finding yourself in an insulated room with no edges. There is absolutely no release, not in one frame of the thirty-two-hour film.

I wanted to like it, I tried really hard, but I didn't. It might have been the day, or what I ate for lunch, but this movie just didn't cut it. Sure, the film was well made, beautifully shot, almost exclusively at night with a lot of rain, and it did instill in me a tension of unfulfilled longing. But it damn near drove me crazy and it certainly drove me to sleep. So, I'm a film hater, because every critic in the world has hailed it as an unparalleled masterpiece.

In the Mood for Love is one of the most gruelingly long and annoyingly actionless movies I have ever seen. I will hold to that, but you should also know that images in that film still dwell in my mind, often when I'm dreaming, so damned if I don't have to consider the film to be a work of art, not because it is boring but because it is transcendent and enduring, beautiful and problematic. Most of all, it has etched a place in my memory, the art gallery in my head, where I keep some paintings by Grant Wood, the second movement of Beethoven's Seventh, Chagal's stained glass, and a brace of Coltrane solos. So, did I like the movie or not? I don't know. Damn. How do I resolve this?

Recently, the Walker Art Center, in that gray sepulcher of a screen-

ing room, presented the Korean film *Seom*, or *The Isle*, by Korean artist Kiduck Kim.[8] The movie's main themes are murder, misogyny, sado-masochism, violent sex with hookers, and fishing.

Remember, this is being shown in a *museum*. Right there alongside the Yoko Ono exhibit, which speaks volumes about the Walker these days. I'm surprised I didn't see more than a dozen people leave. A lot of people were laughing during the film, that nervous, jittery laughter of people who are so stunned by what they see they don't know how to react. The audience was perturbed. I was perturbed.

Perturbed enough to have a chat with the curator of film and video at the Walker, Cis Bierincx. I asked him straight away: Don't you feel this film was misogynistic in its portrayal of violence against women? Absolutely not, he said, and further he believes that feminism has become so politically correct that the themes this film dealt with, themes of obsession and death, of Eros and Thanatos, have become taboo. Look at Peter Greenaway, he says, the same themes, just as disturbing.

Cis had a point: If you want to see gratuitous sexism and pointless violence, look no further than this year's Oscar winner *Gladiator*. And it's true, the American audience would rather have their creepy themes of sex and death served up as a sporting event rather than high art. And it's also true that we've become so inured to scenes of death and sex that one must hit one's audience over the head with a giant penis these days just to get their attention.

I told Cis I didn't like this film. I hated this film. I'd talked to a number of people in the lobby after the screening and a good lot of them hated it, too. Cis thought that was fine; he'd much rather have a divided audience that talks after the screening than one that goes home unchanged and unchallenged.

Damn it, he's right. No one went away unmoved. There was a lot of passionate discourse, a lot of angry dismissal, followed by more thoughtful reflection.

Me, I couldn't get past all the rape and woman-beating and muti-

8 Credits include the animated TV series *Super Taekwon Robot*.

lation. It got in the way of any deeper meaning, any truth deep inside the work, that we are constantly struggling to understand our passions; sometimes we win, sometimes we lose. Like in the classic themes of the Greeks, the stories of Oedipus, of Orpheus, of Helen and Paris; themes of love and hate, of humanity groping to rise above our basest instincts. But we never can, can we? That creepy shadow side is part of what makes us human, isn't it? And to ignore it is to ignore the elephant in the parlor.

Cis returned that, hey, it seems that I *did* draw out something from the film beyond all the sex and violence, didn't I?

I can't get around this guy; it's like talking to a Moonie. He's right, and he's wrong. He's right that art must connect us with ourselves and with each other to be vital, and he's wrong that this film accomplishes that. He's wrong about this film because there are other ways to ennoble us besides vividly showing us women getting raped, beaten, belittled, robbed of any dignity.

The people who argue that the American audience is dead to art are the same ones who give us disgusting films like *The Isle*, or challenging films like *In the Mood for Love*, and simply expect us to buy into it. It's hard enough to get stiffs like us to look at subtitles, let alone have our sensibilities shocked at every turn.

There is a huge middle ground between the unwatchable and the unredeeming. A potential audience, raised on the vastly alternative artistic styles of music videos, now has a taste for something new, the popular art film. Sort of a Grant Wood or Edward Hopper equivalent somewhere around Jim Jarmusch, Julian Schnabel, Agnès Varda— hell, even Peter Greenaway. Let's see more of *these* in museums, eh?

I'll tell you my favorite art-film experience. I saw Derek Jarman's *Blue*, a delightfully iconoclastic testament against our culture's morbid fear of death and AIDS made by a man dying from the disease. It features witness from friends and colleagues, cyclic poetic statements, variations on themes, powerful painful passages, humor, pathos, depth. That's what you *hear*.

What you *see* is seventy-six minutes of nothing but a blue screen.

This is the kind of thing I would normally laugh off as pure pre-

tense, like John Cage's silent anthem on his contempt for the audience, "4'33"." But *Blue* has purpose and intent that is perfectly evident from the outset. The filmmaker, dying of AIDS, is going blind. He wants the audience to feel some of that. So he challenges us to see something of what he sees, which is nothing but the color blue, as he and his friends bring us into his waning world. He wants us to go blind with him.

And as an audience, we do, staring at a big blue rectangle in a darkened room. As an audience we go blind, and we listen, and it is effective and painful and funny and wonderful and it is the only art film I have ever really loved.

Why does *Blue* succeed while *The Isle* fails? Simply put, Derek Jarman loved making films, it's obvious. And it's also obvious that he loved his audience. Loved us enough to challenge us to try something new, take an adventure.

Well, look at me—gushing over an art film.

✳ WEEK 14, APRIL 2–8 ✳

William L. McKnight 3M Omnitheater, St. Paul	**Everest**
William L. McKnight 3M Omnitheater, St. Paul	**Wolves**
Imation IMAX Theater, Minnesota Zoo	**Adventures in Wild California**
William L. McKnight 3M Omnitheater, St. Paul	**Thrill Ride: The Science of Fun**
Imation IMAX Theater, Minnesota Zoo	**Galapagos 3-D**
Imation IMAX Theater, Minnesota Zoo	**Dolphins**
Imation IMAX Theater, Minnesota Zoo	**All Access: Front Row. Backstage. Live! Presented by Certs**
Oak Street Cinema, Minneapolis	Hong Kong Series: **Young and Dangerous: The Prequel**
Mann St. Louis Park Cinema 6	**Blow**
United Artists Eden Prairie 4	**Along Came a Spider**

Me to Universe: Send More IMAX Films!
From Technological Novelty to Cinematic Novelty

I just got back from seeing an enormous Sheryl Crow, and boy, is she impressive when she's big! I also saw a capacious Kid Rock, a gargantuan George Clinton, a stupendous Sting, a massive Dave Matthews, a towering Rob Thomas (with a colossal Carlos Santana), a monstrous Moby, and a Brobdignagian B. B. King.

Thanks to IMAX, people and things are bigger than ever. Is this good? Maybe. Could it be better? Definitely.

The film was *All Access: Front Row. Backstage. Live! Presented by Certs*. This is the full title, the title they chose. The punctuation is theirs, as is the titular product placement. This film and its titanic

title symbolize what I love and hate about the IMAX format: It's an amazing visual spectacle with a vast unrealized potential surviving on corporate support.

If you have never seen an IMAX film, do it. Now. Put down this book, find the nearest major tourist attraction—zoo, amusement park, museum, giant mall—and look for the jumbo-jet hangar with the IMAX logo. You'll scurry into a comfortable, county-size theater where you'll see the biggest, clearest, sharpest, most detailed image ever on a movie screen.

That's not another exaggeration, it's a simple fact, due to the sheer size of the actual film these folks use. It's a regular 70mm-size film stock turned on its side and given extra perforations. That's all you need to know, the rest is technical.

Think of it this way: When you take pictures of your sister in her hideous bridesmaid dress on your Kodak insty-everything camera, they look okay—fuzzy and flat, and of course your sister has her eyes closed. When you go to Sears to have that family portrait done, the lady with the toys and too much perfume uses a really big camera that holds really big film. Because when you use really big film, you don't have to blow up the picture so much. Simply put, in the hands of a professional, bigger film, better-quality picture.

And the IMAX picture is stupendulous magnifical gigantular big.

IMAX Corporation has been tinkering with extremely huge film formats since the late sixties, when the original partners were doing those trippy multiscreen presentations that went so well with Maui red bud or Acapulco gold. I first saw the technology in San Diego at the Reuben H. Fleet Space Theater, back in the disco era. I said it then and I'll say it now: This is an amazing, underutilized way of seeing movies.

First let's finish with the techno-poop: There are two predominant methods of presenting this giant film format: IMAX, which uses a massive square screen, and IMAX Dome, formerly OmnIMAX, which projects on an equally massive or possibly massivier semispherical dome. My personal preference is for the IMAX format. I'll tell you why.

This week, the Science Museum of Minnesota's William L. McKnight 3M Omnitheater held Omnifest, an event arranged ostensibly to celebrate thirty years of OmnIMAX greatness. Actually, it was a transparent attempt to get asses in seats while the schools were on spring break. I went to five of these films, and I'm here to report that it is at once a very thrilling, breathtaking, annoying, overrated experience. It's part carnival ride, part documentary, part classroom.

But it's not the movies, not really.

First, you line up in a fidgeting mob full of pale museum nerds and kids on field trips. As you stand behind the stanchions, a man who wants to be perceived as important takes a microphone and tells you many, *many* important statistics about the OmnIMAX technology, as if there'll be a test afterward. The Dome weighs sixty-two and a half jillion tons, and is supported by counterweights each weighing as much as a herd of sheep! The projector is fully automated and costs as much as it takes to feed the Sudan for a year! Isn't that amazing? The film is very special, costing over X amount of dollars per foot. We should be impressed.

We are told to behave like adults and not to run to our seats. At this point the stanchions are lowered, and all of us, the young and the old, run for our seats.

We are all running because we all believe we're the only ones who know the OmnIMAX Experience Secret Spot. The secret spot, the best seats—in fact the *only* good seats—are top center, directly above or below the projector housing. If you sit anywhere else in the auditorium the picture is tremendously skewed, almost bizarre, and you've spent eight bucks to look at a wolf whose kisser appears to be projected on the side of a hot-air balloon.

Once comfortably ensconced in the secret spot, in your very cushy, high-backed seat (no drink holders, since no food or beverage is allowed in the auditorium, thank you), the cavalcade of corporate support begins. In a small screen a slide show appears, proudly naming proud sponsors.

I have an issue with proud sponsors. Sure, museums live and die on the strength of their corporate sponsorship, but the humiliation

corporate branding puts on an exhibit diminishes it. I don't really give a hoot in hell if U.S. Bank, Qwest, and Star Tribune companies are Premiere Partners. They need to be, whether they are acknowledged or not, or guess what: no museum to host your little martini-and-salmon ass-kissing events.

Such is the age we live in where anything educational or cultural-ly beneficial must have a patron on the NYSE or Nasdaq, and that patron will loudly trumpet to the world how benevolent they are. I am always greatly gratified when I see a work of public art or learning sponsored "by a friend." That's class.

After we've become thoroughly familiar with the fine companies that make our culture possible, the massive half-sphere on which the IMAX Dome presentation is projected begins to lower over us. And it is impressive, some three hundred feet wide, it slowly lowers itself over the audience and we are encased in the world's biggest Ping-Pong ball.

But even better, as the dome comes down we get a little preshow brought to you by—hey!—your favorite local news team at Channel 5! Oh, and they tell us all sorts of neat statistics! Did you know that the sound system alone could deafen three hundred Pete Townsends? And, hey, the screen itself is composed of fourteen incredibillion quantities of construction material! Wow! Could you guys smile any more with those voices? And weatherman Skip Dimple wants us to know how big the projector bulb is! Jumping butterballs!

Eventually, you will find that more time in the OmnIMAX experi-ence is spent talking about the OmnIMAX experience than is spent actually experiencing OmnIMAX.

Finally, after what seems like two hours of psychic buffing, the film begins, sponsored as it is by even bigger corporations. And, depending on the film, the experience is a lot of fun. One of my favorites was *Flyers*, which has oodles of point-of-view aerobatics done in nifty little stunt planes. The effect is vertiginous and exhila-rating. Like a ride. Not like a film. When an intimate story is told in this format, it doesn't always work. There is too much to take in on the screen, and the eye wanders to the periphery. OmnIMAX loses

its impact on the simplest shots, lovely as they are, because they were not meant to fill your entire field of vision from eyelid to eyelid.

As an actual movie, *Wolves* loses its way. It's a very thoughtful documentary, but the OmnIMAX sensation overwhelms it. *Thrill Rides* is a corny amalgam of visual stunts and the effect actually gets boring. So far, the best experience I've experienced in the OmnIMAX experience was the documentary *Everest*, shot during the very public tragedy on the mountain in 1997. The story has emotional impact, even pathos, and some awe-inspiring photography. You begin to understand why a person would be so mad as to risk the likelihood of death to see the roof of the world.

I was glad to get out of the Ping-Pong ball and have a go at the other IMAX, the regular IMAX; the one with the six-story Sheryl Crow. IMAX is closer to being the movies than its IMAX Dome novelty counterpart, and IMAX and other producers are doing some actual feature films in the format. IMAX is also more like the real movies because, for starters, they sell snacks and beverages and trust you not to projectile vomit on the person or persons in the row or rows in front of you. This is a big trust, because the auditorium is huge and steep, and the IMAX image does more messing with your cochlea than a helicopter could. No matter where you sit in this theater (the center rear is still best) the picture fills your field of vision with little distortion.

Adventures in Wild California made me, and many others in the audience, want to leave the theater, fly to the Golden State, and jump out of an airplane with a snowboard on my feet. The movie is filled with "extreme" people of all kinds, including some who were extreme back when it was just called "nuts or something." People jump out of aircraft, rappel down sequoias, dance on top of suspension bridges.

IMAX lost a lot of dough last year, and they'll probably lose more this year, and it may just be—not to insult anyone—*because they have the coolest film format in the world and all we get to see are bears and stuff!* Even the new president of IMAX Filmed Entertainment admitted in an interview that IMAX has been famous for making three types of movies: "Bear movies, dolphin movies, and seal movies."

I'll put a finer point on it: IMAX has to lighten up.

IMAX needs a *Lawrence of Arabia*. IMAX cameras ought to be put in the hands of great cinematographers. Can you imagine *Lord of the Rings* in IMAX? You'd have to scrape the audience off the back wall with a putty knife. How about *Spinal Tap to the MAX*? Loosen up that G-rating thing and put a real movie on at night. At the very least, hire some decent writers now and then. I have never heard a funny joke in an IMAX film, including the allegedly funny ones, except for the tiny *Simpsons* segment on *Cyberworld 3-D*, and that was taken right from the TV show and blown up.

This is a field full of diamonds just lying on the ground. IMAX is all grown up but it won't let the kids have the keys to the car.

✳ WEEK 15, APRIL 9–15 ✳

Uptown Theater, Minneapolis — **The Dish**

Bell Auditorium, University Film Society — **Esperando al masías (Waiting for the Messiah)** (Minneapolis–St. Paul International Film Festival)

Oak Street Cinema, Minneapolis — **Egy tél az Isten hata mögött (A Winter in the Back of Beyond)** (Minneapolis–St. Paul International Film Festival)

Landmark Lagoon Cinema, Minneapolis — **The Widow of St. Pierre**

Parkway Theater — **Company Man**

Oak Street Cinema, Minneapolis — Hong Kong Series: **Young and Dangerous: Born to Be King**

Cedar Six Theaters, Owatonna, Minn. — **Josie and the Pussycats**

Crouching Audience, Hidden Talent
Hong Kong Action Films and the Saturday-Morning Gang

Minneapolis, Saturday morning, 11:00 A.M. When most kids are home watching violent, confusing Asian cartoons, a brace of adults are at the Oak Street Cinema watching the adult equivalent: Hong Kong action. I call them the Saturday-Morning Gang, because every Saturday morning they assemble in the creaky dinge of the Oak Street Cinema in Minneapolis to watch the Asian Media Arts ongoing series, "Hong Kong Cinema with Passion." It's only about forty people, but it's *the same forty people every Saturday morning*. Most of them are white, middle-aged freaks who might as well be Trekkies or Tolkien loonies. A handful of them smell bad. All of them are passionate about

their Hong Kong films. And like huge fans of anything, they can be the strangest and most unpleasant people on the planet.

I'll give you an example. One Saturday while watching *Butterfly Sword*, I jotted some notes with my pen and trusty penlight, cupping my hand over the beam so as not to offend, as I always do, just letting a mere crack of light illuminate my tiny notebook. I swear it. Nobody objected, nobody complained; I wrote for a few scant moments through the first thirty minutes, then put my stuff away.

Then, as the credits rolled, a woman marched right up behind me, her jacket rubbing against the back of my head. She had a lion's mane of gray hair, sticking out in all directions, a lot of layers of flannel clothing, some kind of dolphin-safe sneakers on her feet. Boy, was she pissed.

"I just wanted you to know that you *ruined* the film for me." She shrieked, loudly, so all in the room could hear. "You kept waving that *huge* flashlight around so much my husband and I couldn't watch the film, and it just *ruined* the entire movie. I just want you to know that other people *care* about these films, but we don't *ruin* it for each other like you did."

There's a lot to unpack here. She mentioned "ruin" three times in one paragraph, so I'm detecting a leitmotif in her shrieking. Her face had an expression I'd seen before, in San Diego, on a peacock as it was hit by a bus. But I'm used to this behavior, having lived in Minnesota as long as I have. It's an offshoot of Minnesota Nice, a detestable form of passive aggression in which people pretend to suffer and endure a situation without comment until everything is just *ruined*; then, they arise and proclaim to anyone who wants to hear and many who don't that everything has been *ruined* by one person, who, by the way, is not one of us.

I was surprised at the mention of her husband. He is a mammoth. I don't simply mean a very large and hairy person; I mean a wooly mammoth, species *Mammuthus primigenius* clad in matted dark-brown fur, with tusks and a trunk, standing fourteen feet at the shoulder. No doubt he'd been caught in an ice crevasse during the late Pleistocene epoch some fifteen thousand years ago, and subsequently

thawed, dressed in a flannel shirt, and taken to husband by this great shrieking peahen. He stood a good ten feet away, said and did nothing; in fact he wouldn't even look at me while she shrieked.

I apologized instantly, but Chicago born and bred as I am, polar opposite in demeanor to Minnesota Nice, I suggested in my own nasal grunt that perhaps if she would've gotten up and walked the ten feet over to me and said "turn off your damn flashlight" when I first offended her, instead of waiting until the film was just *ruined* by my thoughtless blinding of the audience with my massive carbon-arc searchlight, this whole unpleasantness would have been avoided. To this her livid, birdish eyes widened and she now shrieked with renewed zeal, in a voice so high-pitched I could hear car tires popping out on the street.

She's always there, she and her hubby, *M. Primigenius*, for every film, drinking in every frame, steeped in the odd conventions of Hong Kong cinema. In the States among white people, Hong Kong films in particular and Asian film in general still belong to a sort of cult audience, like Goth music or fantasy role-playing games, and it may be due to this weird audience that a whole generation of Hong Kong filmmakers came and went without anyone here really noticing.

Critics have always wanted to like Hong Kong action movies, and with good reason. Even the worst of them cannot be accused of being slow or dull. Hong Kong action movies, comic or tragic, from the historical medieval Shaolin-master type to the modern Chinese Mafia type, at their best are inventive, wildly energetic, and a lot of fun.

For most people, Hong Kong cinema simply means Bruce Lee or Jackie Chan, and that's okay by me. Getting any deeper into the genre can bring you face-to-face with the shrieking peahen and her extinct pachyderm. Bruce Lee was actually born in San Francisco, and then moved at a young age to Hong Kong. Hong Kong is as big an ethnic mess as San Francisco, so it stands to reason that an American in New China would bring New China back to America. I remember the TV series *The Green Hornet*; Bruce was Kato. How confident he was, how smooth his moves. And when the *Dragon* series of movies appeared, how cool they were.

Enter the Dragon, Bruce Lee's first American film, which came out the year he died, was cooler than cool. Quentin Tarantino wishes he was half this cool. It was also my first initiation into Hong Kong movie snobbery, when a high school friend chastised me for not knowing that *Return of the Dragon* was before *Enter the Dragon*, and was far superior because it was actually Chinese and, further, it didn't feature John Saxon.

Return of the Dragon has some of the most thrilling fights ever filmed, without all the ridiculous flying tackle they seem to need these days. Just fists and feet and bodies getting slapped around, as natural as free-range chicken. It also may be the last time Chuck Norris played a villain instead of a good cop who doesn't play by the rules.

When Bruce Lee died, the American fascination with popular Hong Kong film died with him, at least for a while. In the meantime, Hong Kong went through some earth-shattering political and cultural change, while of course nothing much happened over here except Reaganism, Desert Storm, and the dot.com madness. A new generation of filmmakers grew, influenced by Japanese, European, and American film styles, as the urban crucible of Hong Kong shaped them into mad urban artists. Out the other end came the likes of Chow Yun-Fat, Jet Li, and Michelle Yeoh and directors Tsui Hark, Wong-Kar Wai, and John Woo.

With them came the Saturday-Morning Gang. And suddenly Hong Kong film is famously popular again, aped by directors in other countries, coveted by its own people. It's a film style that plays like a living comic book, reveling in its wildness, offending in its bluntness, never stopping to catch its breath.

David Bordwell, film scholar and author of *Planet Hong Kong*, points out that Hong Kong is one of the few foreign markets where local films do better than their heavily marketed American competitors. Audiences in Hong Kong eat these things like candy. And the Hong Kong film community, in spite of its prolific output and breakneck production schedules, has managed to create tremendous innovation, marvelous craft, and even cinematic art.

Most familiar to us these days is Jackie Chan, who is sneezed at by

the Saturday-Morning Gang as something of a sellout. That's too bad, because I like Jackie Chan; he's brilliantly talented and funny as hell, so he epitomizes Hong Kong action films. He's also sloppy and uneven, which also epitomizes Hong Kong films. But getting beyond Jackie Chan can be an adventure.

I'm going to mention a director here, Tsui Hark, who has made over sixty films, many of them conventional action films, many of them downright bad. But he is Hong Kong all the way. *Once Upon a Time in China* is a series of six films starring Jet Li that tell tales of old Hong Kong as it was picked apart by colonial imperialists like the English and Americans. Hong Kong, proud and ancient city-state, is defended by the old ways embodied by Master Huang Feihong, played by the perennially young Jet Li. It's part history, part comedy, part grand opera. Confusing and beautiful.

This year Tsui Hark gave us *Time and Tide*, a modern tale with slick production and a talented young cast. It's every bit as wild and confusing as the *Once Upon a Time* series, and every bit as captivating.

These particular Tsui Hark films share an important theme: reluctant heroes. These are not antiheroes; these are not even violent people. But they are forced to defend those too weak to defend themselves. It's an age-old story, of course, and in many of these films violence is portrayed as an unfortunate means to an end, even when it's extreme.

See *Time and Tide* some day and compare it to that ugly American blood orgy *Swordfish*. Tsui Hark's film has a lot more shooting but a lot less violence. Violence in *Swordfish* is eroticized, sexualized; it symbolizes the male power of the antivillain John Travolta. Freudian as hell. But with Tsui Hark you get a much less macho version, and a visual style much closer to ballet than ballistics.

However, Hong Kong doesn't hold back on ambiguity. The strangest, most slickly produced, and apparent favorite of the Saturday-Morning Gang seems to be the *Young and Dangerous* series, which deals with the history of a triad, a Chinese gang called the Hung Hing. The Hung Hing are divided into branches, which seem to be like Boy Scout troops within the larger Boy Scout council, except the Boy

Scouts don't routinely crush one another's skulls with aluminum baseball bats.

Among their ranks are the charismatic leader, Ho Nam, who is a nice enough guy except to people he doesn't like, whom he chops in half with a large sword. There's also the plucky Chicken, a hale fellow who prefers a gun or two, and tends to enjoy sex more frequently than food or perhaps breathing. "Chicken," I've learned, is a nickname for "one who likes sex a whole bunch, especially with hookers." It also refers to young male prostitutes. That's a lot to carry around in your name, so I'm not surprised the guy's so hostile. They and their pals— the goofy Pao Pan, the tough but shy Banana Skin, and the older, wiser Big Head—round out the gang and work for the branch leader, Uncle Bee.

Banana Skin. Big Head. Uncle Bee. I couldn't make this stuff up if I wanted to. And although I snicker, looking at police blotters and top-forty lists from coast to coast finds you Eminem, Snoop Dogg, and various Puff Daddies who mutate into P. Diddies; so Hong Kong has no corner on the funny-ass names.

There is one standout actor in all of this: Francis Ng Chun-Yu plays rival leader Ugly Kwan with such power and seething menace he scares me. I like him because he plays evil so well. Not the sniggering arch-nemesis sort of cartoon evil you get out of John Travolta, John Lithgow, or other such evil Johns. Nope, I'm talking hairs on the neck, walking time bomb, moral-depravity-style Evil with a capital E. Christopher Walken Evil. David Lynch would be scared of this guy. Ng's acting is almost pure. His characters stand out from his movies as if they occupied an additional dimension.

Watch for him. Francis Ng. I want to single him out because if he learns enough English, Hollywood'll swallow him up within weeks. This guy acted in sixty films in the last ten years, five of them in the last year. American film would ruin him. I want to find him and warn him: Stay in Hong Kong. Be great in your native land, and send us your films, only with better subtitles.

Hong Kong movies are just plain fun. Like garage bands are fun, like freestyle hip-hop is fun. In turns they're loose, brutal, silly, and

ingenious. And they're going through a revival; recently I saw *Iron Monkey*, a film that came out of Hong Kong in 1992 and just sat there until *Crouching Tiger, Hidden Dragon* hit the stage. This is very interesting to me, because the Saturday-Morning Gang just despises *Crouching Tiger*. They call it a rip-off of authentic kung fu movies. They say that director Ang Lee stole from everybody, most notably the bamboo tree battle from *A Touch of Zen*. To this bunch, Ang Lee is the Paul Simon of kung fu films. Although I liked *Crouching Tiger* well enough, I was never one to jump on the campaign truck headed into town to declare the movie the greatest piece of film ever made, as so many rushed to do. In fact, given the choice right this moment between seeing *Crouching Tiger* and the terrific old Jackie Chan movie *Fearless Hyena*, I'd go with Jackie Chan and never look back.

Because, as I said, Hong Kong movies are just plain fun. Don't get too hung up in their intricacies, or knowing all the names of the actors, or following the careers of certain fight choreographers like the Saturday-Morning Gang does. I have a friend who roasts, grinds, and brews his own coffee, all in special equipment. He'll only use an Italian espresso machine costing thousands. I'm certain he measures the surface darkness of his beans with the Agtron scale. I think he enjoys coffee less than I do, because I can savor a cup of perfectly roasted espresso (no sugar) with a 9mm layer of *crema*, but I can also get off on a reheated mug of Yuban pissed through a dirty Bunn-o-Matic with a paper towel for a filter. For me, it's all coffee. For me, it's all Hong Kong cinema.

Nuthin' but Furrin' Films
Going Around the World Without Leaving Your Western White Male Provincialism

This week it's nothing but foreign films. Think that's tough? How about nothing but *foreign language* films, eh? No trying to pass off New Zealand films as foreign. I'm talking foreign language films, presented in their native tongue, with English subtitles, if you're lucky. Now who has the guts to join me?

I didn't think so.

The town's crawling with 'em right now; they're coming out of the woodwork like booths at the New York Ninth Avenue food fair, thanks to the Minneapolis–St. Paul International Film Festival, or M-SPIFF. Emspiff. It's an odd and confusing mélange of world cinema, taking

place at seven different theaters, and like the above-mentioned food fair, some bits will have you hungry for more, while others will leave you running for the bathroom.

I have spent the better part of the last two weeks crawling around the dusty venues where the festival shows, and in spite of endless schedule changes, rock-hard seats, and bad screens, it's been a most enjoyable, rewarding two weeks of moviegoing.

Minnesota is hungry for this. People are flocking in to watch better than a hundred films from over forty countries. We have two Irish films, four Iranian films, four Italian films, twelve German-language films, a whole boatload of Scandinavian films (this is, after all, Minnesota), we got your Czech, Spanish, Egyptian, Korean, Macedonian, Turkish, Kurdish, Nepalese, Thai, Croat, Chinese, Slovenian, and on beyond Zebra.

Even the real foreigny films have people lining up at the doors to get in. And it's not just a hemp-fiber-and-Birkenstock crowd either. Folks from the suburbs are coming out to catch their roots. Remember, Minnesota is more Scandinavian than Scandinavia. Wisely, there is a wealth of Finnish, Icelandic, Norwegian, Swedish, and other horn-helm country films. Suddenly Volvos and Saabs full of health professionals and investment specialists are taking up all the room in the narrow parking ramps around the university campus where most of the festival lives. These people are looking for a glimpse of the old country, a taste of what they've left behind for the good life in the States.

Not only that, but lacking the incredible budgets and publicity that even the stupidest of Hollywood films enjoys, foreign films have to be pretty good to fly into the U.S. radar. What's more—and why I could live on nothing but foreign films and be happy—is that they often have no Hollywood equivalent, and if they do, the foreign equivalent is generally better.

Here, I'll prove it.

CASE #1:

FOREIGN FILM: *Amores perros* (English release title: *Love's a Bitch*): A quilt of separate stories about love, rage, crime, and conse-

quence that intersect, amid showers of gunplay, tugged together by sheer circumstance and people's dogs.

U.S. FILM: *Pulp Fiction:* Also a quilt of separate stories about love, rage, crime, and consequence that intersect, amid showers of gunplay, tugged together by a perfect lack of human compassion.

SIMILARITIES: Both feature hit men, sexy women, brutal scenes of violence, shock-value editing, nonlinear time-line storytelling, pensive articulate murderers. Both are maniacal, brutal, funny and shocking, brilliantly crafted, controversial, and groundbreaking.

DIFFERENCES: *Amores perros* has a deep moral core, and its inhabitants, no matter how depraved, seek redemption. Whether that redemption is found or lost, all three interwoven stories address the pains and joys of the human soul, in suffering and at ease, and ultimately the film fitfully, violently, informs us that life, although not easy, is not simply desperate.

Pulp Fiction has no moral core; in fact, it scoffs at the very notion of morality. *Pulp Fiction* tells us that life is a planet-size copper kettle full of bubbling feces, in which we stand, knee-deep, until the coffee break's over and we all have to stand on our heads again.

WINNER: Mexico, hands down.

CASE #2:

FOREIGN FILM: *Da jeg traff Jesus . . . med sprettert!:* A fine film from a terrific story, from *Min barndoms verden* (*The World of My Childhood*) by Norwegian author Odd (!) Børretzen. A young man and his pals trade stories, share adventures, and grow up a whole bunch in rural midwar Norway.

U.S. FILM: *Stand by Me:* Also a fine film from a terrific story, *The Body*, by Stephen King. A young man and his pals embark on a quest to find a dead body and collect a reward. Along the way, they trade stories, share adventures, and grow up a whole bunch in rural midwar Norway. I mean postwar America.

SIMILARITIES: They are both coming-of-age stories. They are both bucolic and dreamy, and have an undulating base note of fear and dread. They both feature terrific performances by their young ensemble casts.

DIFFERENCES: *Stand by Me* relies on a chapter structure, quite like reading a teen novel, and keeps its pace through an almost impossible set of predicaments for a couple of nights in the woods. The soul-searching nature of the work is occasionally poignant and telling, but it's forced into the story with a crowbar.

Da jeg traff Jesus has no real narrative the way we like it here in the U.S. of A. It's simply a series of events in the lives of its characters. These simple lives and seemingly harmless incidents reveal character, and it deepens those characters in reflection. In one such scene, the principal kid, Oddeman, stares at a clock for minutes on end: That's the only action. But come on, who hasn't caught her kid doing something like this?

Ultimately, *Da jeg traff Jesus* has a more credible fiction, by which I mean it better reflects the lives of its characters, without resorting to high drama or melodrama.

WINNER: *Da jeg traff Jesus*, but just by a nose.

With the exception of the occasional *Crouching Tiger*, Americans just plain don't like foreign-language films. We want to like them, but we don't, not really. Take a look at *Chocolat* for instance. People were endeared to it because it pretended to be foreign. It wasn't. It was an American film, shot in English, set in a foreign country. It was Europeland at Disney World.

Long ago in a mythical time known as the postwar era, city people would line up at little "cinemas" to see films of the Italian neorealists and the French New Wave. Sure, they didn't score the bucks that American films did, but they drew a loyal and substantial audience. Later on, in the sixties and the seventies, the college culture deemed it cool to see films by your Werner Herzogs or your Wim Wenderses. And Lina Wertmuller movies with their ten-word titles were considered entertaining.

Only a handful of popular filmmakers—John Frankenheimer, Elia Kazan, Nicholas Ray, Otto Preminger, Stanley Kubrick—dared to make anything like them. Martin Scorsese directly credits postwar Italian films with shaping his identity, as a filmmaker and as an Italian-American. This was an era of international filmmaking, when

foreign-language films had faithful American audiences. Then along came television and turned us all into idiots.

These days distributors will take perfectly good foreign-language films and make pale American copies of them. Here's a little three-question quiz:

1. Was *The Birdcage* as funny as *La cage aux folles*? The correct answer is no.
2. Was the English-language *Just Visiting* anywhere near as enjoyable as the French *Les visiteurs*, even with the same two guys in the lead of both films? No way.
3. Was *Point of No Return* as good as *La femme nikita*? Trick question, neither was very good.

Now I read that Miramax is going to make English versions of several of their own foreign-language films. *Sheesh*. And all because we won't require kids in elementary school to learn a foreign language. *Zut alors*. Holy *guano*.

It's time to go back to foreign-language films, for many reasons. First, there's a good chance that you who are reading this have foreign ancestors. Watching a film from your native soil can do a lot to inform you of why you are the way you are.

And of course we should broaden our horizons, always. Overcoming fear of the unknown other is one of the keys to world peace, pure and simple. Foreign language films teach tolerance.

One of the finest film experiences I had all year took place this week. On a rainy, gray April afternoon I cozied into the St. Anthony Main Theater—the only actual theater in downtown Minneapolis, by the way—and saw *A Time for Drunken Horses*, the story of a family of orphaned Iranian children struggling not to die and to keep their family together as they labor in the snowy mountains of the Iraqi border.

There is no way to explain how good this film is. The photography is so perfect, the acting so natural, the story so raw and heartbreaking, it is as if I had been given a gift, along with the rest of us in the chilly half-filled auditorium, a window into the tragic lives of people far

removed from our own, yet with emotion so familiar that I felt I could almost reach in and intervene in the sad chain of events. Of course, I couldn't, and so I felt helpless, guilty; I experienced genuine grief.

And then the film was over. I was filled with a feeling—I can't say it any other way—of love. Of compassion, sadness, hope. I had not expected an ordeal, in fact I had been warned away from the film hearing that it was either "hard" or "boring," depending on who I was talking to. Nothing could have prepared me for this film. It made the horrors Spielberg portrayed in films like *Schindler's List* and *Amistad* seem superficial, almost fetishistic, too well done. See *A Time for Drunken Horses* in a movie theater, and do not see it alone.

So here's your homework assignment: The next time a foreign-language film comes to town, go see it. If you live anywhere near a college campus, there's a good chance that there will be a foreign film playing somewhere on or off campus. Always sit near the back of the theater or in the balcony; the film becomes a gestalt and you can read the subtitles without missing the action. Pick a country you've always wanted to visit, and see a foreign-language film from that country. Make an evening of it. Make an *event* of it. See a Spanish film and go to a *tapas* bar beforehand. See a German film and cap off the night at a *Gasthaus*. See an Indian film and go to an Indian restaurant for dinner. Learn a few words in Hindi. Speak them to your waiter.

Sure, there's a chance that your waiter will turn out to be Kashmiri, he'll grab a decorative scimitar off the wall and try to kill you, but, hey, it'll be an adventure.

General Cinema Centennial Lakes 8, Edina	**Freddy Got Fingered**
Muller Family Theaters Lakeville 18	**Joe Dirt**
Carmike Apple Valley 15	**Just Visiting**
Chanhassen Hollywood Theaters	**Spy Kids**
General Cinema Centennial Lakes 8, Edina	**Driven**
General Cinema Mall of America 14	**Town & Country**
General Cinema Mall of America 14	**Town & Country** (paid for **Spy Kids**)

Do Not See *Town & Country*!
And How to Prevent This from Happening Again

For the love of all that is holy and decent, do not see *Town & Country*. Not at a theater, not on video, not on cable, satellite, or broadcast television. Do not glance at it as it spills out from someone's portable DVD player. Put on an eye mask and go to sleep if it winds up on your flight. If you are invited to dinner at your friends' trim suburban home, grope through their personal belongings while they're putting the sea bass and Italian eggplant on the grill; if you happen across a copy of *Town & Country* in their video collection, run out to the little Mexican fireplace back near the hot tub and hurl the tape in, laughing in the glow of the flame as the acrid black smoke of burning plastic ascends into the neighborhood.

Do not see *Town & Country*. Do not give these people one more penny with which to laugh at us and do us harm.

It's a movie about the depraved, perverse, and twisted excuses for lives that rich people lead. It's about them endlessly boinking each other. Maybe I'm just different, but I don't give a good healthy damn about rich people.

A great number of successful, talented people living and working in Hollywood collectively decided that this film would be seen by enough of us regular idiots to warrant an eventual budget of more than ninety million dollars.

More than ninety million dollars.

Movie reviewers tend to snicker and sneer when that kind of money circles the drain, but I don't. I cry. I get very sad and very angry when I realize that they care so little about us that they would green-light a vanity production for Warren Beatty and company in a trice, then let it explode out of control, for the same amount of money it would take to fund the entire careers of a dozen terrific independent filmmakers.[9]

Sure, *Town & Country* is an easy target. Rumors of its imminent demise far preceded its release; writers chuckled about its fate as "another of those expensive Hollywood disasters." It faltered early in production, and a lot of money was thrown at it, kind of like the Vietnam War. At some point the decision was made to finish it, unlike the Vietnam War. And like the Vietnam War, it never should have been started. If this movie succeeds in any way, I'll have to begin a class-action lawsuit and demand that the studio pay us, the millions of moviegoers, treble damages for intentionally lowering our standards and for damaging our culture. Based on the movie's budget, that'd be close to a dollar for every U.S. citizen.

Ninety Million Dollars. I suddenly find myself sympathetic for that legendary mob of fascists who attacked a theater to stop the Luis

9 Here's another indication of wrongness: Because it was not produced by a major studio, technically *Town & Country* could prance around calling itself an independent film. That is wrong in more ways than can be counted.

Buñuel film *L'age d'or*.[10] I holler the question: *Who decided that we should see this, and that we would care?*

But it has helped me to coalesce my theory on the main problem with Hollywood movies. The problem is that they are made by rich people who don't care about anything other than being rich and successful and being among other rich and successful people. Is this a surprise? I guess it is, because we keep flocking to the theater, we poor dumb sheep, watching these gilded turds with their Californicator's version of what is good and right and worth telling as a story.

I've seen plenty of crappy films this year; so why does *Town & Country* stick in my craw? It's the money, big duh; more so, it's the triumph of ego over talent, which drives up the cost and drives down the quality. I'm sure of it.

The problem these people have is called Narcissistic Personality Disorder: The subject tends to obsess with self. They exist in that odd Woody Allen universe where people create their own sphere of morality, lofted above us, coming in contact with us only as the jerks who sell them bagels or get hit by their town cars. If I see another movie in which the principal protagonists get away from their troubles by driving their Range Rover to the Hamptons, I'm gonna burn down the theater.[11]

The stories of how *Town & Country* got off track are many and varied, but one thing in my mind is certain: It was finished the minute writer Buck Henry typed something like this:

```
Porter, a well-known New York architect,
enters his fabulous Central Park West apartment,
having just cheated on his wife ...
```

10 Yeah, I know, they were fascists. I don't condone fascism in any way. And it must be said that I am not condoning any sort of violence or aggressive behavior toward any filmmaker, producer, studio, theater owner, or anyone involved with Hollywood. However, if I ruled the world, there would be laws to prohibit certain persons from ever making movies again, ever, ever.

11 I'm really not, I promise. I just say that for effect. Please do not burn down theaters, it is a bad idea.

Porter is rich. Porter is successful. Porter has fathered rich, intelligent, successful kids with a rich, intelligent, successful partner. But Porter is missing something in his life, poor Porter. Amazingly, we're ordered to like Porter, who is in every way unlikable.

And here's the first clue for any Hollywood producer, writer, or actor. I need to set it apart so it isn't missed:

We do not care about these people.

Not now, not ever. Why don't we care about these people?

Because they are unpleasant, self-obsessed, and amoral.

They are spoiled, they are evil, they are worthless to us. Wastes of perfectly good tissue. Maybe you can cultivate some sympathy for a man who has his own underpants cleaned, folded, and put back in the drawer by a woman he has never met; I can't. And what bothers me more is what lies in the subtext of this story about rich people boinking each other, which is that the people involved in making the movie have no idea what constitutes a real personality, a real human being, and therefore cannot conceive of a real character.

Let's contrast this *Town & Country* with a real movie I recently saw, *The Pledge*, a film made by a different bunch of equally rich, intelligent, successful Hollywood people, but vastly different and vastly better. Directed thoughtfully by Sean Penn, *The Pledge* tells a moving, troubling story of a retired cop who pledges his very soul to find the killer of a child. It is the best thing I have seen Jack Nicholson do in years.

Now here is a vanity production—let's face it, movies like *The Pledge* do not pack theaters in this country—made by a capable journeyman director learning his craft, filled with legendary performers in small parts, yet it manages to have a soul. I've read that between roles Sean Penn gets in a car and drives somewhere, anywhere, only far from Hollywood. That makes sense to me. While I can easily imagine seeing Sean Penn, hair dirty, eyes bleary, huddled over a cup of coffee and cold eggs at the Happy Chef outside Cozad, Nebraska, I can't envision Warren Beatty next to him. Instead, I envision Beatty behind the glass in a Mercedes limo with Quentin Tarantino, en route to a private airstrip in Texas, puttin' the wood to a production assistant from *Kill Bill*.

How could they not know? How could the producers of this film even think that a withered sexagenarian prune like Warren Beatty could conceivably pull off a sexy role? He's not that kind of sexy; nowadays he's not *any* kind of sexy. Robert Mitchum might have pulled this off; Gregory Peck, maybe, Cary Grant definitely. Not Beatty. He simply looks like one of those old, tired, bewildered golf-loving bastards who clog up the freeways with Range Rovers on the weekend and expect valet parking at the supermarket.

Just think for a minute about the amount of ego potential involved with *Town & Country*: Warren, of course, but then Diane Keaton, Goldie Hawn, Garry Shandling, Buck Henry, Andie MacDowell, Charlton Heston (!). That'll account for at least fifteen fancy movie-star trailers on location right there.

At least Diane Keaton should know better. This is the woman who directed episodes of *Twin Peaks*, who amazed me in *Looking for Mister Goodbar*, who infatuated me in *Reds* and *Annie Hall*. Who was fantastic in *Marvin's Room* and *Crimes of the Heart*. Shame on her.

Sitting in the theater with eleven other people (this was a *Saturday evening* show, mind you), I scanned the bored group, and I am certain that if the theater offered remote controls to change the movie, it would have been done within the first five minutes and nobody would have minded.

Movies like this will continue to be made, with varying degrees of failure, until Gabriel plays his solo. Millions of dollars will be sacrificed to the egos of middling actors who were lucky enough to become movie stars. Bad stories will be crafted, good stories hacked to bits, and second-guess rewrites will assure the failure. And we'll be expected to see it.

So, here's my solution: Warren Beatty, Diane Keaton, Goldie Hawn, Buck Henry, and, yes, even Garry Shandling, are on audience probation. They will make another movie together, but this time the rules will be different.

They work for us now.

They are enjoined from making another movie unless we, the audience, approve the deal and the movie.

Call it open-source filmmaking. We will be their producers. Story and script drafts will be reviewed by the public on the Internet; notes will race by the millions back to Buck Henry and whatever screenwriters he has do the hard work for him these days. We will have final script approval. We will pick the director; Warren and company must work with him, no pissing and moaning, no special trailer for the Feldenkrais practitioner. We will look at the dailies, on-line, every night after shooting. We will have final cut approval, and we don't give a damn if they're happy with it or not. They work for us, remember?

And here's the fun part: They must do this next movie for union scale. And they must keep doing this for scale until we approve of their work. Or they can give back whatever money they were paid on *Town & Country* and retire from making movies altogether.

Back me up on this. If we all band together, it could work.

Uptown Theater, Minneapolis	**Memento**
Dinkytowner Bar, Minneapolis	**Freestyle** (Undercinema series)
General Cinema Centennial Lakes 8, Edina	**Spy Kids**
General Cinema Mall of America 14	**Forsaken**
Parkway Theater, Minneapolis	**The Tailor of Panama**
General Cinema Centennial Lakes 8, Edina	**The Mummy Returns**
Oak Street Cinema, Minneapolis	**Blade Runner** (Plus short: **Heart of the World**)

Show Up Late or Suffer

The Stuff We Have to Sit Through
Before the Previews, and Why We Just
Sit There and Take It

So, for eighteen weeks I have been attending movies, dutifully showing up on time, often early, to make sure my geeky little lighted pen has batteries to log the day's screening, and anally file away the ticket stub in the envelope for that week. As a consumer of theater chain products, I have lived up to my part of the bargain.

But the theater chains have failed me. I have to wait for them to be ready, and I have to sit through an amazing myriad of junk before I get to see what I paid for.

These days there are marketing interests that will give you hotel vouchers or airline tickets to sit through a short presentation during

which guys in suits try to sell time shares in resort communities or investment opportunities with which you'll want nothing to do. But if you are patient, good at saying no, and don't mind sitting in a big conference room at the Airport Comfort Inn and Suites for an hour, you'll walk out with a weekend at a resort hotel or a pair of plane tickets that actually work.

In a modern chain theater, you don't get a plane ticket or a hotel voucher for sitting through their endless premovie ads. You don't get squat. You pay your six or eight or ten bucks to get in, then you are aggressively sold a number of products and services from local and national vendors before your feet have a chance to stick to the floor.

It's advertising posing as entertainment, selling you things you don't want and didn't ask for. In fact, you are subsidizing this advertising.

This is wrong. And it should stop right now.

It's an old and somewhat charming tradition to present local advertisers before the show. The ads are often slide-tape stuff like we used to do in high school AV classes before video cameras came along. One of my favorites happens at Chanhassen Cinema out in the meta-suburban farmland. Dippy music accompanies amateur slides for places like "Someone's House," an unfortunate name for a store that sells the kind of knickknacks you will find in a psychotic grandma's home. The Giant Panda Restaurant offers us thoroughly unappetizing slides of their lunch buffet accompanied by bad pipa music.

One memorable night at the Chanhassen, the slides had been scrambled and the soundtrack was way out of sync. The narrative for a furniture store played under the slides for the Chinese restaurant; the Chinese restaurant music played under an ad for a law firm. A whole ad went by without an address or a logo, featuring men and women talking about something over a desk, and I still have no idea what the ad was for. Trivia questions sped by answerless. Odd pictures of stuffed toys showed up between slides for a flower shop and, again, the law firm. This was fun, it had a local charm, it was like seeing a movie at the picture shows in Mount Pilate—y'know, near Mayberry.

But I'd rather see a short or a cartoon.

Now, when was the last time you saw an actual short or a cartoon before a movie at a major chain? I have to go back to my childhood, or look to the novel exceptions, such as the Roger Rabbit cartoon *Tummy Trouble* that played theatrically before the excessively stupid one-joke comedy *Honey, I Shrunk the Kids*. Sure, it wasn't a great cartoon, but it was a cartoon. Roger Ebert, who screens a lot of movies as a paying audience member, God bless him, pointed out in his review: "It was fun to see a color cartoon before the feature, and the kids cheered."

The kids cheered. The little children, they laughed with glee. Now, please, Mister Eisner, Mister Spielberg, please, Misters Weinstein, can't we please have some funny cartoons before our movies? For the little children? Please?

The only places where you can count on seeing a short or a cartoon that's not an ad in disguise are the independent single-screens, the college film societies, the art houses, or the revival houses. If you don't have one of these in your neighborhood, get on a bus. The Oak Street Cinema, our brave and fiercely independent single-screen, will often start a show with a short.

This week, before screening the original theatrical release of *Blade Runner*, the Oak Street presented Canadian short filmmaker Guy Maddin's latest, *Heart of the World*. Guy has a love for the era of silent spectacle—the in-camera effects, the oddly erotic nature of very pale women in gossamer clothing—so expect this short to be weird. And weird it is, an amalgam of at least a dozen silent-era motifs, all rapidly cut and set to rich swirling music. I've now seen this short three times, and I've enjoyed it every time. It never fails to get the audience unsettled and on edge, ready for the feature.

Also recently, before the restored print of Hitchcock's 3-D *Dial M for Murder*, the Oak Street gave us the only 3-D Bugs Bunny cartoon ever made: *Lumberjack Rabbit*. Boy, was it fun to watch people squirm when the Warner Brothers' WB shield popped right off the logo into our laps.

Shorts are fun. Cartoons are fun. Isn't this why we go to the theater? To have fun? Then why in God's name have we allowed

shorts and cartoons to disappear and be replaced by *advertising*?!

Ads push the edges of my patience. Chain theaters have plagued my mind with product-sponsored trivia I don't want, facts I can't use, and ads that make me hate the product, the theater, and humanity at large. We've all sat through these things, listened to the smelly guy behind us answering all the trivia questions correctly and loudly, while we develop a headache waiting for the film to start.

In London, at those lovely, sumptuous theaters in Leicester Square, a whole reel of ads unspools before the film starts. However, because London exhibitors have respect for their audience, the ads stop promptly when the movie is scheduled to begin. What's more, I think British advertising and marketing are in general less pernicious. The English are far more savvy about advertising, and less likely to sit there and take it when their paid movie entertainment should be starting. I have found the same to be true in France. Perhaps it's the fact that these countries have actual cultural traditions that go back more than fifty years and which they honor as living elements of the public personality, rather than simply bits of rubbery nostalgia they call up when they need a campy way to sell sneakers.

Now, I'm not anywhere near a Europhile, but I do know that we show no respect for our own culture, probably because we have no real culture; and that leads to the anarchy of irony and self-parody that nibbles away at any budding public aesthetic like a flesh-eating virus, and which explains why audiences will sit patiently, or at the very worst mumble quietly to themselves, as we pay to watch bad advertising before our movies start. This causes me no end of pain, and has compelled me to arrive at least five minutes late for any screening at any national chain.

A great contributor to my pain is caused by National Cinema Networks' wide variety of prepackaged products offered to theater chains to punish the captive movie audience. The first thing you'll see when you sit in an NCN-supplied theater might be "On-Screen Entertainment," a name they've had the shamelessness to trademark. An offshoot of this is the Coca-Cola "Screen Play," featuring many Coca-Cola images and brands. We are constantly advised to remain

refreshed, to bubble up some answers, and of course to enjoy Coke. Movie facts are given punny titles like "Personalities that Pop," "Bottled-Up Passions," and "Big Openers." I have a few more suggestions for nifty names, such as "Tooth-Rotting Tidbits," "Kaffeinated Kiddie Kwiz," or maybe "Abdominal Cramping Due to Excessive Gas-ertainment."

More insulting is NCN's "Pre-Show Countdown," another brand name that offers "entertainment," otherwise known as "advertising." An ad intended to stir us into giving shows Lance Armstrong running the Olympic torch through a serene Americana landscape, passing it off to some earnest dope who is helping to keep the Olympic dream alive, as if major sports equipment manufacturers aren't waiting in line to do that already, with their own brand prominently featured. Coca-Cola paid for the ad, so I was half-expecting Lance to hand off a two-liter bottle of Caffeine-free Diet Coke to the next runner.

But the most insidious thing Coke has thrown at me is the Refreshing Filmmaker's Award, the result of a competition for students at eight major universities and probably the only short film most Americans will see in a chain movie theater for years to come. I am all for encouraging young filmmakers to take a chance and show their talent, and I did enjoy this year's winner, called *You Too Could Be a Winner*. It was mildly funny and bluntly cynical, featuring an obese woman who sits in her trailer home, obsessively stuffing her face and watching game shows. The short is introduced with rapid-cut pictures of the winning filmmaker, Peter Hunziker, nattily dressed in conservative director wear and leaning smugly against a massive Coke sign. The judging panel included an actual talent, Billy Bob Thornton, as well as those amazing film artists Burt Reynolds, Sherry Lansing, and sensitive auteur Michael Ovitz. This means that artistic merit was everything and marketability wasn't even considered, right?

I don't know what I am expecting. What the hell else is Coke going to do if they fund a film competition, leave their name out of it altogether? But they should make no pretense that this is a competition designed to advance the art of the cinema. This is advertising, as bald-

faced as it gets, and a glaring, neon red-and-white sign that popular film in this country is co-opted to the point that people will make no distinction between ads and arts. They are now one and the same.

Well, I think it sucks. Most of this happens on my time. When any ad happens after the advertised start time passes, I complain. I complain loudly and frequently. Excuse me, Mr. or Ms. Chain Theater Manager: You, the film exhibitors, are making me pay for something you already get paid to show. And you're doing it on my time, so you're going to hear about it.

Generally I demand my money back. Generally a thin guy with bad skin and thick glasses tells me that there's nothing he can do about it, but he has a form I can fill out and send business-reply mail to the chain theater's regional headquarters. Well, now I have a form, too. It follows this chapter, and I invite you to copy it and use it whenever appropriate.

I have a fantasy of organizing about a hundred people to storm the manager's office with torches and pitchforks the next time I have to sit through a bunch of ads in the theater, but what would that accomplish? Not much, but it will widen the gap of alienation between the people who show films and the people who watch them. I'll be branded some sorta hippie Marxist, which I'm not. Not really. I suggest instead that if you find yourself being advertised to, head out to the lobby, complain to the management, and people-watch for a few minutes. If you fear losing your seat, then bring a copy of *Adbusters* magazine into the theater with you and inoculate yourself. Practice that meditation exercise you've been putting off for months. Write a letter to the editor of your local paper. Do anything but sit there and take it.

Be an enlightened consumer. It'll be good for your soul.

Use this handy form at your local theater! Please feel free to photocopy this page as often as you like.

Dear Theater Manager:

I object to the presence of advertising on your theater's screens. I particularly resent these ads playing after the time the movie has been scheduled to start. Having shown up on time and paid admission, I have fulfilled my part of the deal; sitting through advertising only serves to subsidize your theater owner's income, and it detracts from my enjoyment.

I ask you to respond in some way to my request, either by changing your procedures or personally explaining why you won't. I ask you to remove advertising from your screens, begin your features closer to the advertised time, or in your print ads include "Movie will begin after trailers and five or more minutes of advertising," or words to the effect.

I'll take my business elsewhere if you cannot respond in any of these ways, and I'll inform all my friends that your theater would rather take money from advertisers than satisfy its customers.

Ultimately, we fund your paycheck; more than any advertisers or soft drink vendor.

Sincerely,

NAME

ADDRESS

PHONE

Courtesy of *A Year at the Movies* by Kevin Murphy.

Mann Hopkins 6 Theater	Spy Kids
Mann Hopkins 6 Theater	Snatch
Mann Hopkins 6 Theater	Finding Forrester
Mann Hopkins 6 Theater	Chicken Run
Mann Hopkins 6 Theater	What Women Want
Mann Hopkins 6 Theater	You Can Count on Me
General Cinema Mall of America 14	Bridget Jones's Diary

Off-Release Will Save Us All

A Week at the Local Discount Movie House

It's Tuesday Night. We've come for the evening show, and the place is packed. But here's a change: Everyone is happy, even polite! Couples hold hands, retired folks smile and chat amiably with strangers, even the counter workers are helpful and efficient. We sidle right up to the ticket counter girl, and it feels like family; even though I don't know her name, I've been coming here enough lately that she knows my face. I get a sincere smile and a pair of tickets.

What's going on here? This isn't the multiplex I know, where the audience is surly and the staff is worse, where the film selection is only slightly more depressing than the ticket price. This is the Mann

Hopkins, a discount theater, where every show is two bucks and on Tuesdays they're a dollar. A dollar!

The Hopkins 6 is the only theater in the local Mann chain that's a discount theater. The Mann family has managed their modest Midwest business into a thriving multiplex chain that's survived the vicissitudes of a business run by savagely competitive money grubbers who know little about film and have probably never heard the word "vicissitude." The Hopkins, Mann partner Steve Mann explained to me, is a way to provide a decent product at a very attractive cost.

Attractive? A good recent Hollywood movie or independent gem for two bucks, any show? And a dollar admission on Tuesdays? It makes me cringe to say it, but, dude!

The theater is nestled in downtown Hopkins, Minnesota, generally a working-class suburb, the kind that has a lot of fried food and ladies' nights and bowling leagues and guys sent to prison for manslaughter. Think camouflage hunting caps in summer. But there's another side to Hopkins. Across the street from the theater is a new arts center; along with the discount theater, we have an island of gentility in a beer-and-pickup-truck suburb.

Everybody's very happy at the Hopkins, and that's probably because on accounta da cheap seats, ya know. Minnesotans are at heart honest, hardworking cheapskates, and this theater is like a love letter from Mann theaters to the good folks of Hopkins. Steve Mann told me that the theater does all right; it's not a cash cow but with low rental prices for films that are off–major release, and with concessions that cost the same as a regular theater, the profit margin goes up and the savings get passed on to you.

I saw a widely diverse assortment of movies, good and bad, popular and obscure, and best of all I paid no more than two bucks each for the pleasure.

Take, for starters, the really bad, genuinely dumb, and not-very-good-at-all film *What Women Want*. Paramount rolled this film out like industrial carpeting, opening on thousands of screens nationwide, accompanied by the usual promotional campaign that precedes the film like the most expensive circus train in the universe. When

audiences reacted and critics opined, movie executives must have realized that the film really blows. Off it goes to the second tier of release, the discount house, before it's shuttled to the video store.

This is the second time I've seen *What Women Want*; the first time it gave me a kidney stone. And, yes, I do blame the movie.

Success, failure, fame, obscurity, quality, or lack thereof, all manner of popular film plays here, given a second chance to woo the public before expiring and passing into the heaven of video distribution. *Chicken Run* extended its fantastic and well-earned time at the top of the family movie heap by playing here for weeks—largely, it seems, to appreciative repeat viewers. *Chicken Run* is an example of a perfect theater film: The whole family can watch; it has plenty of laughs, thanks to great comic characters, terrific timing, and good writing; yet it also has genuine drama and the most pathos you can elicit from lumps of clay; and it has a fine hero in Ginger, who at times makes us forget that she's a hen. Once again I sat in a theater and watched kids have a smashing time, laughing all the way, worrying for their friends the chickens and cheering at the triumphs.

Odds and ends show up at the off-release house, as do films that refuse to die. Occasionally a film like *Spy Kids* generates more excitement than the distributors expected. It is a kids' film through and through; in fact it looks like the kind of film actual kids would make if they were given all the money they could possibly spend, and that's a compliment. Director Robert Rodriguez, who has given us bloody but tightly directed and unconventional action films like *El Mariachi* and its fancier version, *Desperado*, still makes home movies for the sheer fun of it. And *Spy Kids* captures that fun. The kids seem real, bickering and taunting each other like siblings do, but standing up for each other when the chips are down. Every kid I know who has seen this film has loved it, and that's great praise.

Spy Kids was good enough and successful enough that it has had a long stay at the Hopkins, so it was no surprise to learn that the film was re-released in theaters in August with new footage. I saw it in a theater full of kids, parents in tow; got the feeling that they were smart kids, because it is a smart movie with a smart sense of humor, quite

like *Willy Wonka*. Thank God someone has made a film that assumes children are more intelligent than fresh-water fish.

The nicest surprise was the film *You Can Count on Me*, a small independent with a great cast that was a critical hit, and which had an initial run of about twelve minutes. I was gratified to sit in the house with a small crowd and see a simple drama well told, but it reminded me that the once-promising "independent" film world may be in trouble.

Not long ago, when people in the business of movie distribution pretended to have souls, they occasionally used a marketing strategy called the "platform release," or the "slow rollout." Movies would be released in a small number of select markets, allowed to gain an audience and build a reputation through critical praise and word of mouth, then the market base was moved and expanded.

This requires certain virtues, like "not panicking" and "standing behind quality work." This is also known as "earning your money with a good product," another thing popular film has recently left behind. These appear to be the virtues of the past, back when independent film in the States was truly that and there were a lot of good things to see. It began with Jim Jarmusch and may have ended with the Disney purchase of Miramax.

There are a few other off-release houses in the Twin Cities, and I want to mention them because I love them just as much as I love the Hopkins. The Parkway is tucked into a cozy old neighborhood in Minneapolis, and offers a slate of movies off initial release as well as some brand-new independents, foreign films worthy of a bigger audience, and revivals of classic popular works. It's a bit worn but very comfortable, and feels like a real family-run theater, kept open by sheer love and savvy financing. Nobody's getting rich off this theater, but we are getting a quality of experience all but lost in the googolplexes.

The Riverview is slightly more polished than the Parkway, having revived the ultramodern styling of its fifties roots. It has a more conventional off-release schedule and is the current home of midnight *Rocky Horror* showings, which is not necessarily a plus if you've ever sat on someone else's stale toast; but it also hosts the Friday midnight Hong Kong Cinema series, which is a whole lot of fun.

They both have cheap admission, and they both vie for having the best popcorn in the world. Reason enough to go often.

These theaters are a great comfort to me, and as I reach the middle of this year I realize that when this whole cinema safari is done, they're the kinds of theaters I'll come back to over and over again. I can see what I want. I'm not marketed to like a brainless prole. Everybody's happy, and it's just a couple of bucks. After sitting in massive blockhouses, spraining my tympanic membranes with Surround Sound, and mortgaging the house for the likes of *Dr. Doolittle* 2, they seem like heaven.

Carmike Apple Valley 15	**One Night at McCool's**
Landmark Lagoon Cinema, Minneapolis	**The Center of the World**
General Cinema Mall of America 14	**The Mummy Returns**
United Airlines Flight 942	**The Legend of Bagger Vance**
United Airlines Flight 942	**The Dish**
United Airlines Flight 942	**Comes a Horseman**
Cinéma les Arcades, Cannes	**L'adolescent**
Salle Bazin, Palais des Festivals, Cannes	**Il mio viaggio in Italia**
Théâtre Claude Debussy, Cannes	**Les ámes fortes**
Théâtre Claude Debussy, Cannes	**Le parole de mio padre**
Salle Buñuel, Palais des Festivals, Cannes	**The Man Who Wasn't There**
Salle Bazin, Palais des Festivals, Cannes	**Éloge de l'amour**
Salle Bory, Palais des Festivals, Cannes	**Desert Moon**
Salle Bazin, Palais des Festivals, Cannes	**Millennium Mambo**

It's Pronounced "Cagnn"
Sneaking into the World's Unfriendliest Film Festival

First thing you should know, because people will hit you if you don't: It's commonly pronounced *can*. Not *kahn* or *khans*, but *can*, like what they put Spam in down in Austin.

This was made painfully evident to me by a production executive from a major studio, who shall remain nameless and whom I will describe only as a horse-toothed sexless prat. She mentioned very loudly and without provocation that she'd be in France in May, so she'd be out of touch. I asked her, "Oh! Are you going to *kahn*?"

She looked at me as if I had an eel wrapped around my head. "It's *can*. In France they pronounce it *cagnn*." She even swallowed the "n"

in the way the French and Bugs Bunny do. I wondered who had put the pole up her ass, and I politely offered that in France they pronounce it *Frahnce*.

Our professional relationship went straight to hell from there.

Two years later, and here I am, still mispronouncing the name. It's ninety-five degrees in Cannes, and out on Boulevard de la Croisette it's starting to smell. Bad.

La Croisette is the main drag for the festival, where ninety-five percent of the stuff goes on, where the deals are made, where the money changes hands, where cops patrol like they're working for the pope; and where, every damn evening at about 5:30, the street swells up with drooling, sunburned gawkers, who haven't taken a shower all day, who stink of suntan lotion and perspiration and cheese-sandwiches. I thought Wisconsin had the world cheese-sandwich concession. Then I came to Cannes.

La Croisette serves as Hollywood and Vine, Sunset Boulevard, and Santa Monica all rolled into one for the weeks boiling up to the Cannes Film Festival, or *Festival de Cannes* as the French say, because apparently nothing we say is ever good enough for them, unless it comes out of the mouth of Jerry Lewis or David Lynch.

All these people are here, shoving and swearing, to get a glimpse of rich people getting out of cars. That's it. Every night during the festival, another film, either a glossy showpiece or another entrant in the official competition, opens at the Grand Théâtre Lumière. The filmmakers, their hangers-on, and those lucky or powerful enough to get in with the festival brass line up in freshly waxed cars to get out and have their pictures taken on the pointlessly long grand staircase outside the theater. This event has become more famous than the festival itself, and it speaks volumes for what the festival has become: a bauble. An earnest, insightful, but ultimately impotent exercise in artistic integrity; a powerless, titular head-of-state, smiling and waving at the head of the parade in the biggest media marketplace in the world.

Cannes is a convention, plain and simple. A massive trade show with a schmancy film festival to class it up a bit. For about six weeks

surrounding the two-week festival, most of the films people around the world will see for the next year will have been bought and sold. Twelve hundred exhibitors, six thousand buyers, seventy-four countries, two thousand films, a thousand screenings. For every starlet getting out of a car there are twenty fat guys with laminated name tags and tote bags full of promotional material, sweating and eating a cheese sandwich. Conventioneers.

I entered this melee (or mêlée) on its last three days, just wanting to catch a few flicks at the world's most prestigious festival. I return to report that the average filmgoer at Cannes is not only uninvited and unwanted, but shunned, with an attitude ranging from blunt indifference to outright contempt. Forewarned that I couldn't even sneeze without a press pass, I talked to my friend Colin Covert, film critic for the *Minneapolis Star-Tribune*. He managed to hoodwink his editors into believing that I was an actual film writer of some stature, and they agreed to apply for my credentials. This would be dicey, applying as I was almost a month after the deadline, facing a bureaucracy that makes the Kremlin look casual.

I set foot on La Croisette after thirty hours in transit by plane, bus, and taxi, only to find that the press office where I would pick up my credentials was closed. *At four-friggin'-thirty in the afternoon!* This meant I was without credentials, and therefore *persona non grata*. Every door of the Palais is guarded by at least two gruff, officious, Gallic White Guys in blue blazers. It's true: They're all Gallic, they're all white, and they're all guys. They must truck 'em in from the north. If you approach the door without credentials, they look down on you as if you have leprosy.

Well, I didn't come this far to be put out by Gallic White Guys. I was here to see movies, and only one option lay before me.

I had to sneak in.

(Note to youth: Sneaking into world-renowned film festivals can get you into a whole heap of trouble.)

To gain entrance to the Palais, I employed the classic Distracted-Guard Tactic, honed in college at expensive rock concerts. I waited until the Gallic White Guys were busy hassling some other poor dope

without credentials and simply walked in behind them. In less than five minutes, I was in! The Palais des Festivals, nerve center of the world famous festival, was mine!

The Palais is a monumentally ugly edifice. In comparison, Trump casinos appear understated, graceful, and refined. Vegas-style lighting and linoleum really dress up the joint. However, it has one feature perhaps no other convention center in the world has: several very comfortable, state-of-the-art screening rooms.

Once inside, I employed the Credential Block. Take your coat off, put it on. Hold your backpack in front of you. Check your watch a lot. Hold one of the several billion pieces of promotional literature up high where your credentials ought to be. And, above all, *always appear to know where you're going or you're done for.*

I did know where I wanted to be: the five o'clock screening of *Le parole de mio padre*, a promising Italian family melodrama playing in the Salle Bazin. I joined a throbbing mass of impatient moviegoers. People smoked right in my face. People pushed me right out of the way to get ahead of me. But this was promising: Perhaps I could use the Mob Rush tactic to get in: just mush your way along with everybody else and hope they don't spot you.

Well, they spotted me. Two Gallic White Guys yanked my arm and asked me where my card was. I pretended I didn't know French. I pretended I was just a big dumb guy from Minnesota. I pretended I was a mild-mannered reporter from a great metropolitan newspaper.

They didn't go for it.

Out of the corner of my eye I saw a *gendarme* (a cop by any other name) and I decided to, er, "go back to my hotel and find my credentials." I'd snuck into enough rock concerts to know that once the cop eyeballs you, you're toast. (Note to youth: Do not sneak into rock concerts. It's wrong. Oh, and moderate your Red Bull intake, will you?)

One hope was left: the ten o'clock showing of a French family melodrama (what is it with all the family melodramas?), *L'adolescent*, playing at the Cinema les Arcades, an independent venue safely distant from the Palais where I was now shunned.

The line outside the Arcades was dangerously long. But the spirit

was different. This was a small independent theater showing a small independent film firmly on the fringes of the big huge festival. I decided to use the only tactic left to me: Tell the truth. I told the Arcade's alarmingly friendly Gallic White Guys that I had arrived in town late, and couldn't get my credentials, but had to see this film. I spoke in halting high school French. I tried to make my eyes look like those of the little penguin in the Bugs Bunny cartoons.

It worked.

Finally, after traveling some five thousand miles, with no sleep for forty hours, after wandering lost and credential-less through the streets of Cannes, I was sitting in a fine little theater watching a real Cannes movie.

Hooray. *Vive du cinema!*

L'adolescent was in French with no subtitles, a melodrama of pure dialogue with a plot slower than the Dan Ryan at rush hour. I was asleep within twenty minutes, snoring loudly.

The next day brought bright sunshine and that most rare of gifts, a press pass. After two hours of bureaucratic battle, in which I had to prove that I was indeed representing a newspaper and wasn't simply a loon, I was issued a two-day *press-pass temporaire*, a ridiculously crude laminated card I could have forged in half an hour with the right equipment. Suddenly, the closed doors of heaven were opened to me, and the very same gruff Gallic White Guys, who only yesterday looked upon me as one of the leprous mass of *them*, now smiled for me, and held open doors and acted, well, downright chummy. For two days I paraded around La Croisette like I owned the joint, flashing my crude little pass and sauntering around the tents. I put on my tuxedo and acted like I was important. But more than all this, I saw some of the best films I'll have seen all year, I had as fine a time as I could have hoped for.

Comfort came quickly in the form of Martin Scorsese's documentary and love letter to the Italian cinema, *Il mio viaggio in Italia*. I sat in the Salle Bazin for four hours, mesmerized, as I watched the history of popular Italian film play before me, not in the words of scholars but through the films themselves, whole chunks of them, some of the

finest films ever made. It was like walking through a museum of Italian cinema, stopping long enough to enjoy but leaving with an appetite. And the best part is that Martin Scorsese is the tour guide. Scorsese introduces these films as the work that shaped not only his craft and his talent but also his very personality and his life. And with Scorsese along, we can see the influence, particularly among the neorealists Roberto Rossellini, Luchino Visconti, and of course Vittorio De Sica, the guy who made *The Bicycle Thief*, still on many critics' best-movies-ever-made lists.

I loved *Viaggio* because it reminded me of what I love about watching movies: At their best they are an art form unto themselves, that lifts us, devastates us, but always ennobles us. I had forgotten, until an extended excerpt from De Sica's *Umberto D.*, what it's like when every single person in the theater is crying.

Now this is what I came for.

That night I got to see a film in one of the big rooms, the Théâtre Claude Debussy, which is about as terrific as a theater can be in every way: grand in scope, huge in size, perfect in screen proportion, acoustics, you name it, and easy access to the bathrooms. *Les âmes fortes*—English title: *The Savage Souls*—the film chosen to close the festival, was previewed one night early for the curious. This spared a lot of people from having to see the festival close with a turd.

Les âmes fortes is a lush and pretty but sick and heartless drama about anger and passion and murder and jealousy and a lot of other unpleasant things. It might have been good, possibly excellent, but the real boat anchor crashing through the hull of this film was the casting of Letitia Casta. Most American men know Letitia as the curvy big-lipped teenage girl who parades around in bra and panties in Victoria's Secret catalogs, and whose appearance as such borders on kiddie porn. I have not seen a worse job of casting since Ang Lee picked Jewel to star in his dopey Civil War movie. Letitia, God bless her and her nubility, is remarkably bad, chewing her lines like a ruminating cow and moving with the subtlety and grace of André the Giant. I felt sorry for her.

The next morning I had a smashing time in the Salle Buñuel. It's

a small room, custom-made for wide screen and Surround Sound, laid out to experience a state-of-the-art aural and visual film as it was meant to be shown, the way few get to enjoy it. Such was the case when we saw the Coens' *The Man Who Wasn't There*. The world will have judged this film by the time this book is published, but there at Cannes in the Salle Buñuel it was splendid. I don't think I've ever seen a black-and-white print of a film so vivid, so detailed, so rich in every scene. The Coens may have been paying homage to film noir, or making a satire of it, or simply offering their interpretation of it. It doesn't matter, because it came across in every frame as the kind of filmmaking the Coens do best: filled with their own peculiar style, and entertaining throughout.

Then I had one of those moments that will become a notch on my life's gun belt. I spotted *Time* magazine film critic Richard Corliss, a brilliant, well-studied, thoughtful film lover who in my mind is one of the few true film critics in the popular press. He's also a real teddy bear of a man. I spotted him in the line for the new film by Jean-Luc Godard, *Éloge de l'amour*. We chatted. He told me Cannes war stories as we waded through the cattle-herd pack pushing into the Salle Bazin, with the unruly mass of critics and crazies, Marxists and marketers. And I know when I look back, I will feel the most star-struck and the most pretentious for having sat next to him for the screening. Someday, when I want to impress someone over an espresso, I'll pull it out: "Yeah, I pretty much sat next to *Richard Corliss* for the screening of the new *Godard* film at *Cannes* (I'll be sure to say *cagnn*); it was pretty cool and all. . . ." I'll pretend it happens every day. I'll pretend I'm bored.

Jean-Luc Godard is still a wild man, making punk jazz on film. *Éloge de l'amour* combines razor-sharp black-and-white images with wildly oversaturated color video, and it rails at the stupid world. I love this guy; he's like Bob Dylan, Allen Ginsberg, Neil Young, and Frank Zappa rolled into one person and given a good eye. The film has a very loose narrative structure and thrives on thematic repetition, which makes it lyrical if you relax and repetitious if you've had too much coffee. The film deals with characters who hope to retell history, specifi-

cally the struggle of the French Resistance during World War II, an event that Godard seems to feel split the century in half. Anger dominates the mood at many points, which the audience loves; and when a young French woman verbally tears a movie executive a spankin' new asshole, the crowd cheers. An extended monologue proves through a stilted logic that the United States of America doesn't exist, and that we over here live in a nameless country. Lots of cheers from the Marxists for this. In another tirade, a woman protecting her *grandmere* insists that history should not be embodied by the likes of Julia Roberts.

On the last night, the awards are handed out. Once more the stinky throng gathers to take pictures of well-dressed people devehiculating themselves. But it's also the test of this festival as a judgment of the current craft of filmmaking, and it's all about the jury.

These days the festival jury, if it's feeling good about it, will hand out a Grand Prix. That means the grand prize, doesn't it? Top honors? Well, then they go and award the *Palme d'Or*, the Golden Palm, a big leaf, which somehow is grander than the Grand Prix. As if the grand prize is now chump change. Imagine being Michael Haneke, winning the Grand Prix for your excellent film *La pianiste*. The audience cheers, the prize is lofted, the world is at your feet. But you're pushed aside, grand prize and all, and they hand some gilded palm frond to this Nanni Moretti feller, done some film about death, and suddenly *he's* king of the world and *you* may as well head to McDonald's for a Royale because that's about all your Grand Prix is worth now.

This odd caprice is at the heart of the festival, perhaps its only remaining sign of life. In 1946, the Festival's first official year, they gave out *eleven Grand Prix du Festival international du film* awards. Eleven, for forty-two feature films entered. I think they wanted people to come back. The next year it was five, including *Dumbo*, which lends the jury a lot of respect. In 1949, they really calmed down and gave only one Grand Prix, to *The Third Man*. The first Palme d'Or was awarded in 1955 to a most deserving film, *Marty*. In several years there was no Palme d'Or, just a Grand Prix, such as in 1964 to *The Umbrellas of Cherbourg*.

Here's a festival whose jury historically has been composed of some of the best, the weirdest, and the foreignest of filmmakers, writers, and critics. The jury has no restrictions as to which type of award goes to whom for what reason, they just watch films, drink wine, and vote. In 1968, in response to the madness in Vietnam and the riots in the European capitals, Louis Malle led a host of judges to resign from the jury, sit-ins were staged outside the Palais, and, best of all, the story goes that Godard and François Truffaut physically held the curtains shut in the theater so that no films would be projected. No prizes were awarded. Eight years later, *Car Wash* would be feted by the Cannes jury.

Obviously, then, beyond all the conventioneers and the marketplace and the house-size ads for *Shrek*, there's still a festival here, and it is still vital.

But it has lost something, and that's us: the audience.

Throughout my credentialed time in the Palais this gnawed at me: The only reason I'm here is because I got a press pass. Otherwise, I'd be out in the street gnawing on a stinky cheese sandwich with the rest of the smelly crowd. If Cannes is a festival, what exactly is it celebrating? Itself? What point is there for a kingdom to have a feast if the citizens aren't invited?

Godard bemoaned it best at his overcrowded (and therefore stinky) press conference: Once upon a time Jack Nicholson could be seen carrying the cans of his own film into the theater, and now it's just a bunch of people talking on cell phones.

On the last night, before the limos showed up to drop off all the self-important luminaries for the blessedly short awards ceremony, I went back to my hotel. I'd had enough. This part of the festival isn't for the likes of me. It's an exercise in elitism, in which thousands mob to see even a partial glimpse of some big star, and the big stars play along. It felt like the stories of prerevolutionary France when the nobility would throw the scraps from their feast out in the mud and the hungry peasants would fight each other for a crust of bread or a dog-chewed bone.

Cannes has come a long, strange way from its carefree eccentric

roots; now it's an orgy of commerce and privilege, a festival by title alone, because we, the audience, *their bread and butter*, mind you, are not invited. I was lucky enough to get in, thanks to Colin Covert of the *Star-Tribune* and my own tenacity. But I go to film festivals to be entertained, to be challenged, and to open myself up to bold new films, new cultures, new styles. At Cannes I felt like an outsider, and I don't like that feeling.

Besides, I don't think they'll invite me back, and I don't much care.

✳ WEEK 21, MAY 21–27 ✳

Casino Cinema, Antibes, France	**Billy Elliot** (English with French subtitles)
United Airlines Flight 952	**The Great Train Robbery**
United Airlines Flight 952	**Spy Kids**
United Airlines Flight 952	**Finding Forrester**
Mann St. Louis Park Cinema 6	**Shrek**
Landmark Lagoon Cinema, Minneapolis	**A Friend Like Harry**
Mann St. Louis Park Cinema 6	**Pearl Harbor**
General Cinema Mall of America 14	**Angel Eyes**
Oak Street Cinema, Minneapolis	The Best of Aardmann Animation

The Savvy Movie-Watching Person Presents:
How to Prepare for
BLOCKBUSTER SEASON!

Boy, oh boy, am I ever psyched up! The Summer Blockbuster season is nigh! Wow! All those stars, all those explosions, the special effects, the sweat, the tight clothes, the references to the freeze-frame jump-kick from *The Matrix*! Holy cats, it's going to be a *blockbuster* Block-buster Season! According to *Variety,* "Summer Promises Hot Pic Lineup!" I couldn't agree more!

How to prepare, that's the big question! Well, here's the definitive guide for getting yourself ready, willing, and able to see every single one of these gems before your friends do, so you can tell them, "I guess it was okay for what it was s'posed to be!" And you can say it with authority! Let's go!

Read Up: Essential Literature for Your Summer Movie Watching!

My bible for the season is, of course, the *Entertainment Weekly* Summer Movie Preview! How could I live without it? There they are, all laid out with release dates and everything, every single important movie that's coming my way! Do I need anything else? Hell, no! *Moviemaker*? Forget it! *American Cinematographer*? Heck, they don't even have reviews, they just talk about pictures! *Cahiers du Cinema*? It's in French, how does that help me? *Film Comment*? What's that about, all they do is talk about the "importance" and the "significance" of this film or that, usually something I haven't seen! They review films from Iran and China, for crying out loud! And where are the stars, the letter grades, to help me along? Nowhere! I actually have to read the article to find out what they think of the movie, and even then I'm confused! I'd put more trust in them if they just put little boxes of popcorn next to the title so I know what they really think! Nope, it's always been *EW* for me!

Psych Up: With Exercise and Diet!

There are more than fifty movies to see this summer, and that's about a hundred hours in the seat, so you better be ready! First, I recommend conditioning the butt to keep it toned and well padded! Start with your usual Tae Bo workout, but concentrate on the little squatty things that hurt when you do them! These tone the lower and upper butt quadrants and strengthen the gluteal regions! Next, move on to target training with *Buns of Steel*! For beginners, I recommend the *Buns of Steel 5: Beginner's Workout Tape*! Then, when you're ready, move up to *Buns of Steel Target Toning* for optimal bun steelness! If you have the guts, try Tamilee Webb's *I Want Those BUNS!* Tamilee has an M.A. in exercise science from Cal State Chico, so you know she's the Bun-thority! Hee-hee!

Now that you have rock-hard buns, it's time to pad those babies! Padding is important so that your hip points don't bruise the well-toned bun muscles you worked so hard to attain! Diet is the key to developing helpful moviegoing fat! I recommend bacon! Bacon is the

best way to deliver a great protective fat layer to your buns, your midriff, upper thighs, and chest! And bacon is so versatile, it goes with any meal! I even crumble crisp microwave bacon on my ice cream just before bedtime! It tastes great, and it helps you develop fat during the important fat-building inactive hours! Try bacon with every meal for at least a month and soon you'll be putting on fat quickly, even in your sleep!

Fattening up has an additional side benefit, it makes you bigger and wider, which means fewer folks will want to sit by you or be near you, leaving you more room at the theater! We'll discuss this more below under "This Seat Is Mine!"

Keep Up: Keeping a Kalendar Is Kritical and Key!

If you don't already have one, buy yourself a wall calendar! Find the opening dates for all the summer movies and write them down on the calendar! The writing-down part is critical, otherwise the calendar will only inform you of dates and some holidays!

Here's what I do! Take this week for instance: We have *Pearl Harbor* opening on May 25! So, I go to my calendar and on the box marked 25 I write down *Pearl Harbor*! With a pen—that's important! I make sure that the box marked 25 is on the page marked "May" on my calendar or it won't work! Then, when May 25 rolls around this week, all I have to do is look at the calendar and it tells me that *Pearl Harbor* opens today! A calendar is a great system for remembering things that happen on specific days and I highly recommend it!

Or, log on to the Web! It's the latest thing, you know! The Web has it all: show times, movie reviews, special screenings, behind-the-scenes stuff; it's all there! And even better, all the really good movie Web sites put grades, stars, little boxes of popcorn right next to the movie title so you don't have to read anything! Just glance and go! Try Moviefone, Fandango, Hollywood.com, or Movietickets.com! They all have nonthreatening capsule reviews and profiles of Catherine Zeta-Jones, so you can depend on them! Some of them even let you buy your movie tickets right there, on-line! This is an amazing conve-

nience and the service charge isn't that large, only a dollar or two per movie! Heck, by the time you get to the box office, the ticket price has gone up anyway, so why not give it to a Web site? It saves you the annoying step of opening a newspaper and actually scanning the page to find out what's playing when!

Getting There First: A Blockbuster Must!

Naturally it's important to be the first person you know to see a film, so here are some tips for beating the crowd!

First, go early! If it's an important film like *Final Fantasy*, *Planet of the Apes*, or *The Animal*, lots of people will want to go see it, so get there early, perhaps several hours early! For instance, Rob Schneider's *The Animal* opens on Friday, so I'll take a sick day from work and show up at the theater at 7:30 in the morning! I'll bring a lawn chair and pack a lunch so I can keep on padding while I wait! Bacon, lettuce, and tomato sandwiches are great line-standing snacks!

If you can't go early, butt in line! That's right, go straight to the ticket window even if the line is a hundred deep! Your extra weight will help here! When people yell, giggle nervously or ignore them altogether! If you encounter a frowning ticket-taker, just say "I'm handicapped!" You might just be, depending on how much weight you put on! Now just push your money through the little window and say, "People are waiting, what are you going to do?" If they want you to move back, ask for the manager, but hold your ground! The time you waste will motivate the staff to let you in! It takes a little courage, but if you want to be first, you have to be B-O-L-D! That's bold!

Take Charge: Getting the Most for Your Money!

Once you're in the theater, it's time to make sure your movie-watching experience is the best it can be! First, use the line-butting technique to get yourself some snacks! Make sure you get the large of everything, and get the following items: a super-size buttered popcorn, a nachos, a large carbonated drink, and a large candy item! Not only are they good for fat-building, they will help with your in-theater strategy!

Here's how it works: People are nice by nature as a rule, and they will instinctively get out of the way of a very large-butted person with two armfuls of snacks! This way you'll be first in the theater!

Now, make sure you get the right seat by trying out several! Get up, sit down, move around! You'll lose some popcorn and maybe some melted cheese, but you bought the large of everything so you'll have what I call "acceptable losses"! Heh!

Take several minutes to hunt for the right seat, then stake your claim! Wide as you are, arms bursting with concessions, you will need at least one seat on either side of you to be comfortable! This can be difficult, especially in a sold-out show, but it is critical to your movie-watching satisfaction! Your girth and your payload will help, but you will need an edge! Try not bathing for the week before the show, and wearing the same underwear! The smell, comfortable and familiar to you, will intimidate those around you and naturally create an aura that you are a serious movie watcher and need your space!

YOUR Time: Make the Movie YOUR Movie!

Now it's *your* time! Your snacks are set, your buns are primed, your seating area is cleared! The Coke ads have played, the theater chain logo has run, the other Coke ads have played, the previews have pumped you up! Time to enjoy what you came for!

There are many lofty theories about the role of the spectator in the popular film! The most helpful theory for Blockbuster Season perhaps comes from the prewar Frankfurt school of critical theory, which suggests that popular films manipulate us into a passive acceptance of the common values of the movie industry, and we become putty in the hands of the overlords of the culture!

Well, heck, yes, we're manipulated, what do you think we go to the movies for? Hello-o! We are there to be entertained! What, do they think we look at Ben Affleck as a revisionist historical monad of America's rationalization for imperialism and global hegemony wearing the noble hero's mask?! Do we sit there and see Vin Diesel as symbolic of a faux anticultural iconography that simultaneously embraces the dominant sex role stereotype?! Rob Schneider perceived as a low-

mimetic archetype compelled to the animal nature of the primal male self by embracing the animal mythos?

Please! We want to see Ben get the girl and beat the Japs! Vin is there to drive fast and kick ass! Rob is just plain funny! Did you see the previews? He wants to have sex with a goat; that's just funny! Who cares if there's any meaning or subtext in all of this; leave that to the navel gazers who read *Film Comment*! The Frankfurt school is right, and we love it! Manipulate us! Sucker us in! Suspend our disbelief, that's why we're here!

Here's how you can help those around you who are resistant and therefore less entertained than you! Comment loudly and often about what's going on in the film! Laugh suddenly and loudly at jokes, to clue people in on what's funny; this is critical to the crowd's enjoyment of any Rob Schneider product! And if anyone says things to you like "shut up," or "Will you shut the hell up or I'll call the manager," just give him a smile and remind him that he is the one wrecking the film right now, not you, and he should just relax and enjoy!

Be the Envy of Your Friends: Tell them everything!

Tell all your friends about the blockbusters you just saw! Tell them everything: the plot, the jokes, even the *climax*! This way they'll know for sure that you indeed saw the film before they did and you "got it"! This is especially important for films with a surprise ending like *Memento* or *Along Came a Spider*! Your friends will be impressed! You might even want to find a film-fan chat room on the Web, and join the fun by revealing "spoilers" so everyone can marvel at your movie smarts!

Affirmation!

Remember that *you* are the most important person in the theater! *You* love movies more than anyone else; more than anyone in the theater, the staff, or management; more than the stars or the directors themselves! *You* are the consumer, and all the world is there to wait on *you*! *You* deserve to be first, to have extra space to talk whenever *you* please! This is what blockbuster season is for! Thousands of people

have spent millions of dollars to entertain *you*, so the right thing to do, the American thing to do, is to see them all, see them first, and take pride in being the one who tells your friends, "It was an okay movie for what it was s'posed to be!"

And have a great Blockbuster Season!

✴ **WEEK 22, MAY 28–JUNE 3** ✴

Oak Street Cinema, Minneapolis	Yi-Yi
Imation IMAX Theater, Minnesota Zoo	Cyberworld 3-D
General Cinema Centennial Lakes 8	Shrek
Uptown Theater, Minneapolis	Time and Tide
General Cinema Mall of America 14	The Animal
Loews Cineplex Edina 4	Moulin Rouge
Carmike Apple Valley 15	Pearl Harbor

Picking Your Seat at the Movies
Just Don't Pick Mine

By the first of June I have parked my ever-widening hinder in over a hundred and fifty movie seats. I believe I have sampled the best, and I'm afraid I have yet to sample the worst; but I am ready to file my report: There is hope for our tired little buttocks.

My research indicates that a generous movie theater allows us roughly twenty by thirty-six inches in which to preserve our precious personal space. That's seven hundred twenty square inches, or the footprint of a file cabinet.

Toilet stalls in theaters allow more space than the seats do. Phone booths, voting booths, business-class airline seats all afford a generous

amount of space compared with a movie theater. I'm not complaining here, I'm just not planning to go to a sold-out movie theater, ever.

I have three basic criteria for a good movie seat: butt comfort, back support, and elbow room. And the greatest of these is elbow room.

Let's start with the best. My experience of this year has shown me the seat of my dreams: It's in any screening room or theater at the Palais des Festivals in Cannes. It's reason alone to get there. Never have I sat in a more comfortable seat, of any kind. I wanted to change my address, put in a reading lamp and a small kitchen, and live there. Sturdy but not stiff, cushy but supportive, upholstered in soft plush velour, these seats beckon to the weary festival-goer with soft chants promising a soothing balm. The Cannes seat supplies a perfect combination of all the right elements. The seat cushion is soft and yielding, wide and not too long, like sitting on your mother's lap when you were two. The seat back is supportive, with an ever-so-slight rock, just enough to allow you to back away from the idiot who mushes his way down the row in midfilm, but not so loose as to cause back strain. And not too high, because a seat back that cradles your head is an instant invitation to slumber.

And the most revolutionary thing of all: the armrests! Massive wide armrests, a good foot wide, like first-class airline seats. This is the critical distinction that vaults the Cannes seats above all others.

I cannot overstate how important this is to me. Elbow real estate is the last bastion of personal space in a movie theater. You've all had to sit next to a top-heavy moose like me, with wide shoulders and even wider arms. There is nothing more uncomfortable than having to share an armrest with a stranger, to feel the clammy skin of a naked elbow touching your arm. It creeps me out just to write it down. The Cannes armrests allow seat neighbors to rest their elbows blissfully free from contact.

This is where movie seat design becomes economic and perhaps political. The extra-wide seats and armrests mean fewer seats in the auditorium, meaning less potential revenue. This is why so many theaters in the early days of multiplexes jammed as many seats into a space as they could. The lack of concern for the audience backfired as

home video ascended, and movie exhibitors paid dearly. That's why any decent new theater or theater redesign is putting good money into comfortable, wide stadium-style seating.

The seats at the Odeon and the Prince Charles in London tied for a close second. Armrests weren't quite as wide, but still quite forgiving. In Helsinki, even the massive multiplex Kino had gracious spacious seating and copiously roomy armrests, seven inches wide. The CineHall chain in the great art capital of Florence presents conventionally narrow armrests, but each seat is self-contained, separated from the next by a good three inches.

Brilliant.

I think Europe still treats the cinema as an art form and not just a competitive marketplace, so theater design affords us more respectful treatment, from the seats to the screen, much like the legit theater and concert halls. Seatwise, one gets one's money's worth in the capitals of Europe.

Here in the States, the best we generally get is stadium seating. Sports venues have been doing it for years; it's only recently caught on in new movie theaters. It's a decent innovation when it's done well, as at the Carmike Cinema googolplex in Apple Valley. As much as I hate this place on general principle, its big theater is a fantastic place to take in a great big movie.

The Carmike seats feature retractable armrests, which you can fold up for snuggling, and the cup holders are plenty wide enough to fit the large soda or my smuggled-in stainless-steel coffee mug. And as a bonus, the theater has a handful of double-wide seats, which amply accommodate a parent and child, two thin adults, or one double-wide person.

In general, modern seating is a vast improvement over the foam rubber and vinyl of the past. At the local IMAX theater, back support reigns supreme while elbow room is lacking. The Edina Theater, with its lovely big room and lovely big screen, has yet to update its seats since it first showed *Annie Hall*, and that's awhile ago.

The General Cinema chain has the crummiest seats around. They're narrow, which allows the theater to jam more people in, and

also allows me to enjoy the second half of any movie without feeling in the lower half of my body. My hips smash against the sides; my lower thigh has developed a callous from the cup holder, and thanks to the proximity of the person next to me I can describe seventy different forms of body odor.

This irks me to no end, because General Cinema's Web site proudly trumpets their latest innovation, the Premium Cinema, that boasts a restaurant and bar and even a concierge in addition to massive plump leather seats in a state-of-the-art auditorium while Hollywood's latest unspools. Here in Minnesota, we get to watch Rob Schneider in his underpants and some cookie from *Survivor* while our hip bones poke through our pants.

See, I'd sit on a rum-soaked razor blade for four hours to see the restored Super-Panavision 70mm print of *Lawrence of Arabia*, simply because it is one of the most magnificent uses ever made of the motion picture, and if cinema has a life it will be remembered as fondly as we now remember the works of Raphael, Da Vinci, and Michelangelo.

However, sitting on a slightly padded slab of hard plastic for the mere eighty-four minutes it takes for Rob Schneider's latest film, *The Animal*, to stop hurting me, was almost as bad as passing a kidney stone. Schneider offends me on so many levels it's hard to know where to begin. He offends me with his lack of talent; he offends me with the fact that he is probably a millionaire in spite of his lack of talent; he offends me because he is friends with Adam Sandler; he offends me because he was never funny, even when he was perceived as funny; he offends me by getting film after film no matter how much I scream for the pain to stop; he offends me with his looks, the constant mugging, the Larry Fine hairdo, the "goofy-eyes" pose used by talentless comics who finds their bag of tricks contains exactly one; and, most of all, he offends me with his exuberant willingness to take off his clothes at every opportunity and expose his lumpy naked body to the entire world.

On top of all this, the horrid seat makes the experience all but unbearable.

This matters. The comfy little Riverview Theater here in Minneapolis recently installed new seats, making it the comfiest single-screen in town. They aren't cushy, but they're comfortable enough to pass the two-hour test. Cupholders are mounted on the seat back rather than the arm, which is wise beyond words. What's more, the theater actually *removed* some rows to make for more legroom. And, to top it off, it's a discount theater! Two bucks to see previously viewed, slightly damaged prints of some fine movies.

Now to the more strategic arena: *where* to sit. Everybody has a preference of course.

By now most people know that the best seat in the house for screening a movie the way it was intended is center seat, about two-thirds back, depending on the theater. Here, the screen comfortably fills your field of vision from right to left. Sit any closer and you feel like you're in a video game. Farther back, you feel like you're missing something. And on a curved wide screen, the center seat becomes more important.

Please be careful when choosing a center seat. It gives you at least a hundred ways to cheese off the people behind you. In the seventies and eighties, I used to take in a lot of movies with my good friend Bob, who was and is six-foot-eight and at the time wore an Afro. Bob liked to sit in the center seats. The problem was, Bob looked like an elm tree, and in a crowded house, people would berate him for being so damn tall, as if he had done it on purpose.

Being so tall, Bob required the entirety of the armrests. Being a passionate movie lover, Bob would talk about movies passionately. When talking passionately, Bob would gesticulate wildly, as if he was guarding his man under the paint on the basketball court. At any given moment, Bob would make a rhetorical point by hurling his forty-two-inch arms toward your face, your popcorn, your beverage. It was less like going to the movies and more like playing racquetball, and more than once I hollered, "hinder" as I felt his forearm muscle between my teeth.

Come to think of it, why the hell did I go to the theater with this freak anyway? Partly because his height allowed him to get a lot of real

estate around him. Nobody wants to sit next to the basketball player, so we'd always have a ton of room around us and behind us. This was strategy.

My personal seating preference is on the aisle, left side, two-thirds back. There's almost always an open seat. I can swerve my right arm around without danger. I can escape quickly. I am in charge, in control. And if the theater has a balcony, my absolute sweet spot is the front row, center seat. Always take this seat. You look slightly down on the movie instead of up, a metaphor that works to your advantage, and you'll usually have elbow room even if the seat doesn't. People don't like the balcony as a rule; I think it's because we all share an archetypal Jungian dream about falling over the edge and breaking our necks. Happens all the time in the movies. John Wilkes Booth broke his leg jumping from one. Christopher Walken got shot in one, in the film *The Dead Zone*, then he fell over.

But this is myth. Don't worry about falling over, just don't beer up before you get there. My very favorite spot in the whole world is the balcony of the Egyptian Theater in Hollywood during a screening of some magnificently restored movie gem. It's worth the trip, believe me.

How do we make the seating better? Complain, often and loudly, to your theater manager. Vote with your dollars and your feet, and try to see movies where you're most comfortable. Or, like I do, make a judgment on which is more important, a good seat or a good movie. Good movies win every time.

✳ WEEK 23, JUNE 4–10 ✳

General Cinema Mall of America 14	**The Animal**
General Cinema Har Mar 11 St. Paul	**Along Came a Spider**
Landmark Lagoon Cinema, Minneapolis	**Panic**
Paris Theater, New York	**The Golden Bowl**
Ziegfeld Theater, New York	**Atlantis**
AMC Times Square 25	**Swordfish**
Oak Street Cinema, Minneapolis	**My Night at Maud's**

I Love New York in Early Blockbuster Season, How About You?

Oh, and by the Way, I Saw the Future of the Cinema and It Scares the Hell Out of Me

A great story buzzed around midtown Manhattan this week. *New York* magazine reported that Martha Stewart was in line (here it's *on* line) at the Paris Theater, kitty-corner (or katty-corner) to the Plaza Hotel, for the local premiere of the latest Merchant-Ivory film, *The Golden Bowl*. Martha was well back in (on) line and, as Martha is wont to do, she was getting impatient, I mean really bugged, about having to stand with the likes of us. She marched up to the ticket window and demanded to be let in. She said it was too windy on the sidewalk.

Too windy.

Later a person who works for Martha told *New York* magazine that

she actually had to use the bathroom, so I'm guessing the wind thing was subterfuge. And instead of doing the traditional New York thing and squatting against the nearest architectural feature, she wanted to exercise better taste.

The ticket booth person said no. Martha persisted, saying that she just couldn't stand outside anymore, she just couldn't do it. An eyewitness said that Martha simply stared at the Paris employee, apparently amazed that someone would not recognize her, or, worse, couldn't give a rat fart in a windstorm who she was, then she huffed back to her place in (on) line. Rumors say there was a smattering of applause. I assume that she tried to fire several people in the line, and when informed that they didn't work for her, she was furious, so she had an assistant hire them, then she fired them on the spot.

And I love the finale. *New York* reports that when she got to the door, she said to the Paris employee, "Oh, now I can come in, I suppose."

This is one reason why I love New York. It's a city with a bajillion millionaires, but everybody's equal when the power goes out or the taxis strike or the streets buckle. This many people in one place is a great human equalizer, it's a reminder that no matter how much material wealth I accumulate in this life, it won't mean beans when I die, or when I'm standing in line at the Paris Theater.

If the lines outside every venue I found in Manhattan and Brooklyn are any indication, New York is also a place where every type of moviegoer can be satisfied. Although it's much more spread out than London with its West End theater district, New York wins hands down for its availability and diversity of venues and films. There are more than a hundred and fifty moviegoing venues in Manhattan alone, plus museums, auditoriums, schools, and nightclubs as cozy as Nell's that occasionally show movies. And don't forget Bryant Park in the summer. There are at least six places to see silent films, there are dozens of venues for films of almost any ethnic variety. Finding the right movie when confronted with so may choices can be overwhelming, and you may find yourself curled into a ball outside a SoHo hotel whimpering the name of an Iranian director who has

three films showing at the same time. So get yourself a copy of *Time Out New York* or the *Village Voice* (still free here), take a few calming breaths, discern your mood, pick your borough, find a theater, and go, man, go.

I wish I'd had more time in New York. I usually come here on someone else's ticket, so I don't have to sleep on the old futon or in the bathtub of someone's eleven-square-foot sublet. This time around I was the guest of the Toyota Comedy Festival. I got to stay at the Hotel Lucerne, actually a bargain, and a very nice place. It's just off Broadway and it has a view of the legendary Needle Park, so it made me nostalgic for the seventies and heroin. I'd recommend this joint for anyone who wants to have a moviegoer's tour of New York. It's a block from a major subway artery and if you're good at trains you can get just about anywhere in about half an hour. If you're not good at trains, again you'll find yourself curled in a ball outside a SoHo hotel, this time whimpering "How do I catch the 1-9? Suddenly there's *two* Broadways in Manhattan and nobody bothered to tell me?"

It's an odd thing here, but the theater and its show and its audience were perfectly matched wherever I went. My first stop after hitting town was, naturally, the Paris Theater. It's around the corner from Bergdorf's, off Central Park, which is to say that a lot of the people walking the hot summer streets are reeking of expensive perfume and wearing mink tennis ensembles. The Paris is sumptuous, like a fancy European theater, except the armrests aren't wide enough. Muted grays and reds accent the accents. Indirect lighting makes it all look like the interior of a Rolls. Polite attendants hold the door for you and greet you. When was the last time this happened to you at a movie house? Roughly never.

If you're not familiar with Merchant-Ivory as a producing-directing team, and have always figured they were a soap company, a little explanation is in order. American director James Ivory and Indian producer Ismail Merchant have made about thirty films together, most of them written by Ruth Prawer Jhabvala. Their films are visually rich, their settings sumptuous and often historical. Their landscape is the

heart, from the love of simple folk, um, all the way to the world's movers and shakers. They, hmm. . . . are tales of love, betrayal, triumph, told with passion and epic sweep . . . la la lahhh . . . luhh . . . hunh . . . zzzzzzzzzzzzzzzzzzzzzzzz.

If this all sounds like the jacket notes for some ten-thousand-page airport novel, it's supposed to. This team has made some of the most suffocatingly boring films ever conceived. Like those massive historical novels, they all tell the same story, only with different costumes and settings. I can safely say that I have fallen asleep at every Merchant-Ivory film I've ever attended. They remind me of a dream I once had, of dying in my grandmother's house, being suffocated by her giant long-haired cat, and eventually rotting and decaying right into one of her doilies.

Which would explain why the Paris was packed with Merchant-Ivory groupies: women, alone, white, overread, educated, snobby. The kind who own Robert Graves's autograph and have had their picture taken with Peter O'Toole at a book signing for his latest memoir, *Dear God, But When the Hell Will I Die?* I think it's a good guess that the women who attend the Thursday matinee screening of a Merchant-Ivory film at a theater in the shadow of Trump Tower are not sneaking out of their office administrator jobs; rather, they have Constanza taking the kids to dance lessons, and they just nipped out for the hundred-dollar salad plate at Aqavit before Drummond dropped them off at the Paris for a show with the girls.

This stands in sharp relief to my time at the AMC Empire 25 Theater on 42nd Street off Times Square. This is an amazing place for a guy like me who lived in the suburbs most of his life. The Empire was actually moved down the street awhile back, and all the new auditoriums were built above the old: twenty-five theaters and over five thousand seats. The theaters are all stacked on top of each other, each auditorium nicer than the next. The competition for the movie dollar on Times Square is fierce, so gone are the sticky-floored firetraps and the converted single-screen hellholes. This is first-rate comfort, from the seats to the screens to the sound. Sure, you have to hike up eighty-three escalators to get to your show, but it's worth it.

The place is packed for the opening weekend showing of *Swordfish,* a patently dumb, convoluted caper story. It has two strikes against it from the start: critical plot scenes where a guy sits at a computer, and John Travolta.

This is Bad Travolta, not evil but just plain bad; the one who can't act, the one who merely mugs and parrots lines, the one with the bad hair and the cab-forward face. The one from *Face/Off* and *Broken Arrow.* Unfortunately, it's Bad Travolta that seems to make the most money.

It also features Hugh Jackson as a smug computer programmer who can handle a weapon; in other words, a complete fiction. The fatal flaw in high-tech-based movies is the critical scene when the guy works on the computer. In *Swordfish*, they actually tried to make it look cool with a fast-paced jump-cut montage of Jackson as he programs to very loud DJ mixes. Dress it up and make it dance, but it's still a guy on a computer.

However, the film also has some huge crowd-pleasing features. First, it has Halle Berry's naked body, which may be the reason why all those teenage boys were in the crowd with their dads. Isn't that just sick? This is *The Man Show* audience; the guys who share *Maxim* magazine with their kids and watch *MTV Spring Break* together, as a family.

The movie is also fat with explosions and automatic weapons and car chases, because that's what this crowd wants. People cheered when the bad guys got vaporized. They got into the movie. They went along for the ride. I hated the movie but enjoyed this sort of unabashed moviegoing. Just let the film knock you around like a carnival ride, and don't think too long about the message. Whaddya wanna complicate yer life for? I think that's the Times Square state of mind I caught from this crowd. They all had a great time and walked out of the theater energized and talking a lot about the movie. Sure, they were talking about the explosions and the cars and Halle Berry's breasts, but why not? I had fun. A lot more fun here than I did at *The Golden Bowl* at the Paris.

Oh, and on the upper level of the theater, there's an open-air deck,

a promenade of old, essentially an empty space. You can just walk out there, about ten floors above the street, and catch stunning views of Times Square.

Finally, I saw a vision of the future, an oracle of things to come, to change forever the nature of the motion picture. According to several New York native friends, the best screen in town is the Ziegfeld, right smack in the theater district. I went there to see the very first screening on the opening day of *Atlantis*.

The Ziegfeld Theater is heaven. If you're looking for a place to die and you love movies, think of the Ziegfeld. The lobby looks like a pimp car, there's so much thick carpet and velvet. The theater is a single screen, a massive one, and the auditorium holds about eleven hundred.

Everything is velvety. Thick velvety drapes cover the screen; velvety-plushy gooshy seats caressed and supported me. Velvety walls and carpet dampened the delighted giggles of the hundreds of children waiting for the movie. Even the guy sitting next to me seemed velvety. It's like lying inside your own coffin, all the more reason to die here.

And here is what I love the most: rolling snack carts. No need to wait on line, as Murphy's law would have it, behind the guy who played Rerun on *What's Happening!!* as he orders up one of everything and pays in nickels. No, at the Ziegfeld, velvety vendors roll up and down the aisles like God's own flight attendants, dispensing bottled beverages and fresh popcorn at alarmingly low prices. This sort of treatment would be nothing short of revolutionary here in the Midwest; in fact, most people would think it's Bolshevism or worse, and run in fear for the snack line. A velvety announcer politely told us that it was ten minutes to show time, then five, then two, then he announced the movie, and the curtains rolled back, and without any of the usual up-front junk, we went right into the film.

I don't have to tell you how rare this is, to be treated so well in a movie theater. No ads for Coke or the Marines, no previews. No stupid, pointless computer animation announcing which theater chain we were in. The curtains parted, the film began. I almost cried. I loved

the world and everybody in it at that moment. I looked at the velvety person sitting next to me and told him I loved him.

He got up and moved, but that's okay, I love him to this day.

There was only one thing preceding the movie: a notice from the good geeks at Texas Instruments announcing they were about to blow our collective minds with their new technology called DLP, or Digital Light Processing.

And then they did it. The projection was perfectly focused, sharp in every detail in every corner of the screen. No print scratches, no reel-change pops, in fact no reel changes at all. No projector flutter, no soundtrack rumble.

You might not realize how rare this is. Even the very first screening of a virgin print of *Apocalypse Now Redux* with Francis himself running the projector is going to have some small flaws. Having every single inch of the screen in perfect focus almost never happens in any theater.

This film was *flawless*.

It was flawless because it wasn't a film. *Atlantis* never was a film; it was conceived, created, animated, edited, and, at the Ziegfeld, projected completely in the realm of digital information, without one single frame of film involved.

It was beautiful, the color density full, detail razor sharp. With video projection there is always some artifacting or scan line problem: In layman's terms, video still looks lousy when projected. But this isn't video. It's a completely new technology using ones, zeroes, and mirrors.

I was overwhelmed. I couldn't believe my eyes. A half hour into the movie, I ran to the lobby to find a manager. I found about six of them just out of a meeting, all sharply dressed and scowling. They looked like mobsters on break. I approached the scowliest of them all, the one who the others seemed to fear, whom I took to be the head man. He was. He very politely told me all he knew about DLP. Yes, there was no film being projected. No, it wasn't video, it was something new he didn't pretend to understand. Yes, there's lots of information on it at the TI Web site. Then he excused himself and went to loudly berate a loafing employee.

The import of what I was seeing rolled over me like the Pacific surf. It could mean the end of film for motion picture exhibition. DLP will be flawless every time it's shown. This means the magnificent picture I was seeing at the velvety Ziegfeld theater in Manhattan will look just as magnificent in decidedly less velvety venues in the various boondock theaters around the country. We'll all be able to see really good-looking films. Even in Idaho. I don't want to alarm anybody, but it just might raise our aesthetic standards.

And another ramification: It will change the way we look at a motion picture, physically. No flicker, no shutter, no frame. It seems to work better than our own eyeballs at envisioning information.

It doesn't stop, no sir. Home projectors will be better and cheaper than ever, and they won't weigh two hundred pounds and cost ten thousand dollars. We'll have a picture on our wall that's every bit as sharp and detailed as the one in the theater. And we won't have that massive Toshiba taking up half the room while the recliners take up the other half leaving no room for our pizza-stuffed bodies.

This ain't no dope-fueled prognostication. Unlike the personal helicopter in which we were to commute to work or play, this could actually happen, and within my own lifetime.

One last story, a joke actually, that I first heard from my pal Frank Conniff, a native New Yorker. He says you can save time when asking directions by soliciting people in the street thusly: "Excuse me, could you help me find Lincoln Center, or should I just go fuck myself?"

I had a whirlwind three days here and I saw five movies. The New Yorkers I met on the street were brazen, outgoing, very endearing people, filled with character and a genuine love for their city. And to my delight, nobody told me to go fuck myself.

It was midnight, naturally, and I stood on the edge of a cliff overlooking a roaring stream lit by the sun, a sun that would drop to no more than three fingers from the horizon, then start right back up again. It was day four of the Midnight Sun Film Festival in Sodankyla, Finland, a hundred miles above the Artic Circle in southern Lapland.

Several things sprang into my head, muddled by a ringing caused by the punch of lemonade and cheap vodka they were serving over near the campfire:

- I have not seen the dark of night in five days;
- Finns seem to survive on a diet of beer, potatoes, and

sausage, and yet they are not all seven thousand pounds;
- I love this festival, it's the best festival I've ever attended;
- The vodka punch is really crummy;
- I forgot one;
- I have to go but I haven't seen an outhouse;
- In a moment, after I go, I'll get a little more vodka punch to aid my headache, then return to the campfire and talk to filmmakers, writers, and film lovers from at least a dozen countries about movies, politics, sausages, and bad jokes the world 'round;
- And I love this festival; it's the best festival I've ever attended. Did I say that?

The first reason that this is the best film festival I have ever been to is simple: The people who founded it, who operate it and keep it thriving, love movies, all kinds of movies, highbrow, and lowbrow, award–winning, controversial, simple, silly, deadly serious. Comedies, musicals, documentaries, art, experimental, silent. In any language, any genre, any era. The world's most popular and the world's most obscure.

The second reason is also simple but must be experienced to be understood. Since the sun never goes down, films are shown all night, well into the morning; eventually there's no sense of time. But it's not a Las Vegas–style loss of time-sense; it's much more natural. Every summer Lapland becomes a sort of trance state for diurnal creatures like myself, in which the natural inclination to sleep when it's dark is gone, and in its place movies are presented. Not your run-of-the-mill movies either, but compelling dramas, spaghetti westerns, 3-D cult horror films, magnificent silents, and Beatlemania to boot.

Before it's over I'll have seen about twenty films of a variety as broad and wonderful as you can imagine. And I've found what I have been seeking in a festival. There's no underlying commercial push here, no political agenda. No exclusivity, no star treatment. Just people who love to watch movies, coming together to celebrate that love.

Getting here is the biggest challenge. Since I am an underfunded

dope just trying to see movies, I traveled coach on three different flights: Icelandair from Minneapolis to Reykjavik to Stockholm, then SAS Stockholm to Helsinki. Oh, and then it's a ten-hour train ride across the length of Finland to Rovaniemi (which is the purported ancestral home of Santa Claus, though I'm suspicious).

Then it's a two-hour bus ride from Rovaniemi to little Sodankyla, where the festival is held. Of my seven days in Finland, I spent five in Sodankyla, one in Helsinki, and two in cross-country trains, so I feel I got a good long snapshot of the country and enough information to make some very broad and inaccurate generalizations about Finland.

When I arrived by train in Rovaniemi, I began to notice the very odd assortment of characters getting off and streaming to a nearby bus. There was a fellow in a pirate bandanna with a well-worn bulldog by his side, a number of women clad all in black and smoking continuously, and a very Russian-looking man with a severely beaten motorcycle jacket and a bowler derby. No doubt this was the festival bus.

A nice young woman named Mina seated herself next to me, and immediately struck up a conversation. In less than five minutes I learned that Mina was studying documentary filmmaking in Helsinki, had been in New York several times, and had a penchant for folks like D. A. Pennebaker. Her English was better than mine, and lacked the characteristic Natasha Fatale accent so many Finnish women have. Turns out she studied at the University of Wisconsin-Madison, my alma mater! Suddenly I wasn't scared of her, and someone started passing a big box full of beer and wine and sandwiches around. I got to know Mina, her friends, her new acquaintances, several strangers, even the scary fellow in the leather and the bowler derby. We had a grand old time, and as we passed into Lapland the bus had to stop for a herd of reindeer crossing the highway.

This and the rest of my experience dissolved my first stereotype of Finns, that they keep to themselves and are loath to meet strangers. Every Finn I came within eight feet of started a conversation. These festival-goers were altogether lighthearted, amiable, smart, a little crazy, and passionate about film.

But passionate in a healthy way. The festival is no exclusive club,

nor is it a collection of pretense or exotica. It is a wide-ranging spectrum of the broadly popular, such as *A Hard Day's Night* and *The Exorcist*, to the extremely local, such as a documentary on unemployed youth in a small town not far from here. There are historical treasures, like the outtakes of several unfinished Orson Welles films. There are retrospectives of great but often overlooked filmmakers like Jerry Schatzberg and Sergio Sollima. There is a great celebration of film legends and new filmmakers alike.

We arrived in Sodankyla and checked in. It is a disturbingly clean and quiet little town, with an abundance of shops but no visible liquor stores (to combat alcoholism, the government has made it difficult and expensive to get booze outside a bar). Actually, it looks a lot like a small town in Minnesota, only it's cleaner, and the people are friendlier. Oh, and people stay up all night.

As I parted company with the bus festers, Mina told me to check out a film called *The Stars' Caravan* playing tonight at the Teltta. The Teltta (Movie Tent) is the center of activity at the festival. It's big, dark, and appears to have been bought from a Polish circus at some time in the fifties. At 10:30 P.M. it was broad daylight outside, but the heavy canvas made it feel like night. It holds about a hundred people on stacking chairs and a thousand more on butt-wrenching wooden bleachers, but blankets are available to share and sit on and snuggle under.

And the very first film I saw there made me fall in love with this festival.

It was *Taivasta vasten*, *The Stars' Caravan*, a documentary set in Kyrgyzstan, a country I'd really never heard of, smack in the middle of central Asia, bordered by China and several other stans: Kazakstan, Tajikistan, and Uzbekistan. Due north of India, due east of Turkey, high in the mountains of the middle of nowhere.

That's not even the coolest part.

Kyrgyz have ranged the country for centuries as nomads, brilliant horsepeople, living in yurts and raising falcons. I think it's the land John Huston had in mind when he filmed Kipling's tale *The Man Who Would Be King*.

The film's subject is a man who carries a projector and films to the remotest places in this mountainous land, in failing health, in his

beat-up car, and on horseback through the high Tien Shan mountains to the yurted nomads. The nomads hunger for this window on the world, to learn of other lands and gain insight into their own history. The film is intercut with an epic film of these same people, these horse warriors, these fierce indigenous Asians, these ancient people.

At one point our hero spools up the film upside down and reversed. Everybody looks at him funny. In order to save a little face and have fun with these folks in front of the documentary crew, he tells the nomads, hey it's your fault, you put up the screen upside down. As they turn the screen around, he quickly rethreads the film and no one is the wiser.

This is the perfect film for me. To see a sane man spending all his time making hard travel to hard places in order to celebrate film gives me strength for my own journey, and tells me that I am far from alone.

As you can see, this small festival is rich in content. There are three screening venues in Sodankyla. One is an actual theater, the Elokuvateatteri Lapinsuu, which is the town's nice little cinema. For the week of the festival, the local *koulu*, or school, opens its auditorium and crams it with chairs. The most fun is the tent, of course, and while the benches are hard to take and it's always cold, I have no complaints. In fact, I would have to say that I have only one complaint about the whole experience:

The food.

One fresh new prejudice I will bring home from Finland is that they never learned to cook, and aren't planning to. Sodanklya offered meat, primarily in the form of sausage, with every meal. The Finnish breakfast included pickled herring, salami, meatballs, and cucumbers. The favorite Sodankyla lunch is a plump little sausage, naked save for a sheet of wax paper, drizzled with a nasty sugary mustardlike discharge. The ubiquitous tap beer, Lapin Kulta, is reminiscent of Bud Light, so it's best to stick to the giant bottles of Heineken available everywhere.[12]

12 I've noticed in my travels around the globe that certain products are available everywhere; one such is Heineken. Another is Marlboros, which may be precious as gold, but you can get them. And I once bought a mini can of Pringles in a Guatamalan cantina a hundred miles from anywhere.

And the night, oh, the nightless night. Arriving back home, it's all anyone wanted to know about. They didn't care about the purported home of Santa Claus or the amazing variety of films or the serene, occasionally dramatic landscape, or the reindeer everywhere, they wanted to know what the midnight sun was like.

Well, it was, like, weird, man. It was like day. It was a novelty the first couple nights. I was dumb and giddy enough to take a picture of my watch in the broad daylight of 2:30 A.M.

But then something began to happen, as the endless days wore on, and as I watched films long into the next day. Any sense of day or night left me, and I simply slept when I was tired and woke when I wasn't. Even my traveler's cocktail of kava kava and melatonin didn't help, so I stopped taking it, and just floated along with everyone else.

Soon it became no surprise to walk out of a film and over to an ice cream stand at four in the morning, or to be hungry for corn flakes at seven in the evening. It made a sort of terrific sense to have a sausage and a beer for breakfast. In all, I think I slept an average of three and a half hours every twenty-four, and while I probably couldn't operate anything more complicated than a flashlight, I was in the perfect frame of mind to see movies.

Now here's another generalization about Finns: They have a remarkable capacity for new things, new film styles, new filmmakers. The Finnish film community is large and growing, as the means of production become cheaper and more accessible. And—big hint—the government avidly supports that film industry, while there's no centralization of power or money.

Hmm. Could that explain why they're getting so good at being filmmakers, and why they're even better at being an audience?

Every day at the festival had a highlight, an occasion for delight. And then came the silent film, D. W. Griffith's *Broken Blossoms*, accompanied by the string ensemble Avanti. Say what you will about Griffith, hate him for *Birth of a Nation* if you must, but to see *Broken Blossoms* illuminate the screen in the circus tent to the graceful, lyrical music of Avanti is to recall when American film stepped out of vaudeville and became its own art form.

Not without its faults—the now frightening main character called the "Yellow Man," played by a white guy, the naked brutality it presents, and the corny melodrama that frames it—the film is a transcendent piece of work nonetheless, and this performance hoisted it out of my film school memory as a boring historical relic to a living thing. Here's why:

Midway into the film, as the abusive thug Battling Burrows terrorized his fragile daughter Lucy, a storm blew up outside the tent, and became more fierce as the threat of violence built on the screen. In the tent the ensemble played on as Lucy defended herself against her bastard of a father, and we all shivered. Water dripped on me through a hole in the canvas. The wind whipped the big top, causing the projection screen and the film with it to wave like a banner.

Now it may have been the lack of sleep, the sausages talking back, or the beer, but I was transported, and I wasn't the only one. The melodrama played inside as the storm played outside. The screen and picture waved; the ensemble built the tension as lightning flashed. They hit the crescendo and thunder rolled as poor Lucy died and with her the dim hope of love she almost felt. And while strings mournfully intoned the quiet cadenza, the film ended like a candle being snuffed.

Spontaneously the crowd was on its feet. The applause lasted several minutes. I didn't realize I was crying until I felt tears on my cheeks. There were four curtain calls. This was like a night at La Scala, or the Met, this was grand live spectacle.

After the magnificent experience of *Broken Blossoms*, the storm lightened. As we headed out into the rain, the sun broke through the clouds, arching a double rainbow over the tent that lasted about an hour. I have pictures. Seeing a double rainbow high above the Arctic Circle at ten-thirty at night is the kind of story you bring home to your kids.

Two buses pulled up. A flyer had been handed out, inviting the press and the guests to "a traditional Finnish Tangoevening" with music by "our band 'The Reindeers,' as well as some snacks and a drink or two (on the house) in the beautiful Finnish woods."

This is what separates the Midnight Sun Film Festival from the likes of Sundance, Cannes, all the "important" film festivals: They've remembered what's important. Having fun, enjoying life, thrilling at art, sharing a laugh and a drink and an insight with someone you've never met from a country you've never been to, that's important. For this festival, film is not a product, it is a living, breathing thing, a part of our lives.

On the bus, three local Finns stormed in, loud and a bit drunk. They passed their bottle of toxic brandy and flirted with every woman. For our purposes I will call them Thøm, Dik, and Harri. Harri was the most articulate and sober of the three, and the only one with any advanced education as far as I could tell. Thøm and Dik reminded me of trade school dropouts in northern Wisconsin, and they wasted precious little drinking time on talk.

Harri flopped down next to me after his flirtations were turned down, and, like nearly every Finn I met, he struck up a conversation. His English was quite good, embarrassing me for my lack of any Finnish at all besides *hej* (hello) and *kiitos* (thanks). He knew where Minnesota was, kind of. He sure knew where Hollywood was. He planned to go to film school in Helsinki when he could get the money together. Though he lived here in the Finnish arctic wilderness, his film knowledge was diverse and sophisticated; and though his favorite films were action films, he loved stuff like *Run Lola Run*, as intelligent an action film as you'll ever see. It seems that Sodankyla's culture is not nearly as rural as one might think.

I told Harri I was excited to see a real Finnish "Tangoevening," and I asked him what to expect. Harri said don't expect too much. "Vell, dar wass the Tangoparty for a vile, you know? Becuss da local fellow here, he vould put dem together for vonce the month, eh? But now this fellow, he kill himself, and now is nobody to organize da tangoparty, you know? And iss too bad, I love the dance. But I love the rock and roll better." He smiled and passed me the brandy bottle.

Within an hour I was where you found me at the start of this chapter: tipsy, teetering on the edge of a stunning view, belly full of sausages and bad punch, loving this festival to pieces. Clouds of mos-

quitoes circled, the lemonade punch swirled in my head, the damp chill invaded my very bones. Harri made bad dick jokes as he dangled a sausage from the end of a stick, and I chatted about film with people from at least six countries. At midnight, a brace of us ambled out to this cliff overlooking a river in the midst of this ancient forest, and peered over, way too close to the edge, and I got all giddy. Here, more than at home, and far, far more than I ever could at Cannes, I had spoken and listened to the language of film, and I felt at home in the world.

Icelandair Flight 532	**Anti-Trust**
Loews Cineplex Edina 4	**Evolution**
Carmike 15	**Tomb Raider**
Landmark Lagoon Cinema, Minneapolis	**Sexy Beast**
Landmark Lagoon Cinema, Minneapolis	**The Luzhin Defence**
Hayward Cinema 4, Hayward, Wisc.	**Evolution**
CEC Lakes 7, Rice Lake, Wisc.	**Shrek**

Sit on the Aisle
To Repeat: Sit on the Aisle

There is a transcendental joke that begins and ends the wonderful and courageous 1942 Ernst Lubitsch film *To Be or Not to Be*. Jack Benny, playing the self-proclaimed "great, *great* Polish actor Josef Tura," stands on a stage in the stereotypical Hamlet costume, about to deliver the prince's most famous soliloquy. Posturing with all his might, he gets out the first two words, "To be . . . ," when from the center of the third row a big fellow with a coat and a hat rises and makes his way to the aisle. A bomb going off in the theater would have less impact; a flock of turkeys falling from the ropes above would be less funny. The scene says that there is no better way to

deflate an actor's ego than by getting up and walking out. It is the perfect insult.

It is a movie moment that waves the banner for my most passionate issue in the movie theater and my appeal to you who would mill: Sit on the aisle.

In the dramatic theater, with actual, live, real persons sweating under makeup, getting up and shuffling to the aisle is one of the rudest things you can do, next to unwrapping a Brach's butterscotch lozenge. But in a movie theater, it seems to have become a tradition to get up, stroll around, use the phone, talk loudly and openly, pretend you're at home. Next thing you know people will be coming to the movies in their underwear, with coolers and floor lamps. The very editor of this book, my friend Tom, has flat-out told me that he won't go to a movie theater anymore except on very special occasions and for very special films. I understand the feeling.

Why does this happen, the endless milling? Part of the fault lies with the enticing smell engineered into the polymer-rich corn-popping medium. But a larger share of the blame goes to the producers of the films themselves. Believe me because I've seen it in action: The more enthralling and engaging the film is, the less the chance people will stir like kindergarteners. During a movie like the splendidly nasty *Sexy Beast*, where the tension reaches down into your socks, you won't dare move from your seat, you'll risk peeing your pants because you can't miss what happens next.

Conversely, during the lifeless embarrassment *Evolution*, the Friday-night crowd milled around like mad. The theater looked like the wheat pit at the Board of Trade. Why? The film was dull, predictable, and stupid, and didn't even hold attention through the credits. The movie seat becomes a small prison, less comfortable than a coach seat on a 727, stuck on the ground with a mechanical problem. In July. In Houston.

But I put most of the blame on the audience. We have the attention spans of mayflies and our respect for personal space is somewhat less than that of the uniformed guys who pack commuters into the

Tokyo subway cars. Some of us just can't sit still. It doesn't matter how good the film is.

I'm not talking about children, I mean full-grown adults with jobs and insurance policies. People who wouldn't think of getting up to hit the can in the middle of the Monday team-building power breakfast, no matter how suicidally boring the guest speaker is.

Here's a f'r instance: I sat down to watch *Memento*, a riveting film, packed with constant revelation leading the plot into wild new territory. And yet a woman in the middle of the row got up and left, *during the first two minutes of the film!* If you've seen *Memento*, you know that those moments are critical; indeed, almost *every* moment is critical. But this woman, who'd been sitting there all through the previews, got up and left almost immediately after the film started. *Vummp, vummp, vummp,* her legs rubbed against her unfortunately tight spandex shorts, *vummp vummp,* as she squirmed down the row, past a large number of annoyed people; many like me had to stand up to let her through. She popped out of the row like a rubber duck in a bathtub and *vummp*ed up the aisle.

In a few minutes she was back, arms full of snacks. I knew she was back, because without warning she simply forced her way past us again, spilling half her corn in the process. No apologies, no excuses. She just waited for the movie to start and went for provisions. Maybe this was a strategy, I don't know. It makes no sense to me; heck, maybe she comes to the theater to snack and the film is inconsequential.

Last week at the Mall of America, a woman grabbed my face. She'd come into the screening late, and blinded by the darkness of the theater and the night shot on the screen, she mistook my face for a seat back and simply grabbed it fully. Before I could react she seemed to realize that theater seat backs don't have lips, and she started, angry with me for assaulting her.

But this is routine. Getting up and sidling down the row in today's packed movie houses offers occasions nothing short of groping. Stadium seating helps, but only to a point: It helps the people in the row behind you, but not in your own. I can recall at least five incidents this

year alone where my face, hands, and/or body has/have come in direct contact with the buttocks and/or the entire crotchular region of another person.

In New York, at the massive AMC 25 off Times Square, during a screening of *Swordfish*, a man tried to sit on my head. I have no explanation. He simply got up during the car chase, moved down the row, planted both his feet squarely on mine and leaned his ass hard into my head. What's worse, he didn't stop, he bore down. My neck was compressing, and I could smell his jeans. I had to push him off me, grabbing the flesh of his back with both hands. He apologized and said that he'd tripped. I wanted to hit him, and he knew it. When he came back (hands full of snacks, of course) he sidled in from the other way.

This bothers me to no end. I can take the pagers, the cell phones, the candy wrappers, the hecklers, and the kibitzers. But it drives me mad that ostensibly grown-up people can't sit still for just two hours, no matter how compelling the reason. I don't understand why this has to happen. In fact, it doesn't.

You see, movie theaters have a marvelous thing called the aisle. In case you don't know, the aisle is the long, seatless area one uses to convey oneself on foot to the row of one's choice. The seats directly adjacent to this aisle are suitably called aisle seats. Aisle seats are plentiful and available, even at a crowded show.

So, if you know full well that it simply will be impossible for you to sit in one place for less than the duration of a film, I appeal to you as a movie lover: Please sit on the aisle.

If you have a small bladder, a large prostate, a spastic colon, or some other form of digestive unpleasantness, please sit on the aisle. If you regularly have a sweet tooth, a salt craving, low blood sugar, or you're just plain a glutton, for the love of God sit on the aisle.

If you are a sneezer, a wheezer, spasmodic, psychotic, dyspeptic, epileptic, if you're prone to spontaneous human combustion, please do yourself and all of us a favor and sit on the aisle.

I want to post it like Martin Luther's ninety-five theses on the doors of every theater in the land:

OUT OF LOVE AND CONCERN FOR THE AUDIENCE,
WE REQUEST THAT THOSE WHO WOULDST WILLINGLY
OR KNOWINGLY BE COMPELLED FOR WHATEVER REASON
TO RAISE THEMSELVES UP AND VACATE THE PUBLICK
EXHIBITION OF A MOTION PICTURE,
WE FIRST AND LAST APPEAL:
SIT ON THE AISLE.

You know who you are. Now get out there and strike a blow for human evolution.

✳ WEEK 26, JUNE 25–JULY 1 ✳

CEC Lake 7, Rice Lake, Wisc.	**Dr. Doolittle II**
CEC Lake 7, Rice Lake, Wisc.	**Tomb Raider**
Palace Theater, Spooner, Wisc.	**Evolution**
CEC Lake 7, Rice Lake, Wisc.	**Atlantis**
CEC Lake 7, Rice Lake, Wisc.	**Pearl Harbor**
Bruce Theater, Bruce, Wisc.	**Evolution** (Canceled due to lack of interest)
Miner Theater, Ladysmith, Wisc.	**Atlantis**
General Cinema Mall of America 14	**The Fast and the Furious**

Movies in Vacationland

✳

Some days ago—never mind how long precisely—having a little time on my hands, and nothing particular to interest me in the suburbs, I thought I would drive about a little and see the watery part of Wisconsin. It is a way I have of balancing the humors, filling my spleen with schooners of Lienenkugel.

But enough of my gratuitous bitch-slapping of Herman Melville. I have returned to tell the tale, and it is a harrowing tale, for I was ensconced in Wisconsin in a four-room cabin with six adults, relatives all, and ten children. We were outnumbered, yet we escaped with our skins. There were two infants, two toddlers, six preadolescent youth of

varying degrees of behavior and temperament. The weather was ninety-plus and likewise the humidity. The mosquitoes threatened to make off with two of the younger nephews and dehydrated a cow. The lake turned a livid green with the algae bloom, and there was a dead skunk under the porch.

The rest is a blur.

The family of my beloved spouse, Jane, has made a habit of spending a week at a cabin on a lake, as is practiced by every single human inhabitant of Minnesota and Wisconsin, by law, every summer. Boats must be rented or purchased, fish must be caught, s'mores must be eaten, songs sung, mosquitoes endured, rashes developed. Children must plummet from bicycles, Razors, and in-line skates, and hurl themselves headlong into shallow water and beehives; those in their terrible twos must practice the art of being terrible with renewed fervor. And adults must endure it in the name of the vacation.

I have been through ten-day courses in wilderness survival training. I have endured grueling two-a-day football training in hundred-degree Illinois late summer swelter. I have slept on rotted foam mats in lizard-infested tropical hotels, drunk questionable water, eaten questionable food. I have survived pickpockets, rip currents, light aircraft flights, and insects as large as my dog. But not a single moment of this prepared me for spending a week in the woods with my nieces and nephews.

Thank God for my job. Thank God for the movies, and thank God twice for movie theaters in resort areas.

Every afternoon, as the infant twins filled their pants, the toddlers warmed up for their hour-long afternoon scream, and the older cousins began to hit each other with lunch-fueled furor, I got to leave to see a movie. Just as the afternoon sun was bringing the fat humidity to the boiling point, I'd get in my beat-up old Isuzu Trooper and drive twenty to thirty miles in the rolling lake-dotted countryside to sit for two hours in a dark cool place. And I would return to a scene of gleeful kids splashing in the lake, toddlers who collapsed in mid-tantrum, and babies sleeping like babies. The adults, however, were red-faced and exhausted and ready to murder.

In my week in Chetek, Wisconsin, the Gateway to the Northwest Lakes Area, I visited the five theaters I'd found within a fifty-mile perimeter. None of them was great, at least one was actually charming, and one will haunt me for a good long time.

I do love this part of the world, filled with farms, prairie, and lakes, where the road stretches out amid the cornfields and dairy cattle grazing land. The rusty tractors and field trucks, the old decrepit barns, the little aluminum fishing boats with the five-horse Johnsons, it's all so John Mellencampy.

Even in the remotest parts of the state, three miles won't click by on the odometer before you whiz past a bar. Some are nostalgically cozy; harkening back to the days when Chicago swells drove their Lincolns and Caddies to remote fishing lodges. And more than a few are simply alcoholic crash pads, grim and darkly milky with fluorescent light, stale from generic cigarettes and light beer. The air-conditioning is always set on polar and the walls are festooned with promotional beer signs and massive televisions. You can depend on a very cold beer and a pour on your brandy and Seven that's more than fair. At any time a NASCAR race will glare from the big screen and the song "Tush" can be heard.

Of course, we're not gonna find an art house playing any sort of Gay British Cinema Retrospective here, and this means I'll be seeing a lot of the same films a number of times. I've learned that for all its brouhaha, the summer season delivers a pitifully small number of films to these remote outposts, and because of the Compulsory Films Act of 1975, known as the *Jaws* Act, everybody must forsake variety and see the top three or four films as determined by the National Blockbuster Administration. I dearly wanted to avoid this repetitious viewing, and yet it gave me a chance to study these films under vastly different conditions, from the city to the lake cabin country.

It's this limited availability that helps the Lake 7 Theater in Rice Lake do so well. On its seven screens we get the compulsory Hollywood films of the week, and the place is bustling. Not everybody likes to fish up here; in fact, I'd say that the majority of visitors don't want to fish at all, but they come because Dad wants to fish. In this part of the world,

Dad still wins. So Mom and the kids fill up the Lake 7 during the day; teenagers, young married couples, and overfished sunburned dads fill it up at night. At the Lake 7 the ticket price is six bucks, four for the matinee, so with a regularly full house, somebody's gonna retire well.

The Lake 7 is truly the only game around for people in this chunk of Vacationland because it's the only theater within about two hundred square miles. Way back in the iron age before the VCR, there was a theater in just about every small town in the area. Someone built a lot of these sturdy little movie houses after World War II. Expendable income and Jimmy Stewart back in Hollywood, how could you miss? That video closed these places down is beyond a doubt, and it led to the consolidation of competition into multiplexes.

But, wait, what did I find on the Internet? Spooner, Wisconsin, has a nifty looking theater, the Star Cinema, right on Maple Street. A single screen, showing *The Fast and the Furious*. Great! Off I went. I found Maple Street, Spooner's main drag. No theater, not on East Maple, not on West Maple, not on the two blocks that make up the central business district of Spooner. Off to the gas station, where a very nice snuff-dipping old feller tells me that the theater's not on Maple, it's up on Walnut in the old part of town.

So, big deal. Maple, Walnut; put 'em together and you have a Baskin-Robbins flavor. I rounded the corner on Walnut Street and saw the theater. It's called the Palace. Turns out the Star is in Sparta, a hundred miles south.

The Palace was no palace; in fact, it was badly split in two, but it's holding its own here in the rural country of northern Wisconsin. And that's saying a lot. Judging by the number of single screens still open in this state, I'd have to say that folks 'round these here parts just love to go out to the picture show.

It has been a good week at the cabin, even though near the end the kids have been at each other *Lord of the Flies*–style, breaking off into factions and plotting great harm. The parents, however, had rallied at cocktail hour and celebrated the waning of the week. It was Saturday, fish-fry night; we would grill up all the fish we'd caught that week.

The thing is, we had no fish to grill. When this many kids are

around, one cannot get any decent fishing done. The kids want to go along. Children under ten years of age cannot fish. They pretend to fish, get bored and whiny, and begin to pound each other. So my enterprising Jane coaxed a bucket of bluegills from a pair of very successful locals, and we slapped 'em in the skillet and ate 'em with relish and lots of Miller High Life.

Every region in the land has its own proud cuisine, at least one dish that can be said to surpass its like anywhere. In Chetek, it's bluegills dusted with flour and herbs and flash-fried in a cast-iron skillet on an open fire, complemented with sweet corn picked within the hour and beer colder than Don King's soul. It sounds simple, basic, even crude, but I put it up against dinner on any given night down there in the big town. A great meal cannot be separated from its place and time, its surrounding and circumstances. The same goes for a vacationland movie theater.

This leads me to the Bruce Theater, in Bruce, Wisconsin, population 843, a fly speck on my road map. I wasn't even looking for a theater here; instead, I was screaming down U.S. 8 trying not to be late for the next showing of *Atlantis* at the Miner Theater in Ladysmith, another twenty miles down the road. But out of the corner of my eye I caught a big marquee in the twilight with the glowing red letters BRUCE. I brodied the old Isuzu Trooper to a halt in front of a theater old before its time. It wasn't listed on any database, not in any newspaper, yet here it was, a ghost of a theater in a one-road town, showing *Evolution* nightly at 7:00 P.M.

I took a few pictures of the place in the bright evening, then went to get a ticket to the show. The lobby was a horror; any vestige of yesteryear's charm had been swept away with dirt-colored carpeting and dingy paneling. Nobody at the ticket counter. In fact, the corridor was dark. From behind a curtain came a young man about seventeen, baggy pants and the little chin hair and all. I asked him if there was a show tonight. He said no, we closed down cause nobody came, they're all over at the thing in the park tonight. How does this place stay open? We do okay, we just put in new seats. He showed me the auditorium. More than one storm and flood had caused the six-foot-high

water stains on the pressboard paneling and on the screen itself. The concrete floor was painted, and the seats were new, but the air held the musty smell of a dead relic. If Larry McMurtry had been from Wisconsin, *The Last Picture Show* would have been set in Bruce.

And so I was off like the wind to the decidedly cheerier Miner Theater in Ladysmith, a dandy old house built in 1947 with a dandy old staff, packing the kids in for the Saturday-evening show of *Atlantis*. Little families bought little bags of popcorn and sat in the little theater, which retains a lot of its postwar fancy. But everybody came in and went out happy. They were in Vacationland, and Vacationland is much more a state of mind than a cramped muggy cabin on a lake. The struggles of family on holiday can be vastly different from those at home. Worrying over whether to swim, fish, or suntan is about as hellish as it has to be up here. The cold beer in the afternoon is a minor miracle for the adults, and after a day of fierce activity in the hot sun the kids sleep well at night.

So the dark cool theater becomes a pillowy dreamland for all, and people smile away even during the credits. For all its heat, its animal stinks, its bugs, a cabin in the woods in northern Wisconsin is a haven; but when haven turns to trap, the movie theater provides a haven from the haven.

General Cinema Mall of America 14	Tomb Raider
General Cinema Mall of America 14	Pootie Tang
General Cinema Mall of America 14	Cats & Dogs
General Cinema Mall of America 14	Scary Movie 2
General Cinema Mall of America 14	A.I.: Artificial Intelligence
General Cinema Mall of America 14	Ferris Bueller's Day Off
General Cinema Mall of America 14	Kiss of the Dragon

A Theater Near Me
Sadly, I Live Near the Mall of America

Starting the second half of the year, I decided to explore my home turf. I would spend the entire moviegoing week at the theater closest and most convenient to me. Because I live in Bloomington, Minnesota, said theater is not some quaint little single screen with the popcorn in the striped boxes and the smiling old lady behind the candy counter putting a few extra red jelly coins in my bag while I jump with anticipation 'cause I'm about to see *It's a Mad Mad Mad Mad World*. With cartoons.

I *wish*. No, seven miles from me, a comfortable bicycling distance, my local theater is the General Cinema 14 at our country's biggest retail freak show, the Mall of America.

We call it the Mall. There are a lot of malls here, but when you say, "You see that new thing at the Mall?" or "N'Sync is signing posters at the Mall," everyone knows damn well which mall. The Mall is, I believe, seventeen million square miles in total area, and contains, if I got my information right, sixteen thousand retail stores, eleven thousand six hundred restaurants, eighty-five thousand kiosks selling wrestling T-shirts, cellular phones, and ear piercing, one of the five oceans, an indoor airport, the state of North Dakota, George Wendt, and a herd of buffalo. I got this information from my seven-year-old niece, so I can't account for its veracity.

Truth be told, it is indeed the largest shopping mall in our retail-sick country, attracting—according to Mall literature—more tourists annually than the Grand Canyon, Disney World, and Graceland combined. Judging by shoppers' fashions, I think it's the exact same people.

A community of sorts has sprung up, between the Mall staff, the Mall regulars, the Mall addicts, and the hundreds of seniors who put on their walking shoes and get in their five to ten every morning between six and nine. This is a strange and very calm time to visit this mall, a time where the community is apparent. People stop and say hello, they talk, they have coffee and a scone, they smile and wave, get a little exercise, socialize.

But then *they* come. The consumers. No event takes place within these walls that is not attached in some way to a brand. Honey Nut Cheerios Family Fun Days, Field of Dreams Presents the Pete Rose Autograph Signing, and the SpongeBob Squarepants Back-to-School Character Breakfast are just some of the daily events that fill up this replacement for actual society. If I wanted an M.B.A. in marketing, I'd just move in here for three years and save myself a good fifty large in tuition.

And you know what? Nobody seems to mind. I noticed one desperate character standing on the high balcony overlooking the amusement park and the stores, bent and twisted like Munch's screamer, eyes glazed in panic, mumbling to himself over and over again, "It's the end of the world, it's the end of the world," while he dropped his

Banana Republic purchases one by one over the rail, surely contemplating that when he ran out of purchases he'd be the next retail item to go. But before I could fling myself over the edge and impale myself on the Lego Eiffel Tower, the cops showed up and chased me away.

We seem to look at marketing like the weather: Everybody complains about it, but nobody does anything about it. And nowhere is that culture more evident to me than in the theaters. Way up on the fourth level, overlooking the whole mess, is the General Cinema Mall of America 14, my local theater. It makes me feel like I live next door to the Los Angeles in *Blade Runner*. On any evening in the summer, people are standing in line twenty deep at the ticket counter to this movie mill, this supplier of the cinematic narcotic people like Michael Bay and James Cameron have the gall to label "art." I saw eight movies here in eight days, and I don't care to do it again. It is the most soulless moviegoing experience I think I'll have this year.

The pain begins at the ticket window. In line, waiting to see the John Singleton drama *Baby Boy*, I'm about fifteen folks back. The other lines move along almost as slowly, but ours is definitely the slowest. A mom has four kids with her. They are all well over twelve, and yet Mom insists that they are not. This takes five minutes. Mom loses. Then Mom pulls out a credit card.

This is death for the entire line. It takes at least five minutes to transact a credit card movie ticket purchase. So, naturally, the next folks in line are four teenagers, all underage, all without ID, all wanting to see an R-rated movie. Nothing doing. They do have credit cards though, each of them, and each buys his ticket with his own card.

So we learn that, in the future, the check-in time for a movie is roughly the same as for an international flight.

A good dozen people stepped out of our line while this happened. I decided to stick it out. In writing this book, I have pledged to have every moviegoing experience I come across in full. This was part of the mission.

I am not exaggerating when I say that it took twenty minutes to move fifteen spaces in line. *Baby Boy* had started, I decided instead to see *Pootie Tang*. I gave the woman a smile and exact change.

Two young black men behind me taunted me.

Pootie Tang?

I'll remind you that I'm a big red-faced Irish man.

You're going to see Pootie Tang? *The hell would you wanna see that?*

'Cause *Baby Boy* already started.

Damn, how long have we been in line?

About a year. The ticket taker is, um, slow.

No, I think she's just dumb.

Why don't you see *Pootie Tang* with me?

'Cause I'm afraid it's gonna be as stupid as I think it's gonna be.

His pal was up for *Pootie Tang*. I was up for *Pootie Tang* and we bonded over dumb humor. The two of us ground him down. He made me go in for the popcorn. I was actually glad not to be seeing this alone.

Well, we saw *Pootie Tang*. My skeptical new pal asked me if I was planning to give him his money back. My fun new pal was still chuckling, telling him to lighten up. *Pootie Tang* crosses all cultural barriers to become the dumbest movie I've seen in an entire generation. But it is also funny as hell.

Pootie Tang strives for the dumbness it achieves, a feat few films can do. Undoubtedly inspired by the funny, dumb seventies comedies *Dolemite* and *Putney Swope*, *Pootie Tang* is loosely pulled together, intentionally low-rent and rambling, and features a main character so sublime in its construction it transcends stupidity altogether. The film cost three million dollars, and I think most of that went to the *Matrix*-inspired bullet-dodging special effects.

This is a good kind of dumb. Like mooning. Like a cat falling off a table. *Pootie Tang* is an oddity in this suburban mall, which otherwise puts forth the top box-office stuff and quickly does away with the rest.

On the Fourth of July it was a beautiful day here in the Cities, hot, humid, cloudless. I always expect the malls to be empty on days like this and they never are. My pal Brad, my ten-year-old niece Clair, and I went to see *Cats & Dogs*. I don't know if it was good or bad, because I wouldn't have liked it anyway. I dislike talking-animal movies. I always

have. Frances the talking mule was never funny, and Mister Ed was a stupid, one-joke bore. All other talking animals are derivative.

But, hey, the kids loved the movie, and, truth be told, I do not know why. I certainly felt marketed to, like this was a movie made out of Lego blocks, cast with "popular" voices, and branded the Talking Animal Comedy of the Summer. There is nothing really innovative in this movie except they made the impossible (animals talking) look more possible and therefore very creepy.

I did have a great learning experience, though. I got to see my niece Claire, a very sweet, bright, and eccentric young woman, the absolute target market for this film, become disappointed by a movie. She had been thoroughly pumped up by the ad campaign; she'd already memorized her favorite lines from the trailer. But then the movie unspooled and we found that the funniest moments were in the trailer, so I saw her expectations dashed.

It didn't bother her in the least. She shrugged it off like only an intelligent, well-adjusted ten-year-old can. She'd paid her money, she'd taken her chances, she'd had a few laughs, and she would keep quoting those lines from the trailer, at least for a week or so.

Movies are only part of the problem here. When I first arrived on Sunday night to begin my close observations, the first thing that hit me was the general smell. For some reason the place smelled like a dirty diaper. It doesn't always smell like this, but it does often enough to be disturbing. I think it's the synthesis of powdered cheese, popcorn-frying medium, pizza sausage, perspiration, paper pulp, air-conditioning, and actual loaded diapers. This is not what I call curb appeal.

A major cause of this redolence is the men's room. Now, I know the women's can is always an order of magnitude nicer and cleaner than the men's, but at the Mall of America 14 it gets ridiculous. I've been to this theater at every time of day, and I can safely say that four times out of five the men's room floor is flooded, the result of a urinal clogged with God knows what, and so you get to walk through human excrement before heading to your seat. Every time I see this, I men-

tion it to a staff member. Every time I have done that, nothing has changed by the time the movie is over.

It's my general rule of sanitation that I never buy a bag of popcorn and a soda, then proceed to the loo before the movie. I don't like to set food on any surface that has come in contact with human waste. And yet man after stupid man trundled into the can, sloshed through the urine on the floor, set his food down on the top of the urinal, peed, picked up his contaminated food, and headed to a fun time at the movies.

Let's continue to kick the theater while it's down, shall we? The auditoriums are small and unremarkable; the seats are narrow and uncomfortable, and many are broken; I have noticed that the sound is characteristically too loud or too soft, but never quite right. I counted the times this year that I have had to leave the theater to complain about the focus, the framing, or the sound (fifteen), and have found most of these (nine) happened at this theater. Unconsciously I have found myself heading here when I know the film I'm about to see is less than average. I am drawn here for bad movies; now that's a clue.

Two things stood out from the otherwise desultory feel of the theaters: a small group of excellent staff members, and the special screenings on weekends. In defense of the staff, I understand that working in a movie theater has slightly more cachet than working at Wendy's, only because you can get free movie tickets. I did meet three different staff people who were not only helpful but who went out of their way to be friendly to everyone they saw. They stood out like Roman candles. And they're walking examples of how to get ahead in the world: Be good at what you do, and do it with a positive attitude, and you will stand out from your dull coworkers like a Roman candle. Sure, you may not move up to chain ownership, but your life won't seem as miserable. These three staffers were the only thing that lifted me out of the depression I developed after a week here, and the only reason I may go back in the future.

On Friday and Saturday nights, the theater offers one auditorium for special screenings, thematic monthly showcases of classic popular

films. This allowed me to skip out of the hallucinatory last half-hour of Stanley Spielberg's *A.I.* so I could go to the midnight screening of *Ferris Bueller's Day Off*. What a delight this movie is, especially after my second screening of *A.I.* This was John Hughes's work at its best, somewhere between Judy Blume and Monty Python. I've seen this many times on television; it's one of those that seems to be on every day of the year. But I forgot how much fun it was to see it in a theater. The crowd was a great mix of folks my age and folks that could be my kids. We all loved it.

Ferris Bueller's Day Off behaves like a classic comedy: Ferris is a knowing buffoon, a tour-guide through a hellish world, a certified nonconformist who miraculously avoids disaster and dances in the midst of chaos. In other words, he could be a character out of Aristophanes. He could be Bugs Bunny. Ferris combines genuine pathos with slapstick. When was the last time you actually cheered for a character in a comedy? Well, people were cheering for Ferris as he raced to beat home his parents, his sister, and his school principal. Seeing Ferris in this setting, at the Mall of America movie product pavilion, reminded me that there is still hope. Now, if we could only get Adam Sandler and Rob Schneider to go into marketing instead of filmmaking, the world could be a beautiful place.

Here's a ray of hope, I suppose. Recently, GC Companies, which owned this dismal place, tanked and was acquired by the aggressive AMC chain. Nothing has changed, yet. It's a shame that the largest mall in America has a theater no different from a fading strip mall three-screener. Movie experiences, expensive as they are, should be better than the experience of eating at the food court. Wouldn't it be lovely, what with empty store space always available, if someone would put in a nice art house, with a nice bar, decent eats, and movies an intelligent adult is not ashamed to see, and without lakes of urine on the men's room floor?

Ah, I'm dreaming again, aren't I?

✱ WEEK 28, JULY 9–15 ✱

Loring Park, Minneapolis	Smash-Up: The Story of a Woman
United Artists Eden Prairie 4	The Fast and the Furious
Stevens Square Park	The Adventures of Mr. Ichabod and Mr. Toad
General Cinema Centennial Lakes 8, Edina	Final Fantasy: The Spirits Within
Mann St. Louis Park Cinema 6	The Score
Regal 16 Cinemas, Eagan, Minn.	A.I.: Artificial Intelligence
Loews Cineplex Edina 4	Legally Blonde

Hot Town, Summer in the City
Movies Out of Doors and Not in a Car

Dear Kevin:

Okay, here is what you should do: Do not write too much this week. It's summer in Minnesota, a season as rare as a perfect orchid that blooms for one night, then is gone with the north wind. This is the time to laze about out of door, protected of course by government-strength DEET, to roll around in grass that hasn't been rendered toxic by a lawn-care company, and take in a movie in the park.

Don't read too much into this. Lots of cities enjoy outdoor movie series—the warmer cities much more than the cool ones—so it's no novelty. Instead, dear writer, encourage those too frightened to ven-

ture into urban parks at night to do so for a film. Like a concert series, a film out of doors has a sweetness to it, an ice-cream-social festiveness, in which families gather, friends huddle around a bottle of cool wine, and lovers contemplate love without mackin' like they might in the relative privacy of a drive-in.

Well, I guess that depends on which city you're in. Here, we're so proper even the street gangs call before they drive by. Take, for example, Kevin, the Monday-night film series in Loring Park, right in the heart of downtown Minneapolis, called "Summer Music and Movies: The Summer of Love," sponsored by the Walker Art Center, whose museum space you so heartlessly trashed in week 8. Loring Park is a grassy little oasis across the bridge from the Walker's famed sculpture garden with its Spoonbridge and Cherry sculpture by Claes Oldenburg and Coosje Van Bruggen; a titanic spoon with a big nummy-looking cherry in its bowl, a bowl that has become legend as a place for couples to spoon.

One day, Kevin, one day; but for now, you can see the stem of the cherry from Loring Park as the sun goes down and the music begins to play. Music by Viovoom, an exotic quintet that plays a seductive sort of cabaret music. They're led by Jessy Greene, a lovely young lady in a miniskirt who plays a Telecaster and a violin who used to fiddle with the Jayhawks, so they must be cool.

The music sets the proper mood, one of summer romance in a park. The weather cools off from a sultry Minnesota high of about eighty. Little stands sell homemade ice cream, fresh popcorn, and lemonade. People lay blankets, pop corks, dance slow dances. This is grown-ups' night out; the movie is *Smash-Up: The Story of a Woman*, an over-the-top melodrama in the style of *A Star Is Born*. Susan Hayward is a singer who marries a bandleader. Bandleader's career takes off and Susan, the dutiful forties wife, stays in their fancy apartment and drinks herself silly. Child, divorce, inevitable bottoming out, and tearful reconciliation follow. Lots of swank nightclubs, sultry singing, and even a closed-fist girl fight. You could chalk it all up as canned corn, but Susan Hayward has Courtney Love's nerve and Al Pacino's chops and she got nominated for an Oscar as a result. It's just plain

fun, bordering on camp, so it's the perfect movie for this venue.

See, Loring Park is what you might call a gay neighborhood, seeing as how a lot of gay people live there, so you can always find a good cup of coffee and a pastry, and people clean up after their dogs. It's also what scares away the suburbanites, which is a shame, because who isn't up for a night of camp every now and again? Try to imagine the suburban crowd at Bryant Park in New York where they showed *Breakfast at Tiffany's* and the boys dressed up as Holly Golightly and vogued around to the delight of the crowd. Here, people would scream, rush their kids back to the Vanagon, and burn rubber to the freeway. It's their loss, you see, they're missing a lovely night with fine women in great performances.

This summer's series is loaded with fine women in great performances. It's all Lana Turner and Susan Hayward: *Madame X*, *The Postman Always Rings Twice*, *The Bad and the Beautiful*, *I'll Cry Tomorrow*. Lots of shadows and women in push-up bras, lots of yelling and slapping around, lots of sex without the overt physical act that might be taking place in the Spoonbridge across the way.

Still if it's family fare you're after, remember Stevens Square and its outdoor series "Tunes and Cartoons." It's a tiny urban park, a couple of woody acres in the center of an old apartment complex in downtown Minneapolis, which not long ago was a place where gangs gathered and drugs were sold; the sound of a pistol was not uncommon. Thanks to a lot of families who care, the park has been taken back, and evenings like these are cause for celebration, a reward for hard work, a place where you can lie in the grass and let your kids play with others and not worry if they'll come back alive.

On Wednesday night the weather is starry and fine; Jake Wisti and the Centurions rip up the place and have the kids dancing before the sun goes down. Then we are all treated to a Disney rarity from back in the days when Disney was not a world-conquering behemoth. *The Adventures of Mr. Ichabod and Mr. Toad* is the melding of two fine animations. The first, *The Madcap Adventures of Mr. Toad*, retells a story from *The Wind in the Willows* in which Mr. Toad, an overbred English gentleman, spends his family fortune on one passion after the other,

this time on a motorcar. He gets in a lot of trouble, of course, and his friends bail him out, of course, but he's right back at being the English Upper Class Twit of the Year at the end, as he should be. It's a beautifully done piece of very funny animation, adapted from a wonderful children's tale, narrated with panache by Basil Rathbone, who put the "ahh" in panache.

While it's playing, your dog, Humphrey, gets himself into several tussles and manages a couple courtships, accomplished by trying to pee on the corners of people's picnic blankets. Sorry. But where else can you and your beloved bring a bottle of wine and your dog and see a classic Disney work?

Next up is *The Legend of Sleepy Hollow*, full of songs and goofery in the Disney tradition, and then the horseman shows up and the kids start to tremble. It's a great scary telling of Ichabod's disappearance, and far more watchable than the Tim Burton version. I love the narration by Bing Crosby, who, for all his inner turmoil and love for things eighty proof or higher, had the kind of voice that told you that "all is well" even if it wasn't. Better still, you can look up from the screen and see the stars, or you can roll over and pet your dog, making sure he's not marking his territory on a cooler or a bicycle kid hauler.

Last week it was a festival of Warner Brothers classics and a country pop quartet. Next week it's the Minnesota Sinfonia, all twenty-seven of them, giving us classical music, waltzes, and show tunes, paired with the underrated fantasy *Dark Crystal*.

This is summer, Kevin, a mere moment in the North Country. Put down your pen and your notebook and look at the stars through the leafy oaks, listen to the Disney score and the crickets, hold hands with your partner, and swat mosquitoes.

Enjoy it. It'll be over in the wink of an eye.

✳ **WEEK 29, JULY 16–22** ✳

Parkway Theater, Minneapolis	Smell of Camphor, Fragrance of Jasmine
General Cinema Mall of America 14	Crazy/Beautiful
Oak Street Cinema, Minneapolis	Quadrophenia
Lake Theater, Oak Park, Ill.	Jurassic Park III
AMC South Barrington 30	Final Fantasy: The Spirits Within
Classic Cinemas, Woodstock, Ill.	Legally Blonde
Desert Star Cinemas, Wisconsin Dells	America's Sweethearts

Searching for the Theater of My Youth
Guess What—It's Been Multiplexed

I really don't remember the first film I ever saw in a theater. It might've been *Bambi*, which I saw with my mom; I remember when Bambi's mom was killed I went into mild shock and utter denial. Mom, she's not dead, she's just hurt and she, um, went away, right? She can't be dead; she's Bambi's mom, right? It disturbed me to the point that Mom almost took me home early, but somehow I got through. I slowly accepted it, but then I discovered the Golden Books version of *Bambi*, which simply cut out the whole "dead mom" thing, and realized at seven years of age that the world of media was able to manipulate me. Another life lesson.

Or it might have been *Mary Poppins*. The whole family went to the Highland Theater, all eight of us. It was a surprise, and I loved it more than I thought I could love a film. In no small part because the whole family was there, and I wasn't being taunted or beat on, and I connected with the story, the magic, and the lessons of growth, and the clear message that money and wealth are illusory and magic is a commonplace thing.

Or maybe it was when I got to go with my brothers to the Lake Theater to see *The Great Escape*, a film upon which I built my early understanding of the war in which my dad had fought.

Understand that I give no quarter to nostalgia; I think it's a waste of time to sit fondly and talk of things that no longer exist. That said, it intrigued me to visit the spots where I had first encountered movies in the theater, and perhaps get a perspective on how they helped to mold me into the sniping, crabby old snob I am today.

My first memories of anything at all took shape when we lived in the old Chicago suburb of River Forest, a town that was, as I learned later in life, thoroughly mobbed up. My siblings and I went to Saint Luke's School, a half a block away, the scruffy Irish bunch of us mixing in with the local Italian kids, but I never had a clue that Anthony Accardo, the Big Tuna, Joe Batters, lived a few blocks away. My sister Kassie reminded me of the time the school was closed down because Accardo's daughter was getting married over in the church, and Lake Street was lined up and down with big black Caddies. Whenever I see *The Godfather* I think of that story.

The closest theater was the Lake, in Oak Park. It was a big old deco design, with a huge candy counter and a fancy-pantsy auditorium, which was routinely trashed by kids on Saturdays. We had to take the bus, so it was a *big* deal. Somewhere in the attic closet of my mind I pulled out the memory of going to the Lake to see *The Great Escape*. I'd been deemed too young (and rightly so at six) to see *The Longest Day* a year before, so you can imagine how out of the clique I felt as my brothers ran around the house in helmets whistling the Maurice Jarre theme. No way was I going to miss out on *The Great Escape*.

It was thrilling. It was mesmerizing. The razor-sharp Panavision,

the brilliant color, tunnel king Charles Bronson going ape, and those damn Nazis. I believed then and now that Steve McQueen's character was the coolest being who ever existed, fictional or real.

And the score. God bless Elmer Bernstein, seventy-nine years old and still going strong. Every time I hear the theme from the movie, "bum-bum, bum buhhhh-bi bum-bum . . . ," I am scrunched in the sandbox with about three hundred tiny plastic men, sifting for one of those rare bazooka guys or one of the teetering grenade-throwing guys. Or I'm somewhere in occupied France, usually the dining room under the table, ducking behind the café counter with James Coburn as the resistance guys come around the corner in my Matchbox Model A and they wipe out the Nazi officers sipping Pernod. How anachronistic it seems now to have had such a clearly defined enemy. Lousy Nazis.

So, I went to Lake Theater with my brother Brian, and we saw an afternoon show of *Jurassic Park III*. Naturally, the theater had been chopped, split lengthwise to create three impossibly long and narrow theaters with crappy sight lines and boomy acoustics. But a little of the old place remains: The walls and fixtures are as they were when I was a kid, the indirect lighting snaps my head around to the early sixties. The lobby is as it was, with all its faded art deco and indirect lighting, which looked really ritzy to my young eyes.

When I visit a place of my childhood it's usually smaller than I remember, but the Lake was actually larger. And to my delight the crowd was the same: kids, barely able to contain themselves, just waiting for a dinosaur to chop someone in two. Boys are always out for blood at the theater, it satisfies some primal desire to kill and eat in a way a hamburger and soccer practice can't. There were lots of gleeful squeals when the computer-generated beasts bared their teeth and sank their claws into the back of Broadway's irascible Michael Jeter. As Mr. Jeter's neck was snapped by a velociraptor, I couldn't help but flash on his role as the junkie transvestite who bellows Ethel Merman favorites in *The Fisher King*. But that's just me.

The mood became odder as we walked down Ashland Avenue to the house where we lived as young kids, a splendid wood-frame on a

tree-lined avenue once filled with kids, wearing baseball jerseys or cowboy hats, caroming on bikes, slamming go-carts into trees, and trying to kill themselves through play. Now the kids play in their own backyards, and any mother who'd just let her kids run out the door and say "Be back for lunch" would be brought up on charges.

Our next stop was the Hillside Theater, located on a vicious confluence of freeways and avenues locally known as the "Hillside Strangler." It was the foundation of one of my fondest memories of early childhood.

My dad rarely went to movies with us. Too chaotic, I suppose. But on one fine fall day when I was about to enter the horrors of second grade, we all got in the car, ostensibly to buy "school supplies." But Mom and Dad pulled a fast one, and the whole family went to the Hillside to see *Mary Poppins*, which remains one of my favorite Disney films. It was wonderous, it was magical, it was all the good things of Disney with none of the bad. And it inspired me in that deep and personal way to say to myself, *You could do this. You could entertain people, show them a little magic, make them laugh, make them wonder.* That single delightful surprise of a movie experience helped to shape the rest of my life.

So, Brian and I visited the Hillside, or what's left of it. As I might have predicted, the theater was closed and dilapidated, and its final humiliation was that it stopped being a theater and became a fundamentalist church before it was mercifully condemned.

See, every major religion teaches us that the stuff of this life is impermanent and transitory, and that nothing made out of matter stays the same. Everything changes, everything fades, and we don't get to carry any of it out of this life into whatever's next.

But one of the amazing and enduring things about cinema is its ability to take a frozen section of a period of time and allow us to recall moods and emotions we had and have no more. *Mary Poppins*, even when I see it now, brings me back to that moment in time when our family was all together and happy. That's a gift.

My personal movie memories really kick in when I was seven and we moved from comfortable old River Forest to a spankin' new house

in a subdivision on the edge of Wheaton, Illinois, a whole lot farther from the big city.

It was a hard time. I hated school. Bonding with my three older brothers meant getting beaten up a lot, as happens in any respectable, large Irish-Catholic family. My brothers, all very intelligent, became masters in the art of psychological torture, so much so that when I finally saw *The Manchurian Candidate* at about fourteen, I understood exactly what was going on. I always figured I could cruise through marine basic training because no drill instructor could be as good at reducing a young man to a quivering blob of tapioca as my brothers were.

Still, there are more good and great memories than there are bad or terrible. One is with brothers Chris and Buzz; we went to the Wheaton Theater to see *The 7th Voyage of Sinbad*, a delightfully gory showcase for the talents of Ray Harryhausen, complete with rotoscoped dragons and fighting demons and the like. It was garishly colorful and featured gallons of blood, virtual floods and showers of it. God, it was great.

The Wheaton had twinkling stars in the ceiling, and I would gaze heavenward as I built my early repertoire of movie knowledge. I got kicked out of the Wheaton for throwing Sugar Babies at the kids in front of me. I got my first kiss there. I got kicked out again for sneaking in. I laughed my head off at *It's a Mad Mad Mad Mad World*.

Recently the Wheaton was bought by a consortium that hopes to restore it to the very fine theater it once was. I surely hope they do, and if I can do nothing else to help them, I'll relate how this dandy little single screen is a far better place for some kid to fall in love with the movies and become Wheaton's great filmmaker than the massive multiplexes on the edge of town.

But there they are, looming like creepy castles above the strip malls and the Targets, people streaming in and out, unchanged by what they see, overloaded with special effects, unaware of their hunger for story.

Will these kids today, with their Razor scooters and their MP3s, look back on *Jurassic Park III* the way I look back on *Sinbad*? Maybe.

The thrill of moviegoing for a kid is the opportunity to be carried out of your life and build the imagination. Think of all the little Busters and Bettys who sang the Indiana Jones theme while they hacked at each other with cardboard holiday gift-wrap tubes.

I only have to look at my godson Darby, who saw *Spy Kids* and now plays spy at every opportunity. I only have to look to my niece Claire, who is far smarter than I, and see her repeating, line for line, all the jokes from *Shrek*. It's there I see those little bubbles of cinematic memory planting themselves in the psyche to be carried into adulthood. Like it or not, our kids' mythos is constructed of what they see on the screen, just as mine was. And there's no better argument than this to keep the little suckers away from the likes of Adam Sandler.

✳ **WEEK 30, JULY 23–39** ✳

General Cinema Centennial Lakes 8, Edina	**Cats & Dogs**
Parkway Theater, Minneapolis	**Songcatcher**
Riverview Theater, Minneapolis	**Willy Wonka and the Chocolate Factory**
Landmark Lagoon Cinema, Minneapolis	**The Anniversary Party**
Carmike Apple Valley 15	**Planet of the Apes**
Muller Family Theaters Lakeville 18	**Planet of the Apes**
Loews Cineplex Edina 4	**Kiss of the Dragon**

Dinner (Belllch) and a Movie, Part 2
The Movie Theater Diet

Tell me if you think this is dumb: This week I plan to live on theater food. And I'm not talking about the cinema grill sort of theater; I'm talking about breakfast, lunch, and dinner based on the stuff they have behind the counter.

I am what you might call a fatty. No, really, it's true, thank you for saying I carry it well, but I realize that eventually it will cause my heart to betray me; so it would be best if I got off my fat Irish ass and did something about it.

So what do I choose to do? Live on movie theater food for a week.

My tolerant and compassionate spouse, Jane, immediately and

directly told me that this was the stupidest idea for a chapter I've had so far. Jane is a terrific judge of stupid ideas. She's the one who keeps me civil at restaurants when I want to thrust chopsticks up my nose, then grunt and slap like a walrus. She's talked me out of buying a motorcycle and shaving my head. And she said to me, "I don't see what you have to gain by living on such a horrid diet for a week. It can be nothing but bad for you, please don't do it."

My first reaction was mild resentment. Don't you understand? I'm exploring a boundary here, like Scott of the Antarctic! Bad example of course, seeing as how Scott starved to death. But it's an extreme exercise to prove a point that theater food is bad for you. Jane returned, calmly and compassionately: Dear Kevin, everybody already knows this. One doesn't have to shoot oneself to prove that handguns are dangerous. I countered: Beloved Jane, the food theaters choose to sell could be better on virtually all fronts. Never mind the nutrition; quality and appeal, expense and the profit margin, all are tied together in this, and if I spend one of my moviegoing weeks deep in movie food, counting the calories, the fat grams, the price, well, I could make a point that we do deserve better, and that better is out there.

Jane gave me the look that says, I love you and think you're a relatively intelligent man, but I'm not buying this line for a minute. Jane is, simultaneously, the most adventurous and the most practical person I know. Remember the things she talked me out of? She also talked me out of wearing a Fu Manchu.

So I struck a compromise, as much to calm her nerves as to question what it was I wanted to prove. So, for the week, for the record, I allowed myself the following, per day:

- One can of Slim Fast;
- One Clif Bar;
- One movie theater "meal," or as much as I could get for ten bucks.

Here and now I will tell you that my spouse was absolutely right, and that the Slim Fast/theater-food diet is the saddest diet you'd ever

188 • KEVIN MURPHY

want to try. I'd rather eat cling peach halves and cottage cheese like my mom used to. But I did manage to find the best tasting popcorn I've ever tasted in a movie theater, and it's right here in Minneapolis.

I started the week with a reprise of *Cats & Dogs* at the General Cinema Centennial Lakes. Sure, I'd seen it before, but by now I'd seen all the summer commercial releases at least once and this was the most innocuous, allowing me to concentrate on food. To their credit, this theater has actual food: Uno's individual pizzas, served fresh and piping hot. Throw in a Frutopia and it about kills my ten-buck limit. But it did the trick, although it was gone before the final trailer.

As I sat, with a belly working on greasy pepperoni and mozzarella, I pondered why people feel the need to eat when they go to the movies. In the book *Shared Pleasures: A History of Movie Presentation in the United States*, Professor Douglas Gomery says that back in the twenties, movie theaters refused to sell snacks; they were trying to maintain an air of dignity, and snacks in the theater were associated with carnivals and burlesque shows.

Well, that air of dignity lasted about ten years, and then the Depression came around. Besides, snack stands and shops sprang up around theaters anyway, so some very smart theater owners started to staff concession stands on the premises. It didn't take long for them to realize that they could make far more dough selling food than movies, and they probably realized that the "air of dignity" around the cinema had disappeared long before the Marx Brothers' *The Cocoanuts* opened in 1929.

Suddenly my stomach growled. A can of Slim Fast, a Clif Bar, a tiny pizza, and a Fruitopia Raspberry-Lemonade Tangerine Wavelength probably came close to filling my daily nutritional requirements, but immediately they played hell on my digestive system. That growling would be my week's bellwether.

Tuesday offered a revelation. I will say it here and now:

THE BEST MOVIE THEATER POPCORN I HAVE EVER
EATEN IS MADE AT THE PARKWAY THEATER, MINNEAPOLIS,
MINNESOTA, USA.

I am certain that this statement will prove out at the end of the year, because no other theater has come close. Occasionally I drop in here just to get some of the popcorn. It's pure white corn, which makes all the difference in the universe. No doubt it's hand-grown from tiny, coddled cornlings by gentle farmers who wear white gloves and bow ties as they farm, caressing the stalks, and perhaps softly singing selected tunes from the Kansas Cycle. Corn as white as God's own beard, that eventually hearkens to the pressure of heat and fulfills its purpose, transforming within its kernelly chrysalis from an insignificant seed into a glorious snack. If you so desire, and I do, the corn is blessed with butter melted by the pound, carefully drizzled on with a squeeze bottle. Just a tad of powdered salt, and you can be happy for days.

It's lighter than Krishna's breath. Kernels dance on the tongue but for a moment until, succumbing to tooth and saliva, they expire, releasing their flavor. It's a corn that will cause you to desire no other corn, treat other corns as traitors to the entire monocotyledon universe.

And the best news is that it's cheap as can be. I was able to buy a large corn for two-fifty. Two-fifty for the world's best movie theater popcorn.

The pleasant but gruff woman behind the counter was unforthcoming with any details on where this ambrosia comes from, and with good reason. The Parkway is a brave little family-run theater, offering carefully selected independents, revivals, and off-release films, such as tonight's offering, the very entertaining *Songcatcher*.

The movie is about a musicologist who goes to Appalachia to study the local music and finds a profound oral tradition from rural England and Scotland transformed into a genuine art form. It's also a corny period melodrama, but I liked it, and so did the crowd. I think we were all high on buttered popcorn, and the lovely photography of the Appalachian hills, and the hypnotic music sung by Emmylou Harris and Iris DeMent among others. I generally don't go in for warbly chipmunk women who sing traditional folk songs as if they were on helium; Nanci Griffith's music makes me think I've contracted tini-

tus. But one scene in which Iris DeMent sings a mournful ballad of lost love stayed with me for weeks.

On day three I went to the dandy Riverview Theater to see *Willy Wonka and the Chocolate Factory*. By now my stomach had been scoured by the tremendous amount of fiber in my diet, and little twitches of hunger made me irritable. So it was great to see a movie about an eccentric surrounded by empty calories who seems to dislike most children and explodes in rage without provocation. I poured more popcorn down my pipe and discovered that the Riverview's popcorn comes in a very close second to the Parkway. Another independent single-screen, the Riverview has the look of a fifties-era, ultrastreamlined Jetsons-style theater, so it's big with the kids these days and the hipsters who listen to the smooth stylings of Esquivel and have cocktail parties. I love this movie, with its smarty-pants attitude that does nothing to coddle its audience. Unlike most kids' movies, it portrays an eccentric, half-crazed adult who is not an idiot.

At the Muller Family Theater Lakeville 18, I was delighted to find that they had sandwiches. They're the frigid, bland, shrink-wrapped sandwiches you normally get at a 7-Eleven, but it was an actual meal. They also had three different types of exotic jerky: The buffalo jerky tastes like beef, the ostrich jerky tastes like a bland pork-tinged chicken, and the crocodile tastes like your tongue.

An odd sensation began to creep over me, and lasted the week: I wasn't hungry, but I wasn't satisfied. Food was filler, chemicals designed to excite different areas of my tongue addressed the concept of flavor in the most rudimentary way. The whole of my mouth seemed coated with wood sealer, and even the toothbrush and Listerine couldn't get rid of it.

Worse, I began not to care. This was my diet and I was sticking to it. Volume became more important than quality. Food-based delirium of apathy set in. I found myself seeing *Planet of the Apes* for the second time in as many days when it struck me that this movie was about as satisfying as the snacks I was eating. A movie was just something to go to, and ten bucks' worth of snacks were just something to do while

there. The dangerous complacency of the average moviegoer filled me up to my beard, which smelled like popcorn oil.

Maybe it was the oil. It must contain some sort of chemical that, when combined with the popcorn topping, evinces complacency. At one theater I asked the guy behind the counter what they used to pop the corn. He said, "I dn' know, it's this liquid stuff? And it comes in a big can? And we just hook it up to the machine? Maybe the other guys know, they been here longer?" in the teenage singsong vernacular in which all sentences end as if they are questions. One of the other guys showed me the huge cans of oil used to pop the corn, and I was told that it was "like canola oil?" Well, a lot of things are *like* canola oil, and you don't want to eat most of them.

Then I tasted the popcorn topping by itself. This was the smartest thing I did all week. Some theaters offer topping dispensers so unwitting customers can drench their own corn in it. I took a ketchup cup and splurted some topping in it and tasted it alone.

The sensation reminded me of castor oil laced with bad margarine. And yet somehow we've convinced ourselves that it improves the flavor of the corn. It does not, it just coats the soul with a protective layer of complacency.

By Saturday night I had a hunger far beyond the need for food. We invited friends to a movie, and before we left they laid out a fantastic assortment of simple, wonderful food: homemade hummus, stuffed grape leaves from the local Greek grocery, fresh bread and lovely cheese, beautiful grapes. For the first time in my life I coveted a grape.

Quickly and with passion I abandoned my diet. It had to be done. Diets are one of humankind's dumbest inventions. They are lies we tell ourselves in order to create a seemingly short and easy path to better versions of us. And the movie theater is no place for a diet.

Jane was right. The whole idea was stupid, and I apologize for leading you all this way to that end. You knew it before I did, didn't you? And yet concessions remain the biggest profit-generating part of the movie theater business. It's a function of convenience, expendable income, and complacency that's built into every drop of artificial flavor.

Do yourself a favor next time you go to the theater: Take the ten bucks you would normally spend on snacks, spend half of it on actually delicious finger food to smuggle into the theater, and give the rest to a food shelf. I guarantee you will be far more satisfied, even if the movie is *Planet of the Apes*.

✳ WEEK 31, JULY 30–AUGUST 5 ✳

Yorktown Cinema Grill, Edina	Trumpet of the Swan
Oak Street Cinema, Minneapolis	Juliet of the Spirits
Landmark Lagoon Cinema, Minneapolis	The Closet
Skyline Drive-in, Barstow, Calif.	Jurassic Park III; The Fast and the Furious
The Movies, Kingman, Ariz.	Rush Hour 2
Giant Travel Center, Gallup, N. M.	A Perfect Murder; Scary Movie
El Morro Theater, Gallup, N. M.	America's Sweethearts
IMAX Grand Canyon	Grand Canyon: Secrets Revealed

Kicks Just Keep Gettin' Harder to Find
The Desert, the Truck Stop, and the Ill-fated Drive-in Tour of Route 66

After several hours of patient reflective listening, while driving through the brutal pans and stunning canyons of America's great southwestern deserts, I have come to the certitude that Neil Young in full voice sounds little different from a cat having sex.

It's true! Camped out at a KOA outside of Barstow, California, I sat dripping in my swimsuit trying to stave off the evening heat with several bottles of Pacifico Claro, and as the sun set and the moon rose, I found myself listening over and over again to Young's *Decade* album. Not long before bedtime, as Neil reached the vocal and orchestral peaks of "A Man Needs a Maid," a pair of cats in the adjacent trailer

park reached the heights of the feline freak dance and began that low ghostly wail cats emit at such times. It became a harmony for the chorus, which goes, "*Woooaaaoooh, hwhoooauuuoooh,* a man neeeds a *maaa-aaaid.*" The cats' part fit perfectly, or as perfectly as Stephen Stills ever did with Neil, although adding a different inflection, so it sounded like the cat was pronouncing the surname "Bauer" over the course of several minutes. Suddenly as Neil sang and the cats added two-part orgasmic harmony, the severe face of 2000 Republican presidential candidate Gary Bauer floated before my eyes. It hovered there as Neil and his cats wailed and the sweat dripped down my face and my beer bottle and the hot wind caked sand on my sweaty neck.

The desert does this to you. The heat exhausts your body, taunts your mind, evokes visions. True, I would rather have had a vision other than the disembodied head of Gary Bauer hovering over my beer while Neil Young harmonized with a pair of boffing cats, but you take what you can get out here. Oddly enough, it became the object lesson I needed to endure my five-day, fifteen-hundred-mile round-trip from Los Angeles to Gallup, New Mexico, and back again.

I came all this way to commence a drive-in movie tour of the legendary Route 66. I had been conjuring this idea since the early winter of last year. I needed to see drive-in theaters, which have become nostalgic remnants of a time when Americans did things together, so I would seek the Mother Road, the highway of legend and song, and follow its length in a classic convertible. Yes! Real dandy, a '57 T-bird or a '67 Vette convertible, silver with red leather, seats protected by Navaho blankets.

I saw myself blasting through the borax flats, worming through the switchbacks, cooking fresh buffalo meat on mesquite fires by the roadside, then watching classic movies in perfectly restored drive-ins, surrounded by other classic cars. And there would be women, lovely young women, all tanned and of various ethnic origins, who would wave at me and speak flatteringly of my car, but it would all be benign admiration as they sensed the power of my marriage and found me to be more a being of great spiritual grace than an object of flirtation. I would sit in silent meditation as the sun rose over the buttes, and I

would make peace with a band of restless coyotes hungry for some angry cattleman's stock. Then, as I barreled westward in the dark, hitting a hundred with headlights off and only the full moon to illuminate my way, the highway would open up and betray its secrets. And within me a brilliant fire would ignite as I attained a profound awareness, a beatific road-worn *satori* like something out of Allen Ginsberg's *Wichita Vortex Sutra*.

Well, none of these things happened. Not a single damn one.

I did get hot, though, and sunburned, and I did get a beer buzz or two at the end of the day, and I did go to drive-ins. But one thing I learned, which perhaps moved the Sisyphusian boulder that is my soul closer to the mountain of wisdom, is that a journey changes even before you embark on it, and the only way to have a successful journey is to embrace everything that is unexpected.

Between the time I started planning and the time I left, plenty had changed. Almost half the outdoor theaters on my route from Chicago to Los Angeles had closed, part of the continuing wave of drive-in closings across the country. The amount of time I could spend was limited to a week or less, so that scotched the notion of a round-trip. The dream of driving a vintage car three thousand miles dissolved like a laugh at a bad joke, and I was left with this reality as July ended: a flight to LAX, a rented '01 Ford Mustang from Hertz, a trip to Gallup and back again, and two, maybe three drive-ins along the way.

But this was okay; it had to be okay. I had plotted out enough theaters to get me all the way to Gallup, actually to Jamestown, some thirty miles away, where I would achieve one of my year's goals: the smallest movie theater in America. My trip would take me on some of the longest unspoiled stretches of Route 66 and through some spectacular scenery, and there were plenty of campgrounds and cheesy little hotels named El Rancho along the way.

I flew into LAX with a pack for my clothes, books, and maps; a massive duffel with tent, sleeping bag, and too many camping supplies; and a cooler. I got it into my head that I would camp all the way. I didn't have it in my head that the desert in August is a certain brain-fry for a man from Minnesota.

I picked up my car, a silver Mustang convertible. The trunk was too small to fit much more than the duffel, so the rest went in the back. If there's anything nostalgic about the modern Mustang convertible, it's the profound lack of room.

I got out of Los Angeles as fast as I could. The city was airless and brown; an inversion layer had enveloped everything from the coast to the Santa Ana Mountains and beyond in a shroud of manure-colored haze. Tom Waits groaned out "Hang on Saint Christopher" as the air started to clear around San Bernardino, and I picked up the old road at Victorville.

Suddenly everything changed. The two-lane road grading up seemed endless, the billboards disappeared, and hollow shells of old tourist attractions half reclaimed by the desert looked soft and ancient. Ruins of the postwar era. Top down, road bumpy, radio off. Heavenly.

I pulled into Barstow and tucked into a KOA north of town. Barstow has a fine drive-in, the Skyline. It's a modest two-screen job set on a plateau overlooking the city, hence the name. On one screen was double-billed *Jurassic Park III* and *The Fast and the Furious*; the other featured *Planet of the Apes* and *Dr. Doolittle 2*. In spite of the annoying sequel-happy lineup of summer films, one of the beauties of drive-ins is the double feature. Remember, you're not likely to see a Hanif Kureishi retrospective here, just a handful of lightweight summer fare, and there is no better way to see it than lounging in a bench seat on a warm night with a beer and your own freshly grilled food in your hand, in the arms of your sweetie.

Well, no sweetie for me, bucket seats rather than a bench, and I didn't bring a grill. But I did have a cooler full of Pacifico, which goes a long way toward perfection. Next to me a pickup truck full of young women did indeed pull up, and I could see they were prowling. They pulled out their lawn chairs and cranked up some Dido. On the other side a little Japanese hot rod pulled up, the kind you now see all over southern California, shining, deep clear-coat red, and growling with throaty exhaust pipes. It was one of those cars that go boom, and I was proud of myself for identifying Kid Rock,

though his music evokes a modern-day Steve Miller, and therefore makes me nauseated.

The dusk painted the sky over the screen that deep desert gold-to-blue, while the rising moon edged everything in my rearview with silver-white. Faint stars shone as both screens lit up at once to the cheers of a hundred car horns.

I'd positioned my car so I could see both screens, which is dandy, and not unlike watching a giant television screen from across a parking lot. I could simply switch FM radio frequencies, and flip-flop between the hairy mug of Tim Roth and blank expressionless gob of Tea Leoni.

I'm hard on summer films, because I forget that people watch them simply to be distracted and sort of entertained, and since I can do this watching a ceiling fan, I bristle at paying good money. But the drive-in cures all that. It's an event, a common experience, a picnic with the television on. The admission was only three bucks and I saw four movies, so I won't complain. And besides, the young woman at the ticket booth looked at me and said "cool car," so already I had won the night.

Intermission came, and to my delight, so did a very clean copy of the classic *Let's All Go to the Lobby* five-minute intermission film. This 1939 animation, produced by Dave Fleischer of Popeye fame, is old and corny. I love it and watch it all the way through every time. A parade of munchies coaxes odd-looking families to the lobby to revel and worship at the snack counter. A box of popcorn juggles its own contents, drenches itself in butter, then bows. A beverage leads a team of malt cups in close-order drill, over and over again, in a bizarre snake dance. And everybody's favorite moment, a firm hot dog bun compels a well-trained frankfurter to turn somersaults, over and over again, then rewards the obedient wiener by spreading its bread open. The eager dog jumps in, and the pair take a bow.

They are images enduring enough to show up in a recent Alien Ant Farm video. This film is now in the Library of Congress National Film Registry, along with *Citizen Kane, Apocalypse Now, Sunset Boulevard,* the Bugs Bunny cartoon *What's Opera, Doc?,* and more than three

hundred of our nation's most memorable films. It is for me what "Take Me Out to the Ball Game" is for baseball fans.

There and then I reached that point of a good journey, that clear moment of the here and now. On my mind's map I realized, You Are Here, and that here was a good two thousand miles from home, on the edge of the great Mojave, in the broiling evening of clear desert air, among summer movie lovers now packing both screens, drinking cold Mexican beer, and watching a hot dog somersault into a welcoming bun.

The next morning it's up with the sun and on to a forgettable blast over the interstate to Kingman, listening to the best of the Yardbirds. Kingman has a small comfy three-screen in the back of an old desert strip mall, and it's a welcome relief from the furnace outside. I saw *Rush Hour* 2, another damned sequel, and it makes me think that we should get up a referendum asking Hollywood to give us all a break and put their money on *new* ideas. But it's cool in the theater and admission is just *two* bucks, and it's a relief to break the day before I start on the long, lonely, and beautiful stretch of old 66 between Kingman and Williams, the self-proclaimed gateway to the Grand Canyon.

It's a splendid chunk of road, from the old gas station outside of Kingman complete with the Corvette I wished I'd had, to the cool of the desert highlands as I passed through the charming old route towns of Seligman and Williams. For those who love to drive, and I'm one of them, this stretch of road is like an amusement park.

I decided to bed down in the classic old 66 town of Williams, and booked myself a room at, as you might guess, the El Rancho Motel. The next morning I blasted off to Winslow. I was looking for the remnants of the Tonto Drive-in. It didn't take long to find the remains of the screen jutting above a field of grass and barbed-wire coils, and the barely readable skeleton of the theater's sign.

I'm not going to head into some rheumy tome about the demise of things that are old, although since my soundtrack for the morning is *The Band's Greatest Hits*, I am perfectly qualified. The Tonto Drive-in is gone and done with, that is the way of it.

There were five hundred and twenty drive-in venues open in

1999, according to the National Theater Owners' Association; then in 2000 it went down to four hundred and eight. Next year it'll be fewer. There are now more than seven thousand cinemas in the United States, and only four hundred are drive-ins. The drive-in movie as a national interest is all but extinct, and where it does exist it is generally a nostalgic novelty.

So I spent all of five minutes looking at the Tonto. I didn't even take a picture. Then I popped in some Fatboy Slim to jolt me back into the aughts and sped on to my real goal for the day, the smallest movie theater in the United States.

Once again I must thank my in-laws, Jim and Kay, for putting me on to one of my year's goals. Kay called on a Sunday morning, after church of course, having just read the latest copy of her favorite magazine, *National Geographic*. There in the cover story was the little teensy movie theater inside the Giant Travel Center, a truck stop outside Jamestown, New Mexico, not far from the Navaho and Zuni lands. The Giant Travel Center is something between a massive truck stop and a strip mall, with a heavy bent toward all things trucking. The gift shop proudly displays and sells every variety of knife, sword, and bladed weapon ever devised, from replicas of medieval short swords to complete three-blade samurai sets, razor-sharp and ready to behead. Massive bowie knives gleam beside jet-black anodized throwing blades. A beanpole trucker with a Deep-South drawl lovingly handled an assault knife and flirted with the woman behind the counter by giving her a lesson in how to slit a throat. "Y'all wanna get the common carotid artery," he points to the middle of his throat on the right side, " 'cuz then the blood pumps right out of the body, boy, *real* fast." I didn't stay around for the demonstration.

In the gigantic restaurant (everything here is big but the theater), a very friendly waitress informed me that the buffet was only $6.95, so I bit. It features fully five different varieties of meat. Bratwurst, pork ribs, roast chicken parts, leathery chuck roast, and ham. In terms of quantity, variety, and sheer mass, the meat offerings outnumbered or outweighed all other basic food groups combined. So, after meating myself up to the esophagus, I headed for the theater.

The Giant Travel Center offers a nice little theater, quiet and dark, with thirty very comfy theater seats, showing movies on a video projector twenty-four hours a day, no charge. Mostly recent releases and a handful of classics. I stayed around for a double feature of the almost-good thriller *A Perfect Murder* and the priapic, infantile *Scary Movie*. The room was half full of truckers, smoking—which is allowed—or spitting snuff juice into pop cans. It was a quiet, attentive audience who watched the fairly obvious twists in the plot of *A Perfect Murder*, which pits the seemingly amoral Michael Douglas against his clever wife and intended murder victim, played by a suitably histrionic Gwyneth Paltrow.

But here's what I loved: As soon as the end credits rolled, everybody started talking about the film! Not in a smug self-satisfied cable-access critic way, but thoughtfully, intelligently. Their comments went to the plot and its pitfalls, and what could have worked better. Everybody knew this was a warmed-over remake of *Dial M for Murder*. A beefy fellow name Wayne insightfully noted that when the sex is less overt, the sexual tension is far more palpable. Michael Douglas was accused of rehashing his Gordon Gekko role, and all agreed that the ending was thoroughly pat and unsatisfying. And although there was some debate as to whether Gwyneth Paltrow's character should have been smarter and more decisive, all concurred that she had a great rack for a skinny gal.

This was fun. In the middle of the day, or in the middle of the night, I could imagine these paunchy, drawling knights of the road coming in here and talking film, creating an invisible aesthetic across the land of truck-driving, meat-chomping, knife-collecting cinemaphiles, talking about Linklater's foray into animation on their CBs while they double-clutch their way across the land.

I left the Giant Travel Center with a much higher opinion of truckers and ranchers in general. My only annoyance was the cowboy hats. A lot of these here fellers wear them, and those who do never take them off. Not in their trucks, not in the restaurant, not in the movie theater. Halfway through *Scary Movie*, a skinny young man with a hat bigger than the entirety of Tim McGraw sat down right in front of me.

The hat obscured two-thirds of the picture. I politely told him as much. Instead of removing the hat, he got up and moved to the back row.

On the way out of town, I stopped to look at Gallup's legendary old hotel where the toast of Hollywood would stay when they were driving the Route or filming in the desert.

The El Rancho.

Westward now, into the desert. I moved with determination, through the desert and landscape that was the location for all those *Road Runner* cartoons.

Dave Alvin's brilliant *King of California* strummed as I ambled over the California desert stretch of 66 through the Black Mountains and the old mining town of Oatman, and barreled down into the valley near Amboy and the meteor crater. I was on my last leg, my last drive-in smack in the midst of this hell-plain of a desert, the Smith Ranch Drive-in in Twenty-nine Palms, California. The desert here ranges from buttes and craggy peaks to dry lake beds and borax flats, and it's about as hot as anything on this planet gets at noontime. Idiot that I am, I kept the top down all the way and nearly collapsed of heatstroke by the time I reached Twenty-nine Palms.

It's not a novelty for people to see the show at Smith's Ranch, in fact it's the only first-run venue within a hundred miles. So, at dusk, on a sweltering Monday night, the place filled to the back fences with pickup trucks, jeeps, and desert hot rods, jammed full of marines and their families from the nearby base. Out came the chairs and the coolers. Kids found each other and gathered into marauding bands, armed with water pistols and pea-shooters fashioned from drinking straws and chewed straw-wrapper ammunition. Frisbees flew, music wafted. The Smith Ranch manager came on the FM radio frequency warning people to watch out for the little ones, who don't mix well with cars, and to keep the litter down so they can continue to offer first-run Hollywood films for three bucks a pop. Smith's Ranch has been operating, out here in the middle of the desert, since 1957, and I hope they go on for another century.

Once again, it was *Jurassic Park III*. By now I know the movie by

heart, not that it's tremendously complicated. People honked for the heroes, laughed at the jokes, all in a picnic atmosphere. The good time was infectious, and I had gained something to take home from the journey, something I had lost long before I started this year: my affection for the movies. Without lowering my own standards, I believe I can once again enjoy a film whole without mentally hacking it to pieces as it plays.

This is why I came to the desert, to gain just an ounce of wisdom. Movies serve many purposes: They entertain, occasionally they enlighten, they bring up all kinds of emotions and responses we normally stuff, like fear and sadness and vengeance. But most of all they tell stories, share adventures, take us away from those brutal hot days and niggling worries about what will happen next in our lives. If you allow it, a movie experience will be a meditation of sorts, right here and right now, if you just let down your defenses a little and let it play, all of it, what's on the screen and what's around you. Share the laughs and the gasps, let those emotions out a little, and you can become part of the story.

* WEEK 32, AUGUST 6–12 *

Smith's Ranch, 29 Palms, Calif.	**Jurassic Park III**
Egyptian Theater, Hollywood, Calif.	**Osmosis Jones** (World premiere)
Egyptian Theater, Hollywood, Calif.	World Animation Celebration: Shorts Competition
Egyptian Theater, Hollywood, Calif.	An Evening with Pixar
Egyptian Theater, Hollywood, Calif.	**Mutant Aliens**
El Capitan Theater, Hollywood, Calif.	**The Princess Diaries**
Grauman's Chinese, Hollywood, Calif.	**Original Sin**
Oak Street Cinema, Minneapolis	**Caddyshack**
Loews Cineplex Edina 4	**The Others**
Mann St. Louis Park Cinema 6	**American Pie 2**
Muller Family Theaters Lakeville 18	**Spy Kids** (Re-release)

Movies in the Heart of the Beast

Hollywood Boulevard and the Myth of the Perfect Movie Theater

I am at the Green Door Café having a cup of old sour coffee and an eight-dollar tuna sandwich on white bread—I made a better sandwich as a six-year-old kid. The blistering heat that cooked Hollywood Boulevard all day, releasing a good seven hundred different odors, has abated. Separated from the café by a wrought-iron gate, a man about my age but with skin like an old Dooney & Bourke bag found at the bottom of a box at the Salvation Army mushes his face between the bars and screams at me, "Nice *belly* button! Is that a machine gun or a *guitar*?!"

Not far from my new friend, an old man in a Planet Hollywood

cap, urine-stained pants, and red suspenders teeters on his cane directly over Gloria Swanson's star in the Walk of Fame and flashes the peace sign at any female under twenty, then follows her halfway down the block before returning to his post. Across the street, near the Chinese, Batman casually chats with James Brown. And now, in front of me, a man swaggers by. He's middle-aged, black, and he's giving us a genuine seventies-style pimp roll, like Huggy Bear. Utterly poised and smiling proud, he wears a shimmering black leotard, very clingy, which reveals every feature of his anatomy. He accessorizes with a foot-wide rhinestone-encrusted belt, and a silver lamé jacket. His long curly black wig is accented with a silver glitter cowboy hat and ski goggles.

Ski goggles.

For me the most disturbing part is that I am not surprised. I'm never surprised by anything I see on Hollywood Boulevard, short of a drive-by shooting or a ritual blood sacrifice, but I'm sure both happen regularly.

This is Hollywood, actual Hollywood. Do not confuse actual Hollywood with West Hollywood next door. West Hollywood is a real city entirely surrounded by Los Angeles. It's nice and progressive, with a diverse ethnicity and culture, rightly proud of its acceptance of people of all origins and sexual orientations. It has terrific stores, restaurants, and hotels, relatively safe streets to walk, and a feeling of immense civic pride.

Nor should you confuse Hollywood with the motion picture and television production communities. I believe the offices of Henson Productions off of Sunset are the closest thing to a Hollywood studio. The others are in Burbank or Culver City, Century City, Television City, Universal City, or a variety of other nearby cities, fake and otherwise. Actual Hollywood is a worn-out amalgam of street people, tourists, small businesses and tacky attractions, odd little dives and spectacular movie theaters, where occasionally the gods of the movie business will descend from the clouds of their Elysium and grace the throng with their presence at a premiere. It is the western Times Square, and like its once-sleazy drug-addict brother in New York, it is

undergoing an expensive rehab program, putting on a suit and trying to act respectable.

Purely from a civic history perspective, Hollywood is not a city at all. It is a neighborhood bordered by Riverside Drive to the east, Beverly Boulevard to the south, the city of Beverly Hills (another actual city) to the west, and the canyon neighborhoods to the north, home to many a junkie, rock star, and junkie rock star.

Long before the white folk got here, the Tongva nation lived peacefully in these hills and canyons, trading with their neighbors the Chumash to the north and the Acjachemen to the south. They fished and gathered food, such as the nutritious grass chia, long before modern man learned to cultivate it on cute ceramic sheep and sell it on television. Some shared a mystical messianic religion, using the powerful herb *tolache* to conjure visions.

It was a rich culture, winding back through the centuries, with the power to endure through all human history. Wouldn't you know it, Spanish conquerors and clergy moved in and immediately yanked the canyon land from the people who lived there and sent them packing to the missions. From this point we all know the story: People came and scorched the land, burrowed into the mountains for the yellow metal, built dams and irrigation and housing developments and amusement parks. Now in place of *tolache* ceremonies, today's sad equivalent is conjured in Sunset clubs by teeners who knock back ecstasy and six-packs of Evian while dancing to Gorillaz and Oakenfield remixes.

Hollywood was a real city for a few minutes, originally planned as an L.A. subdivision in 1887 by strident prohibitionist Harvey Horace Wilcox. Near the turn of the century the city incorporated, but when the citizens ran out of water in 1910, they surrendered to Los Angeles, which swallowed them up. My historical hypothesis is that Los Angeles immediately dumped the host of its criminal and escaped mental patient populations into the small community, and the American film industry was born.

During the next century, Hollywood as a place rose and fell. Hollywood Boulevard itself became home to some of the more smashing

movie palaces still in existence, among them the Chinese, the Egyptian, and the El Capitan.

The Egyptian is one of my favorite theaters of all time. It was 1922 that King Tutankhamen's grave was uncovered in Egypt, spawning several generations of adventure stories and giving rise to an "Egypt craze" in American culture. This was the twenties, the relatively fabulous decade between the Great War and the Great Depression, and Hollywood was the center of an industry thriving beyond all expectations. Gargantuan real estate developer Charles Toberman was looking to snazz up the Hollywood community, a quiet place of bungalows and lemon ranches. Toberman looked to Sid Grauman, who already had made a fortune with nickelodeons, vaudeville theater, and great silent theaters in downtown Los Angeles like the Million Dollar and the Rialto. Grauman showed his legendary bad taste in decoration and commissioned Meyer and Holler architects to create an Egyptian/deco palace.

Boy, did they ever. It's tacky and splendid at the same time. It became apparent that a business based on artifice would allow its fakeness to wash into every aspect of life, and that's Hollywood in a nutshell. It explains what begat Disneyland, bringing things from the world around us home and making safe, user-friendly simulations of them. The people of Hollywood have always sought to re-create the world in their own image, but they had absolutely no taste.

Still, the Egyptian remains my favorite place to see movies in Los Angeles. First, it has been restored to hold two fantastic auditoriums, the six-hundred-and-fifty-seat Lloyd E. Rigler and the new eighty-three-seat Steven Spielberg. Lloyd Rigler is a household name of course, but who the hell is this Spielberg and why does he have a theater named after him?[13] I haven't been to the Spielberg yet, but the

13 Okay, if you must know, Lloyd Rigler made his fortune by marketing Adolph's Meat Tenderizer to a world that didn't even know it was yearning for a meat tenderizer. Later in his life, in honor of his audiophile partner Larry Deutsch, Rigler underwrote the most amazing collection and categorization of recorded sound ever collected. Now called the Rigler-Deutsch Index or RDI, it's a standard of research and reference, and if you're a research geek like me, it's like heroin.

Rigler is a wonderful thing. It looks like an Egyptian tomb crashed into a spaceship: the original sun mural relief graces the ceilings, while layers of visible acoustic treatment give the walls a twenty-four-and-a-half-century look. But, all that disappears when you sit in a big, firm balcony seat and watch a flawless showing of a well-made film.

Second, it is the home of the American Cinematheque, a nonprofit organization I support wholeheartedly. What's a cinematheque? It's a repository of film, the name derived from the French word for library *bibliotheque*, and carrying with it the connotation that it is a collection for the common good. This means that instead of programming Hollywood's biggest hits and targeting huge profit margins, as a nonprofit organization the Cinematheque is out to celebrate the best in motion pictures. And they do it very well.

I have fallen in love with the Egyptian Theater. It could well end up to be my favorite theater in the country. It is a place for lovers of film, not just worshipers of stars.

Imagine then the contrast when I crossed the street to Grauman's Chinese. Just as the Egyptian embodies everything there is to love about Hollywood, the Chinese embodies everything that annoys.

The worst thing about Hollywood is the cult of celebrity, and the Chinese is the original temple to it. Its expansive courtyard is paved with the legendary signatures, hand- and footprints of Hollywood's biggest stars since the late twenties. It is much more a monument to fame and commercial success than to actual talent or enduring art. Sharing the same corner of the theater's forecourt with Humphrey Bogart and Sidney Poitier are John Travolta, Whoopi Goldberg, and Steven Seagal. That's right, Steven Seagal shares immortality with Harold Lloyd. Robin Williams has more real estate then Jimmy Stewart. Bruce Willis and Arnold Schwarzenegger overshadow Peter Sellers. Michael Keaton but not Buster Keaton.

On any given afternoon, while the theater sits half-empty, the forecourt is full of people with cameras looking down. People look at pavement, taking pictures of themselves crouching next to filthy, spit-riddled blocks of specially made concrete containing the trace DNA of Jim Carrey. They actually have these pictures developed, take

them home, and show them to friends and family. They'll go back to Munich and excitedly say, *Hier bin ich, nahe bei den verhärteten abdrücken von* Tom Cruise! And their friends will coo and gasp in awe.

Long ago someone decided that the most important thing in Hollywood film production and distribution is the movie star, and the film industry and moviegoing audience alike have been paying for that folly ever since. Like professional athletes, the stars have made their trade prohibitively expensive. The twenty or thirty million a studio spends on a Jim Carrey or a Mel Gibson doesn't seem to trickle down to the actors who struggle to make scale. The stars have allowed their various parasites, from hairdressers to pet psychologists, to become rich beyond their professions' worth, while teachers and nurses remain underpaid. It is the star system that continues to lower the standards of American cinema. If you disagree with me, do so only after sitting through the entirety of *Town & Country*. Twice.

But it is the star system that also glamorizes Hollywood, and people do love their stars. Sid Grauman, ever the showman, made the Chinese a monument to stardom, with its chunks of star-smushed concrete and with Hollywood premieres. Hollywood has always been about the show, and the premiere has long been a boiling source of manufactured excitement. We can thank Grauman for making a cultural icon out of people in evening dress getting out of cars.

The Chinese may be the tackiest theater ever built. Apparently Grauman didn't think the Egyptian was tacky enough, so he built this decorative crossbreed of a Nanking temple and a Shanghai brothel and made it flash like a skyrocket amid the growing refinement of Los Angeles architecture. But, inside it's different, and still a decent place to see a movie. I saw *Original Sin* there, which is an embarrassment for all involved. I don't know how someone could manage to make a twisty-turny murder mystery thriller that features the naked bodies of Angelina Jolie *and* Antonio Banderas boring. But since it had star power, it made it to the massive screen of the Chinese.

No matter. It gave me a chance to skulk through the Chinese while several people fell asleep in their seats. It is a splendid theater from the inside in the dark, where the deep red upholstery and lacquered

black accents are softly and indirectly lit to great effect. It evokes mystery and menace, it's like a movie set itself, and this became apparent when a kid rammed into me, one of several who were running behind the aisle curtains playing "hide and seek." That they weren't watching naked Angelina Jolie is a true testament to how boring *Original Sin* is: It couldn't even titillate a twelve-year-old boy.

The Chinese is in the midst of a major remodeling effort, thanks to its new owners. Back in the seventies, another very rich theater owner, Ted Mann, bought the place and replaced Grauman's name with his own. This was a stupid thing to do. Imagine Donald Trump buying the Burger King chain and renaming it Burger Trump.

Sure enough, the Mann theater chain foundered, and now the poor dumb theater is about to be conquered again! The Chinese has been bought by a consortium, and soon will be absorbed by the new Hollywood rehabilitation project, the Hollywood Highland Center, which simultaneously is refreshing and foreboding. It is a massive complex sprawling over two L.A. city blocks, comprised of everything they already have in Las Vegas except the gambling, but mostly it's an attempt to make dirty little Hollywood a moneymaking tourist attraction again, and clean it up so people aren't scared to walk down the street after dark.

The three thousand six hundred seat Kodak Theater promises to be the "permanent home" of the Academy Awards Presentation Ceremony. Yeah, right. There's also a seven-hundred-room hotel, plus shops, restaurants, courtyards, and lots of nice places for the weird old men and the guy in the black leotard and ski goggles to stroll through each day.

Here's what frightens me. In the midst of all this will be a literal replica of Hollywood Babylon. The Center's Babylon Court is modeled after the set of D. W. Griffith's *Intolerance*, which was modeled after the Gate of Imgur Bel, one of the eight inner gates to the fortress of the city of Babylon, built during the reign of Nebuchadnezzar II around 575 B.C.E. See, old Neb was the guy history marks for conquering the kingdom of Judah, destroying the Great Temple in Jerusalem, and enslaving tens of thousands of exiled Jews. The cap-

tured tribes of Judah were actually paraded to their imprisonment under the very gate represented here. And yet here we are, in the twenty-first century, and the city of Los Angeles is busily building a symbol of religious conquest, larger than life, in the midst of the show business community. It's huge and sumptuous, imposing to say the very least, and, as replica of an artifact, completely wrong. Yet there it stands, Griffith's Babylon, with full-size stone elephants atop huge pillars and the gate rising above all. A Tower of Babel in the City of Bullshit.

Finally, to the magnificent El Capitan. From the outside, it is perhaps the most graceful building on Hollywood Boulevard. It opened in 1926 as a legitimate stage, or as the *Los Angeles Times* put it, "Hollywood's first home for spoken drama." It led me to believe that at one time silent drama had been all the rage. Evidently realizing that people did not come to Hollywood to watch movie stars try to act, the theater hosted the premiere of *Citizen Kane* in 1941. Having sniffed that movie money, the owners closed the stage, remodeled the house into a movie theater, changed the name to the Hollywood Paramount, and never looked back.

In 1989, Disney partnered with the Pacific Theater chain to completely restore the theater under the El Capitan marquee, to actually transmute it into something it never was: a grand movie palace. And grand it has become, worth the price of admission just to crawl through it. It is the most perfectly restored theater I have ever seen; it looks like they built a new "old" theater and did it right, with a massive screen set back from the stage by an ample proscenium with a thrust for live presentations. A thousand seats and not a bad one in the house. The balcony is as it should be, well maintained and perfectly positioned for the best seats in the theater. It has cutting-edge DLP projection capability and the sound is state of the art, of course, THX certified, Dolby SR-D capable, and no doubt retrofitted for those cranial ports we'll all have installed in the base of our skulls in ten years.

Once again not caring what I saw, I sat in the balcony for *The Princess Diaries*. Courteous, crisply uniformed attendants pointed

the way to the splendid gold-themed rococo auditorium with white-gloved hands. The organist played brilliantly on the glimmering, shimmering gold-leaf theater organ, which rises out of the pit between shows. I learned that the matinee show attendees, almost all moms and daughters for this film, were invited to a cute little high tea with Disney characters afterward, and each little princess would get tea, cookies, and a darling little tiara. Cutesy, but what the hell, you're in Hollywood. As the show started, velvet curtains pulled back, revealing a glittering silver curtain that opened as the song "Hooray for Hollywood" played. I relaxed into my ample, comfortable, velvet balcony seat, with the overwhelming feeling that I had found the perfect movie theater.

But then *The Princess Diaries* started. Do not confuse *The Princess Diaries* with *The Virgin Suicides* or *The Vagina Monologues*. This movie is so wretchedly Disney it raised my bile. I don't think a movie has sucked so much since *Deep Throat*. And it has a truly upsetting feature that I must point out.

Twenty-two-year-old teenager Anne Hathaway plays Mia, who finds out that she is by birth a princess. Mia is a pretty young woman, but with her curly hair and thick eyebrow she is pronounced ugly. A transformation begins, complete with Larry Miller as a gay beautician of indeterminate ethnicity, and after her hair is straightened and her eyebrows plucked, she is pronounced beautiful. In other words, folks, she is de-ethnicized, any hint of Semitic origin is wiped away, and she becomes the ideal Anglo-Saxon beauty. It's a creeping fascism that even the director might not recognize, but it makes my skin crawl to realize its implications.

And it leads beyond the movie to the theater itself, because, as I learned later, the El Capitan shows *nothing but Disney*. It is the flagship of the Disneyfication movement to transform urban America into a family-friendly replica of its ideal self. What could be a better symbol for this than the perfect movie theater?

And it is *the* perfect movie theater, technically, aesthetically, and functionally; this is in part why it is the highest-grossing single-screen theater in the country. It's the kind of movie theater you imagine they

have in heaven. So perfect, in fact, that it all seems . . . too perfect. As if some shadowy hand has created a stunning mask of perfection to extend the moviegoer's suspension of disbelief out from the movie to the theater itself, and in turn to the New Hollywood in the process of reimagining itself.

Or re*imagineering* . . .

Movie Rides
I Paid How Much for This?!

I need to talk about one more aspect of the Hollywood moviegoing experience: the movie ride. On my last day in Los Angeles I decided I needed to have this experience, wrapped up as it is in the whole mythos of Hollywood, and its forced celebration of itself.

Universal Studios Hollywood has taken about ten square miles of hillside and turned it into an "amusement park," at which people pay forty bucks and up to wander through an overplanned sprawl that pays cheesy tribute to . . . guess what—Universal Studios. Parking is a horror show in itself, the lines for rides and attractions snake like Russian bread lines along the broiling pavement, the air is filled with

the smells of grilled meat and fried everything, and nobody seems to be having much fun.

I have managed to stay away from most of these things my whole life, even when I lived in Southern California, because I believe that church bake sales and backyard carnivals are probably as much fun and cost a lot less. So far that's proven out for me. I have never been to Disneyland or Disney World, so I'll have to reserve judgment.

I came to Universal Studios with only a few hours to spare and one goal in mind: movie rides. Rides that use movies as their focal point, technically and thematically. Universal has two of these: Back to the Future: The Ride and Terminator 2: 3-D.

The smartest thing I did was to shell out seventy clams for the Director's Pass. This is designed for impatient people with money, which describes the entire population of Bel Air. With my pass, I was able to skip the lines at the attractions and have a place reserved for me, right up front. It saved me about three hours of sullen parents and overheated children, and it also caused those same people to regard me with a kind of well-deserved hatred. Money brings privilege here, as it does all over Hollywood, so the first theme of this theme park held true. To enjoy these privileges, I had to wear a shiny gold disk about the size of an LP around my neck on a chain. So, not only did I feel like a spoiled rich idiot, I looked the part as well.

Back to the Future: The Ride was my first stop. A bunch of the underprivileged and I were shuttled into a heavily art-directed laboratory, where we watched a video of Christopher Lloyd introducing us to the ride, pointing out several safety concerns and generally overacting. Everything in the ride, from the entrance to the staging areas to the exits, was decorated in the *Back to the Future* theme, that kitschy combination of science fiction and small town.

After the safety litany was repeated by the flight attendants, so to speak, we were shuttled into a little garagelike room and strapped into our eight-seat mutated replica of the film's trademark DeLorean; our little garage door opened and around us a bunch of similarly mutated DeLoreans joined us in front of a massive semispherical screen. Before us a movie began, essentially an exercise in pure movement

and acceleration, in which we, the cars' occupants, ostensibly were compelled to interact, although this is impossible.

The sensation of movement was the best thing about the ride. As the film swooped and spun on the screen, our mutated DeLoreans bobbed and weaved in synch, and the feeling of motion was almost too much at times. We spun and soared for about ten minutes; then the whole thing wound down rather quickly. Somehow, without doing a thing, we had accomplished our interactive task, and we were all hustled out of our seats and out the door, where we wobbled in the bright sunlight and the smell of grilled meat and fried everything.

For this I was paying seventy bucks.

Because of the way my mind works, I took no time to marvel at how much it looked and felt like I was actually in the movie; instead I spent my waiting time peeking behind the curtains and noticing the faded dopiness of it all. It's fake, you see, the whole thing is fake. Is it possible to have a fake experience? Aren't all experiences real? Even dreams, which take place solely in your mind, are they not real experiences? But somehow this movie ride was able to crack through this philosophical construct and present me with a genuinely phony experience, a replacement of actual experience, where everything I see, hear, feel, smell, and taste, especially the fog, was designed to create a conditioned response. Everyone is supposed to walk through the door, share the same physical sensations, jump, whoop, scream, laugh, and enjoy as directed, then get out quickly so the next batch can be processed.

I like to interpret my own experiences, thank you very much. This is why these heavily orchestrated theme rides will never be as much fun as a roller coaster. Roller coasters, beyond their name and a bit of art direction, give you no expectations beyond the simple fact that you are going to be thrown around at high speeds. On a roller coaster we are part of a group, all experiencing the same phenomenon, but we all react differently. Roller coasters need no other conceit, they are enough fun in themselves. And everybody reacts differently, with fear, exhilaration, glee, panic, all of these in unique combinations.

On Back to the Future: The Ride, the physical phenomena have

been choreographed down to the last image and sound. You must look straight ahead; if you look up, down, or to the side, the whole thing betrays itself. You must suspend your disbelief. On a roller coaster you are actually rocketing along in an open can at horrific speeds. You can look wherever you want and you're still there. I love to look straight up on a coaster as it flies through a corkscrew. On the movie ride, all I got to see were the pneumatics.

Disappointed but undaunted, I headed for Terminator 2: 3-D, an altogether different experience. This time, instead of having to pretend I was on a roller coaster, I had to pretend I was at a huge corporation for the unveiling of a new line of killer robots.

In 3-D!

Because everybody knows that 3-D works best when sitting in the middle of the theater, all fifteen hundred of us tried to get middle seats. We must have been an especially feisty crowd, because we were falling over each other as the ushers urged us to "move to the end of your row, all seats are good seats." Nobody was buying that line for a nickel. When I urged a woman with two small children to move down a few seats because people were angrily piling up behind us, she told me to fuck off. Yep, she said, "Why don't you fuck off?" right there in front of her embarrassed preteen kids.

This moment tells me what I hate about theme parks. I understand that there's a lot more to this place than the movie rides, but what of it? To pay a lot of money to spend a hot day in an overcrowded public place, to be pushed and shoved by other angry people, to stand in line for a one hundred percent artificial experience in which we are expected to pretend we live in a creepy corporate future full of killer robots, and, further, to pretend that the swooping images we see through our uncomfortable plastic glasses are three-dimensional, and, finally, to pretend that any of this is actually fun, is folly. I can't do it. I can't abide.

And as the 3-D experience unfolded, and the Liquid Metal Guy loomed out at us, and union actors seemingly popped out of the screen and lip-synched lines from Arnold Schwarzenegger and Linda Hamilton, I just got more depressed. Not simply because the whole

3-D film experience just stank (technically impressive and noisily elaborate as it was), and not just because I had to sit next to a woman who moments before had told me to fuck off, I was depressed because this is purported to be the Olympian mount of Hollywood, the Elysian Fields of American entertainment, a place so impressive and so exciting and so much sheer fun that it's worth the two hundred bucks for a family of two adults and three kids. And I was really bugged by the fact that so many people buy into this. It means that America on vacation is willing to wade through all this hassle and expense because we can't figure out on our own how to have a good time.

The introduction to the Universal Studios Hollywood Web site proudly intones, "Enjoy your stay! You're in Hollywood now!" as if the two have something to do with each other. Me, just put me on a decent roller coaster now and again and take me to the Steele County Free Fair once a year, and I never have to go back to Universal Studios again.

General Cinema Centennial Lakes 8, Edina	**Captain Corelli's Mandolin**
Oak Street Cinema, Minneapolis	**Stranger than Paradise** ('80s Film Series)
Oak Street Cinema, Minneapolis	**Mystery Train** ('80s Film Series)
Oak Street Cinema, Minneapolis	**Fatal Attraction** ('80s Film Series)
Oak Street Cinema, Minneapolis	**Flashdance** ('80s Film Series)
General Cinema Mall of America 14	**The Curse of the Jade Scorpion**
CEC Superior 7, Superior, Wisc.	**John Carpenter's Ghosts of Mars**
Oak Street Cinema, Minneapolis	**The Shining** ('80s Film Series)

For People Who Can't Read
Information and Misinformation on the World Wide Web

In the years after Al Gore invented the Internet back in 1965 or so, it has become the biggest mess of undifferentiated information in history. As a resource for this book, I have found three good uses for the Internet: First, as a research tool for legitimate information, it is deeper and faster than my local library and smells much better. Second, it is an astounding well of opinions, conversations, and outright diatribes, and home to some of the worst writing ever made available to the public, which is just plain fun. But the best of all is the French-language episode guide to *CHiPs*, which I have found to be surprisingly useful in my everyday life.

Let's start with information. Web sites like moviefone.com, fandango.com, and movietickets.com have for me one simple purpose: to find out when the heck something is playing. This has been invaluable for my quest. For instance, I'm heading to Australia soon, and I want to find out what's playing in several different cities. Off I go to the Australian Movie Guide (www.movieguide.com.au) and I get a listing of over a hundred cinemas around the country, plus shows and show times. The list isn't exhaustive, but it's a start; and it certainly makes my life easier, which is what the whole Internet is supposed to do, right?

It doesn't resolve the age-old conflict that arises when more than two people have more than two opinions about what they want to see. This problem has plagued me since I was in college, and yet I continue to try to see films with groups, which is very, very dumb. In the olden days of the age of print, we would pass the newspaper movie section back and forth, debating film styles, subject matter, location, show times, and nearby liquor (food, too); somehow we'd invariably go to a later show because we spent so much time debating.

But now that print is dead, one of us (usually me) will jump up, run to the computer, and start browsing. Of course, I'll browse too fast. Others will browse too slow. You know you're cooked when someone touches you and says "Can I just . . . ?" The whole group will gather around until my office looks like a scene out of one of these shallow suspense movies where the hackers are trying to bring down the huge corporation.

We are awash in CRT light. Somebody points and says, "Go there." Too late, I've already gone elsewhere. "Go back," someone yells in my ear. The local arts paper is available in its full text on-line, but I wouldn't dare tell anyone this because someone in the group wants to see that Czech movie about sexually abused puppets. Whoever controls the mouse controls the movie. They say "go there" and I go elsewhere. They say "go back" and I go forward. I have the power. It's a good way to lose friends.

I think the best way to handle this is for each person in the moviegoing team to do independent research and prepare a concise

executive summary to hand out, including movie descriptions, a few reviews, show times and locations, and then print out the summary and make enough copies for the whole group. We should get together early enough to have an effective meeting, naturally; two hours before tentative showtime should do it. If run effectively in a group of six to eight, this meeting can be wrapped up in less than an hour. I like to set up the living room with a white board and a different color marker for each person present, so that we can map out all the top picks, cross-reference the agreement points and arrive at consensus quickly. With the right crowd, of course, you can simply sync up all your Palm Pilots and save paper. Occasionally, I'll prepare a PowerPoint presentation, with a clear flow chart and a few previews on streaming video, which always gives me an advantage in the room.

The easiest way around this is never to go to a movie in groups larger than four, and only use the Internet after you've decided what to see, unless you are a bunch of I.T. geeks, then, hey, knock yourself out, man.

Now that we've used the Internet to complicate your life and lose your friends, let's use it to confuse you and cloud your opinion. It's fun!

Volumes of writing from legitimate critics and fan-freaks alike are here in equal proportions. You can often look to your favorite arts paper or magazine's Web site, especially helpful for new films or those in limited runs. The *New York Times*, *Village Voice*, the *City Pages*, the *Chicago Reader*, the *New Republic*, *Time*, and the like publish current reviews on their sites. Some will make you pay for archived material. Don't.

Of the magazines that exist solely on the web, *Salon* and *Slate*, noodly as they are, have the most interesting and dependable reviewers. *Film Threat*, once my favorite film magazine in print, has moved out of print and onto the Web. Here you'll find reviews of the latest big releases, the independents, festival offerings, foreign jobs, and everything different or daring. The reviewers range widely in their ability, so seek out reviews by Chris Gore, the mag's founder and most articulate and outspoken critic. What's better is that *Film Threat*, like

Salon.com without the brainy pretense, invites feedback and responds to it, involving the readers in the conversation and creating a dialogue among writers, readers, and filmmakers.

For finding a broad cross-section of reviews, the Internet Movie Database is simply a fantastic resource. Click on the review category for any recent film, foreign or domestic, experimental or conventional, and you'll find links to tons of reviews. Rottentomatoes.com is a compendium of reviews from several popular publications and an assortment of real hacks as well; you could spend more time reading the reviews available than actually watching the film.

Then there are my current favorites, the amateurs. Just take a cursory browse of the Internet and you'll find hundreds of them, crawling around like carpenter ants, opining like mad. The Internet, and the computer in general, has indeed created a revolution: They allow anyone to do what they want, no matter how good or bad they are at it, and share it with the world.

I love them. Nowhere will you find more blunt, candid reactions to a movie than in the amateur critics' Web sites. On most the writing is unforgivably bad, but then there are the gems.

Let's take a look at a review of the movie *Original Sin* on the Web site Dumbass and the Fag. That's www.dumbassandthefag.com, of course.

Original Sin is a movie about sex with mail-order brides. There's a whole big mess of plot and other shit, of course, but sex with mail-order brides is the key idea glowing in the center of the coughed-up hairball that is this wretched film.

Okay, thanks, Dumbass. Much obliged, Fag. Now I know how you feel.

Hey, it's honest, it's earnest, and it has a casual liquory charm reminiscent of an old friend late on a Saturday night who's had one or three too many Meyers and Cokes and needs you to call him a cab.

3BlackChicks.com delivers what it promises: three black chicks reviewing films. But this is no ordinary amateur site: The opinions

here are informed and diverse, and each of the above-mentioned chicks has a genuine critical faculty and a lot of attitude. Of *Mulholland Drive*, Rose "Bams" Cooper coined her opinion right off the bat: "Oh, brudder, where's my shovel?" She calls it "Interminably long, infuriatingly goofy, but Boy Howdy stylish!" You don't get candor like that from David Denby in the *New Yorker*.

This amateur authority has found its biggest voice in Harry Knowles, the founder and inspirational figurehead of Ain't It Cool News. Harry, a most unpleasant man to look at, may be the most unaffected and passionate film lover currently writing about movies.

His prose style is nonexistent, his humor tends toward corny in-jokes, he seems to have tastes identical to Quentin Tarantino's, and he's at times a thoroughly belligerent snob. Harry and his "spies" have annoyed the living hell out of people in every aspect of film production. However, he has coined a brand of populist film writing that rings true for thousands of readers, enough to make Harry feel like he's very influential. See, Harry's audience is the perfect demographic for Hollywood: boys with money to buy movie tickets, merchandise, DVDs, and snack food. He's the poster child for the Hollywood target audience, so studios have begun to allow him and his minions to root around in their business.

It's hard to draw a bead on this guy. On the one hand, he seems to be the most unashamed lover of pop films on the planet; and I appreciate that he reviews films in the context of the screening, mentioning the theater, the audience, the trailers; it conveys mood and perspective to the writing and imbues it with Harry's personality.

On the other hand, having read a lot of his work over the past year, I have a feeling that Harry really doesn't realize just how much he's being manipulated; in a way he's the new model for the junket whore of the future, a sort of "aw-shucks" star-struck dope with no perceivable ethical compass, unaware that he is being led around by the nose by the very industry he loves.

I would love to conclude that the Internet is a fantastic resource, that, after Spaghetti-Os, it's the greatest invention since the napkin. There's only one thing that prevents me:

Pop-up ads.

I'd like to find the people who invented the pop-up ad and push their heads into a vat of suet, because that's what they've been doing to me. I'm innocently browsing along, looking for stuff to make my life easier and therefore better, when suddenly I'm assailed with ads for cameras, credit cards, and weight-loss programs hurled into my face, unsolicited and unwelcome. At movie sites, we have to sit through clever little animations and cheesy film previews, hassling us like the Moonies used to at the airport. Walk down Broadway in New York at rush hour and you'll get less hassle. It is the on-line equivalent of the telephone solicitor, and it needs to stop.

Nobody likes these things, nobody gets excited and says "Hooray! Another ad for a wireless video camera with a picture of a girl in a bikini!" They make using the Web an altogether infuriating experience. If this happens to you, click on over to www.multimania.com/loeki/chp/, the only Web site I've found dedicated to French-language episodes of *CHiPs*. No pop-ups, no banners, just smooth, easy-going facts and stories about *Panch et Jean*, all in French, so you know it's good.

Bon chance! Bon recherce du Web!

Mann St. Louis Park 6 Cinema 6	**Summer Catch**
General Cinema Centennial Lakes 8, Edina	**Jay and Silent Bob Strike Back**
Uptown Theater, Minneapolis	**Apocalypse Now Redux**
General Cinema Centennial Lakes 8, Edina	**Bubble Boy**
Air New Zealand Flight 15	**Blow Dry**
Air New Zealand Flight 15	**Heartbreakers**
Air New Zealand Flight 15	**Finding Forrester**
Majestic Theatre, Pomona, Queensland	Silent Film Festival: Selected Shorts
Majestic Theatre, Pomona, Queensland	Silent Film Festival: **Go West**

AUSTRALIA, Part One
The Best Place in the World to See Movies

I had one big international nickel to spend, one opportunity to go anywhere in the world to see movies and report back. A place with a diverse culture and hence a diverse cinema. A place with its own cinematic history and an influential body of work. Hopefully a place exotic enough to seem far from home, but where I wouldn't contract malaria.

Hong Kong was on the list, but it was too small and, cinematically at least, not diverse enough. India had its appeal as the home of Bollywood, one of the world's most prolific film production centers, kicking out hundreds each year. But a trip to India requires more than a cou-

ple of weeks—more like a year—and there was that whole malaria thing. Japan? Too Japanese for my taste. The land that unleashed *Hello Kitty* on the world was not for me.

I did some research. The world's oldest open-air theater is in Australia. The world's longest-running silent theater is in Australia. The world's smallest movie theater is in Australia. And, as it turns out, the best theater chain I have ever known is in Australia.

This is the homeland of actors like Bryan Brown, Geoffrey Rush, Nicole Kidman, Cate Blanchette, Guy Pearce, Naomi Watts. The home of directors Peter Weir, Gillian Armstrong, Fred Schepisi, Bruce Beresford, George Miller, Baz Lurhmann. Home to the brilliant cinematographers Russell Boyd and Peter Menzies. For better or worse, also the home of Kylie Minogue, Paul Hogan, Elle MacPherson, and (shudder) Yahoo Serious.

In spite of Yahoo Serious, I had to go. Ten days, fourteen films, five cities, eight theaters, three in-flight movies, one airport movie, and a double feature on an all-night bus ride.

I no longer wonder why people get mad at me when I complain about my job.

Pomona, Queensland and the Majestic Theater

The train from Brisbane lets you off on a platform about ten feet wide. You have to be in the first car of the train or you can't get off. Nobody told me this, so I was stuck in the second car with five bags including a projector and four reels, banging at the window to get the attention of the conductor. Otherwise I'd have spent the night at the next stop in Noosa Head.

I would call Pomona a one-horse town if I'd seen a horse. I arrived in the swelter of midday, and was quickly told that this heat was nothing, I should be here in the summer. The land here is astounding in its diversity, as if California had compacted itself into a hundred square miles. The mornings are crisp, days blazing with sun. Pine trees fringe sugar cane fields; cattle graze near eucalyptus trees. Pomona has its own mountain, and twenty miles away is some of the prettiest beach on the planet. There's a smattering of small shops serving the folks

who live on the ample acreage surrounding the town, a decent Chinese restaurant, the Pomona Hotel, and the Majestic Theatre.

The Pomona Hotel is so much like a saloon from an old western movie I found myself looking for a piano playing "Oh Susannah." It's quite old, built in the early twenties, and it is very simple, basic. Bottom floor is almost entirely pub; top floor has sitting porches fore and aft and about twelve rooms, with plank floors, old high-rise beds, and furniture from several eras. There are two toilets and two baths to serve the lot.

The proprietor, Dennis, tends the bar and fits in here so perfectly I got the feeling that he was installed with the plumbing back in 1921 and somehow he never aged. With a bartendery handshake he knows who I am before I say my name: "You must be Kevin. We were expecting you yesterday." I must humiliate myself by admitting that I had spaced out about the dateline. He gave a salutation I'll hear at least a hundred times: "No worries."

The going rate on a room's twenty-five bucks, bar's open till it closes, no dinner on Sunday. The bar is convivial as can be, and if you say nothing for over two minutes someone is liable to strike up a conversation. Lots of stuff on the wall supporting the local rugby team, the Cutters. Go Cutters. Up Cutters.

Tap beer, for no reason I can find, comes in little juice glasses, probably ten ounces tops. Victoria Bitter is good, Four-X is less so, and Four-X Gold is simply vomit fuel.

After a deathlike nap, I asked Dennis to direct me to the Majestic. It's just across the tracks, you can't miss it. The Majestic looks as old as it is, a work of classic Australian bush architecture, posts and beams and corrugated iron. Nice big sign cases carry lobby cards announcing the Majestic's annual Silent Movie Festival, which I am lucky enough to attend. Sign on the door says the first run of selected silent shorts begins at 2:00 P.M.

It is now 3:00 P.M.

Oh, heck. I hustle in and beg a seat, seemingly the only seat left in the house, and I must make an ass of myself stumbling over about a dozen people who all say "No worries."

Even with the fans running full blast it's hot as a wrestler's crotch. Soaked to the skin with sweat, no worries. The shorts program today includes gems by Harold Lloyd, Charlie Chase, Buster Keaton, Chaplin, and my favorite, Laurel and Hardy in *Their Purple Moment*. The story is old, borrowed by every sitcom ever made. Wife keeps the money, husband sneaks a bit for himself, wife finds out, boom. This time Stan and Ollie, married men, tell their wives they're going bowling, then have their titular Purple Moment by picking up two women outside a nightclub. They shoot the works, champagne and steaks; only Stan's wife has replaced the cash in his wallet with cigar coupons. The moment when Stan learns this is beautiful; he exhibits an entire spectrum of human emotion with nothing but his face, from confusion and nonchalance to fear, despair, outright panic. I believe he can make hunger look like an emotion. From there, it's all about them trying to dodge their check, their dates, the maître d', their wives, and a waiter who falls flat into a cake four times in the course of the film.

I don't think I've ever heard an audience laugh as hard. The laughter was in turn explosive, anticipatory, cathartic, joyous. It became part of the score as the organ lilted on at a quick pace. We could barely recover from one laugh when another came.

Something happens to an audience this giddy; there is delight in the air, and everyone is your friend. In every direction from my seat, I collected a dozen more "no worries" and left that day with cramped smile muscles.

On the way out I met the owners, Ron and Mandy West. Ron had played the organ straight through the three-hour shorts program and looked as crisp as a croupier.

No one could be better suited to run an authentic silent movie theater than the Wests. They are one of those couples who have worked together so well for so long they seem to have worn grooves into each other. They are fit, handsome, tanned, and white-haired, and both jump at the opportunity to speak their minds. They do what they do for the sheer love of it, and as great couples learn to do, they let each other do what they do well: Mandy runs the business, manages things and, according to Ron, is the reason for the theater's success. Ron

keeps things running, and in a silent movie theater operating equipment that's decades old, including a pipe organ, that's a lot. It's like owning and operating your own locomotive.

Ron is the consummate tinkerer. Throughout the theater's lobby, auditorium, and back storerooms, the stuff of cinema fills every available cubic inch. Projectors, editing machines, organ consoles, ancient posters for ancient films. Ron has an optical printer and darkroom in the back of the theater set up to print almost any film format, including 9.5mm and 28mm, screen formats unused for decades. The pipe organ, made from the parts of perhaps a dozen other organs, is a mechanical wonder, and takes the same kind of genius a whiz-bang computer code writer has to keep it running. Ron's eyes light up when he shows off the guts of the organ. "Screw electronics," he says, and laughs. "You can keep this thing running with a long-nose pliers and some eight-gauge wire."

Ron grew up in theaters. His dad played in the pit orchestra from 1897 until the vaudeville era ended and the cinema took its place. In the early forties, Ron got his first theater job as an ice-cream boy when he was ten years old. At sixteen he moved up to assistant projectionist and was running the projector himself in six months. He was a natural. "I ran an old Simplex with the low-intensity arc light," he says casually, if I would actually understand. "The sound heads were bad, terrible; I mean the only way you could tell the national anthem was playing was by the picture of the flag on the screen."

They live a happy life, these two, running their theater, staying in touch with their adult kids, all of whom are in the arts. The theater occupies their lives much like a two-year-old might, always needing attention, but giving back far more. Further, they share what I would discover to be the brilliant Australian wit: a love of slapstick and wordplay, an affection for irony, but never too brittle. And a love of the underdog, as best exhibited in the final film of the festival, Buster Keaton in *Go West*.

I think I can count the number of true geniuses of film comedy on the fingers of one hand. Buster Keaton is one of them. He reminds me that comedy has to do with laughter but even more with emotion. No matter how miserable my life has been, when I see a Buster Keaton

film it becomes measurably less miserable and the effect lasts for a long time.

In *Go West*, Buster is a man down on his luck, broke, and friendless. Stray dogs won't even befriend him. Suddenly he gets the urge to follow Horace Greeley's mandate: "Go West, young man." So he finds a job as a ranch hand and gives us some brilliant physical comedy and feats of near impossible timing, but he remains friendless and alone.

Until one day he removes a stone from the hoof of a limping cow, a cow who earlier was kicked out of the corral for not giving enough milk. Not long after, Buster gets his foot caught in a hole and unwittingly presents his wagging backside to a very bullish bull. But just as the bull bears down on poor Buster, the cow steps in its path, chases the bull off. Buster stands, realizing what has happened, and looks at the cow. The cow looks at him. He touches the cow tentatively, pats it lightly. The cow licks his hand. The cow follows him. After endless trials and loneliness, Buster has found a friend.

To describe it is one thing. To see it is another. To see it in a crowd and to watch the woman next to me sigh with tears and pull a hanky out of her bag is to reach into the heart of cinema. Eighty years on, a true anachronism in the modern state of film, and people are crying and laughing in turn. Quick, what was the most recent comedy that made you cry?

Throughout the film, people were completely behind Buster, wanting him to succeed, cringing when he teeters on the brink of failure, and we learned that the love of a man and a cow for each other doesn't have to be the subject of a sick joke to make us laugh.

Sydney and the Dendy

What is it about this city? Is this the capital of Heaven? Can a place be more vital, lovely, accessible, affordable, culturally diverse, safe, cleaner, friendly?

Some people I talked to say yes, there is a city nicer than Sydney: Melbourne. But I don't see how. Staying for two nights at a small century-old urban hotel with a roof garden and a view of Sydney Harbor for sixty bucks, I set out on foot and subway. I wandered China Town, Darling Harbor, Bondi, Manly, the Royal Gardens, and ended

the day slurping oysters and cold beer on Circular Quay, flanked by the Harbor Bridge and the Opera House. I realized that I was in love, and I'm not ashamed.

With apologies to Paris, New York, London, San Francisco, Buenos Aires, and Madison, Wisconsin, Sydney is now my favorite city.

Let's get to it straight away: The Dendy Cinemas are the finest chain of movie theaters in the world, or at least what I've seen of the world. I went to movies at three Dendy theaters, one in Brisbane and two in Sydney, and I was delighted every time.

After a breezy ferry ride to see the skyline at sunset, and a brisk walk around Circular Quay—a place sort of like Golden Gate Park, only it doesn't stink—I sat in a quayside bar and slurped the above-mentioned oysters (local and perfect), and after sloshing back a fine local lager, I wandered across the walkway to the Dendy Opera Quays. Three sumptuous screening rooms, with the wide armrests I obsess about, in a softly lit, minimalist room, spare but warm and inviting.

I bought a ticket to see some local fare, a sort of techno-thriller called *The Bank*, and took a look at the snack bar.

Wait, you sell beer and wine?

'Course. Wha'd you like?

You have a decent Shiraz?

Sh'razz? Sure. Barossa Valley. Like a glass?

The movie's about to start. . . .

No worries. Take it in with ya.

What, in the theater? Red wine, in a glass made out of glass?

'Course. No worries. Ta.

I wanted to cry. I wanted to kiss her, then cry some more. Never before had I been treated like an adult at a public movie theater. I have friends with private screening rooms who don't want people bringing red wine in. For a theater to have this level of trust in their customers is phenomenal. I was reminded of a quote I'd heard, attributed to Bertholt Brecht: "A theater with no beer is just a museum."

I sipped the very passable Shiraz (what the hell do I know) and watched a very passable movie, *The Bank*. The basic story is intrigu-ing, almost science fiction: Jimmy Doyle, a whiz-bang mathematician,

has created a formulaic structure that can predict stock market crashes. Naturally, a mammoth bank catches wind of his application and scoops him up. Thus begins a relationship between Jimmy and the bank president, who is pretty much Satan in a nice suit. But the story gets involved, spins around, and actually surprises at the end.

This is something else I didn't expect, because I so rarely get it at home anymore: a smart thriller that takes some doing to follow but rewards the diligent viewer with a fine ending. The unexpected part is that it assumes that the audience is as intelligent as the filmmakers, which is a fact, but which is acknowledged so rarely as to become a surprise in itself.

And yet another surprise: Anthony LaPaglia. You'd know him to see him, playing a New York cop (*Summer of Sam*), a mobster (*The Client*), or a slick lawyer (*Jack the Bear*). Within his body type and demeanor he is an excellent character actor and plays his role well.

Guess what: He's Australian, born and raised.

Could've bowled me over with an emu feather. And I learned it from a total stranger who spotted me as a Yank coming out of the theater and offered to buy me a beer, because he learned I was from Minnesota and he thought Jesse Ventura was the funniest damn public official he'd ever seen, and he wanted to know what possessed us to elect the clown. His name was Barry; he was a lawyer of some kind, that's all I learned. He was the guy who told me that Melbourne was the only city nicer than Sydney. He goes to the Kino cinema (another Dendy) in Melbourne all the time, but he prefers the screens and the amenities of the Dendy here, so this was a treat. Is there any better cinema in Australia, I asked him. Not in my book, he said. Only other choices are some stuffy art houses and giant multis offering the usual Hollywood drivel; this is what a theater ought to be, he said, and we tipped our ice-cold Victoria Bitters and toasted Anthony LaPaglia as the moon rose over the Harbor Bridge.

Broome and Sun Pictures

I'll never forget the bats.

Broome, Western Australia, on the other side of the continent

from genteel Sydney, is the rough, rangy, funny-accent brand of Australia we in the States hear about and see in movies. And it's butted up against a beach that seems never to end, spotted with a couple of world-class resorts. This is as remote as I wanted to get, since I could still get a decent cup of coffee as I watched a fistfight under a baobab tree while four-trailer, hundred-foot-long trucks barreled through town.

I stayed at the Broometime Lodge, a rugged little shared-bath hostel on the edge of the aboriginal ghetto. The saddest thing about Broome is the saddest thing about all nations that have driven the original landowners into internal exile: There is a palpable wall of fear between the conquerors and the conquered. I'd been warned to watch myself in this neighborhood, by the cabbie that drove me to the lodge and by a local couple on my flight in. Funny, though, the aboriginal fellow at the corner grocery shop was about as friendly as a person can get without knowing me, and gave me the only decent directions I got the whole time I was here.

No, I walked through these dimly lit neighborhoods on my first night in town with only one fear in my heart: the bats. The bats were everywhere, flying around the scant few streetlamps, flocking in the trees. Bats as big as seagulls, a muddy cocoa-red and shiny black. Screeching by the hundreds, swooping to get a better radar fix on me.

I've stood toe-to-toe with drunken Hell's Angels and not been so scared. These bats would dart down within inches of my face and give that horrid dog-whistle scream, veering off at precisely the last second. After awhile I started walking with my eyes closed; although I could hear them dodging within inches of my head, I didn't have to see it.

The sort of cultural center of Broome is called Chinatown. I happened to land in town during the yearly Shinju festival, the pearl festival, which may explain the thorough and unanimous intoxication. Broome was the center of the pearling industry many decades ago, and, as such, had a very large population of Asians from Japan, China, Thailand, and elsewhere. That population has moved on or mixed in,

so a lot of people have traces of delicate Asian features mixed in to the ruddy mutt look of the average outback Aussie.

In the middle of this madness is the Sun Pictures. It's Saturday night, and the line is down the block for the dusk screening of *Bridget Jones's Diary*. Again? Well, no worries, eh? Like the Majestic in Pomona, little has changed here since it was built in 1918. The old corrugated-iron building with its bulb-lettered sign is as inviting as a movie house can be. Inside, a wide-open palm-lined auditorium is filled with resort-style sling-back chairs and the atmosphere is utterly convivial. The day's hot broil has cooled to a simmer and people are milling about the place, looking at the ancient projectors that showed movies here in the silent era, then in the thirties, then during the war.

The walls are lined with memorabilia and photos from as far back as the early twenties. One photo struck me: Looking from the screen at a full-house crowd, the place looked exactly as it does today. The picture showed Asians, Aborigines, whites, packing the house; the plate under the picture read SEGREGATED SEATING, 1920s. For fifty years the theater was segregated. Europeans got the comfy cushioned cane-back seats in the sweet-spot middle of the house, Asians were herded to one side. The rest—Malays, Filipinos, Koepangers, and Aborigines—used a separate entrance and got bunched right in front, or in any other crummy seats left.

Segregated seating continued until 1967. It's part of an open wound Australia has yet to heal. And it's why I didn't much like Broome as a town. It still bears the unhealed wounds of racial hatred, a sickness that a lot of resort areas in poor places share.

But I liked the Sun Pictures, because the current owners have taken pains to speak loudly about the past, and to make everyone welcome. Nobody seemed to care who was what as we paid for our tickets, got ice creams, and sat down for a good laugh. People milled about, chatting, sipping cold drinks, munching popcorn and (ugh) pork rinds. Kids rolled on the large lawn just in front of the screen, where families had laid blankets and couples snuggled close.

The sun had just gone down, and the sky turned several deepening

shades of the most gorgeous blue, jeweled with gold-edged clouds the color of salmon. I got myself a can of Lemon Lift and a Choco-Bomb and struck up a chat with the folks next to me. They first came to this theater just after World War II, they were on their honeymoon. It was quieter then, they told me, a lot of people had moved on after the war. This was one of the few places in Australia to be bombed by the Japanese. They were smiling from ear to ear, these two, saying the theater hadn't changed at all since then. It was like visiting their past. They held hands.

The nearly full moon rose huge and bright behind the screen. A vintage propeller plane, a freight hauler headed for God knows where, lofted into the sky, flying right across the moon, rimmed in silver light. A swirl of bats darted from tree to tree.

I told myself: I am in an utterly foreign place, a deep tropical confusion, my head thundering with jet lag, witnessing a living postcard, and I'm about to share with these people a comedy I've now seen in five theaters in three countries and on two airplanes.

Well, I laughed as much as ever, I marveled at Hugh Grant's lout of a character, smiled at Bridget's pluck, thoroughly enjoyed the smart-assed cheek of a fine English romantic comedy; and I fell in love with another theater. As the boisterous laughter flooded out into the night sky, I disappeared once again with the crowd out there in the dark, and into a movie.

Noosa 5 Cinema, Noosa Head, Queensland	**Blow**
Dendy Cinema, Brisbane	**Nurse Betty**
Terrace Theater, Tinonee, New South Wales	**Himalaya**
Dendy Martin Place, Sydney	**When Brendan Met Trudy**
Ansett Airlines Flight 111	**A Knight's Tale**
Ansett Airlines Flight 111	**Bridget Jones's Diary**
Sun Pictures, Broome, Western Australia	**Heartbreakers**
Sun Pictures, Broome, Western Australia	**Bridget Jones's Diary**
Airport Lounge, Darwin Airport	**Amistad**
Ansett Airlines Flight 007	**A Knight's Tale**
Ansett Airlines Flight 007	**Bridget Jones's Diary**

AUSTRALIA, Part Two

The Delights of the Terrace:
The Smallest Movie Theater in the World

I don't know why or when my search for the Smallest Movie Theater in the World began, but it was an underlying impetus to write this book. I knew it would lead me into a world beyond mere commercial movie-showing. What would possess a person to intentionally provide a theater for the smallest possible number of people? It wouldn't be profit. Would it be passion, obsession, dwarfism? Further, what would be the point?

I had a few simple criteria: No personal home theaters allowed. This had to be a public venue; if not, I could've just gone door-to-door in Malibu. And it had to be a cinema first, not a café that shows movies on Saturday, but a theater as the primary business.

My search led me to a fleeting phone relationship with a charming woman in Anchorage who has a cinema with forty seats with a book-store and café. Too big. It led me out to the aforementioned New Mexico desert where I watched movies with boot-and-hat wearing, chaw-spitting, cinema-savvy truckers. Too big. It led me to a trailer in Park City, the mobile home, so to speak, of the Golden Trailer Awards. Not an actual licensed public theater. Finally, it led me to the almost overwhelming charm of rural New South Wales and the teensy town of Tinonee.

Tinonee is a microscopic village in the picture-perfect Manning Valley, too small to have its own hotel. I stayed in nearby Taree at the Dean's Creek Lodge, a comfortable bed-and-breakfast on a small farm. In the evening and early morning, 'roos hop through the yard. The owners, Brian and Pauline, made me feel so at home I was ready to move in, prevented only by the overt hostility of their savage Jack Russell terrier, Meg, who hated me. I swear the dog came into my room in the night, put a knife to my throat and whispered, "Yer dead, mate," but I can't prove it.

Since I was on foot, and the highways are narrow and dangerous, Pauline kindly drove me where I needed to go. This whole Manning River Valley is reminiscent of rural England, with its cottages and villages and local passions for tea and meat. But then you pass a sign that reads BILLABONG KOALA PARK, a cliché so stunning it can occur nowhere in the world but Australia. And the trees are so foreign, the names of towns and roads so alien, I was certain that I'd taken the overnight bus to the England that exists on the mirror Earth, on the other side of the sun. But it's as pleasant a setting as exists on this planet, and oddly enough it's home to The Smallest Movie Theater in the World.

The Smallest Movie Theater in the World is the Terrace Theater, and it lives in the tidy little century-old house of Darren Bird, the most passionate movie theater fan I have ever met.

Darren worked at the local cinema for quite awhile, and has been enamored of things old and mechanical for a long time—if I had to guess, since his childhood. He's the first to admit that he fell in love

with the places that show movies long before he loved the movies themselves. So, when he bought his little 1880s wood-frame house, a former maternity hospital on a quiet corner in Tinonee, naturally he started to build his own theater.

He didn't mess around. In the projection room is a vintage Simplex carbon-arc lamp projector, about the size of a Ford Escort. Then he built his own large reel system so he could splice all the small reels together for seamless presentations, just like the big boys. Over time he's collected seats from doomed old movie palaces and decorative bits from God knows where. The whole house is a domestic museum of Victorian decor and machinery from an age when machinery was fancy and cool to look at. H. G. Wells would feel at home here.

Now I know that lots of people have screening rooms in their homes, from the simple to the insanely plush. But here's the critical difference. Darren's Terrace Theater is an official, licensed, approved-by-the-government, in-the-directory, ticket-taking, concession-selling, new-release-screening movie theater. It is a business, a going concern. He's showing *Shrek* next week. He showed *Tomb Raider* recently. Naturally, the house was packed.

And as you might guess, this little theater that not only could but did has some drama attached to it. The owners of the local multiplex chain got their undies in a bundle when they caught wind of a guy showing movies in his home—not only movies, but good ones, better than what they show. So they ratted out Darren to the authorities, and in order to keep his hobby, he had to shell out tens of thousands of dollars to install sprinklers, exit lights, all manner of public safety code complicity. He had to hire a consultant to determine the stability of his house's timbers, floor, and roof; no doubt a guy in a tie and a short-sleeve shirt with a clipboard at one time stuck a flashlight in his toilet and had a look. But he paid, and he passed all the inspections, and now he has a real licensed business, a commercial theater, right in his home.

I love it when the little guy wins.

Walking up to the darling little house with its darling lighted sign, I spy Darren at the ticket window, which is actually his bedroom win-

dow. I immediately wonder if he's going to be like one of those hundred-cat ladies or some other sort of domestic-obsessive weirdo. Happily, it turns out he's as normal as you or I. Well, you at least.

The theater proper is a complete, comfortable, exquisite little auditorium with twenty-two plush velvet antique theater seats. It's classic cinema decor, all dark patterns and rich red velvet; the proscenium drapes lit by little statues of Pan or Hermes or some other naked guys with torches in their hands. You get the feeling that you have walked into not just a small theater but a *miniature,* like an oversize dollhouse. And for a man like me who has been mistaken in the wild for an Alaska brown bear, this can be unsettling.

Darren is a young, fastidious guy with a very nice haircut. For the screenings, he wears spotless evening wear. Finished selling tickets out the bedroom window, he puts a cigarette girl–type tray around his neck and saunters down the aisle handing out little bags of freshly popped popcorn, piping hot, salty, and delicious. Darren then introduces the film, welcoming everybody in a bouncy practiced tone, offering the upcoming schedule and inviting all to join him in the kitchen after the movie for tea and biscuits.

And just when you think it can't get any more darling, music begins and the miniature curtain opens to reveal a miniature screen. A little slide show introduces us to local merchants, and all the silly littleness starts to close in on me. My breathing gains weight, a hard helmet of popcorn hull suctions itself to the back of my tongue and I have to *ga-HACK* so loudly people turn around to see me, wet-eyed, jamming an index finger straight back to free the thing.

Then something wonderful happens. A spankin' new Cinema-scope-style screen drops from the ceiling and the film begins. The Terrace transcends its own novelty and becomes a fantastic cinema experience.

The scale for viewing is perfect. When the lights go down, you may as well be in a first-rate widescreen theater. The laughably small proscenium disappears and the projected image fills the field of vision comfortably, as designed. The extremely short throw from projector to screen gives us a picture of intense brightness and extreme sharpness.

You don't get a picture this vivid in most theaters. And the six-channel sound works beautifully here, just loud enough to drown out the massive projector behind the wall, but not so loud as to burst your tympanic membrane as in a lot of THX-certified systems.

All this came into play during the screening of *Himalaya*, a simple story about a society built on surviving in body and thriving in spirit, and how these two wishes come in conflict. It's a drama of images, a film of magnificent photography, color, and light, and immense mountains and bigger skies. Here at the Terrace, the mountains in sunlight are staggeringly bright and sharp; I imagined I could see my breath.

On the surface, *Himalaya* is slick and pretty, like a dramatized *National Geographic* story, and deceptively simple. The actors seem not to be acting; indeed, many seem not to be actors at all. And it would be easy to sit back and dismiss this, as A. O. Scott did in the *New York Times* as "a work of polite ethnography, a coffee-table book of a film that invites us to behold an exotic world from a comfortable and complacent distance."

But we, the tiny little audience, shared something more. I watched a pair of teenage girls, who came expecting to see *Shrek*, move from distracted annoyance to genuine involvement with the story. Man, woman, culture, tradition, nature, drama, image. Powerful tools for storytelling. And it drew them in.

The best thing a filmmaker working in a foreign land can do is share the feeling of foreignness. What we have in common is not all that interesting; it's the oddness of another culture that allows the commonplace to attain beauty. We shared the heart of cinema, as the Lumières might have had it, sitting in the dark in a group watching things we've never seen before, a way of connecting one to another.

It was a wonderful experience, and I told Darren so over tea and cookies in his kitchen after the show. This is a guy so connected to archaic technology that although he has his own commercial cinema at home, he doesn't have an e-mail address. Darren has been showing the off-release biggies like *Shrek* and *Tomb Raider* to help him cover his nut, but he plans to convert the schedule to carefully selected clas-

sics and art-house fare. It draws the kind of audience he'd like to share his house with. I understand that. It just suits him better.

The atmosphere of cinema has changed, Darren says. He doesn't understand why multiplexes don't show anything more than Hollywood crap. He apologizes to me for calling Hollywood crap "crap," as if as an American I might find this offensive. But more than that, Darren doesn't understand why there is no style, no visual appeal, to the modern movie house; it's as if they forgot that going to the movies is an event.

So I envy Darren Bird, and the fact that he can sell tickets out his bedroom window and dress up in a tux every night, and that he can make a roomful of people smile with his little bags of popcorn and he can transport me to a high mountain legend in his back room on a weeknight. Darren has taken his hobby to heart, and we get to share it with him. He has created a classic movie house in the spare room.

He enters the roles of cinema greatness by inviting total strangers to share in his fun, for a very modest fee, and with free popcorn.

It's infectious. It rubs off. And you can see that little-boy twinkle in his eye that says he knows it and he loves it.

✳ WEEK 37, SEPTEMBER 10–16 ✳

Dendy Cinema Opera Quays, Sydney	**The Bank**
Air New Zealand Flight 104	**Bridget Jones's Diary**
Air New Zealand Flight 104	**Someone Like You**
Air New Zealand Flight 54	**Shrek**
Empire Cinema, Rarotonga, Cook Islands	**Waking Ned Devine**
Empire Cinema, Rarotonga, Cook Islands	**Duets**
Empire Cinema, Rarotonga, Cook Islands	**Exit Wounds**
Empire Cinema, Rarotonga, Cook Islands	**Recess: School's Out**
Empire Cinema, Rarotonga, Cook Islands	**Exit Wounds**
Empire Cinema, Rarotonga, Cook Islands	**Swordfish**
Empire Cinema, Rarotonga, Cook Islands	**Dr. Doolittle 2**

I Tasted the Tutti-frutti of Rarotonga
The Movie Culture of the Cook Islands

Rarotonga is in my mind one of the world's perfect places. It's only fourteen miles across, one of the southern group of the Cook Islands in the South Pacific, about fifteen hundred miles from New Zealand and two thousand miles from anywhere else. It's ringed by a massive coral reef, giving it a huge gentle lagoon and water so clear that my kayak appears to float on air. Inland, it's crowned with green-cloaked extinct volcanoes, all climbable. It has no deadly snakes or insects. It's populated by Cook Islands Maori, an aloof but gentle and friendly folk once you get to know them, and by expatriate New Zealanders—Kiwis—who are simultaneously utterly relaxed and insane.

Luckily for me, it also has a movie theater, maybe my favorite in all the world.

It rains a lot on Raro, often for days at a time. It's nothing like weak Seattle drizzles or even Florida frog-chokers. Water comes down with the kind of steady and insistent slamming reserved for fire hoses and Wisconsin Dells fun parks. For the native Cook Islanders, this is a way of life, and they go about their business as usual, driving their little motorbikes on the island's one and only fully paved road. They might take the laundry off the line, but I'm not sure of this. Me, I needed a snorkel just to wait for the Island Bus. It rained heavily and steadily for about half the time I was there. Never before or since have I been so thoroughly hydrated.

This much rain makes the one and only movie house a cultural hub, if for no other reason than you get to sit in a large area that isn't wet. But the Empire Cinema is also a key to the island's past, a genuine icon of the changing world culture, and the last of an endangered species. And if you're lucky, it's a place to get the best tutti-frutti ice cream you ever pushed against your tongue.

Tucked into a corner of the tiny downtown area of Rarotonga's capitol, Avarua, the Empire is a large metal-roofed barn with coral walls, and two screens. On the weekend the place fills with young and old islanders who wander outside the theater on the rare occasions that it isn't raining, sipping the astoundingly sweet local soda and slurping cones of ice cream from the closetlike refreshment stand. Piltz Napa, tonight's proprietor-refreshment vendor, comes out, flashes the lights, and hollers when the movie is about to begin. Folks shuffle in to the larger theater (maybe two hundred fifty seats) or the smaller theater (less than half that) and hunker down. Kids run about. Folks come and go; the doors stay open. Inevitably the rain starts again, in torrents, pounding the roof like a thousand Tito Puentes.

You just gotta love a place like this. This is my second trip to Raro, and the Empire was one of my inspirations to write this book in the first place.

• • • • •

Two years ago I came here for a month's retreat and felt like I'd found my home from another life. I came to the Empire on a few rainy nights and felt how special it was as I watched Terrence Malick's *The Thin Red Line*. Malick doesn't make very many films—this was his first in twenty years—but since they've all been masterpieces, I really can't complain. The story weaves in and out of the minds of the soldiers in the devastating battle for Guadalcanal. In the hands of a less capable director, the story would have foundered under its own weight. It is a walking meditation on war and its cost, and does justice to the original James Jones work.

But what struck me hardest about the film was *where* I was watching it. Guadalcanal and its surrounds are very much like Rarotonga. Everything in the movie reminded me of Raro: the intense lushness of the landscape, the very closeness of the sky, the strong but friendly features of the Polynesian Maori and their angelic choral music. Isolated as it was, Raro played a very small part in the war, but many of these scenes could have happened on the quiet bays of Raro's lagoon. Long gone are the days recalled in the Maori dances and songs when these people were great warriors and explorers; the kind of war waged by our conquering nations eclipses any conception an islander might have had of such horror. It made me certain that we in America can never again be as quiet-hearted as these people.

Then about halfway through, the film stopped.

I thought the projector broke down; it wouldn't have been a surprise. Instead the audience rose and filed out. Intermission. *Intermission*? When was the last time you went to a two-hour film with an intermission? What a delight! Outside the rain had stopped, a huge moon waxed full, lacing the clouds with silver, and the entire audience stretched their legs.

I was learning a lot about this island, right here in the parking lot of the movie theater. Coming as I did in the off-season, there were few tourists, and the theater had none but me. I felt I was seeing Rarotonga as it is, a small town of about ten thousand, doing what it does on a warm, tropical winter night. This was theatergoing in its purest social sense, a chance to meet friends and spend a couple pleasant hours

together. Just townsfolk out to a movie show. Ultimately the place reminds me more of Mayberry than of Bali-Hai—friendly, quiet, simple.

I stepped up to the tiny refreshment stand. Tutti-frutti ice cream for me, flown fresh from New Zealand and fatter than butter. In front of me, a trio of barefoot boys dangled from the counter by their elbows, carefully counting their coins. They all frowned at each other; they didn't have enough between the three of them for two ice creams. Geoff the proprietor scratched his chin, winked at them, gave each an ice cream and took half their money.

I was a long way from the multiplex.

So, I had to come back to Raro to see if things had changed in two years. They hadn't, thank God; but the Empire is the last of a breed on this island, which at one time had a dozen theaters, and it's struggling to stay alive. I met with Harry Napa, owner of the Empire and one-time movie theater mogul on the island, and he explained the cinematic history of Rarotonga.

Back in the sixties, the island held the Guinness world record for number of movie seats per capita. There was the Empire, the Victory, the Sunrise, the Sunset—it seemed there was a cinema within walking distance of every soul on the island. It was all competition. Harry bought the Empire and the Victory, someone else opened another, then Harry opened another, and on and on. It got silly, but, hey, it's a small town, so it never got too silly.

Then, on a trip to Asia to buy films, Harry discovered kung fu movies—more accurately, his kids did, sitting glued to the screen watching a movie in a language they didn't speak. He brought them back to Raro, and the theaters were packed. By becoming the exclusive pipeline for films like *Five Fingers of Death*, suddenly Harry was the Rarotongan movie mogul.

Harry is a true Maori gentleman. Big, Polynesian-shaped, gentle, looking younger than his years, he sits cross-armed in his office at the Vaiora soft-drink bottling plant. That's Vaiora, "The People's Drink, Made the Way You Like It." Well they like it *reallly* sweet here, in fla-

vors such as pineapple and lime. *Yeeks*. Although a busy man, Harry happily whiled away the morning with me as the rain once again hammered down outside and nobody was going much of anywhere until the road reappeared. Harry told me how his cinematic empire came down almost as fast as it went up. The reason: video.

Yes, video, the angry son who killed the king and took his kingdom. Before video, the local cinema was the only way to see movies. When easily distributed, convenient little VHS tapes started to hit the local market shelves, people stopped going to the theaters. So long to the Sunrise, the Sunset, the Sunflower, the Victory. Only the Empire remains.

Harry's genial son Piltz took me on a tour of the Empire. Built with walls of coral, the thing has survived typhoons; it's as solid as the ancient mountains that crown the island. They "twinned" the theater in hopes that it'd help them compete with video. No chance. The projection booths each sport twin English Kalee projectors, furnace-hot carbon-arc affairs made in the thirties and virtually indestructible. It's old-world projection here; the projectionist has to be on his toes changing reels and switching projectors on cue, a craft long gone from the modern multiplex.

Each night of the week one of Harry's adult kids and their families run the theater, taking turns. Piltz's kids smile and giggle as they take tickets and scoop out ice cream—tonight it's just vanilla. Piltz gives a diplomatic smile when I ask him about video. It wouldn't be that bad he said, except for the damn pirates.

Ah, yes, the pirates, *arg, harrr*, me boys. All over Asia, these black-guards are sneaking little DV video cameras into theaters and shooting the screens playing the world's most popular movies, quickly distributing them on VHS and now DVD. "Have you seen one of these things?" Piltz asks me. "The sound is horrible. And the picture, sometimes you see people getting up and moving around the aisle. But who cares if you can get *Tomb Raider* three months before we show it."

It's true. Not a hundred yards away, Video 2000 has every film I'll be seeing this week at the Empire but one, *Recess: School's Out*. Nat-

urally the tapes are horrid, badly subtitled, with photocopied labels. The picture sucks and sometimes you can't hear a thing, but you can see *Shrek* now and it won't be at the Empire until November. *Harry Potter* was available on DVD in Singapore the week it was released in the theaters in England. People are so hungry for Hollywood's latest they can't keep the stuff on the shelves.

What can be done? Not a whole lot, according to Geoff Bergin, Harry's son-in-law, the guy who gave the free tutti-frutti to the kids. The Napa family has tried to get support in the Rarotongan parliament for an antipiracy law, but apparently the owner of the video chain and several pals are in parliament, so that corks it; further, Rarotonga has never gotten around to creating any copyright or intellectual property legislation, simply because the issue has never come up, and because now it would be complicated. When you have a parliamentary system to govern about twenty thousand people on a dozen islands hundreds of miles apart, things can get a bit political.

Besides, it's a worldwide problem, these pirates and their booty. Cheesy videos of current movies are available everywhere if you look for them. It's a hard thing to stop, and it demonstrates how much illicit trade goes unchecked. But it also says volumes about our trade relationship with China, where a lot of these videos originate. We could stop it if we wanted to, but our government wants so much to trade with China that we let this and many other problems go. Such as Tibet.

Harry is understandably philosophical about the whole thing. "I'm not making any money with the Empire; in fact, I lose more each year," he sighs, in a soft New Zealand Maori lilt. "But I love it, I've always loved the cinema, and my kids love it, too. It's a good thing for this island, keeping it open."

I did my bit. I spent every night there; I went eight times in seven nights. I even endured *Exit Wounds* twice. On my last night in town, after seeing the thoroughly disturbing *Arlington Road*, we filed out quietly into the night and its rain. Piltz and his crew were popping corn in coconut oil and chatting with friends under the palms.

Tonight they were serving an excellent banana ice cream. Polynesian music rode on the wind from someone's radio. It had been a hard week in so many ways, as I'll explain, but I got to know the Empire and the family that loves it, and I feel the world is better because of it.

Now if only they'd stock up on the tutti-frutti.

Empire Cinema, Raratonga, Cook Islands	**Arlington Road**
Air New Zealand Flight 54	**Driven**
Air New Zealand Flight 54	**The Mexican**
Air New Zealand Flight 54	**The Luzhin Defence**
Mann St. Louis Park Cinema 6	**Rock Star**
General Cinema Centennial Lakes 8, Edina	**Musketeer**
Muller Family Theaters Lakeville 8	**Hearts in Atlantis**
Oak Street Cinema, Minneapolis	**Jabberwocky**
General Cinema Centennial Lakes 8, Edina	**Herman, USA**

September 11 at the Empire

Tragedy and Comedy Half a World Away

I'm home. After three and a half weeks abroad and several fantastic experiences, I touched down in Los Angeles at dawn in a country that had changed since I left. Eight days ago the World Trade Center went down, the Pentagon was attacked, flight 93 crashed in Pennsylvania, and the new millennium truly began. And in this new country, change occurs rapidly.

I'd been in the air over the Pacific when it happened. American Flight 11 was hitting the North Tower as we were on approach to the airfield at Rarotonga in the Cook Islands, where I planned to spend a week of R&R and movie-watching on my way home from Australia.

My host, Jim Bruce, a Hawaiian Yank who'd just moved to Raro, picked me up in the warm, misty night. It was a little past midnight in Raro, a little past 9:00 A.M. in New York. I'd crossed back over the dateline and my body clock was nearly running backward, so after a celebratory shot or two of rum I hit the bed and slept.

Jim woke me up just a couple of hours later. "You're gonna want to see this."

The island has but one TV station, no home satellite, no cable. There on the screen was the Pacific feed of the BBC from Auckland.

We watched everything.

I've spent a lot of time away from home this year, and I have missed my family and friends. But I'd never felt truly homesick until that day. My heart ached. I wanted to be home and knew I couldn't get there, and I hurt.

None of this had happened to me. I was in one of the safest places in the world at that moment, a tiny tropical paradise with no outward political agenda. Yet all I could think about were my friends in New York: Mike, Tom D., Kirsten, Mary Jo, Sean, Tom V., Barry, Douglas, Andrew. All their faces appeared to me, smiling and laughing, alive. I thought of the people I didn't know, had never met, instantly gone. Their families, their lives forever changed. A world full of people suffered that day and would suffer for long days to come, and nothing could change that.

Suffering is something we all have in common, isn't it? It's part of our humanness. We're born, we live, we die; if we don't want to die, too bad, we suffer. If we do want to die, we're suffering now. Some of the world's oldest stories are those of pain and loss, of heroism and sacrifice, of how the world as it is can come undone, and how we suffer. Those ancient stories were lived thousands of times over this week, and they will spread out into the world to become part of our fabric, our experience.

I thought about my silly little movie project, how in the perspective of the world as it is, it seemed now stunningly insignificant. I thought to myself: No doubt Hollywood in its crass and brutish way will try to

tell those stories. No doubt they will fail. And no doubt Hollywood will drill us with endless stories of bravery under fire, quickly pushed into the theaters, ostensibly to help us, to serve us, to inspire us to be better Americans. I stopped the train of thought there; I couldn't afford to be this cynical. It did me no good.

Sick at heart, I went into the island's main town, Avarua, to the Empire, my favorite theater in all the world. They were showing *Waking Ned Devine*. I couldn't have asked for a better gift.

Waking Ned Devine has become a favorite of mine, a low comedy with high ideals, the story of the Irish town of Tuleigh More, which bands together to defraud the Irish lottery out of a prize won by old Ned, who died the moment he saw his winning ticket. Avarice, charity, love, enmity, folly, nobility, all play out in this small silly story. And we get to see a scrawny old man ride a motorcycle nude.

It's hilarious, and it has a heart. It deals with death, loss, desire, charity, and friendship. Friendship above all. With a crowd of about thirty, including a handful of heartsick Yanks like myself, I was able to laugh without forgetting the day's pain, I was given a moment of relief at a hard time. It helped me beyond belief to share in the foibles of this tiny Irish town, to see that life endures through death. I remembered that Jane and I had gone to the theater to see this film more than a year ago, at home. So I got a taste of home as well.

For the rest of that week, I felt more welcomed on Raro than ever. Everyone knew I was a Yank. People bought me breakfast at the Cook's Corner, beers at Trader Jacks. I sat with my friends Neil and Janet at The Café, tried to enjoy their incomparable food and coffee and found real camaraderie and comfort. And as I listened to dozens of stories about my home country from foreigners, I learned that for all its faults, the freedom we have in the United States and how well we use it is a thing considered rare and wonderful in the rest of the world. People sensed the loss deeply. I was far from the only one hurting.

Now, remember Geoff Bergin, the quiet winking fellow who gave tutti-frutti ice cream to kids with no money? During the week, Geoff found the only two American flags on the island and put them up on

either side of Avarua's main street facing the ocean. Within hours the seaside flag was covered in flowered *leis*, bouquets, and letters of condolence. Geoff said in the local paper, "I put the flags up to show the world that we are mourning, too." At night the town's searchlight was trained on it. And the Empire cinema was fuller than usual, with people looking for some togetherness and a little healing. We were happy to join a tiny Irish village for a laugh.

At the end of the week a prayer service was held, crossing all boundaries, words said by the heads of all the local churches and the island's tribal queen. Dozens of flowers were gathered, blessed, and scattered on the waves, carried out with the tide and into the Pacific. Blessings in half a dozen languages went with them.

This is what grace is to me, a gift unlooked for, coming when most needed, letting us know that healing comes, eventually, to those who seek it. Like I've said, the best moviegoing experiences cannot be separated from their circumstances, and this was one of the best. The movies cannot save us, they can very rarely even change us in any way, but sometimes they can help a little along the way, and the rest is up to us. During hard times people go to the movies, to sit together and feel better for a while.

If the movies could do nothing else for us, this would be enough.

Venue undisclosed	**Glitter** (Paid for **Herman USA**)
Venue undisclosed	**Hearts in Atlantis** (Paid for **Herman USA**)
Venue undisclosed	**Glass House** (Paid for **Herman USA**)
In Motion Video	**Memento**
Delta Flight 66	**Shrek**
Delta Flight 66	**Streamliners**
Delta Flight 66	**A Knight's Tale**
Cinema Accademia d'Essai, Venice	**Le fate ignoranti**
CineHall Exscelsior, Florence	**La maledizione dello scorpione di giada** (The Curse of the Jade Scorpion)

Sneak Your Way to Savings!
Ticket Flopping, Screen-hopping, and Flat-out Breaking the Law

I write this not to encourage people to do anything illegal, unethical, or immoral. Fattening, maybe. But I did what I have done, lame as it is, in the name of pointed civil disobedience, to observe an ongoing social practice and to throw a tiny bit of money the way of the independent filmmaker.

That said, boy, did I have fun.

Sneaking into things is a tradition as old as petty crime. It's a good bet that Gilgamesh and his army sneaked into Kish in about 2700 B.C.E. History's favorite act of sneaking in, the legend of the Trojan horse, coined that quality of humankind we know today as gullibility.

I'm certain that the first great comedy writer, Aristophanes, snuck in to Dionysus festivals looking for material. You can bet that at the dawn of the cinema, little shavers in knickerbockers sneaked into the local vaudeville and got in trouble for it the moment the phenomenon called "persistence of vision" was first publicly demonstrated.

I hadn't snuck into a movie since I was about eleven, when a pal held the back door of the Wheaton Theater open for me. Then, suddenly this summer, for reasons you don't need to know, I was late for the last Sunday-night screening of anything in my part of the metro area. It was ten-thirty and the last show had started at ten-fifteen. By now all the doors were locked and no one would even let me in to plead my case. I went to the next theater down the road—in the suburbs, the glut of multiplexes turned out, this night, to be a blessing. I was only ten minutes late there, but it didn't matter. The lobby was almost empty, the doors were locked. Inside people were enjoying quality entertainment from the nation's major studios; outside I was banging at the door, vainly trying to get the attention of distracted teenagers in dirty uniforms. I walked back to my car, sullen, wondering what I would do. *I couldn't not see a movie.*

I'd parked near an exit. Suddenly the doors opened and folks from an eight-thirty show headed for their cars. Without even thinking, I simply walked in the out door and proceeded, deliberately, to the nearest auditorium. Sure, I had to sit through *Swordfish* again, but I got to see a movie. I broke the law and saved my own ass.

It got me to thinking. Out here in the suburbs, a lot of movie theaters are amazingly easy to sneak into. One theater not far from me has entrances to the bathroom on both sides of the ticket-taker's area, which means someone is either dumb or trusting or both. I just walked from the front entrance into the can, spritzed myself with a little tap water, and walked to the nearest auditorium with nary a look. The next day I simply walked into another unnamed multiplex with a ticket stub in my hand and said to the kid at the ticket-ripping thing, "I'm in theater five; I had to go to my car." I had no clue what was playing in theater five, but neither did he. I said it with confidence. The kid at the thing let me right through.

The full thrill of petty misdemeanor was upon me. I don't consider it good or fair to do this, it can only serve to raise ticket prices and anger theater owners, two bad things. So, if you really want to do something sneaky in a movie theater, let me suggest screen-hopping.

I've been a compulsive screen-hopper since the first time I went to a multiplex, and I will be until the day I die. It's their own damn fault for putting so many theaters in one place, you know. One miserable sleety day in Madison, Wisconsin, I paid for one ticket and saw four movies. After my third, while purposefully walking through the lobby, I ran into my sister Kassie, who was on her second. We saw the next movie together.

Here are the basic rules of successful screen-hopping:

Appearance is everything: Be an adult. Being a white, middle-aged adult with a normal haircut, polished shoes, and khaki slacks is the best way to avoid detection. If you have an Afro, a soul patch, or a lip stud, you may as well be wearing a bull's-eye on your back. If you have any smidgen of ethnicity, avoid screen-hopping in midwestern suburbs. Be white, dress conservatively, and look Republican, and you could disembowel someone in broad daylight and get away with it.

Always pretend you know where you're going, especially if you don't. Don't wander around the lobby with an empty popcorn bag in your hand mumbling loudly to yourself, "Gee, whillikers, what'll I see next?" or you're sure to be shown the door. Most multiplexes now have little lobby cards or flashing LED signs telling you what's playing on each screen. Some are nice enough to provide the start times as well. But appear certain that you know where you're going. If you founder, head for the nearest can, gather yourself up and try again.

Don't be too picky. If you hang around the hallways for an hour waiting to see *Lord of the Rings* for the twelfth time, you'll be spotted and hanged. A little planning and reconnaissance help here: Pick your movies and times before you go. Then, before you see the movie you actually paid for, wander up and down the corridors, pretending this time that you *don't* know where you're going. Check every screen and every screen time, note them, and target your next screening.

Buy something from the concession stand. You're getting a free movie, and it's common knowledge that theaters make their biggest

profit margin on concessions. Further, my experience has proven that no manager will kick you out if you have the extra jumbo popcorn trough and the six-liter promotional drink jug in hand.

If you get caught, don't lie. I can't lie well at all. I haven't lied successfully since 1975. Own up to it, apologize, and leave. Many multiplexes are cracking down on screen-hoppers now, and have installed Vegas-style security camera arrays around the joint. At the Mall of America, actual police have been hired during peak hours to prevent screen-hopping and its nefarious cousin, ratings-jumping.

Ratings-jumping has become a major problem for exhibitors. Earlier in the year, as I waited for *Scary Movie* 2 to start, a couple of nervous kids came and sat down right next to me. They couldn't have been more than twelve each, and they'd snuck into an R-rated film. One of them whispered to me: "Excuse me, sir"—I love it when kids call me sir, it means they want something—"do you have a ticket stub?" Yes, I told him; I didn't reveal that I have hundreds of them. "Can I have it?" I told him sorry, but no dice. I didn't lecture him, but in the secret pact of sneakers he and his pal were on their own.

I couldn't judge the kids. When I was a freshman at St. Francis High School in Wheaton, Illinois, home of the Spartans, I sneaked in to see *Summer of '42* with some friends. It was a scandalous film, with sex between a teenage boy and an older woman! Wow! It was rated R; worse, the film was and still is on the very edge of condemnation by the U.S. Council of Bishops. Holy cats! But it was also funny, *Catcher in the Rye* funny, and it dealt with teenage sexual awakening in a way that was candid and honest. I'm not surprised that the rating has dropped from R to PG. It wasn't really a dirty film.

However, *Scary Movie* 2 is dirty. There is no intelligence involved at all; the subject matter is primarily ejaculation. I couldn't condone helping the kid on simple aesthetic grounds. Now, if he'd snuck into, say, *Our Lady of the Assassins* I might have helped out, even cheered him on. But I'm a snob, prone to snap judgments, and *Scary Movie* is simply about filth and how funny filth is. Kids can sneak into that at their own peril.

My favorite act of cinematic subversion is the ticket swap. Four times in the last week I paid for one movie and saw another. It's my lit-

tle political statement, my way of sending a few dollars the way of a deserving film and keeping it out of the hands of the crap makers. I saw the movie *Herman USA*, a very nice small film, based on the true story of the little town of Herman, Minnesota, which had a brutally high ratio of willing bachelors to wanting women. So, the folks of Herman advertised their bachelors and invited women to come visit Herman and find husband material. Well, they came from all over the nation and created one of those media storms that pop up like freak tornadoes every now and then. A local filmmaker saw the charm of the whole event and crafted a fiction out of it, cast it wisely, shot it beautifully, and created a nice story about nice people trying not to be lonely.

I liked it, and I wanted to support it; but I didn't want to see it three times in a row. So, for the next few days I would pay for a ticket to *Herman* and go see whatever I pleased.

More than once I wished I'd seen *Herman* again, because I saw *Glitter*, the thoroughly stupid Mariah Carey head-shot delivery vehicle, and *Glass House*, a thriller bereft of a single thrill. With apologies to Leelee Sobieski, I really wish she didn't look so much like a puffy scale-model of Helen Hunt, and I wish she could express emotion. If she can get over those two hurdles, she could be a top-notch middling actress.

Ah, well, research is research, and I have to take the bad with the good. And through my efforts in ticket-swapping, *Herman USA* got another twenty-four bucks of box-office gross thrown its way, of which after expenses the producers may see three cents. But it made me feel good as a moviegoer not to waste eight bucks watching Mariah wiggle her clumsy baby fat around and yodel like a Swiss castrato.

Movies should be neither a waste of time nor a waste of money; that's what television's for.

The above practices are not ethical, are not legal, and will not make you any friends at your local theater. So, please do not do them. But if you must, pick a theater you don't frequent and do it only occasionally, do it with purpose, and, above all, do not tell them I told you to.

Rischiando le mie natiche per amore del cinematografo[14]

Film, Flu, and Failure in Italy

Falling into the lap of a well-dressed woman on the bus barreling madly between Positano and Sorrento, I've made a note to myself to find the term in Italian that best describes "crazy." And as we rocket through Hitchcockian cliffside curves that could easily kill this wildly overcrowded busload, I know I'll have to find an idiomatic word or phrase equivalent to "bat-shit insane" or "homicidal bozo."

The furious driver, more than a half-hour behind schedule and apparently tired of constantly being reminded of it, has decided to take

14 "Risking My Buttocks for the Love of the Cinema." I think.

his and all our lives in his hands as payment. We tear through the curves on this cliff-bound road at almost twice the posted speed. We standees are hurtling into the seated people. At least two people now are screaming loudly; one English woman repeats, "Dear Christ, he's trying to kill us," and several others yell "stop" or "slow down" in a rich variety of languages. *Alto. Halt. Arretez.*

But there is no word for stop in this driver's vocabulary, and he hammers it down through the twenty-seven switchbacks and hairpins between Positano and Sorrento.

Let me quickly explain how I came to be here, tasting death in my mouth like postnasal drip, hell bound through some of the most dramatic scenery in Italy.

After all the travel I have done, and the staying home my beloved spouse Jane has done this year, we needed a vacation, a genuine holiday, together. Jane is twice the traveler I am, and has watched patiently this year as I have tripped along to some of the world's loveliest places only to sit on my ass in the dark and watch movies.

Now it's her turn. We cashed in a hundred thousand frequent-flier miles for two tickets to Zurich, only a waypoint, and we immediately boarded a high-speed train for Italy. Our ultimate destination is Positano, as a city a poster child for Italy, tucked into the sheer cliff sides of the Amalfi coast, where even the public toilets have spectacular views of the cliffs and a sea far bluer than any of the United Colors of Benetton.

First stop was Venice, which fairly shimmers in the pale October mist. It's a wonderful time in Venice; the tourists have abated and the weather has cooled. I'm told that during the summer the stench from the canals has been known to bring down satellites, but the rain has left only the clean smell of the sea. It's a stunning place, its own complicated work of art and history, where every narrow street corner reveals a new surprise, and the shop owners, catching their breath after the summer rush, are wonderfully genial and talkative.

It's also the only place I've been offered an antipasto of air-dried horse.

Italian cinema has been an inspiration to me since college. Here

are some of the funniest comedies, the saddest tragedies, the sharpest satire, the most daring avant-garde of the whole first century of film. Italian filmmakers have been adding to the vocabulary of the cinema for decades and will continue for untold decades to come. Why? Hell, why are Italians good at any art form, from music to painting to sculpture to opera?

Passion.

Passion drives the Italian arts because passion is a part of everyday life here. You can see it in everything from the food to the architecture to a simple ride on a train. Here in Venice, the surprisingly modern Cinema Accademia d'essai hides in a medieval shell within pigeon-dropping range of the Gallerie Dell'Accademia, one of the world's greatest collections of old art and sculpture. You'd expect the nearby cinema to offer some substantial fare, and it doesn't disappoint.

Even popular Italian films have a quality of humor, image, and craft that make them very watchable even if you don't know the language. I saw the film *Le fate ignoranti,* in Italian, and I don't even know the Italian word for toilet paper, but I was still able to follow and enjoy this warm and surprising story. Antonia, a conservative upper-middle-class woman, or what we around here call a Talbot's junkie, has her life turned upside down when a reckless driver kills her husband. No surprise; the easiest way to kill yourself in Italy is to step out into the street. To make things worse, Antonia finds out that her husband was gettin' him some on the side, and that some was another man. She confronts her husband's lover, Michele, only to find out what her husband knew, that he is a sweet, caring sensitive man, with a killer bod. Antonia's life and sensibilities are turned around by Michele and his close-knit group of friends, his intentional family, who spend all their time in his house eating his food, as family should.

The experience turned around my own attitude about Italians, whom I'd heard were brutally intolerant of gays; but here, on an autumn weekend, the house was full and the audience seemed happy. I'm gratified by how normal the gay folk appear in the movie, their "aberrance" is thoroughly in the mind of the beholders. In *Le fate ignoranti*, it's just a fact of life. The title has an ironic twist: "The

Ignorant Fairies," if nothing else, indicts the ignorance of those who choose to remain outside and judge, which has been, in general, the religion-centered Italian mainstream, or the Talbot's junkies.

What a great way to start the trip! On we went to Florence, where we ate gelati six times a day. And while Jane sipped wine for two hours in front of the Duomo, I trotted off to the fantastic Odeon CineHall, a true movie palace of grand size and first-rate presentation. The lush seats. The double armrests. A balcony, a mezzanne, *and* a dress circle. Magnificently appointed, quiet, and comfortable. Boy, did I envy Jane.

How's that? I envied Jane? Yep, because I had to spend two hours watching the movie *Bounce*, the most aggressively moronic romance of the year. It was showing as part of the Odeon chain's repertory screening of American films in English. It shows respect, intelligence, and real passion to regularly show foreign-language films without dubbing or subtitles. Just try to find that in the States.

But *Bounce*? Dear God, this movie's more annoying than a Jewel concert! The eponymous fabric softener is more entertaining. Here I was, in Florence, the very heart of the Renaissance, and I had to watch Ben Affleck and Gwyneth Paltrow moon and pout and feel sorry for themselves. I immediately ran out and got a double espresso to numb my overloaded sweet center.

I collected Jane. She was in the same spot, just looking at the Duomo, that point of pilgrimage for lovers of art and history, a building so intricate in design and decoration, it creates its own drama.

Passion. It shows in every aspect of Italian life, from the heavenly art and architecture to the uncanny ability of Italian people to speak their minds, even to perfect strangers. On the train from Naples to Sorrento, I witnessed a small Italian drama. A short man with a bad toupee sat behind us, slumbering. The conductor nudged him, asking for his ticket. He mumbled something and closed his eyes again. The conductor repeated. *Biglietto. Biglietto.* The man produced a ticket with a few gruff words. The conductor frowned, the dialogue escalated.

I didn't know the words they were using but I certainly could follow the conversation:

The ticket is no good.
What do you mean it's no good?
It's no good I tell you.
And I tell you it is!

The dialogue turned into an exchange, quickened to an argument, and then transformed into an opera. Italian, spoken with sufficient vehemence, becomes very lyrical, anger riding up the scale, fury speeding the rhythm. The man's gestures punctuated every word— clenched fists, chest pounding, bunched fingers thrust up and down. Another conductor joined in, and now we had an aria for two conductors and a freeloader. The man started to sweat and curse, his voice high and loud. He was going to lose this argument but he refused to lose his pride.

Without missing a word, the man opened his wallet, flung several thousand lira at the conductors and backed himself into a corner, gesturing to indicate that they were tearing his heart out. Placated, the conductors began a *decrescendo*, patting the man on the shoulder, speaking now in buoyant conciliatory tones, as the man's face grew less red and his fury eased. At the end, they all shook hands, all was forgiven, dignity was preserved, life was good again.

I wanted to stand and applaud. This was what brought me to love the work of Italian movies, this everyday passion, the Italy of the Sorrento train argument. It's funny that I found the essence of Italian cinema not on a movie screen but on a train to Sorrento.

On to Positano, the cliff-clinging village on the Amalfi coast with a view of the islands of the Sirens, and I have developed a miserable flu. My nose runs like a glacial spring, my tonsils fill my throat. And it's a good thing, too, because it keeps me from having to breathe as I climb the several hundred stairways that lead people around town. But it's pretty, friendly, and quiet in the off-season. And as dusk settles in, the lights of the town deck the hills with gold against the dusky blue; you couldn't ask for a more perfect place to hole up for a week. The only thing it's missing is a movie theater.

We reach our villa after a long day of travel all the way from Florence, and we're greeted by our old friends Tom and Vicki, the saints

who invited us to come and share their villa. Tom is a musician, a sound designer, and one of the world's calmest people. Vicki is a gracious life-loving gourmet. We share the villa with them and their friends Connie and Greg. They're all thrilled because I've brought my projector and several silent classics to play. I have a Super-8 this time, partly because it's much easier to lug around in trains, buses, and taxis, but also because my dear friend Diana has provided me with several good prints of classic Chaplin featurettes and Disney cartoons. It's the perfect travel cinema, and will keep me from having to spend half my day going into Sorrento and back, a good hour each way.

Wine is poured. Fantastic pizzas are brought from the nearest of several smashing pizzerias. I set up the projector, pick the movie—tonight it'll be *The Tramp*, the iconic Chaplin. Tom has brought a tiny portable stereo and several disks of movie music by Fellini's favorite composer, Nino Rota. Everything is in place. There's just one problem.

The projector doesn't work.

It's not the voltage. I'd tested it in Florence and it ran fine. It's not the lamp. It's shining bright as can be. It's something in the transport. Tom steps in: He's field-stripped Nagra tape recorders on the Pakistani steppe, he ought to be able to handle this. Out come the Leatherman tools, the flashlights, the magnifying glasses. We take the projector apart, inspect the guts.

Nothing.

We pull out more parts, spin some things around, change the voltage, the polarity, the grounding.

Nothing.

I would try for another hour, to no avail. Too late to head into Sorrento, last show was at seven; it's nine. No other theaters within a hundred miles.

No movie tonight.

What does this mean, what does this mean? Does this mean *no movie tonight*? No, it can't mean that, after ten months, ten countries, fifty cities, three hundred screens, one near miss, the Arctic Circle, the Australian outback, the South Pacific, two thousand miles of

American desert, a Mexican fishing village, an igloo, and a kidney stone? No movie?

No way.

Back I go, tearing into the very soul of the dead machine, knowing full well that the bearings are blown and there's no way film will go through it for us to see in any recognizable way. I pick up the film and peel the leader off the reel, staring at the tiny 8mm frames, barely able to pick out Chaplin, the dusty tramp, ambling up the road. If I have to see the damn thing this way, I will. I'm looking at film, I'm looking at a movie in the most elemental sense, holding the print in my hands, staring at the images.

You cannot hold a video image in your hand. But you can feel film—its texture, its stiffness, its suppleness. Even after all these years it still has the smell of a movie: the base material, the emulsions, the processing chemicals and dyes; they give film a distinct smell, a metallic tang way up in the olfactory. You know it, just grab a fresh can of any camera film and give it a sniff. Movie prints share a little of that, plus an edge of organic sourness that reminds me oddly of the fresh olives I'd tasted and smelled in the market. It's a mood-altering smell, it cleans out the vision, it opens the eyes.

As I run it through my fingers, looking at Chaplin sitting forlorn by a tree, I think of what a long journey these images have made over time and space to reach my hands. From the Essanay Film Manufacturing Company in 1915 where young Charlie Chaplin stayed for a year after leaving Mack Sennett and his measly hundred-fifty bucks a week. He made *twelve hundred fifty* a week for Essanay, in their tiny studios in Niles, California, where this and a host of other short features were made on hand-cranked cameras and dangerously flammable stock, then copied and archived, printed and shared by hundreds of fledgling movie houses. Through endless printings and copies and decades it was packaged and sold, right into the sixties, at a camera shop or Sears or the like as an 8mm print in a nifty box for home use on the new dependable (like hell) Super-8 projectors!

This particular print came from Dr. Teodorescu, one of the lucky ones who got out of Romania during the hideous madness of the

Ceausescu dictatorship, and escaped to this very country, Italy, where he thanked God in heaven for his life and made for America. In the States, where he prospered, he bought this and other classics for his kids to enjoy. From his hands it came to his daughter, Diana, my friend, who, upon hearing that I would be traveling the world with a projector in hand, offered her father's films to me.

I carried these damn films halfway around the world to Australia, protected them from desert dust and sea spray, then here to Italy over the Swiss Alps by rail, through Venice and Florence, keeping it all safe. And now here, as the moon rises over the Mediterranean in one of the most picturesque cities in Italy, I am running this eighty-five-year-old record of wit, pathos, and comic timing through my fingers because I have no way to put it on the screen.

Have I failed? You could say that. Technically speaking, I have not abided by my pledge. But here I am, holding the guts of movie-watching in my hands, able to glimpse back nearly a century and see one of film history's giants.

In this way, as best I could, I was keeping my promise.

The above diatribe didn't help me at all. I was miserable, running a fever from my flu, certain that I had ruined my whole project. My friends sensed my slumping disappointment and gave me a little room as I sat on the moonlit terrace overlooking the dark sea, running Chaplin through my fingers.

From the other room I heard a voice. "Hey, you know there's a television in here, under this kind of TV cozy."

Television wasn't part of the deal. On the film in my hands, Chaplin was poking a poor farmer with a pitchfork.

"I'm sure we can find a ten o'clock movie, Kevin."

"Yeah, we could all watch it together."

"It's sort of like movie-watching. We'll wheel the television out on the terrace."

It is my sincere hope that when things fall apart for you and you feel you have fallen, hard, that you have such friends to pick you up again.

The image of Chaplin fuzzed out. Tears dripped onto my glasses. "Yeah, sure, let's see what's on."

We would watch a movie together, the six of us, facing an open terrace in southern Italy, the full moon lighting the sea and the back of the television. It is to be the only movie in my record of moviewatching that came off a TV broadcast, but I won't soon forget the experience, and that's what I'm after.

The film was called *La monaca di Monza: Una storia lombarda* or, in English, *The Awful Story of the Nun of Monza*. It's a bleak and gruesome tale of a seventeenth- century nun who is seduced and brutalized by a local nobleman, beaten by a priest, castigated by her order, and eventually buried alive in the convent wall.

Hey, I didn't say we'd have a *happy* ending here; it's what was on.

You should know the rest of the story, though. Raging with flu, for four days I went to movies in unremarkable theaters in Sorrento and its diminutive suburb Piano di Sorrento. I wasn't in a great mood for this part of the trip; I had a constant fever and my throat was raw. One night while I watched a film in Piano, Jane set off on one of her favorite pastimes, scrounging through secondhand stores.

Guess what she found. A working Super-8 projector. A nice one, too! Compact, lightweight, with variable speed and voltage. Boy, do I love Jane.

We raced home with our treasure. Our villa-mates cheered. The front reel arm was too small for the large film reels I brought, so we rigged up an architect's lamp and a ball-point pen to hold the front reel, and we were on our way. And on the last three nights in that villa, we watched Chaplin and early Disney to the music of Nino Rota, cinema right there on our Italian terrace. I made a point of looking at frames of each film I showed, actually thanking it, thanking it for making a journey as far as mine, for giving us some memorable entertainment, and for not breaking.

Villa Casa di Giovanni, Positano	Love Pangs
Villa Casa di Giovanni, Positano	Bunny Bed
Villa Casa di Giovanni, Positano	Disney Collection: **Match of the Century; Mad Tea Party**
Villa Casa di Giovanni, Positano	On the Town
Villa Casa di Giovanni, Positano	Disney Collection: **Mary Poppins; Bambi**
Delta Flight B31	Bridget Jones's Diary
Delta Flight B31	Forrest Gump
Delta Flight B31	The Mummy Returns
General Cinema Centennial Lakes 8, Edina	Iron Monkey
Mann St. Louis Park Cinema 6	Bandits

The Captive Audience
In-Flight Movies

I am sitting on United Airlines flight 942, in coach, bound for Paris, having my second glass of wine and the cheese course. It's about ten at night, we fly in silence over Outer Banks. For dinner I had opted for the tiny filet bordeaulaise over the salmon with a frightening crème sauce. *Never* eat the fish course. Sleepy and not too full, I settle back into my narrow seat, ready to gaze at the little personal LCD monitor before me and enjoy *The Legend of Bagger Vance*.

Suddenly there is a rumble from Claude, the long-faced French-man next to me. The instant it happens I realize the naive idiot chose the fish course. Quietly but forcefully his stomach gives back what it

cannot allow, and a riot cannon of undigested food hits his little seat-back monitor, my little seat-back monitor, his shirt and pants, my seat tray and notebook, his handsome wife, my pants, his shoes and socks, the entire seat back in front of him including the complimentary in-flight publication and headset in the seat-back pocket, the floor throughout row 24, the aisle between seats C and D, and the thinning hair of the very tall Gallic gentleman in front of us. Say what you will about the French, they can projectile vomit with the best.

This happened to me, and it could happen to you.

Flying is a hazardous task, even when the actual flight goes smoothly. I can quote you studies showing how commercial aviation is safer than taking out the garbage and it wouldn't help; I could deluge you with industry statistics noting how many tons of humanity are jetted from one country to the next each day, and I'd just be flapping my lips.

Because, as we all know, safe and efficient as it may be, there is no form of transportation more complicated, aggravating, undependable, or stressful than the long-distance commercial passenger airline.

Of my year at the movies, two full weeks of movie-watching took place in passenger aircraft. I spent roughly two hundred twenty hours in the air, almost ten days off the ground in that tight little padded steel tube. I traveled coach the whole way.

I saw thirty six screenings, a total of twenty-six features, three documentaries, and seven repeats—*Bridget Jones* spread across our globe like a virus. It is the most expensive and crummiest movie theater on earth.

Here's the dominant paradigm for in-flight movies: A video projector made in the seventies with a ten-watt lamp throws a pale, hideously off-color image against a three-foot screen about twenty rows from your seat. The foot-high matted hair of the human wildebeest sitting directly in front of you blocks most of the screen. What's left is a milky wash meant to be a movie, a bad movie at that, but you can't see it anyway because the guy in 3F refuses to pull down his friggin' window shade. He's not reading, in fact he's just sitting there, picking his teeth, but he needs that full blast of sun to see what he's pulling out from his gumline. Is it spinach, is it pork shoulder?

Predictably, the light from his window hits the screen point-blank. People kvetch, but when the flight attendant tries to get him to pull down his shade he loudly quotes Congressman Bud Schuster and obscure passages from the Airline Passengers Bill of Rights, bellowing, "This is a wake-up call to the airline industry!" and the like, completely drowning out the thin sound in the cheesy coach headphones so I can't hear *A Knight's Tale*. It's no wonder that frequent fliers bring stacks of books and an MP3 player.

Of course there are dozens of variations to this theme. For example, traveling to Finland via Icelandair I got all clever and politely asked for a spacious exit row seat. I chose Icelandair because they've gotten the knack of flying through perpetual darkness and landing on ice rinks. The flight drops down in Reykjavik, then it's on to Stockholm and Helsinki, each leg on successively smaller aircraft. Minnesotans flock to Scandinavia because most of them still have living relatives there, some of them up to seven hundred years old.

How can this be? Healthy bladders. How do I know this? Because after the meal on the Reykjavik leg, every single person on the flight got up to use the can. As my comfortable long-legged bulkhead seat was right next to the bathroom, this meant they lined up in my personal space and continually blocked my view of the screen. Hundreds of steel-haired men in business casual and thousands of women in stretch pants and theme sweaters chose to stand in line for *my* bathroom rather than sit comfortably and wait for the little "occupied" light to go off. They chatted, stretched their legs, and seemed to believe that I wasn't there at all. Vaguely Scandinavian-looking marms and codgers stood in my space, chatting about ancient relatives and horrid food, while I craned conspicuously and ahemed loudly. "I'm sorry, but I can't see the movie." *Really? I had no idea. Sorry.* They'd bunch in the aisle and continue chatting, take their turn in the can, and then it was someone else's turn to bunch into my personal space again, until "I'm sorry, but I can't see the movie" became a mantra. *Really? I had no idea. Sorry.* Of course you had no idea, you great mindless walking pastry! *Move!*

Eventually, the ample space I had hoped for was gone, passengers

mushing by each other like they were taking communion at the world's smallest Catholic church. And just as I'd get a clear view of *State and Main*, the cycle would start all over again.

Some headway has been made in improving the in-flight movie-watching experience through the use of the personal video system. It's been available in business and first class for years now, with retractable monitors and handheld remote controls. Some even have Wcb browsing and video games available, which a first-class passenger can play while thcy're decanting his '89 Lynch-Bages right after the massage.

For us in steerage, it's a mixed bag. On the U.S. Airways Airbus A330-300 to London I got to try their nifty P@ssport system. It's potentially great for us in the cheap seats because it offers a huge variety of movies and TV programs, including a lot of kids' stuff, at the touch of a button. Better yet, you can start, stop, pause, and rewind the films at will, a very helpful feature. It's almost enough to make me choose U.S. Air every time.

I said almost. Maybe when they work out the bugs. On my flight over, the whole video system crashed several times. It was an odd, seemingly Windows-based system, some sort of cursed proprietary network, and every time the flight attendants tried to reboot, some dork would monkey around with his controls and make the whole damn thing crash again. The problem here of course is that flight attendants seldom moonlight as network programmers, so all they can do is what we would do: panic and curse. After four tries, the head attendant announced loudly and with much more conviction than the previous three times, in three languages, that WE ARE GOING TO REBOOT THE SYSTEM *AGAIN*. THE SYSTEM WILL NOT WORK IF *ANY-ONE* IN THE CABIN TOUCHES *ANY* OF THE VIDEO CONTROLS. SO PLEASE *DO NOT TOUCH ANY CONTROLS UNTIL WE COME BACK ON AND TELL YOU TO. PLEASE DO NOT TOUCH ANYTHING. S'IL VOUS PLAIT NE TOUCHER RIEN. POR FAVOR TACTO NADA. BITTE NOTE NICHTS. POR FAVOR TOQUE NADA.*

I don't think she actually said it in Portuguese, but she could have waved it in semaphore and it would've made no difference, because

mere seconds after the reboot started, the guy across the aisle and up two rows started farting around with his control. Moments later a flight attendant spotted him and actually pulled his hand from the controls, saying, "WHAT IS THE MATTER WITH YOU?! WHAT DID I JUST SAY?!"

The man looked straight at her and said, *"Um, I wasn't listening."*

"PLEASE JUST KEEP YOUR HANDS OFF THE CONTROLS OR YOU'LL *RUIN* IT FOR *EVERYBODY.*"

Once this system is shaken out, it will be a great boon to fliers. But I don't necessarily think it's a great thing for the culture. The film snob in me dislikes the idea at the core because it's just another opportunity to channel surf. A fundamental difference between the theatrical film experience and the home video experience is control. In a theater a film starts, runs through to the end; we must respect each other, sit quietly and let the public event happen. At home, and on U.S. Air, we can sit there and drool while flipping back and forth between *Memento* and *Herbie Goes Bananas.*

But we already know that the chances of enjoying an in-flight movie from start to finish are rare, don't we? The movie always takes second seat to constant interruptions in the name of service. Hot towelettes, beverages, food, more beverages, customs cards, duty-free shopping, another round of drinks; it's a barrage of customer satisfaction. Not that I'm complaining; the only truly nice thing about overseas travel in coach is the free booze. So, what the hell, grab that controller, flip channels, and drool into your complimentary rusty nail.

But let's get back to the gorge-spattered flight to Paris that began this chapter. I'd quite hoped to sit back, relax, and enjoy the movie from start to finish. The seat-back screen was actually sharp and color-balanced. The United headphones were comfy and sounded pretty good (I heisted a pair for future trips). *The Legend of Bagger Vance*, a very Robert Redfordy movie, a better film than most people think, was perfect for the short transatlantic night: wistful, dreamy, unchallenging, vaguely mystical, and s-l-o-w. A nice two-hour cinematic cup of hot cocoa while the lights in the cabin go down and people snuggle into their coach seat cramp-aversion.

Ah, but then, *l'épisode de vomi*. I simply can't win.

Now on to sound, the last frontier of airline comfort. One of these days, airline management will figure out that a big reason for passenger stress and ensuing "air rage" is that passengers in coach are subjected to a continuous ambient noise level of eighty-four to one hundred and ten decibels. Want to know what that's like? Just sit in your living room for several hours with a leaf blower operating at full blast.

The Delta flight from Atlanta to Zurich featured those antiquated stethoscope-style headsets, which rely on air traveling through a rubber tube to deliver a sound so thin you'd get better fidelity by putting a cell phone in a can and sitting on it. In addition, my hip size causes the rubber tubing to squish against the arm of the seat, essentially kinking the sound.

For just such crises I travel with my own compact set of headphones, but of course Delta had foreseen my bit of cleverness and equipped this jet with an alien dual-socket headset connection; I tried plugging my headphones into one of the sockets and the sound I got resembled the voice of Marilyn Manson.

So I did what any conscientious audience member should do. I complained. I told a flight attendant about my kinked tubes and she said there was nothing she could do. This of course was a lie, there was something she could do: grab a pair of normal headsets from business class. So I smiled and waited for her to leave, then strolled into business class and nabbed the first pair of headsets I could find.

On the inbound leg from Zurich to Atlanta, we were treated to three movies, descending in quality as we went. In the purple predawn over the Atlantic I was one of about six people who stayed awake to watch *Forrest Gump*. It was a chance to see it again for the first time since it was released, an opportunity to see if I still felt the same way about it.

Indeed, I still feel the same way. I hate it. I hate this movie's guts.

The experience is like being forced to eat heavily sugared whale blubber. Worse, it's emotional propaganda. The film is set up in such a way that you are not allowed to dislike it. How can you not like a film about a simple man who overcomes endless obstacles to have a charmed, dreamlike life, filled in turn with joy and pain, great courage and deep sorrow?

Because it is ridiculous, it's cloying, it's triter than a Precious Moments figurine. At the same time it's duplicitous; a film can't lionize and ridicule its character's unique features in turn. It's what I call the cute-dog syndrome, using a lovable object to questionable ends. It happens in bad screenplays and amateur writing all the time. A friend urges you to read a story about an irresistibly sweet little dog. It's a really a bad story, almost unreadable, but there's that dog. Tell your friend that you hated the story and she'll immediately assume that you hate dogs. The story becomes impervious to criticism because of that stupid dog.

And yet, as I groaned in my seat, the half-dozen others who stayed awake smiled pleasantly and let the film wash over them like air-conditioning. One woman was crying from the opening credits to the end.

Maybe it's because the whole movie-watching exercise seems so churchlike; it's ritualized, sitting there in your seat, compelled to stare at the front of the room while some sort of sacred spectacle unfolds. Watching a movie on a plane intensifies this feeling, because there simply is nowhere else to go. At a theater you can go out for air, or if the film offends you can simply leave; not so on a plane, unless you want to get arrested in the attempt. On a plane, like it or not, the movie unfolds before you, and if you're like me you can't *not* watch.

There is an alternative. On the Minneapolis-Atlanta leg of our flight to Zurich, Jane and I rented a compact DVD player from InMotion Pictures, a kiosk at the airport. What a dandy idea: Check out a film and a player at one airport, return it to another kiosk when you land. It's twelve bucks for player and one movie, but it's yours for the flight, and it isn't interrupted when the captain comes on to tell you that the Ohio River is sure lookin' purty out the right side of the aircraft. And although this doesn't fit my criterion for a publicly exhibited movie, it was the second most enjoyable in-flight movie experience I had all year.

My best experience happened on the way to Mexico. Our friends Brad and Diana, and Jane and I, took a charter flight to Zihuatanejo, a good five-hour flight from home. We always book the charters

because they are wonderfully cheap, and I'd sit on a chair leg if it got me to a nice beach for two hundred bucks.

The flight is long and featureless. The local charter company has a deal with Ryan Airlines to haul pale Huns from Minnesota to the tropics in the winter when they're not flying pale Bostonians to Shannon. Everybody's going someplace warm, and the crew enjoyed getting us in the mood. Our spankin' new Airbus had a great video system. The crew asked us if we'd like to see *Chicken Run*. The cheer from the cabin was emphatic, joyous, and beer-tinged.

It was all wonderful. The monitors on this plane were flat LCD screens that dropped down from the console above every third seat, which means we all got a splendid image, whether or not the troll in front left his window shade open, which he angrily did.

The great thing about a charter flight is that everybody's in coach, we are all equal in the eyes of flight attendants, so for a few fleeting hours the flight is a kind of quasi-socialist wonderland with beer and pretzels. And *Chicken Run*, the film that has renewed my faith in kid movies, was the icing.

Perhaps it was the holiday mood, but the whole cabin got into it. People laughed openly and lightly, even hissed and booed at the villains. As the plucky flock of chickens triumphed over imminent disaster, the whole cabin raised a cheer. We applauded at the end, then everybody started to talk to each other! It was a far better time than I've had in any googolplex.

The airline industry has gone through a lot of tumult in the past year. Passenger safety and security have made the already aggravating task of flying overseas that much more challenging. For a while at least, I've noticed a spirit of patience and cooperation among passengers in these frustrating situations. Personally, anything an airline can do to make me safer and more secure is far more important than entertaining me. I am an adult; I know at least a dozen ways to entertain myself in public. While I dream of the day that personal video systems are the industry standard, I'll rent a DVD player; or perhaps I'll read a book, write a letter, play Scrabble, learn pranayama breathing.

In the meantime, getting the guy in 3F to close his friggin' window shade, now that would be a real advance in aviation.

General Cinema Centennial Lakes 8, Edina	**Training Day**
United Artists Eden Prairie 4	**Zoolander**
General Cinema Centennial Lakes 8, Edina	**Joyride**
General Cinema Centennial Lakes 8, Edina	**Corky Romano**
Muller Family Theaters Lakeville 18	**From Hell**
General Cinema Centennial Lakes 8, Edina	**The Last Castle**
Mann St. Louis Park Cinema 6	**Don't Say a Word**

Pain Don't Hurt
Bad Movies Cannot Be Good

All right now, pants-wetting little nancy-boys. You Barbie-loving party-dressed femmie girls. Time to get tough, you infants. Forget bungee jumping, that's for brokers on retreat. Forget your lights-out steel-cage matches, that's nothing but men rubbing each other. Put that triathlon bikini in the Goodwill bin. It's time to test your will, your resolve, your pain threshold.

We're going to see *Corky Romano.*

I've known NFL linemen to turn pale at the mention. Women's kickboxing champions run and hide. Sheep castrators whimper and cry. Corporate consultants fill their pants.

Me, I'm just getting into the groove.

I saw the trailers for *Corky Romano* this summer and was convinced that it could be the most terrible movie of the year. Then the reviews came out, and except inexplicably for the *Los Angeles Times*, critics unanimously disliked the movie with an intensity once reserved for Nazi rallies and implied a nascent desire to slap Chris Kattan hard enough to leave finger marks. I had to see this film.

I have seen a whole lot of bad movies in my day, lemme tell ya. They'd come streaming into the offices of *Mystery Science Theater 3000* in their bright colorful packages like evil Christmas presents. Over ten years, we looked at more than three thousand of them. I'm a professional; I know how to do this. Time to gear up.

I call my friend Mike Nelson. For ten years, he sat and watched these horrid movies with me. He rarely flinched. He always kept his cool. Only once, early on, did we resort to drinking tequila to get us through a day of writing jokes, while watching the Mexican film *Robot vs. the Aztec Mummy*. In fact, Mike and our editor Brad, after sitting through a day of bad movies, often would then go to a theater and pay to see something with, say, Jennifer Anniston and Jay Mohr in it, for the love of God.

Our conversation goes thusly:

"Mike?"

"Kevin?"

"Mike, my friend: *Corky Romano*."

"Ah, yes. Of course, *Corky Romano*. When?"

It's that easy. Granted, not everyone can call up Michael J. Nelson, who is perhaps the funniest person alive, and head out to a crappy film with him, so I count myself extremely lucky.

This isn't a guilty pleasure. I don't celebrate bad film. I think the Golden Raspberries are a waste of time. I don't have a "so bad they're good" category. I don't go to conventions and wear tight T-shirts and trade copies of *The Pirate Movie*. Movies that are bad are just that; they exhibit an obvious lack of quality sufficient to cause aversion in the general public. There is nothing good about them. It's all in the watching.

Mike and I meet at the theater, the crummy little eight-screener in Edina. I've been going there a lot this week, sort of trashing around, not unlike choosing to go to loud smoky bars with bad tap beer and Tombstone pizzas.

I pay; it's my book. And I brought the beer. Two generous cans of Foster's Special Bitter, perfect for a movie because they're twenty-two ounces, they don't clink like glass bottles, and they fit neatly in the cup holders.

The theater is jammed with high school kids. The annual Minnesota Education Association meeting takes place smack in the middle of October, giving kids and teachers alike an excuse to goof off for two days. Even during the movie, the conversation is loud and rapid; cell phones are answered and yelled into. Pagers sing their dumb little tunes. It's a continual din, like the wheat pit at the Board of Trade, except everybody's saying "dude" and wondering where the party is tonight.

They think they're all here to see a comedy. All except Mike and I, and our Fosters. There is nothing more pathetic than a bad joke. If you've ever been to a comedy club on open mic night you'll know what I mean. And as the movie unfolds, and the initial willful laughs fade, the room becomes silent, then restless, then downright annoyed.

The movie is a pathetic mess, a train wreck. Nothing that happens is funny, at least not by intention. Attempts to add dimension to the characters and pathos to the plot simply hurt. The whole movie hurts. We're sitting on coarse-grit sandpaper. Mike groans and squirms in his chair. I begin to sweat and pant loudly. Bear down, it can't be more than eighty minutes. Can it?

It's eighty-five.

Chris Kattan is no funnier than a televised colostomy. Ever since America mistakenly enjoyed Jerry Lewis, periodically some suited clod in an office in Century City gets it in his head that we need to see another convulsive monkey do schtick. This is how we got Robin Williams, Jim Carrey, Rob Schneider, Adam Sandler, and Carrot Top. Chris Farley's death spared him this indignity. And now we have Chris

Kattan, who in *Corky* wasn't even funny enough for twelve-year-old boys. If you can't even be funny enough for twelve-year-old-boys, you should switch careers. This is why they tried to wedge some "warmth and heart" into the film, to appeal to girls, the poor girls.

So, the real joy is to watch the whole thing go to smash, to see the film wither and die, in the hopes that careers will get pulled down in the suction, which unfortunately they never do. The film stole twenty million dollars of our money and ran to the video store. Debut director Rob Pritts came from the advertising world, where all great directors begin their careers. Writers David Garrett and Jason Ward made a big splash with a humorous short about old ladies playing Russian roulette and splattering their brains all over a nice living room; they may be on their way to becoming the next Lowell Ganz and Babaloo Mandel.

Now then: Chris Penn plays Corky's mobster brother as a rock-stupid latent homosexual. What the hell happened to him? A few years ago he was digging out from under the leaden weight of the Penn name: *Reservoir Dogs, Short Cuts, The Funeral*, good roles, well-acted. But now here he is, making a mess of a bad role. Worse, he's gained at least eight hundred pounds, all of it in his head. He has become a Macy's balloon animal version of himself, straining the skin of his face to the point where it might burst, sending subcutaneous fat spraying over unwitting press members or premiere party guests.

And please say some prayers for Peter Falk. Peter plays Corky's dad, a vile, bigoted yet loving mobster on his deathbed. Now here's a guy with a bookshelf full of awards, who's worked with Wim Wenders, David Mamet, John Cassavettes, Walter Hill; once the highest paid actor in TV history, a legend whose multifaceted career spans over half a century.

Now, at seventy-four, he does *Corky Romano*.

You know the risk he's running? He could croak tomorrow, and his obituary would have to mention that his last film was *Corky Romano*. Would you want that in your obit? It'd be worse than dying of syphillis. Think of poor Peter Sellers, whose last film was *The Fiendish Plot of Dr. Fu Manchu* and he never got a chance to live it down. The lesson

is to be careful in your old age, and if you are over sixty, under no circumstances do a movie starring Chris Kattan.

In the theater, the teen audience is getting edgy. Forty-five minutes in, two kids leave, then three more, then about six at once. Right at Chris Kattan's supposed "trademark" line, as he stands at a doorway in a Girl Scout's uniform croaking "Y'guys want—some COOKIES?" there is a rush for the door. A full third of the audience will abandon the thing before the ending, out of sheer agony.

They will not sit still for the sublime pain. I like it. I like watching the reaction of a crowd to something that is truly bad. The American teenage audience has spectacularly low expectations for movies, as they have since the invention of the teen movie. This year I've seen people walk out smiling from the likes of *Joe Dirt, The Animal,* and *Saving Silverman,* having enjoyed a scant few laughs and the occasional attractive boy or girl.

Corky is different, and the crowd knows it. I watch the kids look at each other, as if there is something wrong with the projector instead of the movie. It isn't meeting their basement-level expectations of what is minimally funny or entertaining.

And it gets worse as the movie gallops out of control toward its inevitable end—it has to end; even *Berlin-Alexanderplatz* had an ending—as the jokes seem to become more repetitive or more desperately odd. This is when people stream from the theater, made uneasy by the furtive and spastic nature of the third act, as if the film has become unstable and might come out in the audience, grab someone, and hold him hostage with a kitchen knife. I am cringing, rocking back and forth in my chair as if I am on a charter plane on the way back from Mexico with two broken toilets. Mike, who normally sits as stoic and serene as Gautama under the bodhi tree, is starting to sweat. "Good God, how long is this thing?" The movie wants to end but keeps on going; the theater has become so empty the ushers may as well sweep up.

I think of the 1974 Chicago Bears, the 3-11 Bears, the Agony Bears, the pre-Payton Bears, the team coached by Abe Gibron (11–30–1) and quarterbacked by Bobby Douglass, a man who threw a

football harder than a relief pitcher and once put an easy slant pass squarely in the numbers of a referee. The team that caused me to stop caring about football for the rest of my life. I think of these Bears at frigid Soldier Field, closing out their fifth consecutive losing season by losing 21-zip to the Green Bay Packers. It's the fourth quarter, the wind whips the top tier of bleachers like a North Sea gale. Two minutes left: Douglass loses the ball and Green Bay picks it up, sealing the doom. The crowd has dwindled to those scant few weeping idiots who believe the team is winning or losing because of them. Nobody cares.

This is what the last ten minutes of *Corky Romano* are like. The theater becomes Soldier Field in the fourth quarter; Chris Kattan throws jokes harder than Bobby Douglass. No amount of beer could make the experience better. But we stay until the credits. We may be the last ones out of the theater.

This is why I came: to witness failure as it happens, to learn, and to enjoy. I enjoy it because the humor of it transcends the film itself. The makers of the film and the actors stuck in it become players in a bizarre comedy beyond their reckoning. They become the classic object of ridicule they intend to target.

Aristotle in *The Poetics* wrote of comedy with universal relevance. But inherent in my reading of Aristotle is the thought that all forms of drama, comedy included, satisfy us because of an essential foundation in craft: As Hamlet instructed his actors, "to hold, as 'twere, the mirror up to nature," to reflect our actions and their consequences back on us in ways we can understand, and we are better for the experience.

Corky Romano was entirely unsatisfying because the filmmakers do not know the first thing about comedy as set out by a gnarly head-bound Greek more than two thousand years ago. *Corky* is simply a series of adolescent jokes, none of which is good, with nothing to hold them together. Without consciously realizing it, our teenage *Corky* audience knew this, and it sent them screaming from the theater.

So, there, you can gain something from reading classical texts and going to see a really bad movie. But it takes guts and determination, and a big can of Foster's Special Bitter certainly helps.

✳ WEEK 43, OCTOBER 22–28 ✳

Loews Cineplex Edina 4	**Serendipity**
Cedar 6, Owatonna, Minn.	**Serendipity**
Loews Cineplex Edina 4	**Serendipity**
Cedar 6, Owatonna, Minn.	**Serendipity**
Oak Street Cinema, Minneapolis	**Speedy** (with the Alloy Orchestra)
Loews Cineplex Edina 4	**Serendipity**
Cedar 6, Owatonna, Minn.	**Serendipity**

Date Movies: Do They Still Exist?

A Married Man Wants to Know

Ah, dating. That humiliating rite of passage that we all have experienced in one form or another, regardless of our sexual orientation or inclinations toward celibacy. A time when we groom our appearance, mask our flaws, plan, promote, negotiate, and then present ourselves in our best possible light, only to feel the dark-winged ghost of failure hovering over our beat-up VW Beetle as it breaks down in Wisconsin in January, after which our intended sighs heavily and calls a cab. Or our dates, initially thinking of us as funny and interesting, find us so dreadfully introspective that they drink various and several highballs, skip to the bathroom on pretense, call the sexy beefcake with the

motorcycle and the leathers, and finish the evening making out with Mr. Motorcycle right before our eyes.

This kind of thing happens to everybody. Right?

This is why a movie is the perfect date. It gives the poor couple two hours to not engage each other in small talk, two hours to strategize and fret, and, if we're lucky, something fun to look at.

But are date movies the right movies for movie dates? What is a date movie? Do they really exist anymore? To figure this out, I went on six dates, all to see the same movie, *Serendipity*, ostensibly the only Hollywood date movie of the fall season.

This was much to the consternation of my spouse, Jane. As she often does, she wondered what the hell I was doing and why. Research was my reply, research, plain and simple. I made it easy, which made my research suspect. I would date Jane's four sisters and her Mom, and any of our close friends who didn't think I was a perv. Therefore, I asked seven and took six women to see *Serendipity*. One stood me up. No problem. On to the women who had been foolhardy enough to face me.

Monday Night

Bridget Jones Nelson. Married to my friend Mike. Two lovely kids. I arrived at the door with a gas station flower and a Russell Stover four-piece candy assortment. Mike was playing with the kids, the kids wanted the candy, Bridget put the flower in some water. Mike wished us well on our date, and we headed out, Bridget and I.

Already this was kind of weird.

Bridget grew up in the heart of small-town Minnesota, and her dating history reflects that. She and her friends would meet at the theater in a small mob; some would buddy up, more would seek the protection that a gang of friends offers. So the movie selection was broad, whatever fit the bill and wasn't too strange. Single dates to a movie were a way of saying "I want to grope you" and were avoided.

Over quesadillas at a cozy southwestern bistro across from the theater, Bridget's eyes met mine as if to say, "Are we going Dutch, or what?"

I paid. I think she liked that.

Naturally Bridget had assumed that I'd want to take her to *Bridget Jones's Diary*. But I didn't because I'm wild and unpredictable. I think she liked that, too.

And I didn't tell her that *Bridget Jones* had finally left the local theaters, so we couldn't have gone if we wanted to. I withheld information from her. I think she liked that, too.

So I was scoring points left and right when we sat down to see our movie. *Serendipity* is supposed to be a movie about fate and chance and serendipity in the phenomenological sense. If, the movie purports, we leave control of our lives entirely up to fate and circumstance, then we will look like we're thirty when we're forty and we'll be fabulously rich and live in Manhattan and find a skinny girl or a cute boy and no matter what damage it does to those around us, we'll get everything we want in the end.

Isn't that romantic as all get-out?

We weren't buying it, not for a moment. In the movie, John Cusack and Kate Beckinsale play Jonathon and Sara, who meet by chance while vying for the same pair of cashmere gloves at Bloomingdale's in New York. Buck Henry comes up to them and croaks like a snapping turtle, then Jonathon and Sara do something cute, and suddenly they're in love.

First thing Bridget noticed, in the first close-up of John Cusack: "When did he start dying his hair?" Next we see Sara ice skating at what's supposed to be Wollman Rink in Central Park (it ain't, it's Toronto). Poor Sara wears an astoundingly small, brutally tight miniskirt—more of an Ace bandage really—and a garish hook-knit sweater; so she looks like Jill Clayburgh when she played a hooker in the 1975 TV movie *Hustling*.

Sara is obsessed with fate. Bridget and I are obsessed with Sara's skirt. In a test of fate, Sara creates an elaborate scheme involving elevators at the Waldorf. They'll randomly choose a floor in separate cars. If they both pick the same floor, then they can be in love.

The plan is foiled by a kid who gets on Jonathon's elevator car and pushes all the buttons. The kid is dressed as Satan, and acts like he is overmedicated.

It's Christmas, and he's dressed like Satan.

We were the only "date couple" in the theater. We had a fine time laughing at the sheer dumbness of the movie, but was it a date film? Let's see.

Tuesday Night

Angela Donlon. Married to Tom Donlon, assistant principal, with four beautiful kids and one more on the way. I drove the hour down to Owatonna for this date. Dinner at the new Mexican spot near the theater. Angie knew just about everyone in the place, and I think she got a charge out of being seen out alone with a man who wasn't Tom.

Oh, the scandal in a small town like Owatonna.

Over our enchiladas, Angie's eyes met mine as if to say, "Well, I'm not puking in the morning anymore, but I have the flu, so deep-tongue kissing is right out."

One of the critical moments of any first movie date is in the choosing of the seat. This moment will speak volumes about a couple's prospects and perhaps set the tone for compatibility issues that'll take a therapist to untangle.

The general rule in a heterosexual first-date scenario is to allow the woman to choose the seat. Men as a gender group love action movies and dopey comedies full of condom and poop jokes, and they want to sit in "the sweet spot." They spread out. They slump. They want their eyes filled with sound and motion because it will partially take their mind off sex for a short while. Women generally go to movies to see splendid stories and feel an emotional outpouring. To satisfy both sexes, Hollywood crams all of the above into each movie, which explains in part why they are so bad. But my experience dictates beyond exception that a woman will not care where she sits unless it's too close. This is because women are far more intelligent than men and will outlive us three times out of four.

As *Serendipity* drones on, we see Sara and Jonathon many years later, a continent apart. They haven't aged a trace, and they are unhappy in cardboard relationships with shallow people. Naturally they are still looking for each other, the critical driving point of the plot. Sara looks for a five-dollar bill with Jonathon's number on it.

Jonathon combs used bookstores for a copy of *Love in the Time of Cholera* in which Sara had written her name and number.

Angie thought the movie was charming. I didn't understand. First of all, neither of them seemed to have the demeanor to get through a Gabriel Garcia Marquez book; second, Sara just happened to have the hard-bound edition in her purse. Does this ring false to you?

Angie wasn't stuck on this point. She saw two people, looking for a finer romance, a fanciful love. Two people struggling against settling. She saw the breathless, heart-stopping quality of infatuation that movies have portrayed so well, the romantic notion that sells so many books and movies like this one.

This must be the heart of the date movie, I thought as I brought Angie home. I opted out of kissing a pregnant woman with the flu. I think she was relieved.

Wednesday Night

Diana Teodorescu, a great friend. Married, with no kids, to Brad, another great friend. I presented her with a convenience store rose and a Russell Stover candy assortment.

Over sweet potato fries at a nearby diner, her eyes met mine as if to say, "Kevin, you sweet dope, I hope you learn something from this experience beyond a facile joke of a married man dating his friends and family to liven up the book."

Diana is very perceptive.

Diana's notion of a movie date was refreshing: Just go, relax, have some fun, see something you can talk about afterward. Diana has the heart of a romantic, the keen mind of a psychologist; the integrated whole is a dynamic personality with a finely tuned bullshit detector.

In *Serendipity*, Jonathon and Sara suffer the fate of a lot of lead couples in romance films, in that they are surrounded by shallow drips or ebullient eccentrics. Diana plainly saw through this convention and still she enjoyed the evening.

Is it me? Am I that jaded? Later in the film, each actor finds clues to his or her lost flame, and they spend the rest of the film in a madcap chase against the clock. Both are scheduled to be married.

Diana spoke out against this notion. The worst part of these romances is that they assert that we only have one partner out there, one person who fits our ideals. In *Serendipity*, this perfection falls in our couple's laps in the first five minutes of the film. Yet they give it up. What're they doing? Are they idiots? Apparently. Jonathon ends up with a rich, incredibly thin woman who is shallower than the bone-fishing flats off of Islamorada. She has sideburns (watch the film and see for yourself). And Sara is engaged to a predictably self-absorbed new-age musician named Lars. How the hell did our two heroes end up with such losers?

Because if they hadn't there'd be no story. That wasn't enough for me, but I did learn something very important from this dumb film: *We had a good time in spite of it.* We enjoyed each other's company. We talked about our lives and our beloved partners. And since the movie's rather inert, since it has a few funny scenes and some inoffensive characters, we had a good time. I seemed to be searching for the same thing as Jonathon and Sara: perfection. When I let that go and decided to enjoy the moments as they came, it was a fine date.

Thursday Night

Nancy Stewart. Jane's sister, married to Tom Stewart down in Owatonna. Three terrific kids. I presented her with a rose and a Whitman's Sampler from the Kwik-Trip. We had dinner at the same Mexican place I'd taken Angie. I think there are a handful of people in Owatonna who firmly believe that an insane bearded dolt in a leather jacket is trying to destroy the Wagner family name.

Over another plate of enchiladas, Nancy's eyes met mine as if to say: "Hey, this is fun, dinner and a movie. I'll have a margarita."

Nancy is serene and uncomplicated. These are the keys to successful motherhood: If you can be serene and uncomplicated, you will not go insane before your kids leave home.

Nancy had the best movie date story of the whole week. She went on a double date, apart from the usual movie-date mob. Her date chose the movie: *Swamp Thing*. He chose the seats, in the back, in the dark. He even tried the famous "yawn maneuver" to get his arm

around her. Nancy says she and her double-date pal went to the ladies' room about a dozen times during the movie, compared notes, laughed a riot over the poor clod and his "yawn maneuver."

I might have been that clod, in another place and time. I was so frightened of women that the only thing I knew how to do was act like a clown or a lascivious drooler. When I went to college I discovered that film was more than just a distraction you paid money for, and for the most part I forewent dating. I became a downright bore, so nobody wanted to see a movie with me. As you can see, my own movie dating history is scant at best.

So, Nancy's story and our date were object lessons. Being serene and uncomplicated, she saw *Serendipity* as a simple, earnest giddy tale of love lost and found again. Heartache and humor. She had a great time. And I have to admit, after four screenings the film was growing on me as well, but more in the sense of a toenail fungus.

Friday Night

Jane's sister Joanne, the only single woman in the bunch, had accepted the date but then declined. She was "too busy."

Ah, yes, I remember hearing that one many times in my day. I'm too busy. Something's come up, sorry. I just remembered an appointment I never had. Gee, Friday is when I usually program my TiVo. I've come down with a painful boil on an unspeakable part of my body. Someone has made a totem in my front yard using a dead rabbit and a crucifix, so you'll understand. Sure, I understand, just as I did when I dated for a living. These are all ways of saying "I am somewhere between uncomfortable and terrified to be alone with you."

Fine by me. My beloved Jane and I went to the Oak Street Cinema and saw a terrific old Harold Lloyd classic, *Speedy*, which features a cameo by Babe Ruth and a series of car chases as good as any before or since. We ate Vietnamese, we told each other goofy jokes, we sat and watched the beautifully restored film to the frantic and rich original music of the Alloy Orchestra, some of the best silent accompanists you'll ever see anywhere. We thrilled at Harold's stunts, we laughed

with the packed house. We applauded at the end, stood up for the Alloy Orchestra.

We held hands.

Saturday Night

Kay Wagner. My mother-in-law. This is a special woman; how many of you would not even flinch if your son-in-law asked you out for dinner and a movie? We doubled with Jane and her dad for the dinner.

Kay grew up in that seemingly blissful time between wars, when movies were a quarter and candy was a nickel. Dates in her Austin, Minnesota, youth never got too weird. People were proper and polite. Courtship was still practiced.

Over a plate of walleye, Kay's eyes met mine as if to say "Is it me, or are we really late for this movie?" Late we were, and I had to fill her in on the first ten minutes of the story as we raced to the theater.

I think Kay liked it, I'm not sure. I know the casual way in which characters discarded their intended spouses the moment something remotely better-looking came along bugged her. In her world this is called infidelity, and it demonstrates lack of character. By and large that old dusty notion holds true today, but you can't look to Hollywood movies for any evidence of that. In Hollywood movies, wanting something more than you have is the greatest virtue. This is one reason I'm guessing that Kay doesn't go out to the movies too much, and I don't blame her.

Sunday Night

Jane Wagner Murphy, married to me. Ah, but there is something wonderful about dating the one you love. No offense to the others, but it's much better than dating family and friends, and less apt to lead to morally dangerous situations and problems with the county authorities.

Jane and I have learned to have a good time in just about any circumstance. We can entertain each other waiting in line to get on a bus. We can have a riot shopping for driveway gravel. So *Serendipity* is no problem.

At the end of the movie, and truly I am not spoiling anything here, both Sara and Jonathon get what they want. And the film proves its utter gutlessness by letting them out of their existing relationships without so much as a wince; the film shows nothing. Jonathon leaves his bride at the altar, actually a banquet room at the Waldorf; Sara dumps her man somewhere in Central Park.

We see none of this. These folks are perfectly willing to throw away their old lives, regardless of the pain it causes, for something else. It is an attitude motivated by selfish desire, dressed up as "true love." To Jane it's bullshit.

A few weeks later I finally saw the perfect date film: *Amélie*. It's a movie so unabashedly lovable that the Cannes Film Festival arranged a free outdoor screening. The house was packed with couples, and not one looked unhappy. Amélie, the lovely young protagonist, whirls her crazy life around the Montmarte section of Paris, a place only corpses and fascists can dislike.

Amélie has had a lonely upbringing—her mother was killed by a falling Canadian. It's a comedy. And her unaffectionate father, a doctor, never hugs her and touches her only when he's giving her a physical. This makes Amélie so happy her heart rate soars, so her dad thinks she has a heart problem and poor Amélie has to stay home all the time. When she grows to adulthood, she leaves her suffocating home for the big city, and through a chance discovery—real serendipity here—she decides that her mission in life is to secretly bring joy into the lives of others.

Ah, yes, but this is Paris, the mythic Paris, the city of love. And when Amélie falls in love for the first time she panics because now she has to learn to help herself.

Herein lies the critical date-movie difference: *Serendipity* centers on the grasping "I." What can *I* get, how can *I* make myself happy, how can *I* get more, better, perfect? Amélie lives a messy life full of heart, giving out love everywhere, and eventually that love is returned. In its goofy, sexy, Frenched-up way, *Amélie* is a far better lesson in the nature of love.

At one point Amélie looks to the camera and says she likes to go to

the movies so she can turn around and see the faces all lit up by the screen. Which I do, often, and I did then. A theater full of couples snuggling close. At several points I actually heard sighs.

Amélie is a perfect date movie. In fact the movie itself is the perfect date. I suggest you see this movie with any date. If the date is good, you can fall in love. If the date stinks, you can fall in love with the movie. Either way you go home happy.

City Club Cinema, Grumpy's Bar, Minneapolis	**Das kabinett des Doktor Caligari**
General Cinema Mall of America 14	**Thir13en Ghosts**
Riverview Theater, Minneapolis	**The Rocky Horror Picture Show**
General Cinema Mall of America 14	**Bones**
Carmike 15 Theater, Eagan	**Monsters Inc.**
Carmike 15 Theater, Eagan	**From Hell**
Har Mar 11, St. Paul	**The Others**
Regal Cinema Apple Valley	**Jeepers Creepers**

Rocky and Other Horrors
The Nightmare Isn't Just on the Screen

I have been scared by exactly four movies in my lifetime: *The Birds*, *The Serpent and the Rainbow*, *Alien*, and one other film I'll discuss later, just to keep you in suspense. I haven't been thoroughly frightened in a movie theater since 1990. It's the week of Halloween, and the theaters are full of films that are supposed to scare me, but don't. So I'm going to examine the current state of horror, trying to figure out why movies don't scare me anymore.

It's also the week of All Souls' Day in the Catholic tradition, far more meaningful to me than Halloween. All Souls' Day was my initiation into the horror genre. Back at Saint Michael's School, two

masses were said this day: first the traditional weekday low mass, then an abbreviated requiem, said in silence, for which the priest wore black vestments. Black vestments: Is that cool, or what? This mass is said for all the suffering souls waiting to reach paradise but not quite there. It plainly admits the notion that there are lost souls out there, hungering for redemption, needing our help to cross over. It was my first taste of the genre of horror, ritualized into prayer, and I felt the thrill of it, the stiffened hairs on the neck; the intrinsic chill of edging up against Panic and Dread.

Panic and Dread, our fears and our demons, Phobos and Deimos, the mythic sons of Ares who marched with him into war. The Greeks identified and nurtured that aspect of the psyche, and when you watch their plays, you'll see a whole lot of horror. People kill each other in all kinds of creative ways, folks invade the underworld to rescue their loved ones, demonic monsters plague stout heroes—heroes who through hubris bring monsters upon themselves. All the conventional narrative themes of horror were in place a good twenty-five hundred years ago, so don't go looking to Wes Craven for anything new. You want some grisly horror, see a good staging of *The Bacchae*, or rent Julie Taymor's adaptation of Titus Andronicus, *Titus*. Be sure not to confuse it with the Fox TV series.

So, my single criterion for the week was whether a film could reach down into that mythic shadow aspect of my spirit and bring it forward into my waking life. It's asking a lot, but it can be done.

I started off the week with the City Club Cinema screening of a true pioneer work in the genre of scary films, *The Cabinet of Dr. Caligari*, an exploration into the heart of madness. *Hm-hm-hm-mWA-HA-HA-HA-HA-HA-HAAA!* I sat with my pal Peter at Grumpy's Bar, home of City Club Cinema, smoking his Nat Shermans as he ate my tater tots. The City Club folk had brought in a fog machine, which burned our eyes and made my tater tots taste like boogers, but the visual effect was appropriate for "scary" movie night.

Caligari begins with a narrative prologue: young man sitting in a garden, talking to an older man. As they talk a young woman walks by them, apparently in a daze. Then the young man proceeds to tell the old

man a long story, and off we go. It seemed odd and unimportant. Peter and I looked at each other like beagles, our heads tilted slightly; neither of us remembered this opening scene, nor did anyone in the room.

Then the art direction shifted drastically, and the story as we remembered it began. What everyone remembers about *Caligari* is the art direction. Everything is stylized, sharply angled, and off-kilter: sets, costumes, makeup, and the acting, which is broad even for a silent film. We learn of the mad Doctor Caligari, who keeps a sleep-walking dancer in an armoire, which upsets a lot of people. The somnambulist goes out at night and kills people under the command of the evil mad Doctor. The young man who is telling the story loses his girlfriend to the sleeping guy, and brings in the police to hunt down Caligari and his slumbering minion. Caligari is caught, brought to justice, and put away, the horrible mad fool, for believing that he can play God with science.

At the end we return to the young man, who seems to have thoroughly bored the older man with his story. Ah, but then we realize that *it is the young man who is mad and in an asylum*, and it is the very same Doctor Caligari who is in charge of the asylum, and he was in the young man's fever dream, and so was the young woman, and this guy, and that guy; my hell, all the inmates of this asylum populated the very crooked and headachy little German village of the man's dream! *Ahhh! Ahhh!*

Well, we're supposed to think *Ahhh! Ahhh!* And well we should. Film theorist Siegfried Kracaver made a big deal out of how this film foreshadowed the rise of fascist Germany, and he may not be too far off. If we are gullible enough to be pulled in by the madman in *Caligari*, it's easy to see how they could fall under the spell of a seductive and powerful demagogue like Hitler, or worse, like Anthony Robbins or Howard Stern.

Although this film should unnerve us with its dark implications about the instability of the human mind, it doesn't, not anymore. Its devices and motifs have been watered down by allusion, imitation, and outright theft. For the Halloween crowd at Grumpy's it served as a novelty, a style piece not unlike vintage sixties furniture.

No scares to be found. The next night I saw the film *Thir13en Ghosts*, a thoroughly stupid movie in every respect but one: the adroit use of the letter 13, which appears in so few words these days.

The crowd was braced for impact. Horror crowds are an interesting bunch, akin to roller-coaster crowds. They come for the rush. Nothing delights them more than a good shock, and those are harder to come by than ever. So *Thir13en Ghosts* tries awfully hard to fill each and every frame with cryptic clues, dark shadowy figures, prosthetic makeup, bodies vivisected in fresh new ways, and glorious sprays of bodily fluids. People run, get chased, look for each other, and get ripped apart like warm baguettes as unrelenting Danny Elfman–style "horror" music hammers at your skull.

There is not a single frightening moment in this film. There are plenty of disgusting moments, a handful of ostensibly funny moments, but mostly the film has simply loud moments. This does not impress horror fans; they know that when a filmmaker moves the camera around like mad and pumps up the music it's generally because the scene is not inherently frightening.

Horror films live or die on their ability to create a generalized anxiety in the audience, then release it with scream-inducing shocks. *The Birds* horrified me with long, interminable scenes, shot in near silence, suggesting menace around every bend; scenes punctuated with hammer blows of vivid violence delivered not by people or fanciful monsters but crows and seagulls, everyday common things turned against us. It's hard to pull off, and that's why there are probably more horror parodies being made now than actual horror films.

On Halloween, I forced myself to revisit the epitomic genre parody, *The Rocky Horror Picture Show*, a film so affected it has inspired an entire generation of tacky people to band together and be tacky in a group.

I hate *The Rocky Horror Picture Show*. I never, ever liked it. I don't like the songs—face facts, they are all essentially the same tune, over and over again. I don't like the characters, except for Barry Bostwick as Brad, who, contrary to what the audience screams, is the only cast member who is *not* an asshole. I can't stand the story, what little

there is of it, as it decays into the sort of high school musical dream-land one can find oneself in if one has sucked down too much amyl nitrate.

And I can't stand the audience. On Halloween, and on regular weekend midnight shows throughout the year, the local *Rocky Horror* fan club gets together at the Riverview Theater to watch the same movie and make the same jokes about it, week after week. Deviation is not tolerated, unless it's initiated by one of the club's cool inner circle. The same jokes, sketches, interjections, always. I haven't seen so much precision rote behavior since *Triumph of the Will*. Here is an example of a film that was bad to begin with, and now two decades later people band together to celebrate its badness, but they do it badly.

For reasons only God could explain, people have been doing this, repeatedly, for over twenty-five years. What began as an interesting midnight movie exercise in excessive camp has become a haven for witless followers, a sort of church for dumbshits.

If nothing else, *Rocky Horror* proves that the line between the scary and the plainly dumb is as old as the horror genre itself. I was relieved to see *The Others*, a fine story in the gothic tradition, which has a subtle craft to it, and creeps in on the audience like a fog. I saw it with my beloved spouse, Jane, on a bleak afternoon and its effect was what I'd been looking for.

The Others, in which a woman has boarded up her light-sensitive children in a dark old house on a foggy island, exudes the mood I used to feel on All Souls' Day. There's a silent, sullen feel in the audience for a film like this, different from the roller-coaster lovers of the gory films. People come to be put in a dark mood, the kind evoked by Mary Shelley and Bram Stoker and occasionally by Anne Rice, a deep-seated notion that if we look in the right direction we can see beyond our lives into death, a place we normally envision only in dreams; and looking into that world bares our own fears of mortality. People walked from the theater wide-eyed, with the gray cloud of dread hanging o'er them.

Now that's fun. Was I scared? Not really, but I felt that mood, that

shadow place, and dredged up that old Catholic school thought: Where will I go when I die? Will I know it when I'm dead? How will I save myself? What's out there? *Ooowwooohhhowwooohhh . . .*

On to monster films. Films in which murderous fiends and inhuman beasts chill us to the marrow. More often these days, they suck up bullets like Jujyfruits and make sassy ironic remarks. *From Hell*, which ought to have been good, seemed to suffocate under its own style and left the audience rather bored, I think, which is too bad, because of its new spin on an old subject. The poor sick Ripper's tale has been mistold dozens of times: paired with Dr. Jekyll, hunted by Sherlock Holmes, set in New York and Arizona; played by James Spader; he even traveled to 1970s San Francisco in *Time After Time*. He has appeared on *Babylon 5* and was embarrassingly portrayed by Anthony Perkins.

This time the Ripper is a surgeon, a member of English society and a Freemason who has gone a little funny in the head, but is well insulated from the long arm of the law (Johnny Depp). The Hughes Brothers say they've made a new sort of ghetto film, this time in nineteenth-century London, and the parallels to modern ghettoes are vivid: The poor are left to live in Hell and fend for themselves, and the rich prey on them to satisfy their morbid desires.

Scary? No, not at all. Cool to look at, grisly, macabre, but not scary.

Am I inured to a good scare? I was supposed to be scared by Snoop Dogg in *Bones* but instead had a good laugh, especially when the famous canine vomits gallons of maggots onto a club full of jiggy folk. Snoop played a sort of benevolent seventies-vintage pimp who was betrayed and killed by his friends, and returned to haunt his own house, now a disco. I was amused and disgusted, but not scared.

I saw one film that was well on its way to being really scary: *Jeepers Creepers*. It starts with a brother and sister, driving home from college, fighting as only siblings can; suddenly they are nearly run off the road by a huge old truck, driver unseen. *WoooOOOooo. . . .* Then they see the truck later in their drive, dumping . . . *something* down a huge pipe outside an abandoned church. *Zhu-zhu-zhu-zhu-zhu-zhaAHHH!* Yoiks, it

did indeed make my flesh crawl. Well, the kids do all the wrong things for the right reasons, and naturally get themselves neck-deep in it.

Jeepers Creepers sure set the mood. I squirmed in my chair, and I felt the excitement in the crowd, who were eager to have the pants scared off them. But then, after being hit several times with a large station wagon, the bad guy sprouted wings and revealed himself as a classic movie Satan, you know, with a body like The Rock, horns, and bat-style wings. Suddenly he could take bullets from assault rifles and flame throwers, nothing could stop him, and he started to crawl on ceilings and slather out of his prosthetic teeth.

Behind me someone whispered, "Oh, big surprise, it's a monster from hell." In answer, another voiced, "They just ruined the film." I couldn't agree more. All the tension they had built with the unseen other and the relentless menace vanished in an instant.

To genuinely evoke fear, a movie can't simply address our fears, it has to dig them out of where we hide them, in our subconscious. Find a filmmaker who can draw from our subconscious and show it to us, and you have a true master of horror. Like Poe.

This is why David Lynch's *Eraserhead* is the most horrifying movie I have ever seen.

I saw it in a packed house as first of a double bill with *The Elephant Man* and the experience has never left me. David Lynch has managed to do what few other filmmakers can accomplish: to present on film a dream, or in this case a nightmare. The film has no apparent plot, makes no apparent sense. There is no evil nemesis, but it crawls with monsters. Comic images dance in counterpoint to hideously malformed creatures. In the audience, people laughed or yelled at the screen, because they didn't know what to do with what they were seeing. About thirty people left, but I hung on for dear life. I felt that deep transmission of sound and image that separates cinema from any other art: I was in a room full of people, and yet I felt entirely alone, and the filmmaker was communicating directly to me. I didn't like what I was seeing, but I couldn't turn away. I was invited not only to suspend my disbelief but my logical analytical mind, my conscious thought. I bought in, and those images haunt me to this

day. I've not seen the film since, nor do I plan to, but I'll never forget it.

This is horror. This is difficult to accomplish, but this is what we in the audience want from horror. Nobody cares about special effects if a character can scare the wits out of you just by walking into the room. People won't flock to a parody if deft and chilling horror returns to the screen. We need these opportunities to visit the sons of Ares, Phobos and Deimos, Panic and Dread, knowing that the way out is as close as the nearest exit.

�֍ WEEK 45, NOVEMBER 5–11 ✖

General Cinema Centennial Lakes 8, Edina	**K-Pax**
Landmark Lagoon Cinema, Minneapolis	**The Endurance**
General Cinema Centennial Lakes 8, Edina	**Heist**
Kerasotas Inver Grove	**Mulholland Drive**
Oak Street Cinema, Minneapolis	**Home Movie** (Get Real Documentary Film Festival)
Oak Street Cinema, Minneapolis	**Paradise Lost 2: Revelations** (Get Real Documentary Film Festival)
Oak Street Cinema, Minneapolis	**How's Your News** (Get Real Documentary Film Festival)
U Film Society, Bell Auditorium	**The Komediant** (Jewish Film Festival)
U Film Society, Bell Auditorium	**The Producers** (Jewish Film Festival)
Oak Street Cinema, Minneapolis	**Lalee's Kin** (Get Real Documentary Film Festival)

Documentaries Are Good for You
But Please Don't Let That Keep You from Going

I know what you're thinking: "Yuck, documentaries! Two-hour yawn-a-ramas with no cool special effects and stuff. A bunch of talking heads and old pictures they zoom in on, over and over again. Movies about things I couldn't care less about. It's like going to school only you have to pay to sit there and you're s'posed to learn something."

I know people who would do cleansing fasts, attend real estate seminars, or participate in Democratic caucuses before they'd ever go out to a theater to see a documentary. "I can see it on television," you people say.

If this is you, you've been watching too much television. Television

has sanded down the edges of documentary filmmaking to the point where docs don't play unless they're either lurid or they're stultifying. A&E and the History Channel—well known as "The All-Hitler Network"—have managed to wring out all that is innovative and interesting about the documentary form and turn their programming into a block of dull, fact-filled tripe. VH-1's *Behind the Music* has taken the repetitious style of picture-talking head-picture to new heights of blandness; it's *Biography* for pop music fans.

Reality television? Don't get me started. *The Real World* is far from real; *Road Rules* holds no interest for me. *Survivor* is just an odd kind of sporting event. What we get are lives manipulated by producers and edited to force drama where there is none. If you ever saw the work of Fred Wiseman or D. A. Pennebaker, you'd never watch another "reality" show again.

Only HBO and Showtime consistently break out of the conventions that television has impressed on the documentary form and support some fantastic filmmaking, going even further and distributing many of their docs to theaters and festivals. I applaud them for this, in part because I'm too cheap to shell out the dough for cable premium channels, and in part because I think both networks need to atone for the excess of soft-core porn they make available.

In my opinion, PBS fancy boy Ken Burns has done more to skew the public perception of documentary than he knows, by injecting in the mind of the audience the notion that documentaries are at least eleven hours long, contain endless shots of only three pictures, and feature George Will. It's a shame. The documentary remains a vital form of storytelling, a compelling use of cutting-edge techniques and, far more often than any fictional feature film, an agent for actual social change.

Ah, that "social change" thing has you turning the pages, doesn't it? Well, relax. I'm going to cite some of the documentaries I saw this year and target the audience who'd love it. Just about any genre of fictional film has its equal in documentary.

This week, here in Minneapolis, the wonderful and daring Oak Street Cinema has been hosting "Get Real," a four-night festival of

documentaries, presented by our dandy local news and arts magazine, the *City Pages*, and curated by its fierce critic Rob Nelson. Every screening I saw was packed, and not just with the usual grad-school book lovers who have read *The History of the Punic Wars* three times and have a nude picture of Barbara Tuchman on the wall. I was gratified to see a lot of shows quite full. I'd have felt better if the whole thing had been sold out, because every single one of these films was worth seeing.

For instance, any *Blair Witch* aficionado will thrill at *Paradise Lost 2: Revelations*. It's a genuinely scary follow-up to the equally scary *Paradise Lost: The Child Murders at Robin Hood Hills*. It's directed by the same filmmaker who brought us *Blair Witch Project 2*, so you know the kids are gonna love it.

Paradise Lost 2: Revelations picks up the story after three teens, now known as the West Memphis Three, were convicted of mutilating and murdering three young children as part of a satanic ritual. It quickly becomes apparent that the documentary team has been far from simply observational, and has found itself to be one of the subjects of its own story. And we meet Mark Byers, father of one of the victims, who is more frightening in real life than any horror film character since Max Cady in *Cape Fear*.

The film is an utter mess, a shoddy piece of hack journalism, a mishmash of vérité style, flashbacks, and digital effects; but the story is so compelling, the characters so interesting that it's hard to look away.

The crowd was half-filled with young men with black clothes, piercings, jet-dyed hair, and all the other requisites of the Goth uniform that are supposed to make you look "different" but fail because *it's a uniform*. The other half of the crowd seemed to be the parents of such kids, here to figure out what the hell is going on in their Goth kids' minds. The kids got off on the whole story, its sordid nature, its twists and turns, the depravity of the crime at its core, the deep pulsing Metallica soundtrack. The parents were genuinely disturbed not only at the film, but also at the kids who strolled from the movie, smiling and saying, "cool."

Do you like a dry comedy? Something with wit and heart? Something like *The Royal Tennenbaums*, only not as aggressively quirky? *Home Movie* is right up your alley. It was made by the same team that brought us *American Movie*, headed by director and documentarian Chris Smith. It's as simple as a movie can be: five different portraits of people who are serenely happy in their extremely unusual homes. Bill lives on a houseboat in the bayou and raises alligators. Ben builds robots and lives in a thoroughly gadgetized "house of the future," like something out of popular mechanics in the fifties. Ed and Diana, poster children for the new-age stereotype, smile and talk lovingly about their home, a converted missile silo. Linda, an American TV star in Japan in her heyday, lives in a tree house in remote inland Hawaii. Bob and Frances have remodeled their house entirely for the benefit of their dozen or so cats and make their living shooting adorable cat pictures.

These people are here to enjoy. Their portraits are filmed not to ridicule them, which would be easy, but to show the joy they've found in making their homes as unique as themselves. It's a fine line that director Chris Smith treads, but it's clear that the filmmaker likes these people and wants us to share in that joy.

It was a ball. The house was standing room only, and Smith was there to answer questions. At the end people stood and cheered, and went home happy.

Hear that? That's a documentary I'm talking about, in a theater, and perhaps the most enjoyable and warm movie of the year.

I'm sorry I had to miss *Blue Wild Angel: Jimi Hendrix at the Isle of Wight*, if only because the crowd waiting in line to go in as I drove by was most enticing: the old hippies, the local musicians, the die-hard rock fans and their kids. It reminded me of the crowd at the recent Dylan concert, where age held no sway, and the music spoke to everyone.

I missed the Hendrix doc because, wouldn't you know it, the U Film Society was holding its fifth annual Jewish Film Festival, and I had to get a sample.

Forget *Gypsy*. Don't watch *Funny Girl* for the fiftieth time. Don't

pay a fortune for tickets to *The Producers*. See instead *The Komedi-ant*, a sagalike telling of the history of the Burstein Family, renowned in the Yiddish theater, and their journey from prewar Poland to New York, Israel, and the Jewish world at large. Pesach'ke Burstein, the patriarch of this performing clan, became an actor at a time when it brought shame to the family. And yet he could sing, dance, whistle like a song bird; he could make 'em laugh, make 'em cry, make 'em sing. What else was he supposed to do? Filmmakers Oshra Schwartz and Arnon Goldfinger dive in to their subject with exuberance and an unflinching eye, telling a story that's far from rosy. Pesach'ke, whose name means Passover, who was born on Passover and died on Passover, was an astounding talent and a real tough dad. He became a star on the world stage, married and per-formed with Lillian Lux, fathered and performed with his children Michael and Susan, known on the stage as Motele and Zisele. The family made classic works out of traditional Yiddish music, drama, and comedy, lived lives full of love, torment, and tragedy. This fami-ly lived out the kind of drama made universal in the most popular of Jewish stories.

What more do you want from a film?

Perhaps you like drama with grit and substance, you're not afraid of an unhappy ending. You read Alice Walker and you see John Sin-gleton films. *Lalee's Kin: Legacy of Cotton*, produced for HBO, was the most compelling and difficult film of the festival. We see the cycle of poverty in the Mississippi Delta. We meet Lalee, who cares for her own children and any number of her family's children, and just feed-ing these kids is a daunting effort. But we also meet young Cassandra, nicknamed Granny, who struggles to break out of this cycle and claim her own life. We see the sort of institutionalized oppression that has contributed to the stagnancy of the economy and the loss of hope in people who live there. But most of all, we see people kept down because of race. It's unflinching, it's hard to look at, but it's touching and inspiring, as tragedy and hope live together.

Somehow people are far more willing to read tough fiction than watch tough reality. I think that's too bad. In the hands of a good film-

maker, the hard bitter world is seen without bias, as if the documentarian is transparent and the story is given directly to us.

Why can't we see more of this in a movie theater?! This is what "the cinema" is. It requires an audience to complete the art form. A public audience, a group of people sharing the experience. This is what the filmmakers intend, this is what separates real docs from TV docs.

The problem is that docs at the theater are difficult if impossible to find for the average moviegoer scanning the papers rather than combing the movie trade magazines. Who among you has gone to the kitchen during the documentary awards portion of the Oscar telecast to fill up the chip bowl? Come on, admit it. My hand is up right now.

I've seen documentaries this year for which the audience stood up and cheered, that gripped me as tightly as the best thrillers, made me laugh more than any offering in the current dismal comedy genre, broke my heart in a way that the most tragic fiction cannot. Docs are hard to find, but worth the effort. Grab your local arts newspaper, talk to your local art house manager, venture onto the local campus and find the film programs. Hunt them down. At the very least, forgo one dumb Hollywood feature this year and find a doc. If you enjoy it, don't thank me; thank the courageous souls who stay out of the way and let others' stories be told.

✳ WEEK 46, NOVEMBER 12–18 ✳

Megastar 16, Edina	The Man Who Wasn't There
Megastar 16, Edina	Life as a House
Megastar 16, Edina	Shallow Hal
Landmark Lagoon Cinema, Minneapolis	Waking Life
General Cinema Centennial Lakes 8, Edina	Harry Potter and the Sorcerer's Stone
Uptown Theater, Minneapolis	Novocaine
Landmark Lagoon Cinema, Minneapolis	Amélie

Harry in Your Pocket
We Do Have a Choice in This Matter

Okay, just let me run a few things by you. The Harry Potter books are on their way to becoming the biggest success in publishing history since a guy first scratched on a rock with a thing and showed it to another guy. This week is the American premiere of the first Harry Potter film of many—*Harry Potter and . . .* you know what the hell it's called, so we'll just call it *Harry* and number the rest. Anyway, *Harry* opened on Friday on three thousand six hundred seventy-two screens across the USA.

That's one out of ten movie screens in the country. More screens than any other movie.

Harry 2 will open same time next year, not long after this book is published. I'm guessing it will open on as many screens or more, and it will be well on its way to becoming one of the biggest movie franchises ever in the universe. It could become as much a holiday tradition as football and intestinal gas. It's the way of the franchise. Look at James Bond.

Now I want you to find a copy of the lobby poster or the newspaper ad or the video case for the first *Harry* movie.

Go ahead, I'll wait.

Got it? Good. Now take a good close look at Harry. The forward lean of the head, eyes peering over the little round glasses, the slightly elongated upper lip, the squashy nose, the subversive smirk. The look of a kind of genius. Do you agree? Now who do you think he looks like?

I think he looks like Steven Spielberg, and I don't think that's an accident.

It was reported in several magazines that Spielberg said he didn't want to direct *Harry*. He was quoted in *Time* as saying that the project was too easy, it was "shooting ducks in a barrel," it was "a slam dunk," like withdrawing a billion dollars and putting it in your personal bank account."

Why are you going? Because everyone else is? Because you've been teased and tantalized by news reports and TV ads and magazines lining up to say *Potterrific!*

Or are you going because you really love the books, and you're anxious to see this lovely work of imagination brought to the screen? Well, now, think about *that* for a moment.

What is it in this story that's captivated you?

I've read all the books, and I've enjoyed the stories, but most of all I have marveled at the ability of the author, J. K. Rowling, to transmit words into images. She writes much like Michael Crichton, in a style that is entirely cinematic, visual, and kinetic. Take a look at a few pages: We are getting action, dialogue, and scene-setting, much like a screenplay. We get scenes that open and close, segue through narration into each other.

Boy, she does it well. If you're like a lot of people, you were capti-
vated by how the story played in the theater inside your own skull. It
opened up your imagination. Like all good stories, it inspired you to
illuminate the story in your own mind's eye. You have your own vision
of Hogwarts, of Snape, of Harry and Ron, of Dumbledore and Hagrid,
the monsters, the menaces, the magic. If J. K. Rowling has done noth-
ing else truly remarkable in her pages, she used modern language to
absolutely illuminate a fantasy world, and she's done this in a way that
leaves the illumination in the hands of the reader.

Sure, these images were born of J. K. Rowling's book, but they
were nurtured and decorated and set upon the stage by you. This is
your movie, your screenplay, adapted for your own imagination by you.
And since you're working with good material, you probably have a ter-
rific cast, splendid art direction, and a fabulous soundtrack. It's a slam
dunk. Like shooting ducks in a barrel.

But now you're going to shelve all that and let Chris Columbus and
about three hundred people under contract to Warner Brothers coin
all those images and characters for you. Will you be disappointed? I
hope so. Entertained, yes, but disappointed, because your imagina-
tion has been co-opted, redesigned, copyrighted, licensed, and sold
back to you. And you're paying for the privilege. Get the picture?

Does any of this bother you?

This is what people did with epic poems and stories before there
were movies: they *imagined*. Think about Beowulf for a moment.
Think about what that story sparked in people's minds. Beowulf the
hero. Grendel, the monster, the threat. Grendel's mom; in my mind, I
always cast Bette Midler in this role.

Until commercial movies came along, quickly ran out of original
ideas, and began sacking the world's great literature for stories, we
were the greatest filmmakers in the world. We did it all ourselves, in
our minds, and we retold these stories to each other, adding our own
personality, our own elements, making them our own.

This is how it should be. This is how stories work. We share them,
and in sharing them we kindle the fires of imagination.

I'm sorry I missed the first official stage production of *Harry Pot-*

ter and the Sorcerer's Stone at the Fulton Elementary School in Dubuque, Iowa, earlier this year; there were only three performances. But I'm thrilled it happened. On their Web site you can see pictures of the kids, in paper hats and homemade robes, running around a cardboard Hogwarts that's set in a corner of the school gym. But in their minds they're crossing the water to the old castle, battling a giant three-headed beast, matching wits with Professor Snape, without the millions of dollars, or ads, or the drink cups. And guess what: *The story's every bit as good.*

Here's all I'm suggesting: Before you go out and pay good money for the rights to your own imagination, mull the story over in your mind. Not so you'll know it by rote, but so you'll reflect on why you like it so much. Hold on to your own adaptation of *Harry*, hold it close, and maybe you can enjoy the Chris Columbus version, even though it pales next to your own.

✳ WEEK 47, NOVEMBER 19–25 ✳

General Cinema Centennial Lakes 8, Edina	**The One** (dim sum, sushi)
Landmark Lagoon Cinemas, Minneapolis	**Focus** (nova lox bagel sandwich)
Megastar 16, Edina	**Spy Game** (burger and fries)
Cedar 6, Owatonna, Minn.	**Monsters Inc.** (Thanksgiving dinner)
Megastar 16, Minneapolis	**Amélie** (Nicoise sandwich and vouvray)
Loews Cineplex Edina 4	**Out Cold** (hot dog)
Loews Cineplex Edina 4	**Domestic Disturbance** (ham sandwich)

Dinner (Yum) and the Movies, Part Three

Over the Highway and Through the Mall, or How to Smuggle an Entire Thanksgiving Dinner into the Theater

Theater managers the country over will hate me for this, but I have been smuggling food into movie theaters for ages. I was inspired many years ago by Paul Newman, when he started selling his tasty popcorn. On the back of the jar, Paul explained how he made his own and proudly paraded his home-popped bag of delight across the lobby, boldly defying anyone to take it away. Nobody confiscates nothin' from Paul Newman. Besides, it's good popcorn.

We're not lucky enough to be Paul Newman, you and I. And theaters purposefully post several signs forbidding outside food. But your own smuggled food is always better, hand-picked, and enhanced by the flavor of defiance.

There are many easy ways to do it. I always carry a small shoulder bag to the movies (it's not a purse) to hold my notebook, a small flashlight, and my calendar, and I make plenty of room for a bag of home-popped corn, raisins and nuts, or a chocolate bar. Occasionally, I'll bring a whole meal in. This week I made a point of smuggling meals thematically tied to the movie I was seeing. The dopey Jet Li movie invited Asian food, but a note to the wise: Sushi smells really loud, and not everybody enjoys the redolence of raw fish and seaweed, so be careful. *Focus*, a compelling Arthur Miller fable of battling anti-Semitic hatred, necessitated a terrific potato knish from Zaroff's delicatessen. The incredibly Frenchy *Amélie* made for a great dinner-date with spouse, Jane, along with Niçoise sandwiches, French chocolate cookies, and a fine Muscadet. The cheeky teen-boy snowboard movie *Out Cold* screamed for an all-beef hot dog, while John Travolta and Vince Vaughn in *Domestic Disturbance* cried out for ham.

With my ample shoulder bag (again, it's not a purse) and a winter coat, none of this was difficult to pull off; I think theater staff looked the other way, or they simply didn't believe I'd have the nerve to bring delicious food and wine into their theaters. Generally I'd return the favor by buying something to drink and carefully cleaning up after myself, but I will continue to smuggle whenever I visit a theater with my appetite.

My coup de grâce for the week would be Thanksgiving Day, when I would triumphantly smuggle in and serve up an entire turkey dinner during the movie. It took careful planning, a bit of cunning and deceit; and little did I know as I plotted that it all would be eclipsed by a four-year-old kid.

It would be the ultimate act of defiance, as I planned to bring the whole caboodle to the theater: turkey, stuffing, potatoes, yams, cranberry sauce, and pumpkin pie. We'd be in Owatonna, my spouse Jane's ancestral homeland, so we couldn't forget the traditional *lefse*, a sort of Norwegian tortilla, from a recipe handed down by Jane's mother's family, probably since the Viking days in the old country.

Ever-resourceful Jane helped by sewing several pockets into an old canvas military coat we bought at a secondhand store, into which we'd stuff Tupperware bowls filled with all the trimmings. I deemed it folly to bring a whole turkey and carve it on site, but it was important to dine properly, so down the back of the coat Jane sewed a long pocket to hold a roll-up camp table. Tablecloth, plates, cups, flatware, wine, and glasses all got their own pockets.

On Thanksgiving Day we spooned the piping-hot food into the Tupperware and tucked it all into the coat. Fully assembled and donned, the coat was massive to the point of ridiculous and weighed about twenty pounds. The table down the back gave me a hump to rival Quasimodo, so I stood and walked as erect as possible.

The movie for the day would be *Monsters, Inc.*, because three kids of the Wagner clan had excitedly volunteered to come along: ten-year-old Claire, eight-year-old Melanie, and four-year-old T.J., who would be seeing his first-ever movie-theater movie. T.J. is a stunningly cute little guy with sandy hair, a toothy smile, and wily hazel eyes betraying a penchant for mischief. Recently he's had to share his life with his twin baby brothers, so was thrilled to the point of vibrating like a pager, dying to do something fun with the big kids.

On the drive to the theater I had the delicate task of informing the kids that Uncle Kevin was doing something extremely sneaky.

"Kids, you saw the coat I have, with all the food in it?"

"Yeah?"

"Well, I'm going to sneak dinner into the theater, and I might get in trouble if I get caught, so don't tell anybody, okay?" The older girls had no trouble conspiring to do something subversive.

Ah, but then there was T.J.: "Why?"

Leave it to a four-year-old to get straight to the point. T.J.'s a smart kid; he soaks up abstract thought like a baked potato soaks up gravy. "Well, it's just . . . sort of . . . a goofy thing . . . um . . . that I'm doing, 'cause sometimes it's fun to be a little sneaky."

Can you tell I don't have kids?

Jane came to my rescue. "Remember what I told you, that Kevin is going to the movies every day?"

"Yeah?"

"Well, today is Thanksgiving, and we're going to celebrate it in the movie theater and have a little turkey dinner. But people don't usually have dinner in the theater, you know, so if they say no, Kevin will do what they say. We just won't talk about it. Okay?"

Can you tell that Jane works with kids?

T.J. returned bluntly, "I don't want turkey, I want popcorn." He found nothing odd about smuggling a feast into the movies; he simply didn't care.

"Sure, you can have popcorn." Perfect. Jane and the kids would run interference getting popcorn while I slipped into the theater. Whew.

The Cedar 6 is in the middle of the Cedar Mall, appropriately, on Cedar Street. I walked though the lobby in my massive coat, spine erect, and the stuffed coat thrust out in front of me, making me look hobbled and morbidly obese. Boy did I get the stares; with the bushy hair and beard I was growing so I could play Santa at Christmas, I looked a lot like Hagrid from *Harry Potter*. I tottered dangerously from side to side as I walked, Tupperware clanking the whole way. I have never been so self-conscious.

Our little snack-interference plan worked perfectly. Jane bought the tickets, slipped me mine, and headed for the snack bar. Ordering snacks for kids immediately creates a long moment of chaos; so, while they assaulted the counter, I lumbered into the theater, went directly to the front row, and set up.

The theaters at Cedar 6 have generous space between the front row and the screen, perfect for setting up a table for a multiple-course meal. As the theater began to fill, out came the table, the tablecloth, plates, and service. The air filled with the smell of roast turkey, sage stuffing, and pumpkin, which I figured would betray me for sure. But no one else sat in the front, thank God, and I scooped up generous portions for Jane and me.

Just as I was about to crack the wine, the manager came down the

aisle. Turning his back from me, he went to the far wall and did what all managers love to do, fiddle with the thermostat.

The manager turned, all business, and headed back, but then he spotted me. There I sat, exposed, out in the open, red-handed, *in flagrante delicto*. Turkey steamed through the gravy on our plates. Cranberry sauce glistened; my homemade recipe. I'd cooked the yams Cajun-style and the aroma of cinnamon and cayenne perfumed the air.

He looked at the table. He looked at me. I fixed my gaze on him, ready to pack up and go.

Tacitly he gave me a small salute, and in the darkness I detected a wink. "Happy Thanksgiving," he said. "Happy Thanksgiving," I returned. He smiled and headed back up the aisle.

Grace is something normally relegated to an earnest prayer of thanks before tucking into a meal. But grace in practice extends out from the confines of prayer into acts of goodwill. I believe that theater manager graced our meal that day, I never got his name, but I thank him from the pages of this book. What a guy.

Jane and the kids showed up, the cousins with their little kid-size popcorns and soda, as the screen lit up. I was flush with relief, and my appetite surged. It was the tastiest turkey dinner I'd had in years. Even though my beloved father-in-law had cooked the turkey days before and warmed it up in the giant Hamilton Beach roaster-mummifier, it caressed my tongue, thrilled my olfactory, warmed my whole being. The gravy helped.

What a surprise: Before the movie, we got a cartoon! A terrific little Pixar offering called *For the Birds*. I love Pixar for many reasons, not the least of which is that they are not controlled hand and fist by Disney. They also have managed to add back many things missing from animation in the recent past: a real sense of story, told through pictures alone. *For the Birds* is a pantomime piece, actually one long joke with a lightning punch line, with no dialogue, no snappy repartee, just pure narrative through the moving image, the essence of cinema. Anybody can tell a joke, with practice, but *showing* a joke is a genuine art.

Away we munched. *Monsters, Inc.* began, as did one of those moviegoing moments I'll cherish my whole life.

See, T.J. Donlon has an issue with monsters. They have been hiding in the dark recesses of his house: the closets, the unlit rooms, under the furniture. So much so that the Donlon residence was posted: NO MONSTERS ARE ALLOWED IN THIS HOUSE. This only goes so far to quell the fear, so T.J.'s fourth year on this planet had been fraught with peril. As the movie started, with a scene in a child's darkened bedroom into which a massive monster creeps, his eyes widened. Remember, he has never seen a moving image so big, heard sound so loud, never has he been exposed to a movie theater. He has tended to bolt at the first sign of scariness in any movie, so this could be an ordeal. And he's seated in the front row.

Cousins Melanie and Claire sat on either side, gently whispering reassurances. "Don't worry, Thomas, it's just *pretend* scary."

In the movie, the monster looms, shadow falling over the child. T.J. was riveted, eyes scanning the height and depth of the screen. The monster opens its maw, teeth flashing, arms up, poised to pounce. The child bolts upright and screams.

I looked at T.J. If the kid's eyes could've opened any wider, he'd have needed double-jointed eyelids. Suddenly the monster screams back at the child, panics, runs around the room, arms flailing, toys flying. Lights come on in the child's room. Only it's not a child, it's a mechanical kid-dummy. The room is revealed as a simulation. The monster is a trainee who has blown it, and he's dressed down by his trainer.

A great joke, and the crowd went for it. Better yet, T.J. got it, his tight mouth widened into a grin and his eyes wrinkled upward, sparkling with relief and delight.

That grin stayed with him for the next ninety minutes.

T.J. stirred only once during the whole movie; halfway through he bounded from his seat and faced us, simply to say, "You guys, this is so GREAT!"

What a thing to see. What a thing to share. This is what the movies

are for, this is what I'd set out to find. I didn't care that a little kid had upstaged my Thanksgiving dinner gag. As we headed out of the theater, my belly full, Tupperware *clack-clack*ing in my coat, theater staff staring at me and giggling to each other, my eyes were fixed on T.J., who walked about three inches off the ground.

City Club Cinema, Grumpy's Bar, Minneapolis	Selected films of Buster Keaton
General Cinema Centennial Lakes 8, Edina	The One
Megastar 16, Edina	Spy Game
St. Anthony Main, Minneapolis	Harry Potter and the Sorcerer's Stone
Oak Street Theater, Minneapolis	To Be or Not to Be
Mann St. Louis Park Cinema 6	Behind Enemy Lines
Landmark Lagoon Cinema, Minneapolis	Sidewalks of New York
Loews Cineplex Edina 4	Heist

Critics and Other People
And How to Tell Them Apart

What should you go see? How do you choose? How do you know when you are in the mood for a movie in the first place? Is it like dinner, does your aesthetic sense grumble with hunger? Does some yearning deep within compel you to seek the silent shared communal experience of the cinema? Or is it, say, that advertisement in the paper featuring Angelina Jolie's lips as Antonio Banderas caresses her naked upper torso, cups her left breast with his large, strong right hand, and breathes so lightly on that point where her neck descends gracefully into the collarbone?

Nah, it couldn't be that. That's merely window dressing for the real

reason to go: the bold letters of the blurb that tell you "Thumbs up."

It's the blurb, the damnable blurb.

Blurbs, ads, trailers, entertainment journalism—these are the front lines of the massive marketing machine that compels us for whatever reason to put our rumps in theater seats. It is important to realize that the overwhelming amount of movie information available to you is intended to sell.

It's advertising, pure and simple.

Where do we, the audience, seeking good, trustworthy, dependable information, look? How do we stay out of the dysfunctional cycle of marketing, promotion, duplicitous motive, and downright hype? How do we separate what the industry wants us to watch from what we want to watch?

Easy answer: Find critics. Difficult corollary: Find *good* critics.

Critics, like them or not, are one of the keys to quality moviegoing. Good critics balance reason with passion, solid knowledge with solid prose, excitement with skepticism. Good critics serve no one or no entity but the medium of film.

Here's the difference between a film critic and a reviewer: Pick up your local Sunday paper, look for the guy who does the local film column. It will be accompanied by a picture of this person, a man or woman with a confused smile and a bad haircut. The writer will highlight a film—*Lord of the Rings*, for example—and the piece will have a bad play on words for a title: HOBBIT FORMING, or maybe LORD OF THE BOX OFFICE. The review contains a description of the film, reworded from the studio's press kit (but often verbatim); finally the writer's opinion, rarely controversial, generally siding with the majority. The writer may finish out with capsules of the week's new releases and their scores—stars or little boxes of popcorn or letter grades.

That's a reviewer.

Now pick up a recent issue of the *New York Times* and see a two-page article suggesting repeated viewings of Todd Solondz's brutal, unpleasant films, which deepens into a discussion with the filmmaker of the derisive side of humor and the potential it has to become something almost fascist.

That's a critic.

It's true that critics at first blush look like reviewers who can write. Reviewers often seem to think that their prose needs to be colorful; unfortunately that color generally is brown. A critic, at the very least, is more likely to be readable.

But critics at work dig into the marrow; the writing transcends this film or that and adds to the whole conversation of why film is good or bad and how it can be better.

They're out there, helping us to wade through the promotional hype and the marketing ploys. Richard Corliss in *Time*, possibly the most readable critic in print; J. Hoberman and Amy Taubin in the *Village Voice*; Elvis Mitchell, A. O. Scott, Dave Kehr and Stephen Holden in the *New York Times*; the entire staff of *Film Comment*; and my favorite of all, Stanley Kaufmann in the *New Republic*. These are the ones I read regularly. Often I fervently agree with them and often I angrily disagree. But they all contribute to the conversation.

It's funny that television reduces the critical conversation to whining and kvetching, but that is the coin of the realm. Long ago when I was a child in Chicagoland, Roger Ebert and Gene Siskel had a local TV series called *Sneak Previews*, a show partly responsible for my love of the movies—responsible in that they drove me mad, but I'd love to watch anyway. The Howard Cosell phenomenon. That they would embrace or dismiss a film on the basis of a wave of the thumb, that they could be so dopey and personal in their criticism, that they could spend most of the time bickering like junior high geeks is what drove me crazy, but ultimately what endeared me to them. For better or worse, these two clowns changed the nature of popular criticism by doing what *we* do, arguing loudly and passionately over movies. Roger is, and Gene was, a different animal in print, delivering thoughtful, considered reviews of films both popular and obscure. Gene did and Roger does tremendous work in advancing the cause of good filmmaking. But get them on television and it was the battle of the ninnies. Their opinions were often knee-jerk and bating, custom-designed to piss off the other. They would take potshots, they would mumble in a last word, they'd get genuinely angry.

I loved this. It may never happen again. Richard Roeper is a fine and capable movie reviewer, but the chemistry doesn't compel me. Besides, Roger now looks exactly like my grandmother Grace Murphy would if you'd put her in a Lands' End blazer and given her a more mannish haircut. This makes Roger far easier to read than watch.

How do some of the critics rate? Well, this week I went to see a brace of conventionally stupid Hollywood films, then I read reviews from some generally respected sources. Now I'll review those reviews and see how they stack up.

Behind Enemy Lines

Okay, first off, this is a preposterous movie. With a little massaging it could have been a parody, and ought to have been billed as such. But the filmmakers went out of their way to describe it as "a new kind of war film." It isn't. They failed.

Nearly every major critic I read slammed the film to the mat, except for two:

RICHARD SCHICKEL IN *TIME*
I'll forgive, because he patently likes this kind of stuff, and he unashamedly calls it a "ride movie" and takes it no further.

Richard gets a "thank you."

STEPHEN HOLDEN IN THE *NEW YORK TIMES*
does much the same, but he's a little more namby-pamby about it. He calls it "a taut wartime rescue thriller." It isn't. Had he called it "a *trite* wartime rescue thriller," I might've gone with him. Had he called it "Rambo on ice" I would've sent him flowers. It's a junk movie and he liked it. I wish he'd just come out and said so.

Stephen gets a light smack on the forehead.

STANLEY KAUFMANN IN THE *NEW REPUBLIC*
proved why he's my favorite critic in print. Here he converts the discussion into a great piece of film criticism.

Stanley argues that we can with open eyes acknowledge how dumb the subject matter is, but also appreciate the craft that goes into it: the

cinematography, the editing skill, the sound and music, which were all first-rate. Stanley suggests directly and by implication that the Hollywood moviemaking machine still employs some of the most skilled craftspeople in the business, and that maybe their craft seems wasted, but it's good enough to shine through and be admired on its own. Here, the sum of the parts is much greater than the whole.

Stanley eschews letter grades, but in my book he gets an A +.

The One

This is a big dumb chop-socky movie. That's all you need to know, unless you're into that sort of thing. Jet Li plays two Jets: Good Jet and Bad Jet. Good Jet is a cop trying to stop Bad Jet, who wants to become Almighty God Jet and can throw motorcycles around like they're plush toys. It's all bad, the critics knew it was bad, the audience knew it was bad.

STEPHEN HOLDEN IN THE *NEW YORK TIMES*
had a little fun with it, but it took him almost six hundred words to do it. He spent four whole paragraphs describing the film's story, which he'd already declared "largely impenetrable." Now I understand that it's a lot of fun for a good critic to have at it with a bad film, but for my money they should really dig into it, use terms like "crusty heel of poop" and "big dumb chop-socky movie."

Let's give him two little boxes of popcorn.

ED PARK IN THE *VILLAGE VOICE*
uses half that many words in a spare two paragraphs to dismiss the movie, which is good; it didn't waste my time. However, his snootiness showed through as he used, without humor, the terms *"momento mori"* and "solipsistic" in one sentence, and he referred to Nietzsche, all in a pan of a big dumb chop-socky movie.

He used no letter grade, but because he's such a snob he gets a D.

ROGER EBERT IN THE *SUN-TIMES*
had the most fun with it, although his brand of humor sometimes can be confused with mere whining. Roger has great fun when a film-

maker takes a potentially great premise and instead circles the drain. He gave it one and a half stars, and I have to wonder what affords the movie the half-star.

He gets 6.02×10^{23} stars.

Harry Potter and the Sorcerer's Stone

Okay, this was an easy target, because, damn, it looked like a movie and sounded like a movie, and if you bought the theme cup it even tasted like a movie. My theory is that *Harry Potter* is a groundbreaking achievement for the future: a movie clone. It has all the outward appearances of a piece of entertainment without shouldering the onus of actually entertaining. Controversial? You bet, but only among some elitist critics. See how they flock to the theater, my pretties, yes, *perrrfect perrfect*, heh, heh, heh . . .

RICHARD CORLISS IN *TIME*
in spite of the fact that his publication had dedicated acres of print to the "Harry Potter Phenomenon," Richard went out of his way to express his disappointment in how Chris Columbus had wrung all the magic out of the story, even with all the excellent resources at hand, from cast and art direction to the original text, which he quite liked. He nicely points out that Alan Rickman's Snape is garbed like Hamlet. As he often does, he makes what looks like a review into a fine piece of criticism, and yet this doesn't mask a boyish wistful sadness that the movie wasn't what it could have been.

Richard gets a turn at the Sorting Hat. No doubt he'd end up in Gryffindor.

J. HOBERMAN IN THE *VILLAGE VOICE*
likens the movie to "an elaborately planned military operation" in how carefully the film was engineered not to offend anyone. He's right. Not having read the book (he says), he touches on the seemingly unassailable J. K. Rowling, suggesting that the story is derivative of a lot of classic British children's books, and again he's right. And he manages to sneak in the best pun I've read in a review this year, "it's

off to be the wizard," an inoffensive little thing and a controlled use of the critics' general addiction to plays on words.

J. gets no grades, no stars, just polite thanks.

SUSAN STARK IN THE *DETROIT NEWS*

says of the film, "In a word: Potterrific!" Now if that's not blurb fishing I don't know what is. And it's not even "a word." Susan, you must now turn in your title of critic. Please pick up your Fawning Local Reviewer label on your way out.

Grade: F⁻.

ELVIS MITCHELL IN THE *NEW YORK TIMES*

starts slamming the film from the outset with the vigor of a prize-fighter. After crediting the terrific cast, he gets down to gut-punching the movie's sterile style. He suggests the Sorting Hat has more personality than any other character in the movie. He quails at the racial tokenism of "the fleeting appearances of minority kids" at a time when London has become a massive melting pot. J. K. Rowling's imaginings "could be less magical only if they were delivered at a news conference." The movie is "the film equivalent of books on tape." And on he goes for fourteen hundred words, pummeling it like Ali on Jerry Quarry. You can tell he loves pummeling the film, so much so it's almost unfair.

Elvis gets a TKO in the fifth round.

KATE MUIR IN THE *TIMES* (LONDON)

pulls off the miraculous: a full-on love letter to the movie that no one could shoot down. Why? Because she brought her six-year-old kid, that's why. And after she describes the almost unbearable delight of the crowd at the premiere, she lets her boy Barney review the film! How do you criticize that? The kid of course loves the film, and expresses that infectious glee in a way only a guileless kid can. Can't shoot this one down, the lady has a kid in her hands! Back away!

She gets safe passage.

· · · · ·

This year's most stunning insult to critics, reviewers, and the rest of us came in Sony Pictures' choice to create David Manning, a *fictional junket whore*, for the love of God, to give positive reviews to downright awful films, from the simply dumb *A Knight's Tale* to the excrementally offensive Rob Schneider delivery system *The Animal*.

The stunning insult was that nobody was surprised.

Know this: The movie industry and the media industry that serves as its propaganda arm pull this kind of crap only because they are scared to death that we won't go to their movie on opening weekend. They are so scared that they will out and out lie, and compel everybody from actors to ad copywriters to lie along with them. Moviemakers dislike critics because of fundamental creative differences or because their egos have been bruised; but studios hate critics because they're bad for business.

The most powerful thing we as an audience could do to Hollywood is to stay away on the opening weekend. They need us in those theaters or they're sunk. They need us more than we need them. If we don't go opening weekend for the whole summer, studios will lose millions upon millions, and hundreds of studio executives could lose their jobs.

Know what would happen then? They wouldn't stop making movies, but they might stop marketing to us as if we were dull teenage boys. And, hey, maybe they'll stop letting studio executives make creative decisions and let writers and directors do their work. Maybe they'll take more risks, and maybe they'll try getting us into the theaters by showing us *good* movies.

Unfortunately, this will only work if the entire nation cooperates. Could you talk to your friends for me? Thanks.

✳ WEEK 49, DECEMBER 3–9 ✳

General Cinema Centennial Lakes 8, Edina	The Wash
Mann St. Louis Park Cineplex 6	Kate and Leopold
Oak Street Cinema, Minneapolis	Lumumba
Landmark Lagoon Cinema, Minneapolis	Sidewalks of New York
Landmark Lagoon Cinema, Minneapolis	Waking Life
St. Anthony Main, Minneapolis	Ocean's Eleven
Landmark Lagoon Cinema, Minneapolis	Amélie
Uptown Theater, Minneapolis	Funny Girl
Uptown Theater, Minneapolis	Funny Girl
Imation IMAX Theater, Minnesola Zoo	IMAX Nutcracker

Landmark Chronicles, Part One: In the Projection Booth
Why Yelling Doesn't Help

This could happen to you:

Loew's Cineplex Theater, Edina, Minnesota. Summer. Big crowd escaping the heat and the mosquitoes waits for the start of *A.I.: Artificial Intelligence*, a film I happened to like. I think. The usual garbage begins the afternoon screening: ads for movie ticket Web sites, soft drinks, and cars.

There is no sound.

People in the theater look at each other dumbly. Is there something wrong? Am I suffering from an instantaneous bout of nerve deafness? Should I do something?

Nobody moves. From the back of the theater someone lazily yells: "Sound!" Someone else, closer to me: "Sound's off!" Thank you so much for fixing the problem. And there we sit, silently.

The previews begin. Still no sound. As usual, they've all left it up to me to go out and do something. Out the door, down the hall to the lobby, down the stairs to the concession stand. Teenagers stand behind the counter, picking their nails, playing with popcorn boxes, talking about . . . hell I don't know, probably Justin Timberlake.

"Excuse me, but there's no sound in theater four upstairs."

"There isn't?" one of them asks me, doubting me, as if perhaps I'd just suffered an instantaneous bout of deafness. "I'll call the manager."

"Thank you." I head back upstairs, across the lobby, back down the hall into the theater. Previews roll away.

Still no sound.

I sit through another preview. We must be getting close to the movie start. I look back, trying to peer through the tiny projection booth window, scanning for signs of life.

Nothing.

Back out of the theater, down the hall, across the lobby, down the stairs to the concession stand.

"Still no sound in theater four."

"Really?" The guy sizes me up. He thinks I'm lying. "I told the manager," he says indignantly.

Back up the stairs, across the lobby, et cetera. The Dreamworks logo comes up.

Still no sound.

I've seen this movie. I know that the opening scene sets the stage for what is to happen, that it's important to the whole story that we hear this, or Spielberg's odd departure into the dark corners of his kid-obsessed psyche will make even less sense.

This time I short-cut the operation. Down the hall to the door marked NO ENTRANCE; it must be the door to the booth.

Bang bang bang. I pound on the door. Rumble rumble rumble. The door opens. A guy about twenty with a bad tie and a headphone looks at me, says nothing.

"Hi, the movie's starting and there's still no soun—"

"I'm working on it! It's a problem with the reel. It's fixed, the sound's on, just go back to the theater!"

So, which am I supposed to believe?

"You know, the beginning of the film is very important—"

"There's nothing wrong with the sound!"

He closes the door and rumbles back up the stairs. I go back down the hall to the theater. Sure enough, the sound's back on, I've been branded a liar and a troublemaker and I've missed some of the first scene.

Movie theaters these days seem to be run by people who don't know how to run movie theaters. Our first indication of this is when something goes wrong; then we also realize that moviegoers don't know how to go to the movies. When things go kerflooey at the modern megascreen, it is up to us to do something about it. How has it come to this? Let's find out.

To get some straight answers, I talked to Hugh Wronski, the general manager of our town's two Landmark Theater cinemas: the Uptown, a fine old single screen, and the Lagoon, a newer six-screener just a block away. The Landmark is a terrific art-house chain, the best of its kind in the country: fifty-three theaters and one hundred seventy screens in twelve states, showing the latest in independent, foreign language, and occasionally underground work. And the one thing in my mind that separates the Landmark from any other multiplex I've been to in the USA: They care.

I asked Hugh if I could spend some time in his projection booth. He happily obliged and introduced me to his friend Dan Long, chief projectionist for both theaters. I quickly fell in love with Dan, and if we weren't both heterosexual and married, I might have proposed on the spot.

Dan is the epitome of a dying breed: the professional projectionist, a guy who not only knows about movies and their proper exhibition, but who goes out of his way to make sure that films get the treatment they deserve so ticket buyers get the experience we deserve.

Dan is a big fellow, balding, bearded, and sharp-eyed, and he

embodies the sort of calm you normally find in capable technicians. He smiles constantly and laughs easily, and even when things go wrong, he reacts with an easy but determined demeanor. Dan is a pro.

Dan's lair is the large, noisy projection room at the Lagoon. It looks like a combination of a college computer room and an old film society; can after can of film coming in or going out create an obstacle course of some of the year's best viewing. The constant whir of six projectors creates a pink background din that would have me pulling out my hair in a week. Huge three-tier stainless-steel platters, five feet in diameter, rotate slowly and silently like gigantic deli dessert carousels, except the dessert is film. But not film like you might remember it, passing through a mouse-eared reel arrangement into the guts of an arc-lit old black box. No, the modern projector at first glance gives the impression that a rack of audio equipment is trying to have sex with an air conditioner, and the result is sound and light. Film pays out from the platter into a Rube Goldberg array of reels and cambers, moving up from the platter to a big pulley near the ceiling, over another pulley and down into the projector itself, a sort of open-air affair of mechanisms, except for that critical moment when the frame hits the light; then the film goes out again, through more pulleys across the floor, and up into another platter on the dessert carousel. The lamp house, so big it needs its own little vented closet, holds the huge daunting xenon lamp that replaced the dangerous carbon-arc rods of many years ago.

Dan attends to them all, beckoned by a little Casio deally-bob that beeps about five minutes before the next event. As he finished threading up a film I looked through the window of the projector next door just in time to see Amélie of Montmarte staring up at me in the deep blue reflected light of a movie theater.

So there's actually a little magic here after all.

Dan talks dreamily of the Stanford theater in Palo Alto, California, a repertory house that regularly screens archival prints, often on rare flammable nitrate stock. It's not an ornate movie palace, but Dan says it's the cleanest theater he's ever seen. "It looks like they paint the floor every night." He grins. "I mean, if you spilled your Jujubees on

the floor you could eat 'em without fear, it's like a hospital operating room." Tuxedoed, white-gloved ushers cater to the audience; an organist on a vintage theater organ rises to greet the crowd for the evening show with classic movie tunes. "One time, they were showing *Things to Come*, and the owner came down and apologized because there was a scratch in the print. So, he'd sent the print to a lab in Los Angeles overnight to see if they could fix it. I mean, who would do something like that these days?" Dan appreciates the respect, a sort of reverence, with which they treat their movies. Of course they're not showing *Freddy Got Fingered*.

This would be film heaven for a guy like Dan. Movies used to be an event, he ponders, and now . . . well, it's like trying to bring back the Beatles—what happened then and what happens now will never be the same.

Dan's fingers fly as he threads up the movie for screen three, *Sidewalks of New York*. Films come to the booth on six or seven reels, in all manner of disrepair. Dan's main job today is to "build up" the films; load them on to the giant platters that allow the film to play on a single projector without the old reel changes and their attendant "blurps" in the picture and the sound. They're still there, but in the hands of Dan, they're barely noticcable. He opens a new case to start the process. The film came from another theater and it's a mess. Two of the reels are broken in several places; half the reels are "tails in"—the end of the film is at the center of the spool—and the other half are "tails out," just the opposite with the end of that film on the outside of the spool.

Dan takes each cheesy reel and spools it out by hand on to a bigger reel that he'll feed onto the giant platters that feed the projector. Donning a clean pair of thin, white cotton gloves, he chats with me as he cranks it by hand. "I'm feeling for sprocket damage, edge damage, anything that'll make the film feed wrong or stop it while it's playing." On this particular print he will stop about sixteen times and carefully repair the damage.

Independent films suffer from a lot of handling. For a small release, the distributor will make maybe thirty prints, and these prints travel from theater to theater, often through the hands of untalented

dummies just doing their job. Dan lovingly patches the damage with tape, checks them by hand and by eye, before he moves on. He does all this with the attentive eye one normally finds in Ukranian Easter egg painters.

Dan's been in the business for more than twenty years, starting at an art house in Tacoma, a better place for a steak house than an art house; eventually he ran a theater in Seattle for Landmark. He's been pleasing audiences for two decades, and he knows all the tricks to ward off displeasure.

"The main problem that'll stop a film is if the reels on the big platters get too tight or there's a static buildup," he says. That and bad sprockets will bring the reel crashing to a halt. "Oh, and you can't back up the film and start over, not with these platter machines. You just have to move fast and get it running again." Dan has tricks to keep down the static buildup, to keep films from reeling up too tightly, to goof-proof his work.

Dan says, "When I came up through the ranks, the rule was 'Thou shalt not go off screen.' " A good projectionist would keep his machines working. Over the years, with the rise of the multiplex, the spare projector is simply one of the several dozen other screens. A machine goes down, switch theaters. If a film messes up, just give away free passes.

Ah, yes, the free passes. You've paid a baby-sitter, carved out a block of time, laid down your money, paid dearly for bad popcorn, and, halfway through, the film stops. *That's it, sorry, free pass for you.* But, I wanna see the movie now! *Sorry, free pass, see the manager,* if you can find the manager.

All the time he talked, Dan moved from projector to projector, starting films, checking the screens and the sound, spooling up new films, building up this one on a platter, breaking down another for shipping. And all the while he had his mind on his work. As he finished building up a film from the crummy broken reels it came on, he sighed and shook his head. Sometimes Dan won't accept a print from a multiplex, just because he knows what kind of shape it'll be in when he gets it. They don't care; he does.

Dan pulls metallic tape across the edge of the head of the film. This metal tape triggers the electronics in the modern theater, turns off the mood music, dims the lights, changes the lens if necessary, and starts the film. Everything is automated now, Dan says, in the time he's been projecting films there has been a sea change in technology, much like the move from vinyl LPs to CDs, or video tape to DVD. Eventually, as films begin to make the transition away from a physical medium to an all-electronic one, most super-googolplexes will move to an all-electronic delivery system. Films will be downloaded over proprietary lines direct to the projector, then exhibited by automation. Theoretically, I'm told, one person will be able to run all the screens in a thirty-screen theater. The end result seems to be that the job of projectionist will go the way of the milk truck driver.

Of course everybody thinks that this will solve all the problems. Of course it won't. Who do you complain to when a digital film is artifacting, or when the picture locks up, or the sound is out of sync? The programmer? The sysop? We're all in trouble.

Landmark hires and nurtures managers and projectionists who plan to be there a long time. They look for people who will stick with them and not tire of the job, people who know that working in a theater is not a springboard to Hollywood, people who love movies and care about how they're exhibited. There's a difference, and it shows.

"I went to a movie recently at a multiplex and it was out of focus," Dan recalls. What was the film? "A.I." He wouldn't say where he saw it, Dan won't diss a theater outright. "I went out to the lobby and told the guys at the concession stand, 'Hey, the movie's a little out of focus.' I don't even think they knew what I meant! 'Out of focus'?" Nothing was done; the film was shown in its entirety, out of focus. In the case of A.I., it should surely cause mass insanity, but Dan said that nobody else complained, nobody walked out, they just sat there and took it.

"The audience isn't demanding enough these days," Dan says. "Nobody complains." Well, that's the crux of it for me. We need to complain, clearly, calmly, and often. We need to let the manager know that we are not satisfied. We need to fill out those little cards and send

them in. We need to be as picky about what we put in our heads as we are about what we put in our stomachs.

Or we can just sit there and take it.

You want to make a theater manager's head spin? Next time you go to a film, especially at a small multi- or a single-screen that does a good job of exhibiting a new high-quality film, ask to see the projectionist; tell them you want to thank the projectionist for making the film as good as it can be. You just might make someone's day.

Uptown Theater, Minneapolis	Iron Ladies
Dinkytowner Bar, Minneapolis	DV Cinema Series
Historic State Theater, Minneapolis	Lord of the Rings: The Fellowship of the Ring
Megastar 16, Edina	Ocean's Eleven
Regal 16 Cinemas, Eagan, Minn.	Vanilla Sky
Megastar 16, Edina	Not Another Teen Movie
Mann St. Louis Park Cinema 6	Joe Somebody
Mann St. Louis Park Cinema 6	Behind Enemy Lines

Fanboys vs. Punks
Punks Win

They cut Bombadil."

"I heard. And Farmer Maggot, *and* the song at the Prancing Pony, *and* they've got Arwen at the Ford drowning the Riders."

"It's supposed to be Elrond and Gandalf. . . ."

"I *know* that . . ."

"And they got some big kung-fu battle between Gandalf and Saruman. . . ."

"As if that ever happened. . . ."

"And what's with the big stupid Uruk-Hai with the Dreadlocks?"

I paid fifty bucks for the privilege of being one of the first on the

North American continent to see *The Lord of the Rings: The Fellowship of the Ring*. As a reward, I got to scrunch in the lobby of the Historic State Theater in Minneapolis, packed like a sardine against two doughy kids complaining about a movie they hadn't seen.

It was a benefit for Carleton College in Northfield, alma mater of the film's producer, Barrie Osborne. For two hundred bucks I could've had cocktails with Barrie and a few of his alumni, the faculty of Carleton, some reporters, and numerous hangers-on. I passed, and that's how I came to be wedged next to two clammy, whiny fanboys, waiting for the doors to open.

The State, a great old movie palace in its day, has been impeccably restored and now serves as a venue for concerts and touring companies of insufferable Broadway musicals. It's a shame they rarely show movies here anymore, but that's the way of the movies. It has a soaring proscenium, swanky opera boxes, and a massive sweeping double balcony just perfect for cozying in with a thousand or so of your pals to watch a huge movie.

The Lord of the Rings is one such huge movie. Big movie events like this are scarce outside New York and Los Angeles; they present the rare opportunity to make a night of it, dress up, have a good meal, treat cinema like the theater.

But there was another far more compelling reason for me to go: the fanboys.

The term "fanboy" most certainly originated among the obsessive lovers of the comic book, but recently the term has broadened to include interests far beyond the basements of men in early middle age.

It's easy to spot fanboys: They'll be slightly unkempt, often bearded, and always jittery. Fangirls are much the same, usually lacking the beard.[15] Many fanboys have learned to hide their outward traits and blend in with the population, but walk down any crowded street, pull

15 The fanboy is exemplified and immortalized on *The Simpsons* in the Comic Book Guy, proprietor of the Android's Dungeon and Baseball Card Shop. He's known by that and no other name, although this has been hotly debated on the newsgroup alt.tv.simpsons. This fact alone proves that the fanboy term has broadened to include sad and obsessive people outside the comic book world.

out an unopened Volume 1 *Dark Knight* graphic novel still in the wrapper and wave it around. They'll appear as out of nowhere.

Tolkien fanboys are prone to wearing long overcoats, elflike boots, and leather hats. Seriously, leather hats. It's the leather hats that give them away every time, and I spotted a few in the crowd. Other fanboys had dressed down a little, wearing simply the long coat and fantasy tee. Indeed there were a few in full Tolkien drag, including one elf, replete in the movie's elf costumery right down to her pointed ears.

Several fanboys squirmed and anxiously nudged toward the door. They needed the perfect seat. After all, *the experience must be perfect, the fanboy mind says, or my whole life is a lie.*

Putting such high expectations on anything blinds you; it can never be as good as you need it to be, so you will make it so, and continue the fantasy. Such was the case with the hideous *Star Wars* prequel, *The Phantom Menace*, surely one of the loudest and dumbest films of this or any other decade. The movie was so deeply and unexpectedly flawed it caused an epidemic bout of cognitive dissonance. Millions of fans refused to take the opportunity to move on with their lives and started actively hating film, the whole *Star Wars* franchise, and even George Lucas, the very man who gave them their world. It got so bad that an unnamed person or persons chose to reedit the film and distribute it on-line, calling it *The Phantom Edit*.

I feel only slightly sorry for George Lucas. I certainly credit him with starting a phenomenon, but this kind of obsession never plagued Les Paul, did it? And let's face it, folks, the Gibson Les Paul guitar is a far more enduring piece of American culture than *Star Wars*.

J.R.R. Tolkien, however, suffers little of the same fate. For starters, he's dead, and that makes him rather immune to criticism of the movie adaptation. In addition, his work is as complete as it will ever be, barring some huge breakthrough discovery of a hidden manuscript, so there's little chance that the author will kill his darlings.

But among the fanboys, on-line and in line, there was anticipation bordering on dread. How would they pack everything from the book into the film? Will they chop out my favorite parts? *And what of Bombadil?!*

Eventually the doors at the State opened and we sweatily flooded in. To my dismay the terrific State Theater balcony was closed! The bastards! The sweeping balcony of the State is the greatest place north of Chicago to see a huge movie. But I couldn't complain too much; it had been closed for security measures. Ultimately, the Taliban prevented me from seeing this film in optimal conditions.

I was able to find a terrific spot, though, about two-thirds back, just out of the shadow of the balcony. I was beckoned to my seat by a smiling young couple, Anthony and Sarah. They were fans of *Mystery Science Theater* and spotted me from across the room.

Anthony's a big fan of Tolkien, but not a fanboy the way I define it; he's what my dad would've described as "a nice, clean-cut kid." Perhaps a closet fanboy who tamped down his obsession long enough to secure a law degree. Fresh out of law school, he was clerking for a federal judge. His friend Sarah, no Tolkien fan, hadn't even read the books, but she was open to the experience.

See, these two represent the audience for which this film was made: people who are open to the possibility that a written work can be *interpreted* for the screen, and that it will have greater relevance if we do so. Not to put Tolkien in the same ballpark, but think of Shakespeare, of how uninteresting his body of work would be if we only staged it at a Globe-style theater, used only men for actors, and stuck strictly to the first folio full text. Do you have any idea how boring the uncut *Hamlet* can be? Did you see Kenneth Branagh's attempt to film the entire text? Scholars have fun while the rest of us are checking our watches.

Peter Jackson and his team made a film all its own, interpreted from another work, unlike *Harry Potter*, which is more like event coverage than a movie. Jackson and company have taken Tolkien's wide-ranging palette of moods and darkened the colors. They removed all the poetry and song that punctuated the narrative, they compressed the book's time line and combined events. They grabbed the Hobbits by the hair and got busy. It's no *Lawrence of Arabia*, but it's a lot of fun.

After the screening, our fifty-buck tickets got us into a reception at

a nearby club. Standing in the buffet line behind a huge man with a leather hat and in front of the elf-woman in the cape and the pointed ears, I felt as if I were visiting my past; I was attending a reunion of people I don't really know, but with whom I have something in common.

You see, I was a fanboy.

Back in college when my life was miserable, I disappeared into music, marijuana, downhill skiing, and Tolkien. I read the *Lord of the Rings* trilogy over and over again, wanting to make it a part of my life—or, more correctly, make my life a part of the story. I read *The Silmarillion*, a thick, complicated sort of prehistory of the events in the trilogy, and the *Tolkien Reader*, a compendium including "The Homecoming of Beorhtnoth Beorthelm's Son," "Farmer Giles of Ham," and "The Adventures of Tom Bombadil" among others. I could talk Tolkien with the best of my day, and did. I sat in the huge, packed Cinema 120 in Oak Brook, Illinois, and saw Ralph Bakshi's animated mess *The Lord of the Rings*, which I thought was junk and which completely disabused me of the hope of ever seeing such a huge fantasy successfully brought to the screen. Tolkien was a sort of fantasy therapy for a point in my life when I was rudderless and depressed; indeed it would help me get through many bad days.

You also should know that at the time I was listening to music from the Moody Blues, Yes, Emerson Lake and Palmer, Rick Wakeman, and the like. Occasionally I would hang around the fringes of those traveling fantasy cults, the Renaissance festivals.

I owned a leather hat. I was a mess.

Then, in about 1979, I lost interest. Completely. And I can remember exactly when and why: Someone played me the album *London Calling* by the Clash, both discs, both sides.

That's all it took. Gradually I sold or gave away all my Tolkien stuff, my art-rock records, my leather hat; I never looked back. I started making my own films, I began to have a life of my own, and the need for this sort of immersive fantasy therapy simply disappeared. I hungered for something new. I worked in a punk club; saw the best, hardest, loudest, fastest bands of the day.

Sorry, but the punks beat the elves every time.

I don't think I understood all this until this very week. My eyes were opened by a visit to an underground film-and-video series at a rock club. DVCinema shows shorts made on digital video monthly at the Dinkytowner bar, one of those great campus clubs where ethnicity and economic status are meaningless and groove is everything. It's big, loud, and smoky; and they serve Newcastle Brown Ale on tap. That's all I need in a club.

DVCinema invites students, artists, amateurs, filmmakers of all types and ages to contribute their own short offerings, as long as they are shot and produced in the digital world. That's why I'm thankful for Brian Dehler, DVCinema's founder, who has the thankless job of finding stuff worth showing in a public venue.

Shorts flew by, cheered on by each filmmaker's family and friends. Out of the ten shorts on the program this week, most were quite dumb and derivative, some were downright terrible, others demonstrated nascent talent.

But, wait, there was one standout: a brilliant little work of visual art called *Endless Transit* by New York musician and artist Katherine Gordon. *Endless Transit* is what they call an "experimental" film, which normally means that you would like it only if you were an art student or were stoned. I was neither, yet this thing brought me into a frame of mind I generally experience only while meditating.

I can't describe it further than this: a series of images across the screen from right to left, of subway trains arriving, leaving, passing each other, over and over again. Faces surface through the windows as one train stops and the other whizzes by, alluding to film's principle of persistence of vision. The light is diffused and muted, the color is a thick sepia monochrome. The music, perhaps a forward and backward sampling of a gamelan and Tibetan bells, pulses in a repetitive stream, while images flash and meld. We get a glimpse of a body, a face; is it the filmmaker? Who knows? Who cares? I'm sucked into a moving mandala, a small model of the cosmos. The rowdy crowd at the Dinkytowner hushed up, quiet replaced the stamping around and the call for drinks. Everyone's eyes were fixed on the screen.

The film rolled to its end. The mesmerized crowd cheered loudly and unanimously. We had just seen an original piece of work, a compelling visual trip brought about by simple means, a grand illustration of classic techniques meant to draw viewers out of their normal understanding of motion picture and into a new reckoning. This cut through the noise, it was a little dangerous.

Everything snapped into place later in the week as I stood in the buffet line between the huge guy in the leather hat and the chick with the elf ears. The trap that catches the fanboy is not the artistry of the tale but the intricacy of the world Tolkien created, and as I found out, you can dive into this world and never come out. Tolkien re-created the whole universe—new languages, species, history, anthropology—in exquisite, seemingly endless detail. Whether Tolkien created a good piece of narrative storytelling became far less important to me than the minute details of the world in which he staged it.

Punk music jarred me out from under the cloak of someone else's dream world and into my own life. It cut through the noise, it was a little dangerous. How many times in your life are you energized by something that feels utterly new? What a feeling, and watching this wild little experimental film I was reliving it. I was recalling the birth of my own aesthetic.

That may sound pretentious, but it's true. Now I can enjoy *The Lord of the Rings* movie for what it is, a fast-paced, thoroughly contemporary adaptation of a ridiculously popular epic, not the capstone of my life. I don't need it to be the best thing ever. It's a good movie, don't get me wrong. Is it a classic? I don't know; without seeing the other two movies in the series it's impossible to say. But I am free of the bonds of Tolkienism!

Or am I?

The following week I went to see the film again, on its official opening day. As I waited for my friend Brad to show up, I horned in on a conversation between two T-shirted scraggle-bearded guys behind me. The bigger guy seemed to be holding court and the smaller guy squirmed so much his popcorn was falling on me.

"But, Bombadil *was* critical to the story. . . ."

"Well, yeah, I mean he's the one who saves the Hobbits from the barrow-wights."

"But that's not even in the movie—"

"I know that."

"I was going to say, it's not just that, it's Merry's sword."

"It's *all* of their swords."

"No, 'cause Frodo gets Sting from Bilbo in Rivendell. . . ."

I am reminded of images of rabbis surrounding the Talmud, deep in debate.

"See, Merry gets a sword from the barrow after Bombadil saves them, and—"

"That's the sword that kills the witch king—"

"That's the sword that kills the witch king, right, now how are they gonna keep that thread?"

"They're gonna lose that thread."

I couldn't help myself. I turned around. "Wait a minute, didn't Merry and Pippin lose their weapons when they were captured by the Orcs at the river?"

They looked at me as if I had lost my mind. Then with the condescending patience of an adult who wants to say "Honey, we're talking here," the bigger guy sighed and said, as if it was as obvious as the existence of air. "Well, yeah, but Aragorn finds their weapons *and* Pippin's elf brooch and returns them at the ruins of Isengard."

They turned back to their conversation, this time in much quieter tones.

Not a good one, but still a fanboy at heart.

St. Anthony Main, Minneapolis	Vanilla Sky
Landmark Lagoon Cinema, Minneapolis	Dinner Rush
Regal 16 Cinemas, Eagan	The Lord of the Rings: The Fellowship of the Rings
Landmark Lagoon Cinema, Minneapolis	Amélie
Oak Street Cinema, Minneapolis	House of Wax
Uptown Theater, Minneapolis	The Royal Tenenbaums
Megastar Cinema 16, Edina	The Business of Strangers
Oak Street Cinema, Minneapolis	The Shop Around the Corner (Santa)

Landmark Chronicles, Part Two: I've Been Workin' at the Mooo-vieees

And Why You People Oughta Be Ashamed of Yourselves

Hi, welcome, enjoy the show. Thank you. Hi, thank you. Enjoy the show. Hi, there you go. No, I'm sorry, I haven't sent the film yet. Enjoy the show."

Rippin' tickets. Rippin' like mad. It's the last show of the evening, the second sold-out screening of *The Royal Tenenbaums* and the place is jammed. Here at the Uptown Theater, at nine hundred seats the biggest surviving single-screen venue in Minneapolis, the staff is buzzing as the doors open and people start to flood through, pouring like two-legged livestock into the seats, the bathroom, and the tiny concession stand. Here at the Uptown, they do things the old way, the

hard way. Two vendors and two backups serve the whole of nine hundred people between the time the doors open and the movie starts.

But tonight, the last thing I heard from the concession stand before the doors opened was this exchange: "You guys didn't load up the popcorn?"

"We have no popcorn popped."

"Man, we are *fucked*."

I thought it would be appropriate before the year was out to experience the front line of the film industry, the elemental relationship where the people who bring us movies actually interact with the people who are buying tickets. I'm talking about the theater staff, the ticket takers, the floor sweepers, the popcorn scoopers, the guy with the bad tie and the headset.

It is the last step in the distribution chain, the first interface that the movie business has with its public, and in general it garners as many complaints and frustrations as the movies themselves. These are generally folks who don't envision themselves working at a theater in two years, or sometimes two months, or, in a few cases, tomorrow. It's a low-pay, low-skill, low-effort job, for the most part; but when you see it done with a little pride, some coffee-induced vigor, and just a smattering of intelligence, the difference is astounding.

Earlier this year I applied for employment at three local multiplexes, hoping to get a job just for a week so I could blow the lid off this story and scandalize the whole industry. I intended to write about how slack and apathetic the theater staff is, how poorly they relate to the public, how they start off the whole relationship between the movies and the moviegoer on the wrong foot. When you think of it, it's kind of ridiculous that all those millions are spent on movies made by exceedingly well-paid people, but when they're presented to the public they're put in the hands of underpaid part-timers who couldn't give a damn what the customer thinks.

So, I was going to expose this. How many minutes have you waited in line to get a stinking box of popcorn? I used to think that concession people were trained to move slowly, like they were practicing tai chi. The manager's main job seemed to be to sit in the locked office and avoid contact with people.

Problem is, *everybody knows this already*. It's not much of a story.

The other problem was that I couldn't get hired. The whole idea stank of duplicity; I wanted to work for these people only to get some nasty on them. I would have to lie if I had any hope of being hired. I couldn't say, "Yes, I'm writing a book about the moviegoing experience from the audience's perspective, and I think the service in your theater blows dead rats, so I want to work for you without you getting wise and then dig up some dirt."

Something rang false in the process and none of the prospective employers called me back. It was just as well. This won't be an exposé; it'll be an experience. So, I called my pal Hugh Wronski, manager of the two local Landmark Theaters, and asked if I could work a couple shifts. Sure, no problem. Come on in. He suggested I work the opening night for *Tenenbaums*; they expected it to be a full house, and a full house is always a blast.

On Tuesday this week I got in my ad hoc uniform: black slacks, white shirt, and a tie. I had a black vest from my tuxedo that doesn't get a lot of use these days, I thought that'd look dapper. I wore my Wallace and Gromit cuff links, I thought that'd be appropriate.

I think I overdid it. Who the hell wears a starched shirt to sweep floors? Maybe at the Ziegfeld or the Paris in New York, not here. The staff had no problem spotting me as a plant.

Hugh and his Lagoon manager Brian were hunched over the schedule. They were wading through the hell of staffing for the Christmas holidays. Hugh is as amiable a man as you can find, a man who smiles in the face of crisis and takes the body blows of his business in stride. Somehow, everything gets done, the movies start on time, the audience is generally pleased; he's done his job.

Complaints are handled with sincere respect; free movie passes and refunds are handed out with no argument. I can't tell you how unusual this is at the multiplex, where finding the manager is the most difficult part, getting a free pass for a bad screening is a chore, and trying to get a refund is met with an insane grin. At most multiplexes, the manager you see is not really the manager, and the chain of responsibility seems to end somewhere in the clouds. Nobody is in charge.

Here, Hugh is in charge, and he does that by giving full authority to his managers, like Brian, who are simply smart, polite people who care about their jobs. He respects and trusts his employees, and they in turn do their jobs with pride.

My first night was at the Lagoon, a six-screen showing the latest indies and foreign films: *The Devil's Backbone, Tape, Sidewalks of New York, Amélie, Dinner Rush, Intimacy*. My job was to take tickets. Smile, rip, direct. "Hi, that's theater three down the hall to your left, enjoy the show. Hi, theater five, right behind me here. Hi, theater four, down the hall to your right. Enjoy the show."

I was paired with Dan, an amiable young feller with a devilish look. He's in school, studying film, of course. Dan is very candid, he speaks his mind when others might hold back. He eyed a guy who'd simply walked by him; he stopped him politely and the guy produced his ticket for ripping. "How can they do that? Didn't he just buy the ticket?" he said to me. Dan was spoiling for it. "I haven't gotten to bust a dude yet; I really want to." He popped his fist on the flat of his hand. "It'd be fun to kick a guy out."

I appreciated this about Dan, because it made ripping tickets a whole lot more fun. A gentlewoman walked by, gussied up for the special preview of *The Devil's Backbone*. She smelled as if she'd spilled the whole bottle of White Shoulders all over herself. Her scent trailed her for a good fifty yards. Dan's jaw actually dropped as she passed. She wasn't even out of earshot when he shook his head and said, "Now why the hell would you do that? That could make people sick, man. I mean, come on, is her nose broken or something?" Customers of any service industry should know that they are continually being scrutinized and ritually humiliated. It's part of the fun, part of what keeps you from running screaming from your job.

Like Cold Lady. An older woman with badly dyed hair and the puckered embouchure of a career smoker jammed her ticket into my hand and said, before I could even smile, "I hope you have the heat on in that theater, you never have it warm enough." Her eyes drilled into my skull, and I knew what she really meant was "I hate you, you and your little vest; how could you have the bad taste to exist?" Brian the

manager was standing by and must have sensed that I wanted to hit her, so he intervened. "Heat should be fine, ma'am," he said, smiling politely. "If it's too cold, just come and see me." She glared at him, shivered, and marched on.

You could've put odds on it, because sure enough she was back in five minutes or less, angry, judgmental, and cold. "I told you it'd be cold in there, do you even have the heat on at all? My friends are freezing; I have my gloves on!" She waved her paper-thin Isotoners in my face. "Didn't you hear the fucking manager, lady?" I wanted to say, but didn't. Instead, Brian and I followed her back into the theater as she continued her litany of bile. "I can't believe this is how you save money. You charge us seven fifty a ticket already. When I was your age . . . crow crow cackle cackle . . ." She passed the broom closet and I thought of shoving her in.

See, there's a bad gene in me somewhere that makes me want to treat unpleasant older women like the Marx brothers treated Margaret Dumont. This is why I couldn't have a career in the service industry.

Brian and I tiptoed down to the thermostat. It was a pleasant seventy-one degrees, quite comfortable in shirtsleeves. He looked at me and shrugged his shoulders. He turned it up a degree, just enough for the furnace to kick in.

Naturally, as she left the show, Cold Lady took more time out of her busy schedule to gripe. "The heat never came on, I don't know how anyone can stand it. She'd even roped a witness. "Wasn't it cold in there, Helen? Tell him." Helen said, "Yes, it wasn't very warm." But her eyes said "Help me." Cold Lady hadn't coached her witness, "It was *cold*," she corrected Helen. "Tell the *real* manager that he's lost another customer."

Hugh Wronski, the general manager, asked me to walk him to the bank. "It's a hard business," he said as we shivered down the cold streets. "Keeping good people is hard, but I think we have a good group. The folks who work for Landmark tend to like movies a lot."

That's an understatement. During a lull, as we swept popcorn schrapnel from the lobby, I started talking to a few of the folks working the stand. One of them was studying, he had a class in which they

were reviewing John Ford movies. "They're all so canned, he said, "they look so stagy, and the acting is horrible. Think about *The Quiet Man*."

"Think about *The Searchers*, though," someone countered. "Think about *My Darling Clementine*, or *Grapes of Wrath*."

"Stagy."

"Well, yeah, it was stagy, man, he was shooting in like 1940, *everything* was stagy."

I wanted to contribute. "*My Darling Clementine* was great. Wasn't Henry Fonda the bad guy?"

"No, Walter Brennan."

"Stagy."

What impressed me was talking to a bunch of kids who knew film. Most of them made their own, on video, and one shot 16mm film whenever he could get his hands on some stock. What a perfect place to hang out and make a little money. The Landmark chain encourages this, and, startling as it may seem, they encourage their staff to see the current offerings and have opinions on them, opinions far beyond "It's all right, I guess." More than once I've seen a Landmark employee at the ticket window talk someone out of seeing a movie. "Hmm, I didn't like it all that much," I heard one of them say about *Dinner Rush*. "I thought it was just kind of a sort of stupid mob story, you know?"

In the lobby the manager and two customers discussed *Sidewalks of New York*. The popcorn scooper compared notes with his customer on *Waking Life* and *Tape* while he drizzled butter (real butter, by the way).

I like this, this is genial, this is professional, this is why I come back to the Lagoon and the Uptown so often.

On Friday night the Uptown staff was abuzz, gearing up for battle. Four hundred advance tickets had been sold an hour before the show, and that's a good sign. Soon, the line of people holding tickets was as large as the line for the box office, and there was much confusion outside as to which line one should be in. Hugh, calm and smiling, grabbed a hundred tickets and headed outside to direct traffic and sell

tickets on the spot. Some folks thought he was a scalper, others a saint, but there he was, in shirtsleeves in the bracing cold, selling tickets, making change, greeting his customers.

Good way to run a business.

Rebecca and Mike, the managers on duty, were thoroughly pumped. "Man, I love it when it's busy," everybody was saying. Help had come from the Lagoon two blocks over and the machine was in high swing. I tore tickets, tore tickets, tore tickets until I was blurry-eyed. In the lobby, the concessionaires were slingin' corn and soda pop, Junior Mints and fancier chocolates, working like the happy-hour staff at an airport hotel. Staffers could change jobs as needed. Everybody knows how to do everything. I'd never seen service employees work so fast without getting tips.

It was a sellout. In twenty minutes, nine hundred people had been channeled through the doors, catered to and seated, all without a single complaint.

In the calm between shows, I got a bead on the environment at the Uptown. Down the street, the Lagoon, with its atmosphere of calm sophistication, stands in sharp contrast to the Uptown, which feels more like an old blues bar. The Uptown is a funky old place, built in 1930, and it still has that feel. The balcony is huge and comfy, even with its ancient upholstered spring-and-steel-frame seats. It's not fancy, not state of the art, but it has character, personality.

Rebecca and Mike have provided pizza for the hard-working staff. It's genuinely appreciated and gone within ten minutes. Chatting about school, love interests, music, parties, and film, I also notice that the staff is busy stocking, sweeping, preparing for the next show. They do all this without being asked. Compared to the multiplexes, this seems nothing short of a miracle.

The movie ends to boisterous applause. My man Dan is puzzled: "Why the hell do people applaud at the end of the movie? It's not as if anyone involved with the film can hear it."

We can hear it, I counter. "Yeah, and . . . ? It's not like it's gratifying to *me*. It just bugs the shit out of me, is all." Well, I applaud at the end of movies and I'm not ashamed to say it.

The late show looks to be a sellout as well. People are frantically queuing up a half hour before the show. Dan grins as he heads out the door. "It's line psychology," he says. "If they all just went off for a cup of coffee and came back five minutes before show time, they wouldn't have to stand outside and freeze." Personally, I think Minnesotans like to line up for things. It must be all the buffets. I swear, if you put three people in a line for no reason whatsoever, others would queue up behind them.

Hugh says good night, Rebecca says good night; the next show is in capable hands. As the theater empties, I set about my other job, sweeping up. It's a big theater, so we all move in like a squadron, big trash barrels, brooms, and dustpans.

And here comes my most acute observation about American moviegoing audiences: We are pigs.

After screenings in a dozen countries, I know this for a fact. I've been to cockfights in Mexico that were less filthy. Nowhere else in the world do people simply throw their unused food and garbage on the floor as they leave. Every theater in the country provides generous trash barrels at the exit doors, and maybe one percent of the audience picks up on this. Everyone else simply hurls their crap and leaves.

Imagine going to an art opening, with the little cups of wine and the cubes of cheese; imagine people strolling around looking at the paintings and the sculptures and hurling their little cups, their toothpicks, and their uneaten cheese on the floor, without looking back. Outrageous, you say? Hell, yes it is! But these very same people feel no compunction about simply dropping their oily tub of uneaten popcorn on the spot and moving on.

I'll admit that I have been one of these people. I have been sucked in by the lonely crowd and I have left my detritus where I sat without thinking twice. But no more. After traveling through the clean theaters of the world, and after picking up after nine hundred filthy slobs, I will, hereon, pick up my mess and thank whomever is sweeping up.

The theater's ready for the ten o'clock. The doors open, the popcorn debacle is discovered. "We're fucked." And here's what I love:

Without panicking, they simply ask people who want popcorn to wait a few minutes, they pop like the wind, they resolve the problem without calling the manager over. After the rush, I pack it in and head for one of the few empty seats to watch *The Royal Tenenbaums*. It's okay, I suppose, a movie trying to be quirky, and in doing so often fails to be funny. But the crowd loves it, and as happens at comedies, the laughter is infectious; you can find yourself gasping for air and not really know why.

This is the payoff for the manager, the staff, and me. They did their best tonight to make the audience's good time better, and it's because they care. The audience, without knowing it, appreciates it.

Now, if only the audience would pick up after themselves.

✳ WEEK 52, DECEMBER 24–30 ✳

Oak Street Cinema, Minneapolis	**The Shop Around the Corner** (Santa)
Loews Cineplex Edina 4	**The Majestic** (Santa)
Cedar 6, Owatonna, Minn.	**Jimmy Neutron** (Santa)
Megastar 16, Edina	**Ali**
Megastar 16, Edina	**In the Bedroom**
Mann St. Louis Park Cinema 6	**A Beautiful Mind**
Heights Theater, Minneapolis	**White Christmas** (Santa)
Oak Street Cinema, Minneapolis	**Cool and Crazy** (Santa)

Don't Mess with Santa Claus

On Gifts, Strangers, and Christmas Movies

Let me tell you a story.

First, you should know that I firmly and unequivocally believe in Santa Claus. I have no reason to doubt the existence of Santa Claus, and no amount of spiritual, mythological, legal, or hagiographical evidence to the contrary has ever shaken that belief. The guy exists, and we simply have to deal with it.

I know this in part because I played Santa Claus myself this year, and the number of times I was mistaken for the actual Claus was staggering. But I have another reason.

It all started as a bad bit of satire. I had seen the Tim Allen film *The*

Santa Clause, in which the continued existence of the modern popular version of Santa is perpetuated by clever, somewhat cynical elves who hoodwink new candidates into the job by means of a tricky piece of contract law—the Santa *Clause*. Heh. The movie is nice enough, loudly stating that goodness lies in the heart of a man willing to rise above his stilted self-image and open the generous soul within; it's a tepid message, wrapped in a smart-assed comedy suitable for families.

But it ain't Santa Claus. No, it's merely that confused amalgam of popular stories and marketing tactics personified in illustrations commissioned by the Coca-Cola Bottling Company of Atlanta, Georgia. It's Santa Claus, Superstar, the one with supernatural powers who for some indistinct reason is absolutely necessary to the continued happiness of the planet. Apparently, if Santa ceased to be, all the world's children would be plunged into despair.

I couldn't hold with it. So, early in the year, when I heard that the sequel, *The Santa Clause 2: The Escape Clause* soon would be ready for release at Christmas 2001, I got it in my head to present an equally smart-assed bit of public satire. I would go to the local opening of the film, dressed in full Clausian drag, and picket. DISNEY UNFAIR TO SANTA CLAUS, my sign would read as I chained myself to the theater door. I would tell the swarm of press that this movie and most like it discount so much of the actual history and spirituality of Santa, that in essence it's a misrepresentation, intentionally perpetrated for monetary gain, much like nuclear power, and I couldn't sit idly by and watch Disney make millions while trashing the good name of Santa Claus.

It was a gimmick, in its own way just as shameless as the movie, designed to garner attention for myself and my book, and as the year and my plan unraveled, I'd learn, as Stan and Kyle on *South Park* always say, an important lesson.

I planned with care. In Sodankyla, northern Finland, in June, where I'd ventured to the Midnight Sun Film Festival, I hoped to learn a lot more about the legend; because as most Finns will tell you, this is where it started. I had read an odd tale about the roots of the Nordic Santa Claus myth, a thousand-year-old tale of a goatlike beast,

Joulupukki, the menacing Yule Buck who would come in the darkness of the winter solstice and demand gifts. The story seemed custom designed to scare kids enough to keep them in bed at night.

Most of what I found was tourist stuff: colorful hats and jackets from Lapland; Santa banners, books, salt and pepper shakers; and little figures of big-nosed, red-faced men in traditional garb. Most of the books were in Finnish and Swedish and the rest were remedial—"Did you know Santa Claus lives here in Lapland?"—and not much more. I stopped mentioning Santa Claus in conversation because the rote answer was "He's from Lapland, you know." Yes, thank you, I knew that before I got here.

One night the festival staff and press were bused off to a tango party and weenie roast in the Arctic woods. Around midnight, after several paper cups of lemonade mixed with high-octane vodka, I wandered into the hilly forest alone. Although it was bright as midday, I was lost in minutes.

Head buzzing, I was soon ready to park myself against a soggy hill and have a nap when I heard someone singing, softly. Clearing a thicket, I saw a small old man emerge from a cave in the hill, its entrance covered with reindeer pelts.

He was completely naked.

Smoke curled up from behind the pelts and his little body shone with sweat. He doused himself with water from a mossy wooden bucket. It was of course a sauna, something every Finn holds dear, but I'd never imagined one so rustic.

He was built like a bicycle, all sinew and bone. Balding on top, the vestiges of his long white hair clung to his neck and shoulders in thin strands. His wiry white beard was yellow around the mouth, no doubt from a century of smoking. He had the broad bony face of a Sami—a Lapp, skin wrinkled yet supple and shiny as leather. His ancestors have lived here for three thousand years.

He was in no rush to dress; he casually gave me a small naked salute, either that or he was shooing a mosquito.

"Hello?" I said.

Hei?

"Hei. Do you speak English?"

Leetel.

"Thank you. I am lost. I am with group from Sodankyla. I look for bus." When in foreign lands, I reflexively speak my own language like a caveman.

Bussi. Hei, ya, not far. You sauna?

Bad idea. "No, thank you," I said. "Do you live here?"

Nei, nei, the summer yust. I live Korvatunturi. Se vouri, hmm . . . den hill, yes? Den hill! He pointed to a hill behind him.

The hell did he mean, "the hill"?

Den Hill is name Korvatunturi. It has tree ears. Tree. He held up three fingers, twanged his ear.

"Three ears." Uh-huh. Neat.

Ja, kylla. He held his hand to his ear. *I am sit in de hill, and listen.*

"I see. *Kiitos*, thank you." Nod and smile, Kevin, back away slowly, if he lunges you can beat him to the bus.

But then he said:

You know Papa Joulu, Papa Chrissmas, yes? Sinter Klass?

"Ja—yes, I know. Santa Claus. I hear Santa Claus lives in Finland."

He pointed to himself. *Joulupukki! Is me!* He pushed his pointed fingers to his temples like antlers and began a little jig. *Is me! I am Joulupukki, nasty goat man, ha ha!*

What do you say to a wet, skinny naked man doing a goat dance in the middle of a Finnish wood?

"No, you're not nasty, you're very nice."

Yes, I am very nice! You have gift for me?

Well, this was new. Was this traditional, or just bold? Hell, I didn't know. I didn't think. I simply reached for the hat on my head, my old blue beat-up baseball cap from REI outfitters. It had been around the world with me, but you have to let go of these things every now and again.

He eyed it suspiciously, jammed it on his head gave a yellow grin. *It's wery nice gift.* Kiitos. *Thanks.*

In my nonexistent Finnish, I said, "Ole hyva—you're welcome."

I been Amerikka long time back. New York.

"I'm from Minnesota," I said.

Minnyasota, yes, Minnyasota many Finns. Yessie Wentura, grrr. He gyrated like a wrestler, arms out. I couldn't have been more embarrassed.

"What is your name?"

I am telling you! Joulupukki! Yo-OO-loo POO-kee. Is me!

"*You're* Santa Claus."

Ja, ja, yes, yes, meddy Chrissma! he said, and he laughed his goat laugh. *I bring you gift in Minnyasota, hmm?*

"Yes, *kiitos*—thank you. You visit me in Minnesota." I wondered if he wanted my card, but he really didn't have a pocket to put it in, being naked as he was. . . .

Bussi is there. He pointed to a path directly behind me; I heard the echoey honk of the bus horn. *You go to bus now. Good-bye.*

"Yes. Thank you. Good-bye. Merry Christmas."

Meddy Chrissma! He disappeared under the reindeer skin. I turned, head spinning, and ran for the bus.

I didn't share this story with a soul when I got back. What was I supposed to say, that I'd run into Santa Claus in the Finnish forest, and he's a scrawny ranting old nudist who, by the way, does a mean goat dance?

Not long after I returned I started growing my whiskers. If there is one thing I can do consistently and prodigiously, it's grow facial hair. In no time I'd developed a full luxuriant beard, bushing out in all directions. By September I looked like Andrew Weil in a wig.

It was an odd experience, wearing a long gray beard in the wake of September 11. I got looks in public places, few of them pleasant. I got a miniscule taste of what it's like to feel suspect based on appearance alone. It's horrible, it's hateful, and it's an object lesson worth having. Some of my relatives called me Osama Bin Murphy. I didn't laugh.

I planned my costume shunning the traditional Coca-Cola Clausery. I rummaged, and found myself a red plaid flannel shirt and a red T-shirt boldly printed with the word "Santa." I polished up my dad's old, bright-red, rubber gardening shoes, shaped like Dutch clogs. I'd brought home a traditional Sami costume hat, which I thought would look authentic. Everyone told me it was confusing:

"That may be how they dress Santa in Finland, but here you look like a clown." So I opted for the more recognizable stocking style with the white trim. Even this is quietly mythic, a nod to the early garb of bishops and perhaps even to the Magi, the gift givers of legend, who came from distant lands to revere a baby king.

Then disaster struck: In the holiday film previews, *Santa Clause* 2 was nowhere to be found! Quickly I scanned the trades, the Internet Movie Database, anything, for some information.

It turns out that production was delayed on the film. Disney held it back, possibly due to the writer's strike that loomed early in the year. It has been tentatively retitled *The Mrs. Claus: Santa Clause* 2 and slated for release in December 2002.

Shit.

It's at times like these that this writer has learned to improvise. My year at the movies has been full of wrong turns and cul-de-sacs, and I wasn't going to let a little thing like *the entire premise for playing Santa Claus* hold me back.

So, starting Sunday before Christmas, I whitened my hair and my beard, put on my garb, and proudly walked out of my house dressed as Santa Claus. I would attend whatever Christmas movies and holiday openers there were, and see what happened.

My God, the power. Driving down the highway that week I learned that Santa Claus has an extraordinary influence on other drivers. They get out of your way. They slow down as if you're a state trooper. And on the freeway, nobody cuts off Santa.

It was intoxicating. The awe and adulation was like that given to a rock star. Everybody waved. Kids gasped. At the supermarket, a South American woman nearly dropped her groceries and said, "Papa Noel!"

Santa Claus, Superstar. There's a danger in this because once again it belies the roots of the thing. The Christian myth springs from the life of Nicholas, Bishop of Myra in Asia Minor, now Turkey. Nicholas was a clergyman and known to be generous; the story goes that in his town was a man so poor that he'd intended to sell his daughters into prostitution. Nicholas, under cover of night, threw a sack of gold through the window of their house.

This is how legends begin. Whether or not Nicholas did this kind

deed is not nearly as important as the fact that *someone* did, and we remember it. Selfless giving in time of need is the soul of charity.

Oh, and did I see movies. Actual Christmas movies, too! *The Shop around the Corner*, a film I'd never seen, was playing at the Oak Street Cinema, and I took great joy in bouncing up to the ticket window and saying in my little Santa voice, "I'll have two please."

It's an odd thing, *The Shop Around the Corner*, set in Budapest before the war and the Communists, a sort of heavenly time for Hungary. It was remade so very badly into *You've Got Mail* that I winced as it started, but it's a lovely film really, Ernst Lubitsch at his best. It's that young handsome Jimmy Stewart, relaxed as can be, and Margaret Sullavan, who is so confident and contrary. It always amazes me that the image of a woman in a film this old can seem so current and so effortlessly sexy.

There are no miracles or magic spirits in *The Shop Around the Corner*, just a simple story about two pen pals who fall in love through the mail, oblivious to the fact that they know and despise each other in their workaday lives. But it's a smoldering spite really, like Tracy and Hepburn, and you never quite believe it. It carries the thrill of infatuation.

I love the film's warm heart; it carries a poignancy so delicate any current adaptation would shatter it. It reminds me how easy it is to be kind to a stranger and how hard it is to share that kindness with the people we know.

A gift from a stranger is a small miracle, a selfless act done without reward, and it's at the heart of Christmastime, this simple act. This is where Santa Claus lives, you know, in the quiet act of kindness to a stranger. That's why he sneaks into the house and why we never catch him at his act. We can't, the moment is gone if we catch him: a work of the heart indeed requires no witness but, perhaps, God.

Walking out of a theater that week, I passed by some kids. This was the best part of being dressed as Santa Claus: the kids. A tiny girl, couldn't have been more than three, stood agog as I strolled by, all she could get out was a whisper: "Sanna!" I gave her a nod and a wink, which became my Santa salute. Moments later I felt a grip around my

leg down below the knee. She'd run back, she hugged my shin as tight as she could, her eyes squinched closed, and she said "I love you."

How do you respond to that? There's only one way: "I love you, too."

This is why you don't mess with Santa Claus.

To play Santa Claus you must become the Holy Stranger, the hidden Gift Giver, and that, ultimately, has nothing whatsoever to do with a Disney film or the Coca-Cola Bottling Company.

Early in December as I was rooting around for appropriate Santa Claus garb, I came across my faded blue baseball cap from REI Outfitters, the very same one I'd given to the old man in the woods. I remember him putting it on and heading back into his cave. I remember coming home without it.

I don't know. You tell me. But I'm wearing the hat as I write this, and it has a different feel to it now.

It feels like a gift.

Wait a minute. It's over? So soon? No, please, so many more things to see, places to see them! Holy buckets, but this is a big world, and I'm just getting warmed up!

I didn't get to India, to Bollywood, arguably the biggest producer of movies in the world, which they should be with a billion-odd people. I didn't get to Hong Kong, birthplace of whole schools of cinema, to sit in the packed movie houses and cheer with the throngs for a movie with three rows of subtitles. I didn't get to Africa, to Stone Town, Zanzibar, to the Festival of the Dhow Countries. I missed entering my own Super-8 film at the Flicker Festival in Chapel Hill. I didn't get to

meet MPAA president Jack Valenti and ask him what the hell he actually does all day. And I ignored anime.

I so much wanted to venture into Kyrgyzstan, to see a movie projected on the side of a yurt in the high plateaus of the world's most remote inland country, under the stars' caravan. Committing myself to a movie every day meant that I couldn't venture as far afield as I might have hoped.

I don't mind. The best thing that could have happened this year did happen: I enjoy going to the movies again. I enjoy it more because I'm a smarter, pickier moviegoer. But I'm also a braver moviegoer, open to new forms, new experiences, and not afraid to complain to the management when things aren't right, and my money and time are on the line. And I'm much less a snob.

I learned that despite efforts and rumors to the contrary, the cinema is not dead, not even close. Heart pounding away, all over the globe. From the very bottom, where the energy of moviemaking begins in smoky college bars, where budding moviemakers show their stuff to each other, digital cinema is making access to tools cheap, artists are emerging, and a lot of fun is being had. Digital techniques are bringing us films from places with little voice on the world stage, and my hope is we'll hear them, and once again the tired art will have a profound benefit for us, as an audience and as plain old people. While in outposts as far-flung as the South Pacific and the Australian outback, the old ways are preserved by pure passion and eight-gauge wire. Film will not soon die.

And there are other signs of hope, closer to home. I've been frequenting the new local googolplex, the Megastar 16, five minutes from my home, and, boy, have I been surprised. While tired holiday films molder in their auditoria, The Megastar is featuring two true independents and two foreign-language films—with subtitles! Subtitles in the suburbs, and it isn't *Crouching Tiger!* Oh, sweet hope, take flight in my heart.

My friends and family have asked, "Are you ready for the year to end? Aren't you tired of it?" Then my dear friend Judy came right out and said, "You're gonna miss it, aren't you?"

Of course I'm gonna miss it. The cinema is a miracle. Great drama, humor, sound, and spectacle, image and motion, all malleable, all portable, seen in a crowd, the world shown to the world, our modern circus, our timeless stage. It can be crudely assembled or finely polished, but it all has the potential to thrill me. I know full well I won't be going to see a movie every day, at least I don't plan on it. . . .

Well, now *Kandahar* opens this week at the Uptown, gotta see that. *Gosford Park* sits waiting at the Lagoon, that's a good one for a night out with a fancy dinner; I'd love to take T.J. to see his first IMAX film, though he might explode from the excitement; *Lantana* will no doubt bring me back to Australia, *Night of the Hunter* opens at the Oak Street Cinema next week, *The Third Man* at Grumpy's on Monday, and the Egyptian in Los Angeles, my favorite theater in the whole United States, is showing the restored print of *2001: A Space Odyssey*, almost reason enough to get on a plane.

Excuse me, I think I have to take in a movie.

Many, Many Thanks

This book would not exist without the support of friends and family at home, the cooperation of many movie theater owners and managers, and the gracious hospitality shown to me by movie lovers in many countries.

First and foremost, immense gratitude and most heavenly blessings to my beloved Jane, friend and partner, who encouraged me from the outset and supported me, spiritually and financially, through the entire year.

Thanks and all love to my brother Chris, whom I name *Shri-shri Guru Mahavirachristopher-ji*; my muse, teacher, philosopher-at-large, and the finest writer I have ever known.

To my second parents, my in-laws, Jim and Kay Wagner, who travel with me in spirit wherever I go, who clip every article, and who are directly responsible for putting me onto two of my destinations, the Hotel du Glace in Quebec and the Giant Travel Center in New Mexico, I thank you with all my heart.

Thanks to our good friends Brad and Diana, who listen to me read without flinching, and who were just mad enough to invite me to the midnight screening of *Harry Potter* and had the good sense to be disappointed.

Thanks to all my siblings: my brother Brian, who this summer accompanied me back to my childhood; my sister, Kathleen, who reads my writing with a keen eye and who has been my biggest fan since I first stepped on a stage; my brother Matthew, who gets all my jokes and has the good grace to laugh at them; and my brother Buzz, who once drove five hundred miles in six hours just to congratulate me.

Thanks to Tom and Vicki, friends in fun and in the dharma, for their outrageous hospitality in Italy.

Thanks, and flowers, to all of my movie dates: Bridget Jones Nelson, Angela Donlon, Diana Teodorescu, Nancy Stewart, and Kay Wagner. Such ladies they are.

Thanks to Jeff Stonehouse, cinematographer and friend, the reincarnation of Huck Finn.

Immense thanks to Peter Rudrud for his sheer love of movies and for loaning me his reels of film noir, and to the City Club Cinema—may it always have a place on Monday nights at Grumpy's Bar.

Thanks to Andrew Walton for his endless energy, his keen mind, and his humor. Direct a feature, Andrew.

Thanks to Murray Glass and EmGee Film Library, for trusting me to leave the country with his treasured 16mm Laurel and Hardy films.

Tremendous thanks to my editor at HarperCollins, Tom Dupree, who said yes to this whole idea, guided me through my initial panic, and made it possible. Thanks also to ace editor April Benavides, who handled all my neurotic misgivings with care and aplomb.

Thanks to Christi Cardenas and Jonathon Lazear at the Lazear Agency for helping me above and beyond the call of duty.

Thanks to Rick Leed, perhaps the most normal person in Beverly Hills.

Thanks to Randy Adamsick, Georgianna Day, and the Minnesota Film Board, a tremendous resource and fine people to boot, for helping me at the very outset.

Thank you, Michael J. Nelson, for sharing the pain that was *Corky Romano*.

Thanks to Dan Long, Landmark Theaters' master projectionist in Minneapolis, for his care and his craft.

Thanks to Douglas Crosby, stunt man, New Yorker, movie lover, and friend. One of the real movie stars.

Thanks to Cis Bierincx at the Walker Art Center, a thoughtful and daring film curator, who deserves far more credit than he gets in the pages of this book.

Thanks a million to Hugh Wronski and the staff of the Uptown and Lagoon Cinemas, for letting me hang around and renewing my hope in small cinemas.

Thanks to Colin Covert at the *Minneapolis Star Tribune* for his invaluable help and his candor.

Thanks to Richard Corliss, the coolest film critic I've ever met, for letting me sit with him at Cannes.

Thanks to Darren Bird, owner of the Terrace Cinema, Tinonee, New South Wales, Australia, for your help, your passion, and your excellent little theater, the smallest in the world and one of the friendliest. I'm calling the Guinness boys in your name.

Much thanks to Ron and Mandy West, owners of the Majestic Theatre in Pomona, Queensland, for your warm hospitality and your candor. Congratulations to you for keeping silent cinema alive and thriving in Australia. I'll be back.

Muchas gracias to the village of Troncones, Guerrero, Mexico, where I want to die. To Jim and Eva for allowing me to show films at their cantina, and to Christian for the fantastic food and the Habanas. But most especially to Vladimir, *mi amigo veridad*, the finest restaurateur in all of Mexico. *El que es generoso será bendecido, pues comparte su comida con los pobres.* (*Proverbios* 22.9)

Thanks Dr. Bruce Lindberg for examining my back and neck after a week in the front row, and his quite helpful advice on how not to ruin my body while watching hundreds of movies.

Thanks and aloha to Jim Bruce, for sharing his house in Rarotonga and sharing his heart during the week of September 11 when we both felt so far away from home.

Thanks and *kia manuia* to Harry, Piltz, Jeff, the whole Napa clan, and the staff of the Empire Cinema, Avarua, Rarotonga, Cook Islands. I hope you beat those damnable pirates.

And, finally, a very special thank you to my nephew T. J. Donlon, for helping me to look at the movies like a wide-eyed kid again.